WALTHER BERNT

The Netherlandish Painters of the Seventeenth Century

II

The Netherlandish Painters

WALTHER BERNT

of the Seventeenth Century

Three volumes · 800 artists · 1460 reproductions

Volume Two

PHAIDON

All rights reserved by Phaidon Press Ltd.
5 Cromwell Place, London S.W. 7
First published 1970

Phaidon Publishers Inc., New York
Distributors in the United States:
Praeger Publishers, Inc.,
111 Fourth Avenue, New York, N.Y. 10003
Library of Congress Catalog Card Number: 76–105963

TRANSLATED
FROM THE THIRD GERMAN EDITION
BY P.S.FALLA

Heem, Cornelis de

b. Leiden 1631,
d. Antwerp 1695
490, 491

Flemish still-life painter, pupil of his father Jan Davidsz. de Heem, to whom he comes very close in his best work. His range of subjects is the same : bouquets of flowers, fruit with tendrils, vessels, table-ware and cutlery, less often breakfast still lifes. The composition is similar to his father's, but the colours are cooler, harder and less harmonized. His many pictures are for the most part signed but not dated, and were as a rule attributed to his celebrated father, with whose imitators (see Jan Davidsz. de Heem) he is often confused.

Literature: M. L. Hairs, *Les Peintres flamands de fleurs*, Brussels, 1955.

Heem, Jan Davidsz. de

b. Utrecht 1606,
d. Antwerp 1684
492, 493, 494, 495

Important Dutch-Flemish still-life painter; pupil of B. van der Ast, whose work he recalls in his first, economically composed pictures of bowls of fruit. In his early period he painted *Vanitas* still lifes in brown and grey yellow, the composition being well thought out though apparently casual : piles of books, writing materials, musical instruments, a skull, an hourglass and candle. At that time he belonged to the group around Harmen van Steenwijk, Pieter Potter and P. Claesz, which was influenced by Rembrandt. Later he came under the influence of the Flemish artist Daniel Seghers and reached his peak as a still-life painter, combining in an extremely well-balanced composition bouquets of flowers and baskets of fruit with various eatables, sea-creatures, costly ornamental vessels and glasses, often with flowers and foliage strewn amongst them. Birds, insects, musical instruments and clocks are reproduced perfectly; his work is characterized by the impasted, rugged surface of orange and lemon peel. Green or rich red curtains often form the background. Sometimes there is a view of a landscape or of the sea. The colours are elegant and harmonious, becoming more varied and striking in their effect in his later period. His comprehensive work forms a bridge between Flemish and Dutch painting. He is known to have collaborated with other artists such as Daniel Seghers, J. Lievens and N. van Verendael. Among his many pupils were his son Cornelis de Heem, P. de Ring, A. Coosemans, A. Mignon, M. van Oosterwyk and Jakob Rootius; among his imitators, E. van den Broeck, J. de Claeuw, J. P. Gillemans, J. Hannot, J. van Kessel, Cornelis Kick, J. Mortel, M. Simons and Joris van Son.

Literature: M. L. Hairs, *Les Peintres flamands de fleurs*, Brussels, 1955; I. Bergström, *Dutch Still-Life Painting*, London, 1956; E. Greindl, *Les Peintres flamands de nature morte*, Brussels, 1956; "J. D. de Heem," *Oud Holland*, 1956, LXXI, pp. 173–83.

Heemskerck, Egbert van

b. Haarlem 1634/35,
d. London 1704
496, 497

Haarlem painter of genre and peasant scenes : follower of Jan Miense Molenaer and pupil of P. de Grebber. His strong local tones show the influence of A. Brouwer, and his best pictures have often been ascribed to the latter as well as to J. M. Molenaer and, less frequently, J. Steen. His work is very uneven in quality; he depicts inn rooms with peasants eating, drinking or brawling, less often witches, the Temptation of St Antony, sermons or judgements. His son of the same name painted in a similar style, and their pictures are hard to tell apart.

Heeremans, Thomas

active at Haarlem 1660–1697
498, 499

Haarlem landscape painter and follower of Claes Molenaer. His canal landscapes and beach and river scenes in summer and winter are somewhat coarse and animated with numerous sketchily drawn figures. He often painted the beach at Scheveningen and the village and ruins of Egmond. His pictures frequently go in pairs. His winter landscapes might be mistaken for those of Claes Molenaer. His village streets in summer, with people halting at an inn, resemble the work of B. Gael. His signature is usually contracted into the form THMans or THeere-Mans.

Heerschop, Hendrick

HEERSCHOP
1672

b. Haarlem 1620,
d. there after 1672
500

Haarlem genre painter, pupil of Willem Claesz. Heda. His bourgeois interiors, which are somewhat sketchy but full of variety, usually show doctors, alchemists and painters at work. Themes from classical history and the Bible are rarer. He is unsuccessful with faces and the drawing of bodies. He often signed his pictures, but in many cases the signature was removed so that his works could be attributed to better-known Dutch interior painters.

Hees, Gerrit van

d. Haarlem 1670
501

Haarlem landscape painter of Jakob van Ruisdael's circle: he recalls the latter's early work in his dune landscapes with trees blown about by the wind, lonely peasant cottages beside a

sandy path, or inns by a small stream. Although patches of sand are clearly lit up, the tonality in general is more monotonous and less imaginative. He can easily be distinguished from his master by the awkward painting of the rather insignificant staffage figures. His work may occasionally be confused with that of C. Decker or G. Dubois.

Heil, Daniel van

b. Brussels about 1604,
d. there 1662

502, 503

Brussels painter of landscapes, fires and winter scenes. The Flemish character of the landscapes is emphasized by the fantastic architecture of the towns with their tall churches and towers. The large paintings of fires by night are sometimes diversified by classical or mythological figures. The monogram with which he usually signed has led to confusion with the Dutch painter D. Verhaert.

Literature: Y. Thiéry, *Le Paysage flamand*, Brussels, 1953.

Helmont, Mattheus van

b. Antwerp 1623,
d. Brussels after 1679

504, 505

Flemish genre painter and follower of A. Brouwer and D. Teniers. He painted peasant interiors, alchemists, doctors and craftsmen at their work, less often village poultry and vegetable markets. His brightly coloured figures are coarse in type and sometimes borrowed from the above-mentioned masters. He occasionally contributed figures to the landscapes of J. d'Arthois. He recalls J. van Craesbeeck and A. van Tillborgh by the similarity of subject-matter and dependence on the same models. His signature, which was frequent, has often been removed for purposes of forgery.

Literature: F. C. Legrand, *Les Peintres flamands de genre*, Brussels, 1963.

Helst, Bartholomeus van der

b. Haarlem 1613,
d. Amsterdam 1670

506, 507, 508

Important Amsterdam painter of individual and group portraits; pupil and imitator of N. Elias. His portraits betray an acquaintance with Hals and Rembrandt; the sitters have an animated, speaking expression. He shows much invention in devising new, decorative groupings, and his large family portraits and groups of archers and regents are harmoniously composed. The figures and accessories are seen in plastic fashion in a clear, uniform light. He was the favourite painter of the Amsterdam councillors and senior officials, whose portraits he drew with accuracy. His later style is more full of colour and contrasts, with sharper opposition of dark and blond tones; compared with his earlier, quiet and matter-of-fact treatment, the poses are now more elegant and elaborate. The landscape backgrounds to his portraits were sometimes painted by Jan Baptist Weenix, and the sea and harbour backgrounds by L. Backhuysen or Willem van de Velde. He influenced the later work of G. Flinck and F. Bol. Among his direct followers were his son Lodewyck, A. van den Tempel and N. de Helt-Stocade; he also influenced P. Hennekyn, J. van Noordt and W. Vaillant.

Literature: J. J. de Gelder, *B. van der Helst*, Rotterdam, 1921; N. MacLaren, *National Gallery Catalogues, Dutch School*, London, 1960, p. 153.

Helst, Lodewyck van der

b. Amsterdam 1642,
d. there about 1682

509

Portrait-painter and pupil of his father B. van der Helst, in whose studio he worked; at that time his painting resembled his father's. Later, in accordance with the fashion of the time, he introduced richer accessories and a cooler tonality. He generally used the monogram LVH. His pictures are rare: some are at Amsterdam, Budapest and Utrecht. There is also record of a still life of 1669, signed in full.

Helt-Stocade, Nikolaes de

b. Nijmegen 1614,
d. Amsterdam 1669

510, 511

Dutch portraitist and landscape painter. His early paintings, mostly small landscapes in the style of the Utrecht school (C. van Poelenburgh), with mythological female nude figures or Biblical scenes, are rare. Later he painted large decorative pictures in the Italian, academic style, in the manner of J. van Bronchorst, Caesar van Everdingen and J. van Loo: Biblical themes and mythological compositions with large figures. His later portraits recall B. van der Helst or A. van den Tempel, but show stronger light effects.

Literature: M. W. Moes, "N. van Helt-Stocade," *Amsterdamer Jaarboek*, 1902, pp. 69–105; L. Demonts, "N. de Helt-Stocade," *Revue de l'Art ancien*, LXVIII, 1935, pp. 69–84.

Hennekyn, Paulus

b. Amsterdam about 1611,
d. 1672

512, 513

Amsterdam painter of still lifes and portraits. The latter show the influence of B. van der Helst, but are plainer and less spontaneous in expression. His rare still lifes also recall W. Kalf and are closely related to the work of Willem Claesz Heda. His son David, who also worked at Amsterdam, is reported to have painted still lifes.

Herp, Willem van

b. Antwerp 1614,
d. there 1677

514

Antwerp genre painter in the later succession to Rubens. He shows the latter's influence and especially that of J. Jordaens. His interiors, showing domestic occupations or meals, have a personal style despite the influences visible in them. As regards subject-matter only, he has links with G. van Tilborgh, M. van Helmont and J. van Craesbeeck. He occasionally provided staffage figures for landscapes by J. d'Arthois and church interiors by D. van Deelen.

Literature: L. van Puyvelde, "W. van Herp," *Zeitschrift für Kunstgeschichte,* 1959, p. 362; F. C. Legrand, *Les Peintres flamands de genre,* Brussels, 1963; G. Martin, *National Gallery Catalogues, Flemish School,* London, 1970, p. 82.

Heusch, Jakob de

b. Utrecht 1656,
d. Amsterdam 1701

515 516

Dutch landscape painter, pupil and imitator of his uncle Willem de Heusch. In Italy he also painted in the style of Salvator Rosa. His signature resembles his uncle's and they are often confused.

Heusch, Willem

b. Utrecht about 1618,
d. there 1692

517

Utrecht landscape painter, imitator and probably pupil of Jan Both, whom he closely resembles; however, his material – Italianate landscapes – shows less variety and the sunlight is less brilliant. He is notable for the personal style of his minutely depicted foliage. Like his nephew Jakob (Giacomo), he used an Italianized signature – Guglielmo de Heusch – and confusion is frequent as both Christian names were abbreviated to G. In subject-matter and style he resembles W. Schellincks, also of Both's school. J. Lingelbach occasionally supplied him with staffage figures of great verisimilitude.

Heyden, Jan van der

b. Gorkum 1637,
d. Amsterdam 1712

518, 519, 520, 521, 522

Important Dutch painter of architecture, landscapes and still lifes. His best pictures are views, mostly small, of squares and streets, in which the façades of houses and churches are drawn with great care and accuracy of perspective and the masonry is treated with especial delicacy. The composition is very thorough and the distribution of light and shade is excellent. Atmosphere is closely observed, and the effect of depth is strengthened by large figures standing in the shade of a dark foreground and contrasting with the sunny middle distance. (Many of the figures in his early works were supplied by Adriaen van de Velde.) His city scenes, squares and churches are only in part topographically accurate: to improve the composition, he sometimes combined the architecture of different towns or reversed the appearance of buildings left to right. Leafy trees are skilfully introduced. In his later pictures landscape plays a more important part relative to architecture: some of them show in particular minutely detailed painting of foliage and individual bricks, the joints in the masonry being reproduced in strikingly exact proportion. He resembles the delicate painters of Leiden in his excellent still lifes, which belong to the end of the century: a globe and books in the corner of a room, on a table covered with a carpet. On account of the similarity of subject, confusion with Gerrit Adriaensz. Berckheyde is frequent. He shares with the older E. Murant his detailed manner of reproducing brickwork. His many eighteenth-century imitators and artistic heirs can be distinguished from him by their less refined treatment of architecture as well as by the later costumes.

Literature: C. Hofstede de Groot, *Catalogue raisonné,* vol. VIII, Esslingen, 1923; J. van der Heyden exhibition catalogue, Amsterdam, 1937; N. MacLaren, *National Gallery Catalogues, Dutch School,* London, 1960, p. 156; W. Stechow, *Dutch Landscape Painting of the Seventeenth Century,* London, 1968

Hilligaert, Pauwels van

b. Amsterdam 1595,
d. there 1640

523, 524

Dutch painter of histories and battle-pieces. In 1639 he was painted by N. Elias in a group portrait of the Amsterdam civic guard. His themes include historical and political events of the time, battles, sieges and portraits of Prince Maurice and the subject-matter and style he resembles W. Schellincks, also of

Count Palatine, Frederick Henry, seen on horseback with their suites. He is a skilful painter of horses and riders, and the landscape and buildings in the background are depicted accurately. He was best known for his cavalry fights and raids and camps of cavalrymen, which resemble those of J. Martsen de Jonge. The character of his landscape is similar to that of E. van de Velde. He is said to have painted the staffage figures for a woodland landscape by A. Keirincx (Boymans–Van Beuningen Museum, Rotterdam).

Hobbema, Meindert

b. Amsterdam 1638,
d. there 1709
525, 526, 527, 528

Important Amsterdam landscape painter, pupil of Jakob van Ruisdael. Under the influence of Ruisdael's early work he painted the wooded dunes around Haarlem and water-mills with pale red roofs under tall trees in the eastern, wooded part of Holland; less often ruins or town scenes. His master's themes were more numerous: Hobbema painted no seascapes, beach scenes, flat or mountainous landscapes. His motifs, especially in the landscapes with watermills, show a certain sameness: the angle of vision varies little, the whole appears true to nature. Compared with Ruisdael, his colours are more impasted; his landscapes show more contrast of light and shade, bright and dark tints, and are richer in carefully executed detail. He is fond of painting the shimmer and reflection of silvery sunlight between the trunks of slender trees; his palette contains more yellow, fresh green and shady brown as compared with Ruisdael's grey tones. He generally painted his own figures, which are unobtrusive and somewhat awkward; less often, the figures and animals in his pictures are by Adriaen van de Velde, N. Berchem, B. Gael or J. Lingelbach. He had no successors, but around 1800 his valuable pictures were imitated and often forged, especially in England. The only painter with whom he might reasonably be confused is Jan van Kessel, who was inferior to him; less plausibly, he might be credited with works of J. Looten, C. Decker or G. van Hees.

Literature: C. Hofstede de Groot, *Catalogue raisonné*, vol. IV, Esslingen, 1911; N. MacLaren, *National Gallery Catalogues, Dutch School*, London, 1960, p. 163; W. Stechow, *Dutch Landscape Painting of the Seventeenth Century*, London, 1968.

Hoecke, Robert van den

b. Antwerp 1622,
d. Bergues 1668
529

Flemish painter of landscapes and interiors. His scenes of winter sport on the ice are animated by skilfully executed figures in delicate tones. His small pictures of soldiery, battles and camps are distinguished by the extreme elegance and sureness with which the tiny figures are drawn and by the sketchy landscape background. Less often he painted night scenes and fires.

Literature: G. Ollinger-Zinque, *Les Peintres van Hoecke*, Brussels, 1961; F. C. Legrand, *Les Peintres flamands de genre*, Brussels, 1963.

Hoet, Gerard

b. Zaltbommel 1648,
d. The Hague 1733
530

Dutch painter of genre, histories and portraits. Like G. de Lairesse, he was influenced by the French academic style of decorative painting. The many small nude figures in his small Arcadian landscapes represent mythological or Biblical characters. Less often he painted tavern interiors with peasants smoking, drinking and gambling, in the style of the Rotterdam artists Cornelis Saftleven, H. M. Sorgh and P. de Bloot. In his decorative portraits he emphasized rich clothing and accessories. His pictures are often signed but hardly ever dated.

Hogers, Jakob

b. Deventer 1614,
d. after 1660
531

Dutch draughtsman and painter of historical and Biblical scenes and portraits. He was active at Deventer until 1642; according to tradition he went to Italy, but there is no proof of this. He was originally influenced by Rembrandt, but in 1640–5 was more affected by the Haarlem school: P. de Grebber, G. Cl. Bleker and Salomon de Bray. He painted Old and New Testament scenes with large figures; in his later work, as with Cl. Moyart, light and shade effects became more striking (*Reconciliation of Jacob and Esau* in the Rijksmuseum, Amsterdam). An elegant outdoor family group by him was once attributed to G. de Lairesse. Both as painter and as draughtsman Hogers preserved a personal quality that distinguishes his work from the later academic style of many other artists influenced by Rembrandt. About thirty of his pictures and drawings are known.

Literature: B. J. A. Renckens, *Oud Holland*, LXX, 1955, pp. 51–66.

Holsteyn, Cornelis

b. Haarlem 1618,
d. Amsterdam 1658
532

Amsterdam history and genre painter who belonged to the academic group around Jan de Bray and Caesar van Everdingen. Flemish influence is visible in his large figure paintings, mostly

of genre type and mythological or Biblical in subject, as well as in his occasional pictures of children dancing. His pleasant female nudes are slightly reminiscent of Rubens and Jordaens; they are correctly drawn and effective from the painterly point of view.

Hondecoeter, Gillis Claesz. de

b. Antwerp about 1570,
d. Amsterdam 1638

533, 534

Amsterdam landscape painter of the early period. His woodland scenes, with old misshapen tree-trunks and tangled roots, are diversified by animals of all kinds; Noah's ark and Orpheus followed by wild beasts are favourite themes of his and were also used by R. Savery, whose pupil he probably was. He also recalls Savery by the yellowish–green tones of his rocky landscapes with irregularly growing trees. Less often he painted open landscapes in the manner of Esaias van de Velde. He is sometimes confused with his son Gysbert de Hondecoeter, who painted landscapes and poultry.

Literature: W. Stechow, *Dutch Landscape Painting of the Seventeenth Century*, London, 1968.

Hondecoeter, Gysbert de

b. Amsterdam 1604,
d. Utrecht 1653

535

Dutch painter of landscapes and poultry, the son and pupil of Gillis Claesz. de Hondecoeter. He began by painting birds, especially water-fowl and nesting hens, in a somewhat mannered style like that of R. Savery; later, in a realistic fashion more like his contemporary Aelbert Cuyp. However, his pictures are sketchier, with weaker light effects and less atmospheric depth than those of his model. In comparison with the more striking work of his son Melchior, his pictures are more tonal and lacking in drama, but they are powerful in their truth to nature. His later pictures of poultry are successful and were often ascribed to Aelbert Cuyp. His son, the famous Melchior d'Hondecoeter, was his pupil.

Hondecoeter, Melchior de

b. Utrecht 1636,
d. Amsterdam 1695

536, 537

Important Dutch painter of birds and still life; pupil of his father Gysbert de Hondecoeter and his uncle Jan Baptist Weenix. He painted the most varied kinds of native and exotic birds–

poultry, waterfowl and birds of rare plumage, including peacocks, in a lively style and decorative composition. Drama is provided by cockfighting and the attacks of birds of prey. Less often he painted concerts or allegories involving birds, still lifes of dead poultry or gamebirds with hunting gear in the style of Jan Baptist Weenix. Architectural features and distant views of landscape are skilfully introduced. He was exceptionally prolific, and by his masterly reproduction of brightly-coloured plumage became the acknowledged master of Dutch bird-painting, imitated on all hands even during his lifetime. Most of his pictures are signed. Painters in a similar style, but not imitators of his, were Dirk Valkenburg, Jan and Jacob Victors and C. de Ryck. Pictures of poultry and ducks by Gysbert de Hondecoeter, which are in a different style, are also often ascribed to his more famous son.

Literature: N. MacLaren, *National Gallery Catalogues, Dutch School*, London, 1960, p. 176.

Hondius, Abraham

b. Rotterdam about 1625,
d. London 1695

538

Rotterdam painter of landscapes with animals and, occasionally, human figures. He excels at depicting savage fights between animals, with great truth to nature and in bright, fresh colours. The style of his boar and stag hunts, which are less frequent, shows Flemish influence (J. Fyt and F. Snyders). He also occasionally painted genre pictures and conversation pieces in the manner of Anthonie Palamedesz., as well as Biblical scenes. He may be confused with A. Beeldemaker, who painted dogs, and C. B. A. Ruthart, the German painter of animals.

Literature: B. Rapp, "A. Hondius," *Oud Holland*, 1949, pp. 65–70; A. Hentzen, "A. Hondius," *Jahrbuch der Hamburger Kunstsammlungen*, VIII, 1963, pp. 33 ff.

Hondt, Lambert de

b. before 1620,
d. Malines before 1665

539, 540

Flemish painter, active at Malines; nothing else is known of his life. He painted landscapes, full of trees and green or grey in tone, with herdsmen and cattle; they are often enlivened with fights between small figures on horseback. These are so reminiscent of D. Teniers that de Hondt has often been regarded as a pupil or successor of his. The landscapes in question resemble, by their subject, P. Snayers and the somewhat later P. Meulener. De Hondt's pictures are often listed in sale catalogues of the eighteenth and nineteenth centuries. He often signed D. Honnt.

Literature: F. C. Legrand, *Les Peintres flamands de genre*, Brussels, 1963.

Honthorst, Gerard van

b. Utrecht 1590,
d. there 1656
541, 542, 543, 544

Honthorst fc

Active in The Hague: he and his master Abraham Bloemaert are the chief representatives of the Utrecht academicians who painted large compositions after Caravaggio and under Rubens' influence: Biblical incidents, mythology and allegory, genre pictures of soldiers and half-length studies of card and violin players, also merry companies, often by candle-light. Naively cheerful figures are skilfully grouped around a source of light so that some are brightly illuminated and others are in deep shadow. In his portraits and less frequent imaginary figures he imitates the externals of the Van Dyck style: slim hands with long fingers and pale, smooth faces. His brother Willem van Honthorst occasionally worked with him; both their signatures include the G of their Italianized Christian names. Confusion is possible with the other Utrecht Caravaggists such as D. van Baburen, J. G. van Bronchorst, J. van Bylert and Th. Rombouts.

Literature: J. G. Hoogewerff, *G. van Honthorst*, The Hague, 1924; J. R. Judson, *G. van Honthorst*, The Hague, 1959; N. MacLaren, *National Gallery Catalogues, Dutch School*, London, 1960, p. 178.

Honthorst, Willem van

b. Utrecht 1594, d. there 1666
545

Honthorst

Dutch portraitist and historical painter, pupil of Abraham Bloemaert and Gerard van Honthorst, with whom he collaborated. He painted in exactly the same style as his brother, but with less power. His portraits are often framed in an oval. As both he and his brother signed G. Honthorst (in his case Guglielmo), their works can only be distinguished on grounds of date or quality.

Literature: H. Braun, *Gerard und Willem van Honthorst*, Göttingen, 1960.

Hooch, Carel Cornelisz. de

d. Utrecht 1638
546, 547, 548

Chaerles. D. hooch. 1627

Dutch landscape painter, draughtsman and etcher, father of P. de Hooch; known to have been at Haarlem about 1628. He travelled in Italy and stayed for a time in Rome. In 1633 he was a master in St Luke's guild at Utrecht. His landscapes with ruins, grottoes, catacombs and the Baths of Titus near Rome show strong Dutch realism mingled with a Flemish strain, and resemble the work of his Utrecht fellow-artists P. van Hattich and R. van Troyen, C. van Poelenburgh and A. van Cuylenborch. His pictures are often mentioned in old inventories, but as he had many

namesakes confusion was frequent from an early date. Today about forty of his pictures are known.

Literature: C. F. van Aspermont, *Oud Holland*, XVII, 1899, pp. 223–7, with list of his works.

Hooch, Horatius de

d. Utrecht 1686
549

HD·Hooch·Anno·1652

Dutch landscape painter; in 1669 chairman of the guild at Utrecht, which was the main scene of his activity. His Italianate landscapes with antique buildings and ruins suggest that he stayed for a time in Italy. His cool, greenish-grey colours distinguish his work from that of B. Breenbergh, which resembles it in subject but is mainly golden in tone. There is a typical Italian landscape by him in the National Museum at Stockholm. His pictures are very individual in colour and atmosphere and show a good sense of perspective. Nevertheless they are often confused with those of the numerous other Utrecht painters of the same name.

Literature: C. Hofstede de Groot, *Oud Holland*, XIII, 1895, pp. 40 ff.

Hooch, Pieter de

b. Rotterdam 1629,
d. after 1683
550, 551, 552

P. d hooch f. 1670.

Important Dutch genre painter, pupil of N. Berchem, whose use of colour and treatment of light he recalls in his early landscapes with mounted figures. His later guard-room scenes, stable interiors and gamblers with young girls recall L. de Jongh but are more richly coloured: bright lemon-yellow, glowing red and brilliant white. Compared with the negligently drawn figures, perspective also plays a minor role. In his later work the importance of space is enhanced by stronger colouring and warm golden sunlight, or again, in his Dutch bourgeois interiors, by the few, rather faintly characterized figures, such as a maid or a mother and child, engaged in quiet domestic occupations. The masterpieces of this middle period are filled with a sunny and harmonious sense of well-being. The brushwork is tender and fluent without ever seeming trivial; the paint is laid on so thinly as to be often transparent. The surface of materials is reproduced in a most lifelike manner. In his later works he depicted the sumptuous houses of the well-to-do Amsterdam merchants and also stately apartments that can scarcely have existed in reality; he is fond of showing the view of a sunny canal from a dark antechamber. But in his final stage the balanced colour-scheme, the sense of depth that was formerly so convincing, and above all the clarity of drawing, are less in evidence; the shadows become opaque, and unpleasing blue tones appear in the representation of flesh. He is on a par with Carel Fabritius and Jan Vermeer of Delft. He had no pupils; Pieter Janssens Elinga was a

contemporary imitator, and H. van der Burch comes close to him. The landscapes and interiors of the versatile L. de Jongh have very often been attributed to P. de Hooch. Painters who derive from him include E. Boursse, I. Koedyk, C. de Man, J. Vrel and finally C. Bisschop. Occasionally E. de Witte painted similar interiors. J. Ochtervelt was influenced by P. de Hooch's later work.

Literature: C. Hofstede de Groot, *Catalogue raisonné*, vol. I, Esslingen, 1907; A. de Rudder, *P. de Hooch*, Brussels, 1914; C. Brière-Misme, "P. de Hooch," *Gazette des Beaux-Arts*, 1927, XVI, II; W. R. Valentiner, *Klassiker der Kunst* series, Stuttgart, 1930; F. van Thienen, *P. de Hooch, palet* series, Amsterdam, 1945; N. MacLaren, *National Gallery Catalogues, Dutch School*, London, 1960, p. 183.

Hoogstraten, Samuel van

b. Dordrecht 1627,
d. there 1678
553, 554

Dordrecht painter of genre, histories and portraits; pupil of Rembrandt, whose influence is most marked in Hoogstraten's Biblical pieces. His genre paintings with a few well composed figures are more reminiscent of P. de Hooch, G. Metsu and J. Steen, with particular emphasis on details of a still life type, but with duller lighting and less colour. City squares such as the Innerer Burghof in Vienna are accurately rendered; his numerous pillared halls belong to the architecture of fantasy. His versatility is shown in landscapes and still lifes, and in numerous portraits of aristocratic families of The Hague and Dordrecht: the earlier of these belong to the school of Rembrandt. His later portraits are inferior to those of the fashionable painters P. Nason and J. de Baen. Among his pupils were A. de Gelder and G. Schalcken.

Literature: N. MacLaren, *National Gallery Catalogues, Dutch School*, London, 1960, p. 191.

Horst, Gerrit Willemsz.

b. Amsterdam about 1613,
d. about 1652
555, 556

Dutch painter of historical and still-life subjects, pupil of A. de Lust. He recalls Rembrandt by the chiaroscuro of his Biblical and historical pieces, but his range of colour is confined to yellowish brown. His rare still lifes—bowls of fruit, rummers and vessels of precious metal on crumpled tablecloths—belong to the school of W. Kalf and thus resemble works by J. van Streeck and C. Striep.

Literature: W. R. Valentiner, "Zum Werk G. W. Horsts," *Oud Holland*, L, 1933, pp. 241–9.

Houbraken, Arnold

b. Dordrecht 1660,
d. Amsterdam 1719
557

Dutch painter, etcher and art critic. In 1672 he was apprenticed to W. van Drielenburch; later he was a pupil of J. Levecq and, from 1674 to 1678, of S. van Hoogstraten at Dordrecht. In 1710 he went to Amsterdam. He was open to a variety of influences and took themes from the Bible, history and allegory, which he treated in eclectic fashion. His compositions, based on theoretical rules, have a smooth, staid effect, similar to that of his contemporaries G. Hoet and G. de Lairesse. Through his master S. van Hoogstraten he underwent the influence of Rembrandt. His portraits of clergymen and scholars circulated in engravings. He also painted small genre pieces and academic landscapes, and was very active as an etcher. He is especially known for the three-volume work published at the end of his life, *De Groote Schouburgh* (The Great Theatre), which was planned as a continuation of C. van Mander's *Book of Painters*. Though cursory in many places it is a valuable source-book for Dutch seventeenth-century painting.

Literature: W. Suida, *Art in America*, XXXII, 1944, pp. 5–11.

Houckgeest, Gerrit

b. The Hague 1600,
d. Bergen op Zoom 1661
558, 559

Delft painter of church interiors in the style of his fellow-townsmen H. van Vliet and E. de Witte. Like them, he is distinguished from earlier Antwerp church-painters by picturesque slanting views and the closeness of the spectator to the object. In his youth he followed the style of B. van Bassen, whose pupil he probably was. He painted imaginary churches, spacious Renaissance buildings and church scenes with small Biblical figures, in somewhat gloomy brownish tints and from a frontal aspect. Later he produced a more intensive effect of space by means of skilful perspective and by bringing the spectator closer to the scene. The figures, mostly depicted standing and from the back, thus became larger and more important. Warm yellow sunlight plays on the white walls and pillars with escutcheons, which are painted with great realism. About thirty of his works are known today; the small cabinet-size pieces are most highly valued. The colouring is less warm and tonal than that of H. van Vliet, but less cool than in the work of P. Saenredam.

Literature: H. Jantzen, *Das Niederländische Architekturbild*, Leipzig, 1910.

Houckgeest, Joachim

b. The Hague about 1580,
d. before 1644

560

Rare Hague portraitist, influenced by Frans Hals, in the style of M. J. Mierevelt and J. A. Ravesteyn. An elegant portrait of an ensign by him is in the Municipal Museum at The Hague, and he also painted two groups of civic guards. His only known religious picture shows links with the school of Utrecht.

Huchtenburgh, Jan van

b. Haarlem 1647,
d. Amsterdam 1733

561

Dutch battle-painter in the service of Prince Eugene; pupil of Th. Wyck. His cavalry engagements, parades, scenes of the camp, raids and hunting are distinguished by the excellent depiction of horses. In technique he is closest to his more elegant master A. F. van der Meulen, but also shows the influence of Philips Wouwerman; however, he is inferior to the latter owing to his cursoriness and too sharp contrasts of colour. The frequent repetition of particular motifs points to routine rather than invention. His numerous pictures, in both large and small sizes, have a tendency to darken. D. Maas is considered to have been his pupil and imitator. Huchtenburgh also occasionally contributed figures to pictures by Gerrit Adriaensz. Berckheyde and Isaac de Moucheron.

Literature: N. MacLaren, *National Gallery Catalogues, Dutch School*, London, 1960, p. 195.

Hullegarden, Carel van

active by 1647,
d. The Hague 1669

562, 563

Dutch still-life painter, known to have been at The Hague in 1656, 1658 and 1669. His breakfast still lifes with a brightly lit wall behind recall W. C. Heda and especially C. Kruys. His still lifes of vegetables, artichokes and game are painted in broad strokes and show a Flemish strain.

Hulsdonck, Jakob van

b. Antwerp 1582, d. 1647

564, 565

Flemish painter of fruit still lifes on wooden boards. He is characterized by cool, contrasting colours and naive composition. The picture-surface is broken up by bowls piled high with fruit; more fruit lies scattered on the yellow-grey table-top, with branches and drops of water. The pictures of this group recall F. Ykens; confusion with O. Beert is also possible. Besides this painter, who still belongs to the primitive Flemish school, there must have been a Dutch artist of the same name in the later, more developed period, to whom we should ascribe the richer and carefully composed flower and fruit pieces and breakfast tables (works at Brunswick, Schleissheim and Berlin).

Literature: E. Greindl, *Les Peintres flamands de nature morte*, Brussels, 1956.

Hulst, Frans de

b. Haarlem about 1610,
d. there 1661

566

Haarlem landscapist in the manner of Jan van Goyen and Salomon van Ruysdael. His diagonally composed river scenes, with a distant prospect on one side and the silhouette of a town or castle high up on the other, have an olive-green or brownish tonality. Later they tend to become dark brown and are then closer to Roelof van Vries. Many of Hulst's better works were ascribed to J. van Goyen; occasionally they resemble S. van Ruysdael. He may be confused with the Haarlem painter W. Knijff.

Hulst, Maerten Fransz. van der

active in 1630,
d. Leiden 1645

567

Dutch landscape painter and etcher, member of St Luke's guild at Leiden, whose landscapes and beach scenes are similar in type to those of S. van Ruysdael, J. van Goyen and G. Dubois. His technique is characterized by minute detail, with delicate dots and strokes, yellow and green in tone. Many of his works may still be among the early golden-toned landscapes attributed to A. Cuyp. He was probably a relative of the Haarlem landscapist Frans de Hulst. In the Lakenhal museum at Leiden there is a picture of his showing fishermen selling their wares on the beach.

Literature: C. Hofstede de Groot, *Burlington Magazine*, XLII, 1923, p. 16; C. Hofstede de Groot, *Catalogue raisonné*, "J. van Goyen," vol. VIII, 1923, p. 345.

Hulst, Pieter van der

b. Dordrecht about 1583,
d. Antwerp 1628

568

Netherlandish landscapist, figure painter and copper engraver. He was apprenticed at Antwerp and worked there till his death.

He painted open-air scenes of peasant revels with numerous figures, in brown and green tones, somewhat in the manner of J. C. Droochsloot and showing strong Flemish influence. His skilful composition and the assured drawing of his large figures suggest that he painted many more works than have come down to us. Today his pictures are rare. There is a typical village market scene privately owned in Belgium, and the Copenhagen museum has a hunting still life ascribed to him: dead game on a table out of doors, with two huntsmen. He had many pupils.

Huysmans, Cornelis

b. Antwerp 1648,
d. Malines 1727

569

Flemish landscapist, pupil of J. d'Arthois, in whose style he painted many pictures, generally unsigned. His hilly, wooded landscapes with distant views are spaciously composed and show strong contrasts of light. There is usually a dark area in the foreground and beyond it a sandy path and a patch of ground brightly lit by the sun. His landscapes may be confused with those of L. de Vadder and A. F. Boudewyns.

Literature: Y. Thiéry, *Le Paysage flamand*, Brussels, 1953.

Huysmans, Jan Baptist

b. Antwerp 1654,
d. there 1716

570, 571

Flemish landscape painter, younger brother of the better-known Cornelis Huysmans, whose pupil he probably was. In 1676 he was a master in St Luke's guild at Antwerp. His landscapes have a strongly Italianate character: they are rich in trees, there is often a small stream and sometimes a sunlit slope in the foreground. He makes much use of antique tombs, watch-towers and citadels. Details are treated with the minuteness characteristic of the later part of the century. His pictures have in many cases not darkened so much as his brother's, and are consequently more popular today. In general, however, it is hard to distinguish the two brothers' landscapes and many of Jan Baptist's works are probably still ascribed to Cornelis. Five landscapes attributed to the former are in the Wallraf-Richartz Museum at Cologne. His work is apt to be confused with that of J. F. van Bloemen.

Literature: G. Martin, *National Gallery Catalogues, Flemish School*, London, 1970, p. 84.

Huysum, Jan van

b. Amsterdam 1682,
d. there 1749

572, 573, 574

Important Amsterdam painter of still lifes and landscapes, the son and pupil of Justus van Huysum. His luxuriant, sometimes overloaded fruit and flower pieces are drawn with fidelity to nature; the veins of leaves, filaments of blossoms, beads of dew and insects are convincingly painted with a technique of unsurpassed delicacy. Owing to the excellent quality of the material he painted on—especially copper and later mahogany—his pictures are for the most part very well preserved. The composition is careful and varied, combining flowers and fruits of different seasons. He was the first to use a light background, which led to new juxtapositions of colour in his still lifes, the overall tone of which is also light. The influence of his flower pictures is discernible throughout the eighteenth century (J. van Os, C. van Spaendonck, P. T. van Brussel) and well into the nineteenth; actual imitations were unsuccessful, if only because of his incomparable delicacy of execution. His Italianate landscapes with buildings, bridges and distant water-courses are less highly valued; they represent the period's taste in landscape (G. Dughet, J. Glauber, Isaac de Moucheron). Pictures by his father, Justus van Huysum, which the latter did not sign with his full Christian name are generally attributed to Jan.

Literature: C. Hofstede de Groot, *Catalogue raisonné*, vol. x, Esslingen, 1928; R. Warner, *Dutch and Flemish Fruit and Flower Painters*, London, 1928; M. H. Grant, *J. van Huysum*, Leigh-on-Sea, 1954; N. MacLaren, *National Gallery Catalogues, Dutch School*, London, 1960, p. 196; W. Stechow, *Dutch Landscape Painting of the Seventeenth Century*, London, 1968.

Huysum, Justus van

b. Amsterdam 1659,
d. there 1723

575, 576

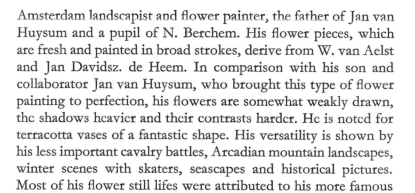

Amsterdam landscapist and flower painter, the father of Jan van Huysum and a pupil of N. Berchem. His flower pieces, which are fresh and painted in broad strokes, derive from W. van Aelst and Jan Davidsz. de Heem. In comparison with his son and collaborator Jan van Huysum, who brought this type of flower painting to perfection, his flowers are somewhat weakly drawn, the shadows heavier and their contrasts harder. He is noted for terracotta vases of a fantastic shape. His versatility is shown by his less important cavalry battles, Arcadian mountain landscapes, winter scenes with skaters, seascapes and historical pictures. Most of his flower still lifes were attributed to his more famous son.

Immenraet, Philipp Augustyn

b. Antwerp 1627, d. 1679
577

Flemish landscape painter and etcher, member of a large family of painters. In 1641 he was a pupil of the well-known landscapist L. van Uden, and in 1655 he was a master in the Guild at Antwerp. While still young he is reported to have travelled to Italy and stayed in Rome for some time. In his own day he enjoyed a considerable reputation in Antwerp. He painted many Italianate landscapes, with waterfalls, ruins and citadels, in collaboration with E. Biset (figures) and W. van Ehrenberg (architecture). He also painted landscape backgrounds for other friends: these somewhat resemble the Flemish scenes of J. d'Arthois with their numerous trees. There is a landscape with a lion-hunt in the Staatsgalerie at Stuttgart. His son, of the same name, was also a painter; the landscapist P. Rysbraeck was his pupil and may be confused with him.

Isaacsz., Isaac

b. Amsterdam 1599,
d. after 1665
578, 579, 580

Netherlandish painter of portraits, genre and historical subjects; pupil of his father Pieter Isaacsz. In 1620 he is said to have been at Munich on the way home from Italy; in 1622 he was a member of the Guild at Antwerp, and he is mentioned at Amsterdam from 1624 onwards. As a painter he ranks as one of the "Pre-Rembrandtists," especially in his Old Testament figure paintings. The influence of P. Lastman and Cl. Moyart is discernible, and his figures also recall P. de Grebber. In his historical pieces he takes the great Flemings as his models, and in his allegory of *Hearing* (1622, signed in full, at Copenhagen) the figures are copied from Rubens. He also painted genre scenes (woman frying pancakes, peasant interiors). About 1644 he executed a very large portrait of the Prince of Orange. In eclectic vein he also painted a banquet in the style of Veronese (1622, at Copenhagen).

Literature: M. D. Henkel, *Kunstwanderer* 1921/22, pp. 197–8.

Jacobsz., Lambert

b. Amsterdam about 1598,
d. Leeuwarden 1636
581, 582, 583

Dutch painter of Biblical themes, belonging to the pre-Rembrandt circle of P. Lastman, J. Pynas and N. Moyart. He is distinguished from these by his personal style of painting. Against a somewhat sketchy landscape background he depicts Old Testament scenes with individual figures, free in their movements and without special characterization. The composition is never overloaded; the garments are often variegated in colour, with a typical violet-red shade. Less often he painted New Testament scenes with life-size figures. The general effect is strengthened by the lack of a landscape background and of still-life accessories and by the emphasis on strong local colours (reddish lilac, light blue). He taught G. Flinck and also J. A. Backer, to whom his works were often attributed. Confusion with P. Lastman, J. Pynas and N. Moyart is due to their contemporary treatment of the same subject-matter.

Literature: K. Bauch, *J. A. Backer*, Berlin, 1926; K. Bauch, *Oud Holland*, XLVII, p. 145.

Janssens, Abraham

b. Antwerp 1575, d. there 1632
584, 585

Flemish history painter of the transition period, familiar with Caravaggio's style and treatment of light. His allegories are more highly thought of than his religious and mythological themes: the large, usually Romanized figures are very well drawn, lively and colourful, but the genre-type naturalism sometimes verges on coarseness. In his later period he sought to emulate Rubens. The linking of his figures is somewhat violent; the naked forms, which are too large for the picture, have a manneristic effect. His pictures are often large; the animals and fruit were occasionally painted in by F. Snyders, the flowers by Jan Breughel.

Literature: P. Clemen, *Belgische Kunstdenkmäler*, Munich, 1922; G. Isarlo, *Le Caravage*, Aix-en-Provence, 1941; J. Held, *Bulletin des Musées Royaux des Beaux-Arts*, 1, 1952, and 3, 1953.

Janssens van Ceulen, Cornelis

b. London 1593,
d. Amsterdam 1661
586, 587

Dutch painter of individual and group portraits. His sitters are almost always portrayed in half-length, in a plain style with delicate gradations of tone. In his early period he was fond of painting an imitation marble surround; later he used bluish-green backgrounds and especially delicate grey half-tones. Occasionally he made miniature copies of his portraits. He was the most prolific portraitist of the English court and nobility in the time of James I and Charles I. True to his clients' taste, he laid more emphasis on pictorial representation than on psycho-

logy. The works of his late period, executed in Holland, show much dependence on Van Dyck. As compared with A. Hanneman, with whom he can easily be confused, he depicts attitudes more naturally and is lighter and more objective in tonality. His son and namesake painted in a similar style.

Literature: H. Schneider, "The Portraits of C. Janssens," *Burlington Magazine*, XLV, 1924, pp. 295–299.

Janssens, Hieronymus

b. Antwerp 1624, d. there 1693
588, 589

Flemish genre painter, who depicted for preference elegant companies engaged in gambling, music-making and especially dancing. The interiors, which are sometimes by a different hand, consist of ornamental halls with tiled floors and stone fireplaces. The overall tone ranges from light grey to yellowish; the costumes are somewhat pale, the figures somewhat stiff and monotonous in posture. He excels his master C. J. van der Lamen in magnificence and in the skilful distribution of many figures. His small interiors are successful and are sometimes attributed to G. Coques; the influence of the Dutch painters of conversation pieces is noticeable. He contributed figures to pictures by other painters of architecture, for instance P. Neeffs.

Literature: F. C. Legrand, *Les Peintres flamands de genre*, Brussels, 1963; G. Martin, *National Gallery Catalogues, Flemish School*, London, 1970, p. 85.

Janssens, Jan IOANNES IANSENIVS

b. Ghent 1590, d. after 1650
590

Flemish figure painter influenced by Caravaggio, whose work he studied in Italy. He chiefly painted religious scenes with large figures for the Ghent churches, e. g. a *St Jerome* and three pictures of the *Crowning with Thorns*. His work is characterized by dramatic movement and contrasts of light. His composition and colouring show affinities with Gerard Seghers. There is a *Caritas Romana* by him at Madrid.

Janssens Elinga, Pieter

Amsterdam,
seventeenth century
591, 592

Amsterdam genre and still-life painter. His early still lifes are extremely delicate in tone, with sparkling lights against a dark background; the source of light is at the side, as with W. Kalf

and Jan van de Velde. He also has in common with them economy of composition: a few oranges or lemons with a jug, glass or saucepan. These still lifes may be confused with the work of G. W. Horst, J. van Streeck or C. Striep. His interiors consist of quiet rooms with a few female figures, often seen from the back; he repeatedly used a particular room with two windows. His best pictures resemble P. de Hooch by the skilful treatment of coloured stuffs and the reflection of sunlight; however, he generally shows weaker perspective and less convincing light effects. The influence of E. de Witte is discernible.

Literature: N. R. A. Vroom, *De Schilders van het monochrome Banketje*, Amsterdam, 1945.

Jongh, Claude de

d. Utrecht 1663
593

Rare Utrecht painter of Italianate landscapes with rivers, ruins and unimportant human and animal figures. He painted the Thames and London Bridge several times. He is noted for distinctive colours and a streaky, mannered style of painting.

Literature: J. Hayes, "C. de Jongh," *Burlington Magazine*, XCVIII, 1956, pp. 3 ff.

Jongh, Ludolf de

b. Rotterdam 1616,
d. Hillegersberg 1679
594, 595, 596

Dutch painter of genre, landscapes and portraits, who skilfully cultivated various types of subject-matter in imitation of his contemporaries. His masters were Cornelis Saftleven, Anthonie Palamedesz. and J. van Bylert. His best-known works are landscapes with hunting scenes and companies on horseback with dogs and their keepers, in the style of the early works of P. de Hooch. The similarity of theme may lead to confusion with A. Hondius, but he is distinguished from the latter by his fondness for painting groups of people under trees. His landscapes are full of sunlight like those of Aelbert Cuyp; the strong lighting and use of vivid red are reminiscent of Jan Baptist Weenix. Peasant cottages, inns and solid bourgeois interiors are enlivened with figures in a genre-type composition, and lighting effects also come into play. These admirable interiors may lead to confusion with H. van der Burch and in some cases even with P. de Hooch. His portraits, which are less common, are in the early style of B. van der Helst. There is evidence that he occasionally collaborated with his brother-in-law, the animal painter D. Wyntrack, and with the landscapist J. van der Haagen.

Literature: W. R. Valentiner, *P. de Hooch, Klassiker der Kunst* series, Berlin, 1929.

Jordaens, Hans

b. Antwerp about 1595, d. there 1643

597, 598

Hans Jordans. F.

Flemish artist who painted landscapes representing the passage of the Israelites through the Red Sea and other Old Testament themes. The small, lively, colourful figures recall F. Francken the Younger but also clearly show the influence of Rubens. His "art collectors' cabinets," which are rarer, are interesting from the point of view of art history.

Literature: F. C. Legrand, *Les Peintres flamands de genre*, Brussels, 1963; S. Speth-Holterhoff, *Les Peintres flamands de cabinets d'amateurs*, Brussels, 1957.

Jordaens, Jacob

b. Antwerp 1593, d. there 1678

I. IORDÆNS · FECIT 1618

599, 600, 601, 602, 603

Important Antwerp painter: with Rubens and Van Dyck he is the third great Flemish painter of mythological, religious and secular historical pictures. Though his style is wholly personal, it was substantially influenced by his collaboration with Cornelis de Vos and especially Rubens. His manner is individual, close to nature and full of vitality, with the baroque fondness for heavy, luxuriant forms; he depicts Flemish types in a popular and realistic fashion. His debt to Rubens is clearest in his church pictures; in his moral and allegorical works he is more independent, with a preference for the popular element. He ran a busy atelier for the preparation of large-sized commissioned works of a formal character: hence the artistic unevenness of his work, which contains much repetition and in which sketchiness alternates with careful execution. His early pictures show harsh lighting with dark patches of shadow, and the composition of figure-groups is often crowded. Later the lighting becomes softer, the colour more glowing and harmonious, the arrangement of the picture more spacious. In his last phase, the spirited drawing and warm brown tonality are subdued to a chiaroscuro that is sometimes a trifle monotonous. His portraits are rarer; they, especially those of groups, are lively and personal in concept. Although Jordaens was capable of all types of painting, he often worked together with F. Snyders, J. Fyt, A. van Utrecht, Paul de Vos and J. Wildens.

Literature: *Album Tentoonstelling J. Jordaens* (exhibition album), Antwerp, 1905; M. Rooses, *J. Jordaens*, Antwerp, 1906; L. van Puyvelde, *J. Jordaens*, Brussels, 1953. M. Jaffé, *J. Jordaens Exhibition Catalogue*, Ottawa 1968; G.Martin, *National Gallery Catalogues, Flemish School*, London, 1970, p. 86.

Jouderville, Isaac de

b. Leiden 1612, d. Amsterdam about 1646

604

Dutch painter of portraits, historical pieces and landscapes. His father was a refugee from Metz, whence he fled owing to religious persecution. From 1627 to 1630 the son was a pupil of Rembrandt, who lived only a few doors away in Leiden: he went with Rembrandt to Amsterdam, but returned to Leiden for further study. Of his many pictures mentioned in old inventories, few certain examples have been preserved: studies of heads, portraits and genre pieces (Judas before the high priest). The system of lighting which he learnt from Rembrandt is no longer convincing; facial expressions are sometimes exaggerated to the point of grimace (*Laughing Man* in the Bredius Museum at The Hague). As his signature was generally deleted, it will remain a difficult task to distinguish his pictures from the large number of other works by pupils of Rembrandt which cannot be assigned to their authors with certainty. His son-in-law was the well-known landscapist F. de Moucheron.

Literature: C. Hofstede de Groot, *Oud Holland*, XVII, 1899, p. 228; C. Hofstede de Groot in Thieme-Becker, *Künstlerlexikon*, XIX, 1926, p. 190; K. Bauch, *Der frühe Rembrandt und seine Zeit*, Berlin, 1960, p. 224.

Kabel, Adriaen van der

b. Rijswijk 1631, d. Lyons 1705

605

AKabel 1652.

Dutch landscape painter and etcher, pupil of Jan van Goyen at The Hague. At the age of twenty he went for some years to Italy, thence to France, where he worked until his death and where many of his works are still to be found. His master's influence is visible in his early beach and dune landscapes. Later he departed entirely from the Dutch style of painting.

Kalf, Willem

b. Rotterdam 1619, d. Amsterdam 1693

W. KALF 1663

606, 607, 608, 609

Important Amsterdam still-life and genre painter. In his early period he painted, mostly on copper, small kitchen interiors or pantries with piles of pewter or earthenware vessels and metal implements in the style of E. van der Poel, P. van den Bosch or F. Ryckhals. These tasteful works are characterized by glowing golden tones, reflections and a transparent half-light contrasting with a sunny wall. His chief works, which are today again much admired, are his close-up still lifes, influenced indirectly by Rembrandt and J. J. Treck: China porcelain and valuable glasses, dishes and vessels of silver or gold, and fruit are arranged on the corner of a table covered by an Oriental carpet; the composition is excellent and not overloaded. The deep, glowing colours, the masterly treatment of materials and the mysterious chiaroscuro with sparkling reflections almost cause the spectator to forget the nature of the objects depicted. J. van Streeck, G. W.

Horst, Pieter Janssens Elinga, C. Striep, Jan van de Velde and I. Luttichuys approach him in their best works.

Literature: R. van Luttervelt, "Ontwikkeling van W. Kalf," *Oud Holland*, LX, 1943, pp. 60–8; H. E. van Gelder, *W. C. Heda, A. van Beyeren, W. Kalf*, Palet series, Amsterdam; L. Grisebach, *Willem Kalf* (dissertation), Berlin, 1966.

Kamper, Godaert

b. Düsseldorf about 1614,
d. Leiden 1679
610, 611

Dutch painter of genre, portraits and landscapes. From 1633 he lived at Leiden, where he was a member of the Guild from 1648 to 1658. He was at Amsterdam in 1659 and returned to Leiden in 1674. He painted interiors with aristocratic or bourgeois companies making music and gambling, in the style of A. Palamedes and with a brownish overall tonality. A conversation piece of his was auctioned at The Hague in 1926. He also painted individual and group portraits (Rijksmuseum, Amsterdam). His landscapes, which are rare, recall J. van Ruisdael and C. Decker. He also had affinities with M. Hobbema and A. van der Neer.

Literature: A. Bredius, *Oud Holland*, XL, 1922, pp. 1–6.

Keirincx, Alexander

b. Antwerp 1600,
d. Amsterdam 1652
612, 613

Flemish-Dutch landscape painter, influenced by G. van Coninxloo and the early Flemish landscapists. His early work is impasted, with strong brown tints, somewhat hard in colour and with minutely painted foliage. His landscapes – rich in trees, yellowish-green in tone and including a distant vista – may be recognized by their clear composition and by the large oaks with hanging branches. His later landscapes, under Dutch influence, are richer in tone and are pale green or monotonously light brown. The small nudes in his landscapes are sometimes by C. van Poelenburgh.

Literature: E. Greindl, "A. Keirincx," *Annuaire du Musée Royal d'Anvers*, 1942, pp. 115 ff.; Y. Thiéry, *Le Paysage flamand*, Brussels, 1953; W. Stechow, *Dutch Landscape Painting of the Seventeenth Century*, London, 1968.

Kessel, Jan van

b. Antwerp 1626,
d. there 1679
614, 615, 616

Flemish still-life painter, pupil of his uncle Jan Brueghel the Younger and Simon de Vos. His small pictures of monkeys, birds and insects are in his master Jan Brueghel's style. His flower pieces recall the work of Daniel Seghers, and like the latter he also painted flowers around Baroque cartouches containing figures painted by others, such as C. Schut. In addition he painted larger flower, fruit and breakfast still lifes, softer in tone, in the manner of Jan Davidsz. de Heem, whom he copied in his early days. His paintings are often attributed to J. D. de Heem or, in the case of his animal pieces, to the earlier and more careful artist Jan Brueghel the Elder.

Literature: M. L. Hairs, *Les Peintres flamands de fleurs*, Brussels, 1955; E. Greindl, *Les Peintres flamands de nature morte*, Brussels, 1956; S. Speth-Holterhoff, *Les Peintres flamands de cabinets d'amateurs*, Brussels, 1957.

Kessel, Jan van

b. Amsterdam 1641,
d. there 1680
617, 618

Amsterdam landscapist and follower of Jakob van Ruisdael, whose pupil he probably was. His landscapes show more contrasted lighting than his model's, and the emphasis on detail makes them appear less spacious. His popular flat landscapes, seen as from a dune in the foreground, with linen-bleaching grounds and the outlines of cities in the distance, resemble the panoramas of Jakob van Ruisdael, Philips Koninck and Jan Vermeer the Elder of Haarlem. The streaky division of the landscape, which enhances the effect of depth, is more marked in his work than in that of his models. Occasionally he painted waterfalls in wooded mountain scenery, in the style of the later Ruisdael or Allaert van Everdingen. His views of towns resemble in some ways those of Claes Hals. His signature was often altered into that of Jakob van Ruisdael or J. van der Haagen, e. g. by the slight alteration of his monogram J. v. K. The staffage figures in his pictures are sometimes by J. Lingelbach.

Literature: N. MacLaren, *National Gallery Catalogues, Dutch School*, London, 1960, p. 206.

Keuninck, Kerstiaen de

b. Courtrai about 1560,
d. Antwerp after 1632
619

Early Antwerp landscapist in the style of T. Verhaecht or R. Savery. He painted wooded mountain valleys with old, riven trees, often with small mythological or Biblical figures in the foreground. His personal manner of lighting up the landscape by means of rays falling obliquely from a clouded sky lends charm to his fantasy landscapes, which go beyond the mere reproduction of nature. Only about twenty of his pictures are known.

Literature: S. Sulzberger, "K. de Keuninck," *Gazette des Beaux-Arts*, XXIII, VI, pp. 57–58; A. Raczynski, *Die flämische Landschaft vor Rubens*, Frankfurt, 1937; Y. Thiéry, *Le Paysage flamand*, Brussels, 1953; W. Stechow, *Dutch Landscape Painting of the Seventeenth Century*, London, 1968.

Keyser, Thomas de

b. Amsterdam 1596/97,
d. there 1667

620, 621, 622

T.D.KEYSER·F AN° 1622

Important Dutch portraitist, ranking after Hals and Rembrandt. In his early period he painted Regent pieces and other group portraits (anatomy lessons), in which his art is obscured by a certain stiffness. In his maturity he produced portraits, mostly half-length, of sitters with an effective air of assurance. These works, impressive in their characterization, are as a rule delicately grey in tone, with transparent shadows and a golden light. To this period also belong genre-type portraits in well composed interiors or against a background of landscape. He is noted for skill in rendering dark clothing in every shade from grey to black. Later he painted prominent burghers on horseback, as Esaias van de Velde, Palamedes Palamedesz. and Adriaen P. van de Venne had formerly done for the nobility. He also occasionally painted Biblical and historical cabinet pieces, in which he imitated Rembrandt's chiaroscuro. His pictures may be confused with those of C. van der Voort and N. Elias.

Literature: R. Oldenbourg, *Thomas de Keyser*, Leipzig, 1911; N. MacLaren, *National Gallery Catalogues, Dutch School*, London, 1960, p. 207.

Kick, Cornelis

b. Amsterdam 1635, d. 1681

623

Dutch still-life painter; pupil of his father Simon Kick, who painted soldiers. His flower and fruit pieces are now rare. In composition they resemble those of J. D. de Heem, and some may be concealed under the latter's name. Among his pupils were E. van den Broeck and probably J. van Walscapelle. He may be confused with Simon Verelst.

Kick, Simon

b. Delft 1603,
d. Amsterdam 1652

624

Amsterdam genre painter in the style of Anthonie Palamedesz., P. Codde and W. Duyster, who was his brother-in-law. He painted interiors with merry parties eating, playing and dancing, officers smoking and banqueting, and soldiers in guard-rooms with all kinds of equipment. These works are distinguished by a delicate silver-grey or yellowish tone. Others of the large group of contemporary painters of soldiers indoors, such as H. G. Pot, Pieter Potter, J. Olis, J. Duck and J. van Velsen, may be confused with him. He was the father and teacher of the still-life painter Cornelis Kick.

Literature: A. Bredius, "S. Kick," *Jahrbuch der Preussischen Kunstsammlungen*, x, 1889, pp. 102–9.

Kipshaven, Isaac van

b. Amsterdam about 1635,
d. after 1670

625, 626

Dutch painter of still lifes and portraits; nothing is known of his career. His well composed still lifes of fruit and vessels, with large surfaces and glowing colours somewhat reminiscent of B. Vermeer, were much admired during his lifetime. His still lifes of the chase (herons and other wild birds) recall W. van Aelst by the brilliant reproduction of plumage. An interior in the manner of P. de Hooch was in an auction at Amsterdam in 1924. His portraits show contrasts of illumination and light against dark tints: e. g. the portrait of a gentleman (1658) privately owned at Murnau, Upper Bavaria, and a portrait of Louisa Henrietta of Nassau (1663) at Versailles. Many of his still lifes probably pass as the work of better-known artists.

Literature: W. Martin, *Mededelingen van Kunsten en Wetenschappen*, II, 1935, pp. 537–8.

Klomp, Albert

b. Amsterdam about 1618,
d. there 1688

627

Dutch landscape painter, follower of Paulus Potter and Adriaen van de Velde. The animal figures in his sunny landscapes are somewhat sketchily and inexactly drawn. He may be confused with W. Romeyn, who however belongs more to the Italianate school of K. Dujardin.

Knibbergen, Catharina van

active at The Hague in the mid-17th century

628

Dutch landscapist, probably related to François van Knibbergen. Member of St. Luke's guild at The Hague. Her mountain landscapes with waterfalls and distant prospects are non-naturalistic, and the trees and brushwood are depicted in a curiously mannered fashion.

Knibbergen, François van

b. The Hague 1597,
d. after 1665

629

Rare landscapist of The Hague, in the style of J. van Goyen and Salomon van Ruysdael. He painted spacious mountain landscapes

with woods or rivers, waterfalls or torrents (cf. Allaert van Everdingen), with thinly-applied green tints and an overall yellow tonality; the style is sweeping and not detailed. His early work is somewhat Italianate, with temples or ruins in the style of B. Breenbergh. He is regarded as an imitator of J. van Goyen, but the style and treatment of foliage are peculiar to him.

Literature: C. Hofstede de Groot, *Catalogue raisonné,* vol. VIII, Esslingen, 1923; W. Stechow, *Salomon van Ruysdael,* Berlin, 1938, p. 54.

Knijff, Wouter

b. Wesel 1607,
d. Bergen op Zoom after 1693
630, 631, 632

Dutch landscape painter in the style of J. van Goyen or Salomon van Ruysdael. His river landscapes with prominent buildings are more exact in all their details than those of J. van Goyen. He often uses a strong steely blue for water in the foreground, roofs or the sky. He achieves a good aerial perspective despite the lack of colour-harmony and the avoidance of definitely tonal painting. Many of his pictures have been ascribed to J. van Goyen as a result of the alteration of his monogram, or to W. Kool by misreading of it. Occasionally he resembles F. de Hulst in theme, but not in style.

Literature: C. Hofstede de Groot, *Catalogue raisonné,* vol. VIII, Esslingen, 1923; W. Stechow, *Salomon van Ruysdael,* Berlin, 1938, p. 54.

Koedyck, Isaac

b. Amsterdam 1616, d. 1677
633

Dutch painter of interiors, influenced by G. Dou. The furniture and other details of his light, comfortable bourgeois interiors are depicted with accuracy. There is usually a single main figure in the foreground and smaller, anecdotic ones in the background: people drinking wine or playing instruments, surprised lovers, maids joking. His work resembles that of P. de Hooch's imitators, J. Vrel and C. de Man.

Literature: C. Hofstede de Groot, *Friedländer Festschrift,* 1927, pp. 181-90.

Koene, Isaac

b. Haarlem about 1638, d. 1713
634

Dutch landscape painter and draughtsman, probably a pupil of Isaac Ruisdael. In his early work his model was Jacob van Ruisdael; later he imitated the style and technique of M. Hobbema.

However, his landscapes are distinguished from the latter's by the coarser style of painting, and the sunlight between groups of tall trees is less lifelike. His foregrounds often include tall withered trees, to which tufts of foliage seem to adhere. Such landscapes are typical of the late seventeenth century. The figures were sometimes contributed by B. Gael. Two of Koene's pictures are in the museum at Emden. Signed examples are rare. He is the only known faithful follower of Hobbema; today his pictures are rare, but many are probably among those ascribed to his master.

Literature: K. E. Simon, *Zeitschrift für Kunstgeschichte,* Berlin, 1940, vol. 9, p. 205.

Koets, Roelof

b. Haarlem 1592,
d. 1655
635, 636

Haarlem still-life painter, said to have been also a musician; member of the Guild at Haarlem from 1642. The breakfast still lifes of his early period recall F. van Dyck, N. Gillis and F. van Schooten. Later ones closely resemble the work of P. Claesz., to whom they are generally ascribed; in their time they were thought superior to his. Stylistic analysis supports the old theory that Koets and P. Claesz. collaborated about 1652. The former has a typical manner of painting grapes and vine-leaves. Occasionally he painted baskets of fruit, which usually included grapes. A portraitist of the same name, who worked at Zwolle and Middelburg in the second half of the seventeenth century, was not related to him. Apart from P. Claesz., he may be confused, by reason of subject-matter, with A. Susenier.

Literature: A. Vorenkamp, *Geschiedenis van het hollandsche Stilleven,* Leiden, 1933; N. R. A. Vroom, *De Schilders van het monochrome Banketje,* Amsterdam, 1945; I. Bergström, *Dutch Still-Life Painting,* London, 1956.

Koninck, Jakob

b. Amsterdam about 1612,
d. Copenhagen after 1690
637

Dutch painter, draughtsman and etcher of landscapes; elder brother of the famous Philips Koninck. He lived at Dordrecht, from 1637 at Rotterdam and later at The Hague. From 1682 he worked for the court at Copenhagen, and became court painter in 1699. His life-story is full of debts and lawsuits. Only a few of his pictures are known, as they were often unsigned and confusion with his brother is easy. About 1650 he painted portraits that are reminiscent of the Rembrandt school (N. Maes). A *Farm under Trees,* signed in full, is in the Boymans-Van Beuningen Museum at Rotterdam. During his stay in that city he is said to

have painted genre pieces. He is most highly regarded for his panoramic flat landscapes, which resemble his brother's work and that of Jan Vermeer of Haarlem. Several landscapes of this type in the Boymans-Van Beuningen Museum are attributed to him.

Literature: H. Gerson, *Philips Koninck*, Berlin, 1936.

Koninck, Philips

b. Amsterdam 1619,
d. there 1688

638, 639, 640

Important Amsterdam landscapist, portraitist and genre painter. His landscapes, influenced by Rembrandt, are painted from a high view-point and show a countryside of low hills and water-courses, enlivened by distant castles and farms and unobtrusive figures of hunters or herdsmen, usually painted by the artist himself. The sunlight breaks through clouds here and there and illuminates the land; light-coloured dunes, sparkling streams, sails and buildings lead the eye into the distance. The clouds cast great shadows over parts of the landscape, which is hilly and forested in his early works but later spreads out in panoramic fashion. In these masterpieces, which seem to embrace the whole world and have made Koninck famous, he reached the level of Hercules Seghers, who probably influenced him, and of Rembrandt. His interiors with peasants making music and drinking are weaker than paintings on similar themes by Jan Miense Molenaer. His early portraits belong to the remoter school of Rembrandt (G. Flinck, J. Lievens); later they became conventional (cf. C. Janssens van Ceulen, J. de Baen). Biblical subjects are rare. Adriaen van de Velde occasionally contributed excellent, unobtrusive figures to his landscapes.

Literature: H. Gerson, *Philips Koninck*, Berlin, 1936; N. MacLaren, *National Gallery Catalogues, Dutch School*, London, 1960, p. 210; W. Stechow, *Dutch Landscape Painting of the Seventeenth Century*, London, 1968.

Koninck, Salomon

b. Amsterdam 1609,
d. there 1656

641, 642

Amsterdam painter of genre and Biblical themes, pupil of N. Moyart. His half-lengths of bearded old men and historical compositions belong to Rembrandt's Amsterdam period. The rich Oriental draperies, adorned with gold and pearls, are impressive. Old men, scholars, hermits and gold-weighers are treated in genre fashion; they often hold their heads on one side. The very harmonious colouring of his studies of heads and half-length portraits has led to his work being ascribed to Rembrandt, but also to the latter's pupils G. Dou and G. Flinck.

Kool, Willem

b. Haarlem 1608,
d. there 1666

643, 644

Haarlem painter of beach, river and flat landscapes in the style of J. van Goyen, whom he recalls *inter alia* by his brownish tonality and the assurance with which figures are introduced. His beach scenes and winter landscapes with sport on the ice also recall Salomon van Ruysdael. Like W. Knijff, he shows excellent aerial perspective and sometimes introduces prominent buildings; for this reason and because of the similarity of their monograms, the two painters are often confused. However, Kool makes more use of human figures; his scenes of fairs are sometimes attributed to J. Steen. His winter landscapes may also be confused with works of C. Beelt and Gillis Rombouts.

Kruys, Cornelis

active at Haarlem and Leiden;
d. before 1660

645, 646

Rare Haarlem still-life painter in the style of Willem Claesz. Heda, with whom he is often confused. Compared with the latter, his composition is richer, sometimes overloaded; the setting often includes a niche. He often painted large pewter jugs or Delft ware and a crumpled white tablecloth, as did J. J. den Uyl. Like R. Koets and A. van Beyeren, he was also fond of large vine-tendrils as a background. His pictures are seldom signed, and consequently some of them are probably still ascribed to W. C. Heda or P. Claesz. Some flower pieces of his are also known.

Literature: N. R. A. Vroom, *De Schilders van het monochrome Banketje*, Amsterdam, 1945.

Kuyl, Gysbert van der

b. Gouda early in the seventeenth century,
d. there 1673

647, 648

Dutch genre painter and portraitist, also painter on glass. He spent much time in France and Italy, including about twenty years in Rome, where he was known by the "Bentname" of Gerardo van Coil. His genre scenes contain large figures, sometimes half-length (couples making music, children with a dog). Occasionally he painted Old or New Testament subjects. He may sometimes be confused with Jan van Bylert. He also painted portraits in the style of the Rembrandt school.

Lachtropius, Nicolaes

active at Amsterdam,
d. Alphen after 1687

649

Dutch painter of still-lifes in the style of O. Marseus van Schriek. He depicts flowering shrubs, mushrooms and butterflies, lizards and snakes together in a forest. His well executed pictures have an effect of fantasy despite their excellent drawing and the hard evening light. Similar nocturnal still lifes were painted by C. Striep and M. Withoos. His fine flower pieces are distinguished by prominent drawing and colour contrasts reminiscent of W. van Aelst and A. de Lust.

Laeck, Reinier van der

b. The Hague, d. about 1658

650, 651

Dutch landscapist and figure-painter; member of the Guild at The Hague in 1644, and probably lived there till his death. His early works are typically Dutch flat landscapes or river scenes with low hills (Dessau); their construction recalls J. Schoeff and the remoter imitators of Goyen. Later, under the Italianate influence of C. van Poelenburgh and A. van Cuylenborch, he painted hill and river landscapes of Mediterranean type with mythological or, less often, historical figures. These themes with large plants in the foreground also recall D. van der Lisse. He occasionally copied early Netherlandish artists (Lucas van Leyden). His early landscapes, which are frequently mentioned in old inventories, have often been attributed to J. van Goyen after removal of the signature; today only about ten of his pictures are known.

Literature: C. Hofstede de Groot, *Burlington Magazine*, XLII, 1923, p. 4; H. E. van Gelder, *Oud Holland*, XLVI, 1929, pp. 44–48.

Laer, Pieter van

b. Haarlem about 1592,
d. there after 1642

652, 653

Dutch-Roman genre and landscape painter, known in Rome by the "Bentname" of Bamboccio. He created the type of painting known as *bambocciata:* naturalistic Italian market scenes, gamblers, peasant dances and moralistic subjects, usually shown in an evening light with strong contrasts in the style of Caravaggio. The shadows, which are often too heavy, have been still further exaggerated by darkening. He is distinguished by his skill in depicting popular life with strong local colour, making full use of his virtuosity in painting figures. Landscape is treated only as a background. His pupil Th. Wyck imitated his manner, and J. Miel and J. Lingelbach were influenced by him. It is often very hard to distinguish the work of J. Miel, P. de Laer, P. van Lint

and M. Cerquozzi. He may be confused with the rare artist Andries Both, but the latter's brushwork is broader.

Literature: G. J. Hoogewerff, "P. van Laer en zijn vrienden," *Oud Holland*, XLIX, 1932, pp. 1 and 205, and L, 1933, pp. 103 and 250; G. J. Hoogewerff, *De Bentvueghels*, The Hague, 1952; G. Briganti, "P. van Laer," *Proporzioni*, III, 1950, pp. 185 ff.; A. Janeck, Nuremberg (dissertation), Würzburg, 1966; A. Caraceni, *P. van Laer*, Rome, 1966.

Lagoor, Jan

active at Haarlem 1645–1659

654

Haarlem landscapist in the style of Jakob van Ruisdael. His rare woodland scenes, generally with quiet waters and a very few figures, and sometimes also with distant prospects in the manner of J. van der Haagen or J. Vermeer the Elder of Haarlem, correspond to Jakob van Ruisdael's style after the middle of the century. He is characterized by an earnest, rather sombre treatment of landscape and the subtle stippling technique with which he depicts foliage. He may easily be confused with the other painters of Ruisdael's circle: C. G. Decker, J. Looten, Salomon Rombouts and A. Verboom.

Literature: N. MacLaren, *National Gallery Catalogues, Dutch School*, London, 1960, p. 214.

Lairesse, Gerard de

b. Liège 1641,
d. Amsterdam 1711

655, 656

Late Flemish-Dutch genre painter influenced by N. Poussin and C. Lebrun. His portraits are rare. His works are enlivened to excess with historical and mythological figures; they are usually set against a background of classical architecture, accurate in perspective and frequently repeated like stage sets. The figures are painted with academic smoothness in strong glowing colours. His ornamentation of walls *(soprapporte)* influenced artists throughout the eighteenth century. He may be confused with G. Hoet owing to the very similar subject-matter. Two of Lairesse's sons painted in his style. He contributed Arcadian and mythological figures to landscapes by J. Glauber, which were also popular in the eighteenth century.

Literature: J. M. Timmers, *G. Lairesse*, Part I, Amsterdam, 1942.

Lamen, Christoph Jacobsz. van der

b. Antwerp about 1606, d. about 1651

657, 658

Flemish painter of somewhat uniform conversation pieces, closest in style to the Dutch artist Anthonie Palamedesz. He painted elegant companies dancing, gambling and making music

in interiors sparsely furnished with pictures, doorways and a stone fireplace. These themes were continued by his pupil Hieronymus Janssens, who surpassed him as regards colour and drawing. Less often, C. van der Lamen painted scenes of soldiers with their girls, plundering and peasant amusements.

Literature: F. C. Legrand, *Les Peintres flamands de genre*, Brussels, 1963.

Lanen, Jasper van der

Jasper·vander·Lanen

b. Antwerp about 1592,
d. after 1626
659, 660

Flemish landscape painter and indirect follower of G. van Coninxloo. In 1615 he was a member of St. Luke's Guild at Antwerp. His wooded landscapes are especially close to A. Govaerts in style and theme. The usual colour-scheme of the Frankenthal school – brown in the foreground, green in the middle distance and blue in the background – has given place to an overall green tone. He is noted for his careful painting of the foliage of great oaks, and for the tall rushes that often fill the foreground. The small colourful figures (Europa and the bull, Balaam's ass, the Good Shepherd, gipsies) play an important part and sometimes recall Hans Jordaens. His pictures have only recently been distinguished from the work of Coninxloo (Copenhagen), A. Govaerts and D. van Alsloot.

Literature: L. Burchard, *Burlington Magazine*, xc, 1948, p. 237; F. J. Dubiez, *Oud Holland*, LXV, 1950, p. 120.

Langevelt, Rutger van

R.V. LAN
GEVELT
INVENTOR
ET PIN:
XIT

b. Nijmegen 1635,
d. Berlin 1695
661

Dutch painter of buildings and historical scenes, also an architect. He studied at the Nijmegen academy; in 1678 he was court painter and architect to Frederick William, Elector of Brandenburg, and director of the Berlin academy. The country mansion of Köpenick and the Dorotheen-Kirche at Berlin were built in the 1680's, probably to his plans. As he was also busy producing decorative wall paintings for town halls and castles, and designs for carpets, the number of his pictures of architecture is not large. He is most admired for his excellent church interiors in the style of E. de Witte. The perspective is strengthened by marked contrasts of lighting; the very prominent, rather large figures are well drawn and painterly in conception. His large historical pictures are in the academic style of the time. Two portraits by him were in the Nijmegen museum.

Lapp, Jan

Jan Lap.

active at The Hague 1650–1670
662, 663

Dutch landscape painter and draughtsman of the Italianate school; member of the Guild at The Hague in 1625. On account of his Italian landscapes he is thought to have spent a considerable time in that country, where his "Bentname" was Gio Lap. His park-like landscapes with antique architecture amid pines and cypresses resemble the work of N. Berchem, K. Dujardin and W. Schellinks, and his signature has probably often been removed in favour of these better-known names. Signed pictures by him were formerly often mentioned but are now rare. There are three of his Italian landscapes in the Mauritshuis at The Hague. According to tradition he also painted portraits.

Lastman, Pieter

*Lastman fecit
1630*

b. Amsterdam 1583,
d. there 1633
664, 665

Dutch painter of Biblical and, less often, mythological scenes in antique landscapes; member of the "pre-Rembrandt" group. His powerful figures, despite the baroque fantasy of their dress, are realistic in characterization and are not idealized in the Italian manner; they are often composed in groups. The rich, unshaded colour and soft, luxurious folds of their garments, the ornaments and accessory objects produce an effect of splendour. The narrative motifs are underlined by a vivid play of gesture, which is often repeated from one picture to another. Rembrandt and J. Lievens were his pupils, as was the portraitist and still-life painter J. A. Rootius. Lastman has in common with his contemporaries L. Jacobsz., J. Pynas and N. Moyart a similar manner of treating Biblical subjects before Rembrandt.

Literature: K. Freise, *P. Lastman*, Leipzig, 1911; N. MacLaren, *National Gallery Catalogues, Dutch School*, London, 1960, p. 215.

Leemans, Anthonie

*Anthonius Leemans Fecit
1655*

b. The Hague 1631,
d. Amsterdam 1673
666

Rare Hague painter of still lifes and figures. In a style reminiscent of Pieter Claesz, vessels, implements, papers and musical instruments are arranged against a quiet background and painted in a sober and lifelike fashion, in broad chiaroscuro. His portraits of family and other groups are rare and less good.

Leemans, Johannes

b. 1633, d. The Hague 1688
667

Dutch still-life painter of the illusionist school. He depicts all kinds of apparatus used in catching birds, arranged in realistic fashion and in their natural size about a birdcage in front of a bright wall. The cast shadows and accuracy of reproduction give his still lifes a *trompe-l'oeil* effect. C. Biltius and the two Gysbrechts painted similar themes.

Leermans, Pieter

b. about 1655, d. 1706
668, 669

Dutch genre painter, said to have been a pupil of G. Dou. We possess pictures of his dated between 1649 and 1689. His genre-type figures in a landscape setting belong to the school of Dou and resemble those of J. van Staveren: a *Hermit* and a *Trumpeter* are in the Rijksmuseum at Amsterdam. His portraits, which are mostly small, recall the work of Frans and Willem van Mieris in the detailed presentation of niches, carpets etc., but they are more coarsely painted and the contrasts of light are stronger: e. g. an aristocratic sportsman with his dog in the Cassel gallery, and a bejewelled old lady representing Avarice, privately owned at Lucerne.

Literature: C. Hofstede de Groot, *Oud Holland* IX, 1891, p. 72.

Leeuw, Pieter van der

b. Dordrecht 1647, d. 1679
670, 671

Rare Dutch landscape and animal painter, imitator of Adriaen van de Velde, in whose style he painted landscapes with cattle, sheep and goats, milkmaids and animal markets. His works, which are often signed and dated, are smoother and more detailed than those of his model.

Lelienbergh, Cornelis van

b. The Hague 1626, d. after 1676
672

Still-life painter of The Hague in the manner of Jan Weenix, whom he approaches in his best work. He chiefly painted dead game-birds and, less often, hares with hunting equipment and cereal plants. His early work is characterized by silver-grey tones. He is a master at depicting plumage. His later pictures are in the nature of showpieces, in the Flemish style of P. Boel. His signature and date were often removed in order to ascribe his works to the better-known J. Fyt and Jan Weenix.

Lesire, Paulus

b. Dordrecht 1611,
d. after 1656
673, 674

Dutch portraitist, probably a pupil of J. G. Cuyp; he was a master at Dordrecht in 1631, and worked at The Hague in 1648. His portraits, mostly half-length, were at first influenced by Rembrandt and later by B. van der Helst. They are painted with great fidelity, typically against a light-grey or light-brown background. He also painted a group portrait of the captains of the Dordrecht militia company. A picture of Queen Henrietta Maria of England leaving Scheveningen in 1637 is in the Municipal Museum at The Hague. A portrait of a lady, dating from the same year, was shown in 1953 by Matthiesen of London in the exhibition entitled "Rembrandt's Influence". In the same style, there is a large Old Testament scene in the Bader collection, Milwaukee.

Levecq, Jacobus

b. Dordrecht 1634, d. 1675
675, 676, 677

Dutch portraitist, originally an imitator of Rembrandt, whose pupil he was about 1653. In 1655 he was a member of the Guild at Dordrecht, where he chiefly worked after travelling in France. In his early period he painted Biblical themes (the Expulsion of Hagar), but most frequently half-length portraits against a dark background, which at the outset show a resemblance to the work of Rembrandt's pupil N. Maes. Like Maes, he progressively departed from the master's style towards a conception dictated by fashion: the subjects are seen in rich garments in front of architectural features, pillars or curtains in the background, sometimes with the much-favoured view of a park in evening light. At this period his portraits resemble those of J. de Baen. A characteristic portrait of a lady by him, dated 1665, is in the Brussels museum. Notwithstanding the fashionable accessories, his portraits are psychologically faithful and serious in conception. Many of them are attributed to better-known names. A. Houbraken was his pupil about 1673.

Leyster, Judith

b. Haarlem 1609, d. Heemstede 1660
678, 679

Genre painter of Haarlem, pupil of Frans Hals and of her husband Jan Miense Molenaer. Her best work is close to Hals as regards subject and technique, but her depiction of jollity, especially laughter, is less lifelike. She has a preference for light-grey and light-blue tones, and at times uses strong light effects like those of the Utrecht school (Gerard van Honthorst, J. van Bylert). She also painted effective groups of children and elegant

colourful conversation pieces in a similar manner to Dirck Hals, P. Codde and Anthonie Palamedesz. Her portraits, flower and fruit pieces are rarer. She almost always used the monogram J. L., together with a "guiding star." Many of her works were ascribed to Frans Hals or J. M. Molenaer; she herself, on the other hand, has been credited with pictures by Hals's less eminent sons, Claes and Harmen.

Literature: C. Hofstede de Groot, "J. Leyster," *Jahrbuch der Preussischen Kunstsammlungen*, XIV, 1893, p. 190; E. Plietzsch, "Holländische Interieurmalerei," *Wallraf-Richartz-Jahrbuch*, XVIII, 1956, pp. 173–196; N. MacLaren, *National Gallery Catalogues, Dutch School*, London, 1960, p. 218.

Leytens, Gysbrecht

b. Antwerp 1586, d. before 1656

680, 681

Flemish painter of the first half of the seventeenth century, hitherto known as "Master of the Winter Landscapes." His charming snow scenes, while somewhat uniform in composition, give a lifelike impression of winter atmosphere. As a rule, the eye is led into the distance on both sides of the picture by a group of fantastic trees. The dark, finely ramified, snow-covered branches are unmistakable in their mannered style. The small, infrequent figures of woodcutters or wanderers with a dog are somewhat reminiscent of Joost de Momper, but the latter's winter scenes are more powerful and the figures are more numerous. If attention is paid to the typical construction, it is hardly possible to confuse Leytens with D. van Alsloot or the rarer P. Stevens.

Literature: P. F. Relick, "Meester der Winterlandschappen," *Oud Holland*, L, 1942; Y. Thiéry, *Le Paysage flamand*, Brussels, 1953.

Lievens, Jan

b. Leiden 1607,
d. Amsterdam 1674

682, 683, 684, 685

Dutch-Flemish painter of Biblical, historical and genre pictures and landscapes; he belonged to Rembrandt's circle and was a pupil of P. Lastman. The chiaroscuro of his early works corresponds to Rembrandt's style of the same period at Leiden, and it is thought that they may have collaborated there. Lievens' heads of flaxen-haired old men are well characterized but are sallower and less strongly lighted than those of Rembrandt. In his later period at Antwerp his Biblical and genre painting shows strong Flemish influence (Rubens, Van Dyck, Brouwer and also J. van Craesbeeck): in imitation of the last two of these he produced impasted landscapes with distant views, that sometimes have a quite impressionistic effect. His portraits belong mostly to his late period, as do his large allegorical and historical pictures; these, like the later works of F. Bol, G. Flinck and N. Maes, belong to the representative style of Baroque art. He occasionally collaborated with the Flemish flower-painters Jan Davidsz. de

Heem, Daniel Seghers and J. van den Hecke, who executed flower cartouches for his allegories or portraits.

Literature: H. Schneider, *J. Lievens*, Haarlem, 1932; N. MacLaren, *National Gallery Catalogues, Dutch School*, London, 1960, p. 219.

Limborch, Hendrik van

b. The Hague 1681,
d. there 1759

686

Hague painter of mythological, historical and allegorical landscapes and portraits. He was a pupil of J. de Baen and Adriaen van der Werff, but has nothing in common with them except his technique. His female nudes reflect the classical ideal of the early eighteenth century and are painted with a porcelain-like elegance. His portraits are occasionally confused with those of J. de Baen.

Lin, Herman van

b. about 1630,
d. Utrecht after 1670

687, 688

Dutch painter of battles and horses, also a draughtsman; known pictures of his are dated between 1650 and 1675. From 1659 to 1670 he was chairman of the Guild at Utrecht. He travelled in Italy, receiving the "Bentname" of Stilheit at Rome, and belongs to the great Italianizing school of Utrecht. He painted Italian landscapes with travellers and horsemen, usually with a white horse in the style of D. Stoop. Roman citadels, courtyards, ruins and stone sarcophagi give his landscapes a typically Italian character. He generally used the monogram HVL, which has given rise to confusion with Hendrick and P. van Lint. From the point of view of subject there may be confusion with H. Verschuring. Cavalry fights are often attributed to him.

Literature: H. Gerson, *Ausbreitung und Nachwirkung der holländischen Malerei des 17. Jahrhunderts*, Haarlem, 1942, p. 30.

Lingelbach, Johannes

b. Frankfurt 1622,
d. Amsterdam 1674

689, 690, 691, 692

Dutch painter of landscapes and Mediterranean ports with markets, also street scenes and hunts, influenced by P. van Laer. The scenes of harvesting and camps of horsemen, with small figures in a Dutch landscape, recall Philips Wouwerman, but Lingelbach's figures are coarser and more colourful. His big, light-toned harbour scenes resemble in theme the Levantine ports and chaffering merchants of Jan Baptist Weenix and Th. Wyck. The broad style and variegated colouring of his figures are easy to recognize. Small figures occur with the same simplicity and lack

of stiffness in the landscapes of Anthonie Beerstraten, J. Hackaert, Willem de Heusch. M. Hobbema, J. van Kessel, J. Looten, Frederick de Moucheron, A. Verboom and J. Wynants.

Literature: N. MacLaren, *National Gallery Catalogues, Dutch School*, London, 1960, p. 225.

Lint, Peter van

b. Antwerp 1609, d. there 1690

693, 694, 695, 696

Flemish figure-painter. He was a master at Antwerp in 1632 and then went to Italy; in Rome he executed church pictures and portraits for a cardinal. He returned to Antwerp in 1640. The pictures of his early period place him among the large circle of imitators of Caravaggio. Later he painted Biblical scenes, mostly from the New Testament; in these, which show the influence of Rubens and J. Jordaens, the whole canvas is filled with a multitude of large, multicoloured figures. Many of these large pictures still hang in Belgian churches, where they may easily be confused with those of Erasmus Quellinus. His technique is as varied as that of his different models; in his last period he imitated Van Dyck's manner of painting apostles' heads and genrelike pictures of saints. Many signed repetitions of works by him are known; he either signed in full or with the monogram PVL. Seventeen pupils of his are known to us from archives; Godfried Maes was among them in about 1644.

Literature: R. Oldenbourg, *Die vlämische Malerei des 17. Jahrhunderts*, Berlin, 1922.

Lisse, Dirck van der

b. Breda, d. The Hague 1669

697, 698

Dutch painter, the pupil and follower of C. van Poelenburgh, in whose style he painted small landscapes in light tones with mythological and Biblical figures, especially bathing nymphs. His work is distinguished by a yellow-golden tone. Occasionally he actually copied paintings by C. van Poelenburgh. He is sometimes hard to distinguish from the latter's other followers, A. van Cuylenborch and J. van Haensbergen.

Loeding, Harmen

b. Leiden about 1637, d. after 1673

699, 700

Dutch still-life painter belonging to the large group around De Heem. In 1664–73 he was a member of the Guild at Leiden. He usually painted breakfast still lifes: grapes, peaches, oysters and lobsters crowded together on the corner of a table, with a well-painted velvet cloth or curtains. In the background are ornamental vessels or a goblet crowned with vine-leaves. His early, economically composed still lifes are reminiscent of W. van Aelst and may be confused with works by J. Denies or J. van Kipshaven. There is a typical still life of 1672 by him, signed H. Lotting, in the Schleissheim gallery. His signature was certainly often removed in favour of J. D. de Heem.

Literature: C. Hofstede de Groot, "H. Luydingh," *Oud Holland*, x, 1892, p. 65.

Loo, Jacob van

b. Sluys about 1614, d. Paris 1670

701, 702

Dutch painter, a follower of Th. de Keyser. His many-sided work includes genre, mythological and allegorical pieces, characterized by strong lighting and an overall tone of warm yellow. His historical and galant pictures with large figures show him to be an excellent painter of nudes and a master of spirited composition. His genre pictures of noble and bourgeois society have a gift of narrative invention and are very similar to the work of B. Graat. Eglon van der Neer is said to have been his pupil.

Looten, Jan

b. Amsterdam 1618, d. in England about 1680

703

Dutch landscape painter and follower of Jakob van Ruisdael. His solemn oak-woods with vistas do not show much contrast of lighting: a somewhat heavy olive-grey tonality prevails. He is often confused with A. Verboom, J. Lagoor and A. Waterloo. The effective staffage figures are often by J. Lingelbach.

Literature: N. MacLaren, *National Gallery Catalogues, Dutch School*, London, 1960, p. 226.

Lorme, Anthonie de

b. Tournai about 1610, d. Rotterdam 1673

704

Rotterdam painter of churches. In his early days he painted imaginary churches in cool tones, with vistas, in several directions, after the manner of the younger Steenwijck, often with candles as the source of light. The great hall churches of his later period are flooded with sunlight. Spatial perspective is convincingly rendered. These, as it were, photographic interiors contain few if any figures: only in his sunny later works are small groups of people to be seen, dotted unobtrusively here and there. Most of his views of churches derive from St. Laurence's at Rotterdam.

Literature: H. Jantzen, *Das Niederländische Architekturbild*, Leipzig, 1910.

Ludick, Lodewijck van

b. Amsterdam 1629, d. before 1697

705

Dutch painter of Italianate mountain and forest landscapes in the style of Jan Both, whose warm yellowish-brown tonality he adopted. J. Asselyn is superior to him, but he may easily be confused with Jan Both's imitators, Willem and Jakob de Heusch. His works, which are seldom signed, are often attributed to Jan Both.

Lundens, Gerrit

b. Amsterdam 1622,
d. there after 1683

706

Amsterdam painter of somewhat coarse peasant interiors, in the style of Jan Miense Molenaer and R. Brackenburgh. The same types recur again and again in his barber's shops, peasant dances and kermesses. These somewhat dark interiors, especially in his later period, are painted in a sketchy fashion and with little taste as regards colour. There exist good copies by him of works by Rembrandt and J. A. Backer. His pictures are sometimes ascribed to J. M. Molenaer, R. Brackenburgh and J. Steen.

Lust, Antoni de

Holland,
mid-seventeenth century

707

Amsterdam painter of bouquets and floral garlands, who in his best work approaches R. Ruysch. However, he is more economical and very careful in composition. Single bright flowers glow amid dark foliage; sometimes he painted small, delicate flowers such as forget-me-nots etc. He also often depicted a gold-mounted glass vase on a carved stone slab, against a dark background. He resembles W. van Aelst. G. W. Horst was among his pupils.

Luttichuys, Isaac

b. London 1616,
d. Amsterdam 1673

708, 709

Amsterdam portrait painter, brother of Simon Luttichuys. His portraits, which are often signed and dated, belong to the good mid-century period. The expression is lively, and a painterly effect is given by white sleeves, ruffs and black clothing in front of shot-silk curtains. Owing to the similar appearance of their initials he used to be confused with Simon Luttichuys.

Literature: W. R. Valentiner, "I. Luttichuys," *Art Quarterly*, I, 1938, pp. 151–79.

Luttichuys, Simon

b. London 1610,
d. Amsterdam 1661

710, 711, 712

Brother of Isaac Luttichuys; he painted breakfast still lifes in compositions of quiet elegance. He often depicts a wineglass with a partly peeled lemon and a silver plate with a roll lying on it. He also painted effective *Vanitas* pieces with soap-bubbles or globes of glass. In a different style, more reminiscent of J. D. de Heem, he painted still lifes in a curtained room with a view into the distance: richly laden tables with large vessels, fruit and musical instruments. The addition of sprays of roses and the broad painterly execution recall the work of A. van Beyeren. As he and his brother wrote the initials of their forenames similarly, their works have often been confused.

Literature: I. Bergström, *Dutch Still-Life Painting*, London, 1956.

Luycks, Christiaan

b. Antwerp 1623,
d. there after 1653

713, 714

K· LVX·

Antwerp still-life painter. His breakfast pieces are mostly signed and are most carefully executed. His somewhat hard manner of painting flowers recalls Daniel Seghers, especially in the garlands painted around cartouches and medallions. His distinctive *Vanitas* pieces with globes, shells, books and insects are realistic and convincing. His works are often ascribed to Cornelis de Heem.

Literature: M. L. Hairs, *Les Peintres flamands de fleurs*, Brussels, 1955; E. Greindl, *Les Peintres flamands de nature morte*, Brussels, 1956.

Luyks, Frans

b. Antwerp 1604,
d. Vienna 1668

715

Flemish painter of portraits and historical works. In 1620 he was a master of St. Luke's Guild at Antwerp. He probably worked for a time in Rubens' studio. In 1635 he was in Rome; in 1638 he became court painter to the emperor Ferdinand III, and in 1658 to his successor Leopold I. Initially he painted historical subjects or religious themes mostly from the New Testament; but his chief work was painting portraits of eminent personalities. Members of the imperial family, princes and generals were portrayed with fidelity and in a style befitting their rank. Many of these portraits of his later period, which no longer show the

influence of Rubens and properly belong to the history of German portrait-painting, are still in the Hofburg at Vienna. He often himself painted replicas of such portraits, which with their Italian and Spanish influences are characteristic of the Viennese court style. There is a particularly charming portrait of the Archduke Charles Joseph as a child, now in the Schönbrunn Palace at Vienna.

Literature: E. Ebenstein, "Der Hofmaler F. Luyks," *Jahrbuch der Kunsthistorischen Sammlungen des Allerhöchsten Kaiserhauses,* XXV, 1906, pp. 172 ff., and XXVI, 1906, pp. 182–254.

Maas, Dirck

b. Haarlem 1656, d. there 1717
716

Haarlem painter of horses and landscapes, pupil of H. Mommers and N. Berchem and a friend of the battle-painter J. van Huchtenburgh, whose style he adopted. His subjects are those of Philips Wouwerman: cavalry fights, hunting, plundering and camp scenes. Although skilled at depicting horses, he is inferior as a painter to Philips Wouwerman and J. Lingelbach. Together with J. van Huchtenburgh he belongs to the late period of Dutch landscape painting. His winter scenes are mostly of frozen canals in front of bastions or between villages, with peasants or burghers disporting themselves; there is often a sleigh drawn by a white horse. He also contributed figures to landscapes by J. Glauber.

Maes, Nicolaes

b. Dordrecht 1634,
d. Amsterdam 1693
717, 718, 719, 720

Important Dordrecht genre painter and portraitist. He was a pupil of Rembrandt, but after 1660 departed from him entirely in both theme and style. His early portraits, painted against a quiet dark background, emphasize psychological aspects and are reminiscent of Rembrandt and Barent Fabritius. His early genre pieces are much admired and also recall Fabritius. They offer a realistic portrayal of quiet bourgeois life: a craftsman, a maid engaged in domestic duties, old men and women reading or praying. Delicate tones of creamy white, lemon yellow and warm vermilion, with little blue, show brightly against a warm brown background. Contrasts of light are carefully observed, as with J. Lievens and G. Flinck. He also resembles these two in showing later a Flemish strain, especially in the portraits, which form by far the major part of his work, and which towards the end of his life become fashionably sentimental. He also reflects the contemporary love of antique, mythological or allegorical disguise. The background is usually a twilit park with a view of the evening sky. The skilful distribution of light

and shade, a fine red and soft half-tones are among the charms of his colouring. His early work may be confused with that of Reinier Coveyn and C. Bisschop; his later portraits show affinity with Caspar Netscher.

Literature: C. Hofstede de Groot, *Catalogue raisonné,* vol. VI, Esslingen, 1915; W. R. Valentiner, *N. Maes,* Stuttgart, 1924; N. MacLaren, *National Gallery Catalogues, Dutch School,* London, 1960, p. 227.

Mahu, Cornelis

b. Antwerp about 1613,
d. 1689
721, 722

Rare Flemish still-life painter, whose breakfast pieces are close to those of the Haarlem school, especially W. C. Heda. He also made accurate copies of the latter's pictures. Metal, glass and earthenware vessels and eatables are arranged on the corner of a table with a crumpled cloth. He also did seascapes, which recall the grey school of marine painting (B. Peeters), with heavy clouds and a rough sea. His son Victor painted peasant interiors, in a style closely modelled on Teniers and Ostade.

Literature: N. R. A. Vroom, *De Schilders van het monochrome Banketje,* Amsterdam, 1945; E. Greindl, *Les Peintres flamands de nature morte,* Brussels, 1956.

Man, Cornelis de

b. Delft 1621, d. there 1706
723

Delft painter of genre pictures: elegantly furnished interiors with chessplayers and people counting money. The characters are animated and lifelike, and play a larger part than in the pictures of P. de Hooch; the rooms depend for their effectiveness more on furniture than on light. His scenes of peasants amusing themselves relate him to the wider circle of Jan M. Molenaer's followers; he shares with I. Koedijk a taste for clear, cool colours. Less often he painted portraits, group pieces and church interiors.

Literature: C. Brière-Misme, "C. de Man," *Oud Holland,* LII, 1935.

Mancadan, Jacobus

b. Minnertsga 1602,
d. Leeuwarden 1680
724, 725, 726

Dutch painter of mountainous and flat landscapes, some with ruins, also with herdsmen and their flocks, especially sheep and goats. He usually depicts a small corner of landscape, with overgrown boulders or torrents beside which herdsman are resting. His conception is personal and unmistakable. The

dominant colour is a cool, silvery grey-green. Crumbling masonry is meticulously rendered. Less often, he painted extensive flat landscapes of the country around Groningen, and mythological subjects.

Literature: A. Heppner, "J. S. Mancadan," *Oud Holland*, LI, 1934, pp. 210–217; C. Boschma, "J. S. Mancadan," *Oud Holland*, LXXXI, 1966, pp. 84–106.

Mander, Karel van

b. Courtrai 1548,
d. Amsterdam 1606
727, 728, 729, 730

Netherlandish painter, draughtsman, poet and biographer. He was in Rome from 1573 to 1577, and spent three years there in company with B. Spranger, who helped to get him invited to the imperial court of Rudolph II at Vienna. In 1583 he moved to Haarlem. His celebrated *Book of Painters* appeared in 1604, after which time he lived at Amsterdam. Together with H. Goltzius and Cornelis van Haarlem he belonged to the famous "Haarlem Academy." A great number of his drawings, but few of his oil paintings have come down to us: only about twelve are known. Most of these are signed; the unsigned ones appear doubtful. An early picture of a Prophet, still in the manneristic style, is in the Frans Hals Museum at Haarlem: it resembles B. Spranger's mythological scenes. In his later career as a painter he abandoned Roman mannerism for the new Flemish realism, especially in landscape and genre subjects, e. g. kermesses in the style of P. Brueghel. The landscapes show the influence of Gillis van Coninxloo, whom Mander greatly admired; the figures become smaller and of less importance. His son and grandson, both of the same name, were also painters.

Literature: E. Valentiner, *K. van Mander als Maler*, Strasbourg, 1930, with a list of his works.

Marienhof, Jan

b. Gorkum,
active Utrecht 1640–49
731, 732, 733, 734

Dutch painter, who worked at Utrecht from 1640 to 1649. According to tradition, he moved to Brussels and died there at an early age. His Biblical and genre scenes show the influence of the Utrecht painters D. Stoop and N. Knüpfer; the Old and New Testament scenes show even more strongly the influence of Rembrandt in their realism and light effects. From this point of view he is also close to B. G. Cuyp and J. de Wet. The mountain and forest landscape which often serves as a background is of minor importance, as are his interiors. The pictures do not usually exceed middle size. Many of his works go under other artists' names, but can be recognized by the striking method

of lighting which emphasizes the principal figure. In the Leningrad gallery there is a typical pair of pictures by him, a painter's and a sculptor's studio. A *St. John Preaching* (University of Göttingen) and a *Raising of Lazarus* (Central Museum, Utrecht) are reminiscent of J. de Wet.

Marlier, Philippe de

b. about 1573,
d. Antwerp 1668
735

Flemish painter of flower still lifes, active about 1640 at Antwerp, where he was a member of St. Luke's guild. The only work known to us is the picture of a garland at Brussels, signed in full, which differs from the style of D. Seghers in being less compact, more painterly and softer as regards lighting. Following Jan Brueghel the Elder, he is said also to have painted breakfast pieces with flowers (carnations in a glass, with herrings, shells and oysters, 1634). The still life painter C. Luycks was his pupil about 1640. In his later period he is recorded only as a copper-engraver.

Literature: M. L. Hairs, *Les Peintres flamands de fleurs*, Brussels, 1955; E. Greindl, *Les Peintres flamands de nature morte*, Brussels, 1956.

Marseus van Schrieck, Evert

b. Gennep about 1614,
d. after 1681
736

Rare Dutch landscape painter, brother of the still-life painter Otto Marseus; active at Amsterdam. His pictures of grottoes with a view into the distance recall the work of his Amsterdam contemporary R. van Troyen by their strong contrasts of light and the placing of dark figures in front of a clear background. In his landscapes, the effect of depth is enhanced by evening light with streaks of illumination and shadow. The ruins which play a prominent part in the composition suggest a relationship to the Utrecht school. The picture here reproduced seems to be the only one so far known which is signed in full; otherwise he used the monogram EM, which has led inexplicably to confusion with E. Murant.

Marseus van Schrieck, Otto

b. Nijmegen about 1619,
d. Amsterdam 1678
737, 738

Dutch painter of still lifes, with reptiles and butterflies grouped about large-leaved thistles, herbs and mushrooms. The land

creatures, which he kept in a private vivarium, are accurately observed; the snakes and frogs lying in wait for their prey impart an atmosphere of suspense and mystery. Bright gleaming colours against a dark, nocturnal background intensify the realistic effect into one of fantasy. His works were admired during his lifetime: C. Striep, N. Lachtropius, M. Withoos and Rachel Ruysch painted in his style, as did the eighteenth-century German still-life artists J. Falch and Hamilton. Most of his works have darkened considerably and have suffered from frequent cleaning.

Literature: V. C. Habicht, "M. van Schrieck," *Oud Holland*, XLI, 1923, pp. 31–37.

Martsen the Younger, Jan

b. Haarlem about 1609,
d. after 1647

739, 740

Haarlem painter of cavalry fights in the style of Palamedes Palamedesz. He is especially skilled at drawing galloping horses. J. J. van der Stoffe painted similar works, but they are less true to life than Martsen's and inferior by their brown tonality. The other Haarlem painter of horses, Pieter Post, may be known by his sharper draughtsmanship and cool, rather sallow tints.

Maton, Bartholomäus

b. Leiden between 1643 and 1646,
d. Stockholm after 1684

741, 742

Dutch genre painter and portraitist. He was at Leiden in 1666 and from 1669 was a pupil of G. Dou, in whose style he painted hermits praying in rocky caves, frequently with a withered, barkless tree. These hermits of his early period at Leiden are easy to confuse with those of J. van Staveren. In 1679 he went to Sweden, where several of his pictures are still in private ownership. His genre scenes mostly consist of two figures: a young lady with an old man, a young woman and a doctor, young men smoking in a window-arch, an old man with an owl or a globe, a violin-player and his audience. These pictures may easily be ascribed to G. Dou and F. van Mieris, but there are others of a very personal kind, bordering on caricature and with an allegorical significance. Besides his full signature he sometimes used a monogram consisting of a contracted B and M.

Literature: H. Schneider, *Oude Kunst*, V, 1920, pp. 224 ff.

Matthieu, Cornelis

b. Vianen, active 1637–56
743

Dutch landscape painter and etcher. He was at Antwerp in 1637, and in 1653 officiated as an expert at a painting contest at Vianen, where his father painted landscapes. His delicate scenes with ruins, herdsmen and travellers are similar to J. Both in subject-matter, but differ from him by their greenish-grey tonality. His typically detailed manner of painting foliage may be seen in a characteristic work which was in the art trade at The Hague in 1955. His portraits are rare. He usually signed with his full name, also using the forms Mathieu and Matheu; less often with a monogram.

Meerhoud, Jan

b. Gorkum, d. Amsterdam 1677
744, 745

Dutch painter of landscapes with rivers, often in evening light. The colours are cool and the pictures lack atmosphere; he repeated them with little variety. He often painted beds of rushes extending into the water. In this type of moonlit or evening scene he was surpassed by Rafel Govertsz. Camphuysen. His landscapes with broad stretches of river and fortified towns in the background recall J. van Goyen as regards theme.

Merck, Jacob van der

b. 's-Gravendeel 1610,
d. Leiden 1664

746, 747, 748

Dutch portraitist and genre painter; member of the Guild at Delft in 1631, The Hague in 1636 and Dordrecht in 1640. From 1658 until his death he lived at Leiden. His life-size portraits (Lakenhal, Leiden) are often admirable for their dignity and perspective. Jan van Goyen, who stayed with Van der Merck at The Hague about 1650, painted the landscape background to a family group of his. There is a good portrait by him of the stadtholder Frederick Henry of Orange. In a different style from the portraits, a number of brown-toned interiors are attributed to him – conversations and dancing, soldiers in guard-rooms – in the manner of A. Palamedesz., P. Codde and P. Quast. It is not clear, however, whether these signed genre pictures and the excellent, colourful portraits are really by the same hand. Finally there are still lifes (grapes and peaches in a basket, at the Lakenhal, Leiden).

Literature: J. T. Renckens, *Oud Holland*, LXIX, 1954, p. 246.

Mesdach, Salomon

active in the first half of the
seventeenth century
749, 750

Dutch portrait painter, dean of the Guild at Middelburg in 1628. His accurate portraits, mostly large, recall C. van der Voort and P. Moreelse. He seldom signed his pictures, and hence they are often ascribed to better-known painters. Many of his portraits (eight of which are in the Rijksmuseum at Amsterdam) were engraved.

Literature: C. Hofstede de Groot, *Oude Kunst*, I, 1915, pp. 281–3.

Metsu, Gabriel

b. Leiden 1629,
d. Amsterdam 1667
751, 752, 753

Important Dutch genre painter. Like his contemporaries G. Dou and Frans van Mieris, he painted huntsmen, smokers, scholars, doctors, women reading (sometimes under window arches) and also kitchen and market scenes. His brushwork is at first extremely detailed, later broad and rich in tone, in the style of Rembrandt's followers. After 1650 his colours become warmer and more luminous like those of P. de Hooch and G. ter Borch, with either of whom he may be confused. His rich and tastefully furnished rooms, with a few standing figures in animated relation to one another, belong, together with the works of G. ter Borch, to the highest achievement of Dutch genre painting. The painting is detailed and harmonious and the chiaroscuro elegant in tone. The figures are quieter than those of Frans van Mieris but livelier than Gerard Dou's. His work is rich in variety, but for the most part depicts the milieu of the solid Dutch bourgeoisie. He painted a few breakfast pieces and some excellent pictures of game birds. His Biblical and mythological scenes are rarer and academic in character. Only in his last period does he reflect the trend of fashion towards cool tints and a smooth, meticulous technique. M. van Musscher was a pupil of his, and others influenced by him were J. Ochtervelt, B. Graat, Eglon van der Neer and Jan Verkolje.

Literature: C. Hofstede de Groot, *Catalogue raisonné*, vol. I, Esslingen, 1907; E. Plietzsch, "G. Metsu," *Pantheon*, XVII, 1936, pp. 1–13; N. MacLaren, *National Gallery Catalogues, Dutch School*, London, 1960, p. 241.

Meulen, Adam Frans van der

b. Brussels 1632, d. Paris 1690
754, 755

Prolific and skilled Flemish-French painter of battles, landscapes and genre scenes; pupil of P. Snayers. He was in the service of Louis XIV and chiefly painted the king's historic campaigns, sieges and cavalry engagements, often featuring Louis and his suite. Less often he painted, sometimes assisted by his pupils, large decorative pictures of receptions and processions. Occasionally he contributed elegant, colourful mounted figures to landscapes by J. d'Arthois. His signature, in roman capitals, was also used by his pupils.

Literature: F. C. Legrand, *Les Peintres flamands de genre*, Brussels, 1963; G. Martin, *National Gallery Catalogues, Flemish School*, London, 1970, p. 94.

Meulener, Pieter

b. Antwerp 1602,
d. 1654
756

Flemish painter of cavalry battles in the manner of P. Snayers, whom he imitated. His cavalry fights, with somewhat crude and wildly animated horses, are yellow or green in tone. He often painted historic battles and sieges of famous towns. Landscape and foliage are treated cursorily. Most of his pictures are signed and dated. He can scarcely be confused, despite the similarity of name, with the elegant horse-painter A. F. van der Meulen, who is a better artist.

Literature: F. C. Legrand, *Les Peintres flamands de genre*, Brussels, 1963.

Meyer, Hendrik de

b. about 1620,
d. Rotterdam before 1690
757, 758

Rotterdam painter of landscapes and beach scenes: especially the beach at Scheveningen, animated with numerous figures, horsemen and boats. His river scenes are characterized by decorative but unconvincing ships. Like his ice scenes with many figures, they have occasionally been ascribed to J. van Goyen. His scenes of encampments and cavalry fights are less common. His pictures are often large and usually signed and dated. The golden tone of his landscapes has more than once caused them to be attributed to Aelbert Cuyp, but the resemblance is in the theme only.

Meyeringh, Aelbert

b. Amsterdam 1645,
d. 1714
759

Amsterdam painter of landscapes with mythological and Arcadian figures of nymphs and shepherds. His Italianate forest landscapes with glimpses of distant blue mountains are similar in conception to those of N. Poussin; in accordance with late

seventeenth-century taste he also painted them as decorative wall-coverings. He is said to have occasionally collaborated with J. Glauber, who was much admired by contemporaries.

Michau, Theobald

T. Michau

b. Tournai 1676,
d. Antwerp 1765

760, 761

Flemish landscape painter, pupil of L. Achtschellinck. His landscapes with watercourses and harbour scenes, full of variegated figures, derive from J. Brueghel the Elder, but apart from the later style they can easily be distinguished by the summary treatment of foliage and the more painterly but less well-drawn figures. His pictures are often painted on copper and are mostly small. They can scarcely be confused with the forest landscapes of the Flemish artists Baudewijns and Bout, though the latter's figures are similar.

Literature: Y. Thiéry, *Le Paysage flamand*, Brussels, 1953.

Miel, Jan

M.

b. Antwerp 1599,
d. Turin 1663

762, 763

Flemish-Roman painter of genre, landscapes and portraits. He worked mostly in Italy in the style of his friend P. van Laer (genre scenes at twilight), but is distinguished by his cooler tints, clearer lighting and delicate silver-grey tones. His scenes of Italian popular life are animated. His landscapes with mountains and architecture are diversified by sharply-lit figures such as he occasionally painted for Claude Lorrain. His pictures are seldom signed and are often confused with those of P. van Laer.

Literature: L. van Puyvelde, *La Peinture flamande à Rome*, Brussels, 1950; G. J. Hoogewerff, *De Bentvueghels*, The Hague, 1952.

Mierevelt, Michiel van

M. Miereveto.

b. Delft 1567,
d. there 1641

764, 765

Delft portraitist. His early portraits, which are today much admired, are closely observed and soberly naturalistic, while the later ones are more conventional, softer in tone and less true to nature. As a rule the sitters are shown in half-length, slightly turned away; their hands are not seen, and the men are nearly always bare-headed. Likenesses of princes, eminent preachers etc.

were often copied in his large studio. His sons Pieter and Jan, and his pupils P. Moreelse, Hendrik van Vliet and J. Delff assisted him, so that his signature, which occurs frequently, is not a guarantee of sole authorship. He was the teacher of Anthonie Palamedesz.

Literature: H. Havard, *M. van Mierevelt*, Paris, 1894; N. MacLaren, *National Gallery Catalogues, Dutch School*, London, 1960, p. 248.

Mieris the Elder, Frans van

Frans Mieris fecit Anno 1680

b. Leiden 1635, d. there 1681

766, 767, 768

Leiden miniature painter, pupil of G. Dou and A. van den Tempel. The best works of his early period, conversation pieces in sumptuous interiors with elegantly dressed figures, are well balanced as regards lighting and colour. He is more animated and colourful than G. Dou. Like the latter, he presents one or two figures, in the usual window-arch setting, engaged in genretype occupations and with still life accessories. His rendering of materials (velvet, silk, carpets) and furniture is masterly. These pictures of his best period are on a level with those by the great interior painters G. ter Borch and G. Metsu. His later works are more detailed and harder in tone and resemble the later style of G. Dou; at that time he also frequently repeated his own themes. This manner of painting in detail themes of less intrinsic interest was continued more systematically by his son and pupil Willem van Mieris. Another of his pupils, K. de Moor, followed more in the direction of Caspar Netscher and Adriaen van der Werff.

Literature: C. Hofstede de Groot, *Catalogue raisonné*, vol. x, Esslingen, 1928; N. MacLaren, *National Gallery Catalogues, Dutch School*, London, 1960, p. 248.

Mieris, Willem van

W. van Mieris.

b. Leiden 1662, d. there 1747

769

Leiden genre and portrait painter, pupil of his father Frans van Mieris; he often copied the latter's pictures, and continued his later style. His pictures are generally small and are typical of the later fashion of miniature painting at Leiden: the execution is hard and detailed, the composition overloaded, the colouring more uniform than in his father's work. He chiefly painted interiors with vegetable and poultry vendors, musical parties, people eating oysters etc. Mythological and religious themes are rarer. His nymphs and galant ladies have small heads and Grecian profiles, their figures represent the contemporary ideal of academic beauty, their gestures are somewhat over-emphasized. Like the other miniaturists of the period of decadence, he was much admired as late as the mid-nineteenth century.

Literature: C. Hofstede de Groot, *Catalogue raisonné*, vol. x, Esslingen, 1928; MacLaren, *National Gallery Catalogues, Dutch School*, London, 1960, p. 255.

Mignon, Abraham

b. Frankfurt 1640,
d. Wetzlar 1679
770, 771, 772

German-Dutch flower and fruit painter: pupil of J. Davidsz. de Heem, whom he followed in style and subject-matter. His early work shows the influence of O. Marseus: fruit, flowers and insects against a forest background at night. His still lifes of poultry are less common. His backgrounds are typically dark grey. His large pictures filled with flowers and fruit are lively in their contrasted colouring, and the details are admirably drawn. The same solid technique characterizes all his pictures.

Literature: I. Bergström, *Dutch Still-Life Painting*, London, 1956; M. Noble, *A. Mignon* (dissertation), Munich, 1969.

Minderhout, Hendrik van

b. Rotterdam 1632,
d. Antwerp 1696
773

Dutch-Flemish sea-painter of the Italianate school. His pictures of sea-battles and Roman town architecture in a Mediterranean or Oriental setting present hard contrasts of sunlight and shadow and are inferior on this account to similar works by J. Lingelbach and Jan Baptist Weenix. But his ports with high-built merchant ships riding at anchor are often pleasing in atmosphere and flooded by warm evening light.

Mirou, Anton

b. Frankenthal before 1586,
d. Antwerp after 1661
774

Frankenthal painter of richly wooded landscapes, in the style of G. van Coninxloo or Jan Brueghel. From a fantastic oak forest on hilly ground, the spectator looks out on to a brightly lit, spacious tract of country with isolated houses or villages. There may be one or two such vistas. The figures (peasants at work, kermesses, hunting parties) are somewhat detached from the scene. He may be confused with other painters of the Frankenthal group. Cf. also the landscapes with similar themes by M. Molanus and P. Schoubroeck, who may be regarded as Mirou's teacher.

Literature: E. Plietzsch, *Die Frankenthaler Maler*, Leipzig, 1910; Y. Thiéry, *Le Paysage flamand*, Brussels, 1953.

Molanus, Mattheus

d. Middelburg 1645
775

Rare Dutch landscape painter, influenced by G. van Coninxloo and Jan Brueghel. He mostly painted small-size village and winter scenes in hilly, well-wooded country, in the usual Flemish style of composition. The colouring, as with Jan Brueghel, is blue-green. Lively and many-coloured figures are skilfully introduced. His work may be confused with that of A. Mirou or P. Schoubroeck.

Literature: L. J. Bol, "Een Middelburgse Brueghel-Groep," *Oud Holland*, vol. LXXI, 1956, pp. 197–204.

Molenaer, Bartholomeus

d. Haarlem 1650
776

Dutch genre painter. He was a member of the Guild at Haarlem in 1640, and in 1646 lived at Haarlem with his brother Jan Miense Molenaer. His peasant interiors resemble early works by A. van Ostade rather than those of his brother. He depicts large numbers of coarse peasants, male and female, dancing and feasting in simple sheds. The middle distance is light, the corners dark, and the general tone is brown. He often depicts a village school in the barn, with many gnome-like children. These pictures were for the most part formerly attributed to A. van Ostade. His usual monogram BMR was often altered in order to ascribe his work to his better-known brother.

Molenaer, Claes

b. Haarlem about 1630,
d. there 1676
777, 778

Haarlem landscape and genre painter belonging to the wider circle of Jacob van Ruisdael. His farms standing on tree-lined river-banks, with washerwomen and anglers, are very reminiscent of Roelof van Vries and C. G. Decker. He may also be confused with the lesser artist T. Heeremans. His numerous winter and summer scenes of canals outside city walls overlooked by houses are animated by many lively, somewhat sketchily outlined figures (peasant vehicles, often drawn by a white horse). The composition of the landscape does not show much variety. His winter scenes recall Isaac van Ostade and Jacob van Ruisdael.

Molenaer, Jan Miense

b. Haarlem about 1610,
d. there 1668

779, 780, 781, 782

Haarlem genre painter, husband of the painter Judith Leyster.
His early work is careful and original, and resembles that of
Adriaen van Ostade in theme only. He is closer to Dirck Hals:
genre-type paintings of well-to-do families on everyday and
festive occasions. He was also influenced by Frans Hals and
Judith Leyster, with whom he probably shared his studio; his
early works can scarcely be distinguished from hers. His later
pictures are mostly peasant interiors with small figures and a
brown overall tone, aiming with subdued colours at a chiaros-
curo effect. These pictures, which have often darkened, are
frequently met with; they have a certain monotony due to the
crowding of the figures into stereotyped groups. Occasionally he
painted religious themes in terms of Dutch peasant life. The
Haarlem painter Egbert van Heemskerck was a follower of his.

Literature: N. MacLaren, *National Gallery Catalogues, Dutch School*, London,
1960, p. 256.

Molijn, Pieter de

b. London 1595,
d. Haarlem 1661

783, 784, 785, 786, 787

Haarlem landscape and genre painter. His early mountain scenes
are impressive but not naturalistic. His later undulating dune
landscapes, mountain passes, farms and inns under trees are
similar to the early work of J. van Goyen, but Molijn's landscape
themes are more varied. The predominant colour is brownish-
green. The figures are of an original type and play a more im-
portant part than with J. van Goyen. Tilt-carts and figures are
sometimes seen in silhouette against the horizon in a country-
side of dunes, the ridges of which are alternately light and dark.
Behind a green foreground there is often a bright stretch of sand
diagonally traversing the middle distance. The foliage is strongly
and somewhat coarsely drawn. He also painted raids, cavalry
fights, fires and night scenes. As many of his pictures are dated,
his development is easy to trace. His work is often ascribed to
J. van Goyen. A. van Everdingen was a pupil of his.

Literature: O. Granberg, "P. de Molijn," *Zeitschrift für Bildende Kunst*, XIX,
1884, pp. 369–77; W. Stechow, *Dutch Landscape Painting of the
Seventeenth Century*, London, 1968.

Mommers, Hendrick

b. Haarlem about 1623,
d. Amsterdam 1693

788, 789

Haarlem landscape and genre painter, pupil of N. Berchem. Like
his master, he went to Italy and there painted vegetable markets
and scenes of shepherds and their flocks. The background
usually consists of antique ruins. The weak drawing and the
strong red and blue local colour in the costumes of the main
figures distinguish him from his more versatile master. The
vegetables which appear in the foreground of his markets are
carefully depicted in bright colours and form an important part
of the composition. A group of Dutch dune landscapes with
herdsmen and cattle recall Aelbert Cuyp by their warm blonde
tonality and are sometimes attributed to him.

Momper, Frans de

b. Antwerp 1603,
d. there 1660

790, 791

Flemish landscape painter who adopted Dutch tones for his
paintings of well-known towns and villages, beaches and winter
scenes. He is characterized by the brownish-red tone of the
buildings, the elaborate foliage and sometimes the clouds also.
The fluid grey tone of the background is somewhat reminiscent
of Salomon van Ruysdael. Owing to the similar treatment of
trees, his winter landscapes are often attributed to Joost de
Momper.

Literature: Th. von Frimmel, "F. de Mompers Werke," *Blätter für Ge-
mäldekunde*, 1905–10, Part I, p. 65; W. Stechow, *Dutch Landscape
Painting of the Seventeenth Century*, London, 1968.

Momper, Joost de

b. Antwerp 1564, d. there 1635

792, 793, 794, 795, 796

Flemish landscape painter representing the transition from
mannerism to the realistic depiction of nature. He was a pupil
of the Antwerp artist L. Toeput at Treviso, and in his early
period painted monochrome views of cities by a broad river
with Italian architecture and cypresses in the background. In his
later mountain landscapes, rocky cliffs are surmounted by
snowy peaks on one side of the picture, and yellowish-green
valleys are seen in the middle distance; the background is deep
blue, and the general colouring particularly light and strong.
His style of painting is extremely fluid: foliage is rendered in
sweeping strokes, and reflections on it by clear lines or dabs.
The staffage, which he himself added (horsemen, peasants, carts,
porters, less often historical or religious scenes) is strongly col-
oured but blends effectively with the picture as a whole. His
pictures were sometimes also animated by small figures from the
brush of Jan Brueghel, F. Francken the Younger, S. Vrancx,
Hendrik van Balen, P. Snayers or D. Teniers. In addition
to the numerous mountain landscapes, his many pictures
include winter scenes and rivers with ships in the style of
Brueghel. Very few of his works are signed. The large and varied
collection of pictures ascribed to him can obviously only have

been executed with the help of members of his family or studio. Since the rediscovery of this mountain painter, who was much admired in his own day, many works by similar artists have been attributed to him. There are possibilities of confusion with J. Fouquier, Willem van Nieulandt, T. Verhaecht and Frederick van Valckenborch.

Literature: J. de Momper exhibition, Chemnitz, 1927; J. A. Raczynski, *Die flämische Landschaft vor Rubens*, Frankfurt, 1937; Y. Thiéry, *Le Paysage flamand*, Brussels, 1953; G. Martin, *National Gallery Catalogues, Flemish School*, London, 1970, p. 96.

Monogrammist I.S.

§.

active in the first half of the seventeenth century
797, 798, 799

Dutch painter of study heads and genre scenes, who has not yet been identified. His half-length portraits and heads of old men and women, some of which are of allegorical significance, are often painted against a light background. The folds of the turban or headcloth are characteristic. His genre themes – a young scholar, women reading – are reminiscent of J. van Staveren and J. van Spreeuwen, which may be explained by the common influence of Rembrandt. The unknown artist is frequently confused with a Dutch or German miniaturist who worked at Stockholm about mid-century and used the same monogram.

Moor, Karel de

b. Leiden 1656,
d. Warmond 1738
800, 801

Leiden portraitist and genre painter, pupil of G. Dou, Frans van Mieris, A. van den Tempel and G. Schalcken. His careful portraits are somewhat devoid of expression but elegant in their colour and smoothness; the window setting makes them look like genre pictures. The influence of late works by N. Maes and Caspar Netscher is visible. His small bucolic genre pieces, painted at the beginning of the eighteenth century, are rare.

Moreelse, Paulus

b. Utrecht 1571, d. there 1638
802, 803

Dutch portraitist, pupil of M. J. van Mierevelt. In his early period he painted religious subjects with much skill in a very individual style. His portraits, which are highly valued, show the sitter in an elegant attitude and richly dressed; the composition is lively, the drawing softer and the colours warmer than those of his master. His pictures of children are especially natural. The serious portraits of his early period stand in contrast to the

blonde, décolleté, somewhat mawkish shepherdesses whom he painted later, and who belong rather to historical or genre painting; they show an affinity with Abraham Bloemaert and Utrecht mannerism. The quality of Moreelse's work is very uneven, and his later portraits are weaker. D. van Baburen of Utrecht was among his many pupils. His portraits may be confused with those of C. van der Voort.

Literature: C. H. de Jonge, *P. Moreelse*, Assen, 1938.

Mortel, Jan

b. Leiden about 1650,
d. 1719
804

Leiden painter of fruit and flowers in the style of Jan Davidsz. de Heem, with whom he is often confused. His fruit pieces and garlands also resemble those of A. Coosemans. His work is characterized by the light emphasizing the outlines and by a somewhat hard style of painting.

Moscher, Jakob van

active about 1635;
d. Haarlem 1655
805, 806

Landscape painter in the style of Salomon van Ruysdael and J. van Goyen. He mostly painted the flat dune countryside around Haarlem, with peasant cottages sheltered by large clumps of trees. His style is characterized by a green or glowing golden-brown tone and by the regular use of foliage with moss-like ramifications. Figures were sometimes contributed by his friends Adriaen and Isaac van Ostade. His pictures are often attributed to Salomon van Ruysdael, G. Dubois, Cornelis Vroom or A. van Borssom, all of whom showed a similar depth of feeling for nature. His landscapes with sandy paths under a high cloudy sky are closely related to the early work of J. van Ruisdael.

Literature: I. Q. van Regteren Altena, "J. van Moscher," *Oud Holland,* XLIII, 1926, pp. 18–27.

Moucheron, Frederick de

b. Emden 1633,
d. Amsterdam 1686
807

Amsterdam landscapist. Although he was a pupil of J. Asselyn, his Italianate wooded mountain scenes, bridges over defiles and light wooded valleys with distant views are more closely related to Jan Both. The figures were often supplied by N. Berchem,

Adriaen van de Velde or J. Lingelbach. His pictures, which are numerous, are almost always signed. Isaac de Moucheron was his son and pupil. He may be confused with W. Schellinks, who was also a follower of Jan Both.

Literature: N. MacLaren, *National Gallery Catalogues, Dutch School*, London, 1960, p. 259; W. Stechow, *Dutch Landscape Painting of the Seventeenth Century*, London, 1968.

Moucheron, Isaac de

b. Amsterdam 1667,
d. there 1744

808

Amsterdam landscapist, son and pupil of Frederick de Moucheron. In accordance with contemporary taste he modified his father's style and devoted greater attention to detail. His park landscapes with castles, Roman architecture and hunting parties are admirable as regards perspective, liveliness and colour. His drawings, which are excellent, are commoner than his paintings. His signature resembles his father's and was sometimes converted into it. Like J. Glauber, he belongs to the late period of Dutch landscape painting. Nicolaes Verkolje sometimes supplied him with brightly-coloured figure groups.

Literature: A. Staring, "I. de Moucheron als Ontwerper," *Oud Holland*, LXV, 1950, p. 85.

Moyart, Nicolaes

b. Amsterdam 1592/93,
d. there 1655

809, 810, 811

Amsterdam painter of historical and Biblical scenes, in landscapes which show the influence of A. Elsheimer and J. Pynas. Later he was also influenced by Rembrandt. His well-composed, lifesize figures are taken from the Old and New Testament and Roman mythology. Warm brown tones predominate. His conception of the relationship of human figures to landscape is similar to that of P. Lastman, L. Jacobsz. and Jan Pynas. His Regent pieces and portraits are good but rare. He painted animals with good observation in a broad style which influenced his pupils N. Berchem and Jacob van der Does, and probably also Paulus Potter. His pupil Salomon Koninck also followed Rembrandt's style but has nothing in common with Moyart.

Mulier, Pieter

b. Haarlem about 1615,
d. there 1670

812

Haarlem marine painter. His pictures of the open sea with fishing-boats in a fresh breeze, or views of the sea from the dunes, recall S. de Vlieger and Jan Porcellis by the silver-grey tone of the soft, hazy atmosphere. He is characterized by the diagonal arrangement of cloud (storm-clouds and showers of rain) and a dark-grey background which is sometimes hard. He usually signed with a linked monogram PML or the letters PMLIER. His pictures are often taken for early works of S. de Vlieger or J. van Goyen, and confusion with Jan Porcellis is also possible.

Literature: F. C. Willis, *Die Niederländische Marinemalerei*, Leipzig, 1911.

Mulier, Pieter, known as Tempesta

b. Haarlem about 1637,
d. Milan 1701

813, 814

Dutch landscape and sea painter and draughtsman, probably son of the marine painter P. Mulier (above). He went to Rome in 1665 and later to Venice, Milan, Genoa and again Venice, where he used the name Cavaliere Tempesta. He painted in a broad, flowing style hilly and well-wooded Italian landscapes with shepherds and their flocks and with citadels in the background. A well-lit central group is characteristic of him, as are strong contrasts of light and dark. The Mediterranean with its rocky coasts and watch-towers is a favourite subject. He was also admired for his pictures of stormy seas and ships in difficulties, with theatrical cloud effects: many of these are in the Palazzo Colonna at Rome.

Murant, Emanuel

b. Amsterdam 1622,
d. Leeuwarden about 1700

815, 816

Dutch landscapist and animal painter, pupil of Philips Wouwerman. Tumbledown thatched cottages occupy the centre of his village landscapes; their walls are painted with especial delicacy. The animals and sparse human figures are painted with care in a rather humdrum style. The landscape part of the pictures has often darkened, and the pallid sunlight makes them seem rather gloomy. On account of his close attention to masonry, his work is sometimes ascribed to J. van der Heyden.

Musscher, Michiel van

b. Rotterdam 1645,
d. Amsterdam 1705

817, 818

Dutch genre painter and portraitist who studied with A. van den Tempel, G. Metsu and Adriaen van Ostade; however, in style and subject he has nothing in common with the last-named. His genre pieces recall G. Metsu and Frans van Mieris. His well composed and richly furnished interiors have particular charm (a painter in his studio, a scholar in his library). His pictures of this type, mostly representing the social life of prosperous Dutch

burghers, have often been attributed to those painters, while his successful portraits have been ascribed to Caspar Netscher and N. Maes.

Myn, Herman van der

b. Amsterdam 1684,
d. London 1741
819, 820

Amsterdam still life and history painter of the later period. His fruit and flower pieces are tastefully composed, with much contrasted lighting; they are enlivened by parrots and magpies and sometimes have a landscape background. His mythological themes conformed to the taste of the princely courts for which he supplied decorations. His elegant, somewhat hard technique is also found in his portraits, which are rarer.

Mytens the Elder, Daniel

b. Delft about 1590,
d. 1647
821

Hague portraitist, probably a pupil of M. J. van Mierevelt. Until the appearance of A. van Dyck he was regarded as the best painter at the English court. In England he was first influenced by Rubens and later by Van Dyck, to whom many of his decorative portraits were ascribed.

Mytens, Jan

b. The Hague 1614,
d. there 1670
822, 823

Hague portraitist and genre painter, father and teacher of Daniel Mytens the Younger. His figures against a landscape background are somewhat reminiscent of B. Graat. He painted pastoral idylls, family groups and elegant companies making music or strolling under trees. His numerous portraits of aristocrats show the influence of Van Dyck.

Mytens the Elder, Martin

b. The Hague 1648,
d. Stockholm 1736
824

Hague portraitist who worked in Sweden from 1677 onwards, chiefly for the court, and painted portraits of high society. His early work is distinguished by acute characterization and clear colours (delicate bluish flesh-tints). His representative figures

in a park landscape, sometimes with allegorical attributes, recall N. Maes. Less often he painted small portraits in grisaille, in an upright oval shape. The quality of his work fell off after 1700. His style was continued by his pupil G. Desmarées.

Naiveu, Matthys

b. Leiden 1647,
d. Amsterdam about 1721
825

Amsterdam portraitist and genre painter, pupil of Abraham Toorenvliet and later of G. Dou, in whose style he painted religious, allegorical and genre pieces. His portraits, which are rarer, are influenced by the late work of Caspar Netscher and are emphatic in gesture. His colours are more variegated than those of his masters. His somewhat hard drawing and lively composition distinguish him from G. Dou and P. van Slingelandt, to whom his work was often ascribed.

Naiwincx, Herman

b. Schoonhoven about 1624,
d. Hamburg after 1651
826, 827

Dutch painter, draughtsman and etcher, of Flemish origin. He lived at Amsterdam about 1650. His oil paintings are few compared to his drawings: he was in fact a merchant and only secondarily a painter. He painted, in the style of A. van Everdingen, wooded mountain landscapes, sometimes with a small watercourse in the foreground, usually with few figures (a river-valley with rocks is in the Bredius Museum at The Hague). According to old inventories he was supplied with figures by G. van den Eeckhout, J. Asselyn and others. The broad style and solemn character of his mountain landscapes caused them to be attributed as a rule to J. van Ruisdael or A. van Everdingen. His later landscapes are Italianate: a southern coast in warm evening light, with trees growing on curiously shaped rocky cliffs. The portrait of a man dressed as a shepherd (1651) was auctioned at Amsterdam in 1905.

Literature: A. Bredius, *Oud Holland*, LVIII, 1941, pp. 19–22.

Nason, Pieter

b. Amsterdam about 1612,
d. The Hague about 1689
828, 829

Hague portraitist and still life painter, probably a pupil of J. A. van Ravesteyn. His excellent portraits, rich in tone, are in the style of C. Janssens van Ceulen or B. van der Helst; they are

usually half-length, and the skyline of a town is often seen in the background. His rare still lifes show the influence of Willem Claesz. Heda. Rich vessels of precious metal are depicted with especial care and accuracy. His dignified portraits may sometimes be confused with those of I. Luttichuys.

Natus, Johannes

active at Middelburg about 1662

830

Dutch genre painter and landscapist, member of the Guild at Middelburg in 1662. He is probably identical with the painter Anton Natus, whose signature is very similar. The genre paintings are of peasant scenes: a wedding, a dance (1658, in the former Weber collection, Hamburg), boys playing cards (1660, in the Rijksmuseum at Amsterdam), or a toper who has fallen asleep. In his landscapes, which are Italianate in style, an important part is played by genre-type figures with strong contrasts of lighting.

Neck, Jan van

b. Naarden 1635,
d. Amsterdam 1714

831

Amsterdam portraitist, history and landscape painter of the later period, pupil of J. A. Backer. As a portraitist he belongs more to the succession of B. van der Helst. His known works mostly depict people bathing in the open air (nymphs, Diana, Susanna) in the manner of C. van Poelenburgh and D. van der Lisse.

Neeffs the Elder, Pieter

b. Antwerp about 1578,
d. there about 1659

832, 833

PEETER
NEEffs

Antwerp painter of architecture in the style of H. Steenwijck the Elder. His well-drawn church interiors are often met with: he confined himself to the frequent repetition of a few types of Gothic church with more than one nave (*Antwerp Cathedral*) and a brightly lit chapel. The painter's viewpoint is generally fairly high, and as the perspective is good, a comprehensive view from above is obtained. The impression is a sober one, especially as the softly painted sunlight is not convincing. He also frequently repeated compositions of H. Steenwijk the Younger. The figures in these pictures of churches were supplied by F. Francken the Younger, D. Teniers, S. Vrancx, Hieronymus Janssens and many others. His pictures are usually signed; they are uneven in quality and hard to distinguish from the work of his son and pupil, Pieter Neeffs the Younger.

Literature: H. Jantzen, *Das Niederländische Architekturbild*, Leipzig, 1910; G. Martin, *National Gallery Catalogues, Flemish School*, London, 1970, p. 98.

Neeffs the Younger, Pieter

b. Antwerp 1620, d. there after 1675

834

Antwerp painter of church interiors, son and pupil of Pieter Neeffs the Elder. The same artists contributed figures to his paintings as to his father's. He is characterized by a schematic division of light and shade and by pleasant mixed tones of yellow and violet. Although his pictures are frequently signed and dated, they are often confused with his father's.

Literature: H. Jantzen, *Das Niederländische Architekturbild*, Leipzig, 1910.

Neer, Aert van der

b. Amsterdam 1603, d. there 1677

835, 836, 837, 838, 839, 840

Important Amsterdam painter of moonlight and winter landscapes (also fires and evening scenes), influenced by the earlier painters Joachim and Rafel Camphuysen. Motifs from the Amsterdam river and canal landscape by moonlight are freely composed and distinguished by a poetic feeling for nature and by their successful treatment of the problem of light; they always give an extremely natural impression. His art is wholly personal and free from every kind of pettiness. In his pictures of the full moon rising or setting in a cloudy sky, the whole scene is pervaded by light. He is an unequalled observer of light effects and reflections on land and water, of cloud shapes by night or in a wintry sky. His winter scenes, which are rarer, are also highly valued. Their characteristic colouring is silvery white and warm yellow, light red and light blue. The golf players and skaters who animate the scene are drawn with extraordinary sureness, an art in which he continued Hendrick Averkamp. His son Eglon van der Neer painted in a quite different style. The moonlight scenes of Joachim Camphuysen, who was a weaker painter than Aert van der Neer, often bear his name, as do the winter scenes of the less important Rafel Camphuysen and J. Meerhoud. The imitators of his moonlit pictures in the Biedermeier period fell into mawkish romanticism.

Literature: C. Hofstede de Groot, *Catalogue raisonné*, vol. VII, Esslingen, 1918; N. MacLaren, *National Gallery Catalogues, Dutch School*, London, 1960, p. 260; F. Bachmann, *Landschaften des A. van der Neer*, Neustadt, 1966; W. Stechow, *Dutch Landscape Painting of the Seventeenth Century*, London, 1968.

Neer, Eglon Hendrik van der

b. Amsterdam 1634, d. Düsseldorf 1703

841, 842, 843

Dutch genre and landscape painter, pupil of his father Aert van der Neer and of J. van Loo. He is famous for the natural de-

piction of the silks worn by elegant and richly dressed ladies at their toilet, in musical parties or on a visit. These themes are similar to those of his model G. Metsu, but the younger man's painting is smoother and harder. In his portraits and small genre pieces (children playing, soldiers, mythological, Biblical and historical scenes) the landscape background is usually of a metallic green. In his later period he painted small Italianate landscapes in a very personal style, with the foliage minutely and carefully rendered and with large, lifelike plants and bushes in the foreground. J. Ochtervelt, who painted conversation pieces with a similar theme, is superior to him in style; his pupil Adriaen van der Werff approaches him. He may be confused with Jan Verkolje, T. van der Wilt or G. van Zyl.

Literature: N. MacLaren, *National Gallery Catalogues, Dutch School,* London, 1960, p. 265; W. Stechow, *Dutch Landscape Painting of the Seventeenth Century,* London, 1968.

Nellius, Martinus

d. after 1706

844

Dutch still life painter. Fruit seen in close-up, a wineglass and a Delft bowl are arranged on the corner of a table, sometimes with a crumpled cloth; typically, flies and butterflies are added for animation. The lighting, in large patches, is rich in contrasts and produces a strikingly plastic effect. Flowers are rare.

Literature: R. Warner, *Dutch and Flemish Fruit and Flower Painters,* London, 1928.

Neter, Laurentius de

b. Elbing about 1600

845, 846

German-Dutch genre painter, active in Holland between 1631 and 1649, in the style of the painters of genre and military themes A. Palamedesz., P. Codde and J. Olis. His composition of large groups is somewhat awkward, and the facial types are rather uniform.

Netscher, Caspar

b. Heidelberg about 1636,
d. The Hague 1684

847, 848, 849, 850, 851

Dutch portraitist and genre painter, pupil of G. ter Borch. However, the latter's influence is visible only in his early work, which is highly thought of: maids and old women in quiet domestic occupations. His glowing, warm-toned genre pictures of high life belong to a later period and recall G. Metsu by the careful depiction of materials (white satin dresses). After 1670 he painted only cool, smooth portraits of a courtly type, against a park-like landscape in evening light. In accordance with the taste of the time, the sitters, who were mostly women and girls, were dressed as mythological or allegorical characters. Netscher

followed the French model of P. Mignard and was thus in line with the later N. Maes and G. Schalcken. The careful placing of the figures in relation to draperies and vistas does not hide the artist's routine production. Confusion with N. Maes is only conceivable in the case of the later courtly portraits: Netscher's style of painting is harder and more colourful. His most faithful successors were his sons Theodor and Constantin Netscher and the portraitist A. Boonen. J. van Haensbergen and M. Wytmans imitated him in their portraits.

Literature: C. Hofstede de Groot, *Catalogue raisonné,* vol. v, Esslingen, 1912, N. MacLaren, *National Gallery Catalogues, Dutch School,* London, 1960, p. 266.

Netscher, Constantin

b. The Hague 1668,
d. there 1723

852

Hague portraitist and genre painter, imitator of his father and teacher Caspar Netscher, from whose later style he derives. The affected conception, the variegated, rather shrill colouring and the love of rich costumes and draperies all proclaim him to be a painter of fashion. The facial expressions are conventional and lack vitality; the drawing is weaker than that of his father, with whom he cannot easily be confused. None the less his works are often ascribed to the latter, particularly as their initials are the same. As a rule, the distinction is facilitated by the fact that the dress in Constantin's portraits shows the fashion of a later time.

Neyn, Pieter de

b. Leiden 1597, d. 1639

853

Leiden landscape painter, pupil of Esaias van de Velde. His pictures of dunes, mostly small in size, are inferior to the early work of J. van Goyen and Salomon van Ruysdael. The shape of the trees is mannered and the composition often unrestful. The figures are strong but somewhat too large, and do not fit well into the picture. Owing to the similar initials he may be confused with P. Nolpe. However, P. de Neyn either used the uncontracted monogram P. N. or signed his full name.

Literature: W. Stechow, *Salomon van Ruysdael,* Berlin, 1938, p. 55; H. Gerson, "De Meester PN," *Nederlandsch Kunsthistorisch Jaarboek,* 1, 1947, pp. 95 ff.

Neyts, Gillis

b. Ghent 1623, d. Antwerp 1687

854, 855

Rare Flemish landscape painter in the manner of L. van Uden, from whom he is distinguished by the very personal and meticulous way in which he paints the foliage of tall clumps of

trees. His spacious river landscapes with forests and low hills often feature castles, ruins and small figures of travellers or huntsmen. He is distinguished by the subdued lighting and bluish-green tonality, which causes the landscape to merge into a whole. His pictures are generally signed.

Literature: Y. Thiéry, *Le Paysage flamand*, Brussels, 1953.

Nickele, Isaac van

active at Haarlem 1660–1703
856, 857

Haarlem painter of church interiors, of the later period. His pictures are as a rule free representations of St. Bavo's or the Nieuwe Kerk at Haarlem. The effect of depth is enhanced by skilfully drawn figures, which were sometimes painted by other hands. Like the other Haarlem painters of churches he is at pains to give a full and accurate depiction of the interior: the spectator looks right down the central nave. Most of his pictures are signed and dated in the last decade of the century.

Literature: H. Jantzen, *Das Niederländische Architekturbild*, Leipzig, 1910.

Nickelen, Jan van

b. Haarlem 1656, d. Cassel 1721
858, 859

Dutch painter of church interiors and landscapes, also an etcher; son and pupil of Isaac van Nickele (Nickelen). The son worked at Haarlem, where he was admitted to the Guild in 1688. In 1712 he entered the service of the Elector John William of the Palatinate at Düsseldorf, and in 1716 he became court painter to the Landgrave Charles of Hesse and Cassel. He began by painting church interiors like his father, to whom his works in this line are probably now attributed. Later he painted Italian-type landscapes with numerous figures, in the style of J. Glauber or J. van Huysum. As was customary at the turn of the century, he devoted great care to representing foliage, antique architecture and citadels in the background. Two views of Benrath Castle by him are in the gallery at Schleissheim. His daughter Jakoba Maria was admired as a painter of flowers and fruit.

Nieulandt, Adriaen van

b. Antwerp 1587,
d. Amsterdam 1658
860

Flemish-Dutch painter of large kitchen still lifes in the style of P. C. van Ryck, mostly with figures that fit well into the composition. His later works with secular, Biblical or mythological figures against a landscape background are reminiscent of C. van Poelenburgh. The figures, however, are larger and more important in the picture but less well drawn. His historical pieces are rare. He was the brother of Willem van Nieulandt.

Literature: Y. Thiéry, *Le Paysage flamand*, Brussels, 1953.

Nieulandt, Willem van

b. Antwerp 1584,
d. Amsterdam 1635
861

Flemish-Dutch landscape painter, brother of Adriaen van Nieulandt and pupil of P. Bril and R. Savery. He painted in fresh colours Flemish-Italianate landscapes with ruins, in which figures in antique or Oriental costume play a prominent part. His views of Rome with antique architecture are frequently met with. His work is characterized by the somewhat pedantic treatment of masonry. His pictures of ruins may be confused with those of S. Vrancx, which are rarer.

Literature: G. J. Hoogewerff, "De beide Nieulandt," *Oud Holland*, XXIX, 1911, p. 57.

Niwael, Jan Rutgersz. van

active at Utrecht 1639–61
862, 863

Dutch portraitist and genre painter from Gorkum. In 1620 he visited Grenoble. His pictures are in the typical Utrecht style of the large group around P. Moreelse and W. van Honthorst. He is especially close to the Utrecht school in his genre-like half-length portraits of young ladies dressed as shepherdesses (allegory of vanity), which P. Moreelse had painted in a very similar style before him. There is also an allegorical portrait of a clergyman with a skull, signifying transience.

Nolpe, Pieter

b. Amsterdam 1613,
d. about 1653
864, 865

Dutch painter of dunes and canal landscapes, which occupy a place between the early works of Salomon van Ruysdael and those of Jan van Goyen. His pictures are often attributed to one or other of these, but his style is cruder and the drawing is inexact and less conspicuous. His peasants are ungainly figures in the style of Jan van Goyen; he depicts foliage in a crude manner and in a fan-like shape. He often painted extensive dune landscapes (P. de Molijn) with inns, in front of which peasants are

resting with their carts; or boats plying on quiet canals, with villages and the outlines of towns in the background. His mannered style of painting foliage can be observed especially in his winter scenes, which are rarer. He usually signed with his initials, the P being combined with the first stroke of the N. He is often confused with P. de Neyn owing to the similarity of their subjects and monograms; however, Nolpe's composition is broader and more varied, and his figures fit into the picture well.

Literature: W. Stechow, *Salomon van Ruysdael*, Berlin, 1938, p. 55.

Nooms, Reinier, known as Zeeman

b. Amsterdam about 1623,
d. before 1667

866, 867

Amsterdam marine painter, influenced by Willem van de Velde. His scenes of ports and of the city of Amsterdam are animated by small, skilfully introduced figures. Ships in large numbers are pleasingly disposed on a calm or moderate sea. He occasionally painted sea-battles in Willem van de Velde's style. His small pictures of coast scenes in Italy are effective by their vaporous atmosphere and harmony of composition. They may be recognized by their characteristic grey-orange and bright red tones; the horizon is often painted in a strong orange-yellow.

Literature: F. C. Willis, *Die Niederländische Marinemalerei*, Leipzig, 1911; L. Preston, *Sea and River Painters of the Netherlands*, London, 1937; W. Stechow, *Dutch Landscape Painting of the Seventeenth Century*, London, 1968

Noordt, Jan van

active at Amsterdam 1644–76

868, 869

Dutch historical and portrait painter under Flemish influence (Jacob Jordaens). His historical pieces are in the style of Jan Weenix or B. Graat: large figures in strong colour and a hard light, against a landscape which serves only as background. His varied portraits of fine ladies and gentlemen with genre-type accessories recall B. van der Helst, J. A. Backer, G. Flinck and G. van den Eeckhout. J. Voorhout was a pupil of his.

Noort, Pieter van

b. Leiden 1602,
d. Zwolle after 1662

870, 871

Leiden painter of fish still lifes in the style of P. de Putter, whose work however is smoother and cooler. Noort's construction is not elaborate, but the treatment, in cool grey tones, is both painterly and plastic. He painted river-fish, or less often shell-fish, laid out on a stone slab with nets and fishing tackle. His hunting still lifes of dead birds and hares are less frequent. J. van Duynen resembles him but is a less accurate draughtsman.

Nouts, Michiel

b. Delft 1628

872

Dutch portraitist, son of a faience painter, active at Delft in the middle of the century. The severe, economical construction and expressiveness of his rare portraits show him to have been an artistic personality of note. His unusual, very effective lighting sometimes recalls Jan Vermeer of Delft. There is a fine portrait of a lady by him in the Alte Pinakothek, Munich.

Literature: A. Bredius, *Oud Holland*, XXXVIII, 1920, p. 180; N. MacLaren, *National Gallery Catalogues, Dutch School*, London, 1960, p. 274.

Ochtervelt, Jacob

b. Rotterdam 1635,
d. there about 1710

873, 874, 875

Rotterdam genre and portrait painter; pupil of N. Berchem, in whose style he initially painted hunting scenes. Later he joined Berchem's other pupil P. de Hooch in painting elegant interiors with music and galant conversation, as well as bourgeois domestic scenes; fish-vendors and street musicians, pedlars chaffering with housewives. The colours are lively, with strong, glowing vermilion and yellow. His figures are typically seen from a low angle and thus appear taller than ordinary. They are usually well-dressed and lively in their movements; the harsh evening sunlight causes them to stand out sharply from the dark background. He shows the influence of J. Vermeer of Delft, G. ter Borch and G. Metsu; his style is sketchier than theirs, but he displays perfect technique in rendering materials. The genre paintings of B. Graat and Jan Verkolje are sometimes attributed to him, but are weaker.

Literature: W. R. Valentiner, "J. Ochtervelt," *Art in America*, XII, 1924, pp. 269–84; E. Plietzsch, "J. Ochtervelt," *Pantheon*, XX, 1937, pp. 364–72; N. MacLaren, *National Gallery Catalogues, Dutch School*, London, 1960, p. 277.

Oever, Hendrick ten

b. Zwolle 1639, d. 1716

876

Dutch landscape, genre and portrait painter, pupil of C. de Bie. His versatility is shown by his landscapes of the polder country around Zwolle, views of cities and their canals and moats, and hunting pieces including scenes of huntsmen setting out. Less

often he painted group and individual portraits against a landscape or city background, which at times resemble the work of G. ter Borch. The quality of his work is uneven. Still lifes are rare.

Literature: E. Plietzsch, *Pantheon*, XXIX, Munich, 1942, pp. 132 ff.; J. Verbeek and J. W. Schotman, *H. ten Oever*, Zwolle, 1957.

Olis, Jan

Olis fecit · 1645

b. Gorkum about 1610,
d. Heusden 1676

877, 878, 879

Dutch portraitist and figure-painter in the style of Anthonie Palamedesz. and Jan Miense Molenaer. Like them, he painted groups of people drinking, smoking or gambling, also soldiers and peasants. His characters are seen standing in a bare room with light brown walls. P. Codde, Pieter Potter, H. G. Pot, Simon Kick and J. Duck belong to the same group of painters of conversation pieces. He painted a few kitchen scenes, and simple portraits in an open, undistinguished landscape. His brown-toned interiors with peasants and soldiers are sometimes confused with the work of P. Quast.

Literature: N. MacLaren, *National Gallery Catalogues, Dutch School*, London, 1960, p. 279.

Oolen, Adriaen van

Adriaenus van Oolen

d. Amsterdam 1694

880

Dutch painter of poultry in the style of M. d'Hondecoeter, whom he imitated. His work shows less delicacy of execution and less glowing colours, but it is true to nature and not dramatized (animal fights are rare). The background landscape is only hinted at. The foreground often contains small plants and moss, for which he used green paint laid on broadly with the spatula. There are two pictures of poultry signed by him (ducks and chickens with a peacock) in the Bamberg gallery. His signed works are rare today, as the signature was often removed in order to attribute his pictures to M. d'Hondecoeter. He may be confused with D. Wyntrack, as they have similar a balanced colour-scheme.

Oost, Jakob van

Jacomo van oost F. 1638

b. Bruges 1601,
d. there 1671

881

Flemish painter of portraits, histories and genre, member of a large Bruges family of artists. About 1620 he went to Italy and stayed for five years. Later he worked chiefly at Bruges, where he was master of the painters' guild. In his early period he was influenced by Rubens, whom he occasionally copied, and by Van Dyck. His family groups of several figures, with a finely executed landscape background, recall G. Coques and J. Cossiers. His later portraits are less colourful, richer in tone and sometimes almost have a blackened effect. His genre scenes with close-up half-length figures sometimes recall M. Sweerts (an old woman and a young man, in the Lyons museum). Many of his religious pictures with large figures, in churches at Bruges and elsewhere in Belgium, are similar to the work of his son J. van Oost the Younger (1637–1713), and confusion is frequent. We have pictures by the father dated from 1633 to 1669; after returning from Italy he usually wrote his Christian name in the form Jacomo.

Literature: R. A. d'Hulst, *Gentse Bijdragen*, XIII, 1951, p. 169. G. Martin, *National Gallery Catalogues, Flemish School*, London, 1970, p. 103.

Oosten, Isaak van

Jv · oosten f

b. Antwerp 1613, d. 1661

882, 883

Flemish landscape painter, son of an art dealer of the same name and brother of the landscapist Frans van Oosten. His landscapes, mostly small and often on copper, recall J. Brueghel the Elder, to whom they are usually attributed, but the drawing and detail are less meticulous. The themes are those of the Brueghel circle: Paradise, Adam and Eve under the tree, the Expulsion from Paradise, also small forest and river landscapes with peasants and cattle: some of these (e.g. at Windsor) are actually free copies of J. Brueghel. The figures are somewhat coarse, the foliage typically rather schematic; the predominant tone is brownish or a uniform grey-green. The landscapes with figures may be confused with those of the two Bouttats; but the latter are closer to J. Brueghel, while Van Oosten's works strike a thoroughly personal note.

Oosterwyck, Maria van

Maria an Oosterwyck

b. Noorddorp near Delft 1630,
d. Uitdam 1693

884

Delft flower painter who worked for Louis XIV and the emperor Leopold I; pupil of Jan Davidsz. de Heem. Her pictures are somewhat harder than those of her teacher and model, but are elegant and spirited despite her laborious technique. Her flowers are loosely grouped together, have a plastic effect and are generally seen against a very dark background. Less often, she painted fruit or *Vanitas* still lifes.

Ormea, Willem

W. URMEA *fecit* 1638.

b. Amsterdam 1611,
d. Utrecht 1665

885

Utrecht painter of fish and other sea-creatures, laid out on fish-mongers' benches or on the beach. These cool, silvery pictures often bear the more eminent name of A. van Beyeren. Ormea can hardly be confused with his pupil J. Gillig. The background of beach or open sea, in relation to which the fishes in the fore-ground are too big from a perspective point of view, was painted by the two marine artists named Willaerts, who signed the pictures together with Ormea.

Ostade, Adriaen van

Av. ostade 1648

b. Haarlem 1610,
d. there 1685

886, 887, 888, 889, 890

Important Haarlem genre painter, brother of Isaac van Ostade, with whom he probably worked under Frans Hals. His depiction of indoor peasant life is a key element in Dutch painting. Until about 1640 he painted coarse peasants drinking, dancing or quarrelling in dark thatched huts with earthen floors on which the light strikes sideways through an open door (influence of Rembrandt), also village schools or a man playing a hurdy-gurdy in front of a cottage; the whole in cool, light-grey tones with bluish or pink local colour. After 1640 he developed a dark brown chiaroscuro. He grouped lesser and greater figures with inexhaustible narrative skill, and became increasingly interested in individual features (character heads). After 1650 the carefully portrayed peasant types become more vivid thanks to stronger local colour. The figures are larger in relation to the picture and are less mobile (half-length figures); they all have a characteristic ungainly build. They sit talking quietly in a comfortable spot in front of a cottage or an inn wreathed with vines. The back-ground of the peasant interiors becomes richer: the kitchen and living room are furnished and decorated with simple pictures. After 1670 the lighting becomes brighter and the colours are again cool. Contrary to the general rule, the quality of Ostade's work did not fall off in the last third of the century. His peasants, despite a uniform ugliness which is not unpleasing, have become figures of universal validity and are a triumph of sympathetic understanding. He also contributed figures to church scenes by P. Saenredam and to the early landscapes of Jakob van Ruisdael, J. Vermeer the Elder of Haarlem and C. Decker. Rarer works of his are quiet still lifes of kitchen or farm implements and portraits of smokers, bakers, fishermen, smiths, lawyers and doctors. Among his pupils were his brother Isaac van Ostade, C. Dusart, C. Bega, M. van Muscher and J. Steen. His brother was closest to him in his early days, but then developed independently. C. Dusart inherited and worked over his pictures. About a thousand by Van Ostade's own hand have come down to us; those by his many imitators and forgers are far more numerous.

Literature: A. Rosenberg, *Adriaen und Isaac van Ostade*, Bielefeld, 1900; C. Hofstede de Groot, *Catalogue raisonné*, vol. III, Esslingen, 1910; M. Kuznetsov, *A. van Ostade*, Leningrad, 1960; N. MacLaren, *National Gallery Catalogues, Dutch School*, London, 1960, p. 282.

Ostade, Isaac van

Isach von Ostade 1644

b. Haarlem 1621, d. there 1649

891, 892, 893, 894

Important Haarlem genre and landscape painter, brother of Adriaen van Ostade, whom he followed closely in his early pictures of barns with numerous peasants eating and drinking, but less often in exuberant spirits: few are drunk or brawling. His pictures have a yellowish tone unlike the warm brown of his brother's early work, yet the two are hard to distinguish. To this period belong the popular picture of a slaughtered pig and the very picturesque scenes of barns with one or two unobtrusive figures. The light falls in from a side opening and is concentrated on a small part of the area. After 1642 the peasants are no longer depicted indoors but on the road or in front of an inn, where a cart with a white horse is often seen waiting. There are large clumps of trees, the branches and foliage of which are skilfully painted, and to one side of the picture there is generally a view past these into the distance. The figures become more and more numerous and of a genre character; dogs and fowls enliven the foreground. His large, spacious winter scenes, which do not show his brother's influence, are animated by figures that fit well into the picture: skaters or a horse-drawn sleigh. The main feature of these scenes is the landscape, with its wonderfully sensitive rendering of light and an atmosphere in which one can see for miles. His favourite colours are a shaded green, a lucent silver-grey and a not too opaque brown. He devotes special care to the arrangement of the animated figures, which are dressed without ostentation and blend harmoniously into the scene. Often the highlight consists of a white horse, standing against the dark landscape, which rises to either side of the picture. Many of these winter scenes are large, and, although the artist died at the age of 28, they are equal in merit to those of the other great Dutch winter painters, J. van Goyen and Aert van der Neer.

Literature: A. Rosenberg, *Adriaen und Isaac van Ostade*, Bielefeld, 1900; C. Hofstede de Groot, *Catalogue raisonné*, vol. III, Esslingen, 1910; MacLaren, *National Gallery Catalogues, Dutch School*, London, 1960, p. 288; W. Stechow, *Dutch Landscape Painting*, London, 1968.

Oudendyck, Adriaen

A oudendyck

b. Haarlem 1648, d. after 1700

895

Dutch painter and draughtsman, member of the Guild at Haarlem in 1670. He painted landscapes with herdsmen and cattle in a delicate style modelled on A. van de Velde. These small, pleasantly composed landscapes with bucolic figures were much

admired at the end of the seventeenth century. Houbraken relates that he was given the nickname "Rapianus" for stealing motifs from other painters. There are typical landscapes of his at Bamberg, Le Havre and Prague.

Oudenrogge, Johannes Dircksz.

J Ouden-rogge.1652

b. Leiden 1622, d. Haarlem 1653

896, 897

Dutch genre painter and landscapist; active at Leiden in 1645–8 and a member of the Haarlem guild in 1651. He married the sister of the interior painter Q. van Brekelenkam. His landscapes and scenes of weavers' cottages show affinities with the work of C. Decker and Salomon Rombouts. The foliage is somewhat coarser, the overall tone is brownish and the perspective is good. These landscapes are sometimes also attributed to I. van Ostade. The best known of his genre paintings are the weavers' cottages: with the light falling in effectively through a side window, and with their strong chiaroscuro, these recall C. Decker and also C. Beelt. A typical interior with a weaver and his family saying Grace was in the Schloss collection in Paris. He also painted stable interiors, e.g. one with a slaughtered ox (privately owned at Herten, Westphalia).

Overschee, Pieter van

P. V. O.

active at Leiden in the mid-seventeenth century

898

Dutch still-life painter; several Leiden artists bore this name. He was influenced by J. D. de Heem, and painted in the latter's style a breakfast still life with a pie and wine-glass which is in the Liechtenstein gallery at Vaduz. His rather broad, painterly handling of colour is more suggestive of A. van Beyeren as a model. He also painted hunting still lifes with hares, game and fish, or hares with dead birds and fruit (1645, Metropolitan Museum, New York). His practised style suggests that he painted a large number of works. No doubt many of his unsigned pictures are concealed under the names of better-known artists.

Palamedesz., Anthonie

PALAMEDES. ƒ:

b. Delft 1600/1,
d. Amsterdam 1673

899, 900, 901

Amsterdam genre painter and portraitist, pupil of M. J. van Mierevelt at Delft. His conversation pieces of upper-class society or of soldiers dining, gambling and making music are similar in subject to those of P. Codde, J. Duck, C. J. van der Lamen, J. Olis and J. van Velsen. His early works are more reminiscent of Dirck Hals and W. Duyster, and are fresher and more colourful. The rooms, with the light generally falling on the rear wall, are furnished with a few pictures, a map, a cupboard or a fireplace. His late pictures are often monotonously brown in tone; the faces are sketchily characterized. His work varies a great deal in quality; he often repeats the same figures in similar attitudes. His rather prosaic and factual portraits, in which materials are skilfully rendered, are in the style of his teacher M. J. van Mierevelt. Among his pupils was his brother, the battle-painter Palamedes Palamedesz.

Palamedesz., Palamedes

Palamedes Palamedesz

b. London 1607,
d. Delft 1638

902

Dutch painter of cavalry fights, pupil of his brother Anthonie Palamedesz. The pictures are in light tones and are in the style of J. Martsen the Younger. They usually show the moment of violent impact of two groups of cavalrymen; the principal figure is often seen on a sturdy white horse in the middle distance. The landscape and clouds of smoke are treated summarily. Most of his pictures are signed. Confusion with the somewhat later I. van der Stoffe and P. Meulener is possible.

Pape, Abraham de

PAPF

b. Leiden about 1620,
d. there 1666

903

Leiden genre painter, pupil and imitator of G. Dou. His interiors show an old woman engaged in some quiet domestic task – spinning, peeling apples, plucking a chicken; less often, a single male figure. They are reminiscent of Q. Brekelenkam, but the latter is much more inventive. Vegetables, baskets and implements are disposed in still-life fashion and painted with accuracy, but the style is inferior to that of G. Dou.

Literature: N. MacLaren, *National Gallery Catalogues, Dutch School,* London, 1960, p. 290.

Paulyn, Horatius

b. Amsterdam about 1644,
d. about 1686

904

Versatile painter of genre, portraits and still life in the manner of the Leiden school (Mieris). The excellent drawing and the meticulous detail of his still lifes also recall J. van der Heyden. There is a lute player, formerly in private ownership at Milan; a man counting money, in the Uffizi at Florence; and two still

lifes in a private collection at Münster. Most of his work is signed in full and dated. The monogram HP, assigned to him in the literature, may also denote Hendrik Pot.

Peeters, Bonaventura

b. Antwerp 1614,
d. Hoboken 1652

905, 906

·B·Peeters· 1637

Flemish marine painter of effective seascapes, initially in a light grey overall tone: views of the Scheldt, usually in a strong wind. Later his local colours become stronger and the light effects more significant, especially in his scenes of Oriental ports. He was celebrated for his storms at sea and shipwrecks on strange rocky coasts, with violent waves and a theatrically clouded sky. There is also an unrealistic air about his naval ports and imaginary sea-battles, some with Oriental figures. Most of his pictures are monogrammed and dated. He may easily be confused with his brother and pupil Jan Peeters, who painted in a similar style but more sketchily, and with the Dutch sea-painters Jan and Julius Porcellis.

Literature: F. C. Willis, *Die Niederländische Marinemalerei*, Leipzig, 1911; G. Martin, *National Gallery Catalogues, Flemish School*, London, 1970, p. 104.

Peeters, Clara

b. Antwerp 1594, d. after 1657

907, 908, 909

CLARA. P

Flemish-Dutch still-life painter, active at Amsterdam and The Hague. Vessels of earthenware and precious metal, fish, rare flowers and fruit are arranged on a plain wooden surface in front of a dark background; the composition appears primitive but is in fact economical and well thought out. The laborious depiction of the material in every detail (silver goblets with reflections, knife-handles, coins, shells) does not detract from the general impression. Her work is distinguished by harmonious colouring and moderate use of chiaroscuro. She shows unmistakable links with the group around Jan Brueghel. Most of her pictures are signed with her full name and dated. Her work has often been confused with that of P. Claesz owing to the similarity of initials and subject-matter. She is an artist of taste and is superior to Floris van Dyck.

Literature: M. L. Hairs, *Les Peintres flamands de fleurs*, Brussels, 1955; I. Bergström, *Dutch Still-Life Painting*, London, 1956; E. Greindl, *Les Peintres flamands de nature morte*, Brussels, 1956.

Peeters, Gillis

b. Antwerp 1612, d. there 1653

910, 911

G. · Peeters.

Flemish landscape painter and etcher, brother of Bonaventura and Jan Peeters; master in the Antwerp guild in 1634. Some of his pictures are signed jointly with B. Peeters, and it may be inferred that they used the same studio. He painted, in clear light-green tones, fantasy landscapes with peasant cottages built of stone, mountains with waterfalls, mills and chapels, or barges on rivers flowing between wooded banks. He often introduces conifers, which are rare in Holland, and this makes his mountain landscapes resemble those of J. Tilens. He has a personal, somewhat mannered style of painting rocks and masonry. Curiously, he also painted Colonial landscapes, topographically accurate views of Recife and Pernambuco. A scene of a battle with natives in a landscape of palm-trees (the Dutch invasion of Guiana) was in the London art trade in 1953.

Peeters, Jan

b. Antwerp 1624,
d. there about 1677

912, 913

J·P

Flemish sea-painter, brother and pupil of Bonaventura Peeters, whose later style he continued. His pictures are harder and more dramatic than his brother's; the water and ships are sketchier, and the clouds are still more dramatized. He too painted Oriental ports and sea-battles of his own invention, less often he painted winter scenes with sport on the ice, whaling, and sketchy, veduta-like pictures of towns. The similar monogram has caused confusion with the two older Dutch sea-painters Jan and Julius Porcellis, but J. Peeters' work is of a sketchier and more decorative character than theirs.

Literature: F. C. Willis, *Die Niederländische Marinemalerei*, Leipzig, 1911.

Peschier, N. L.

Peschier. Fecit.- 1660.

active at Amsterdam in the mid-seventeenth century

914

Dutch still-life painter; nothing is as yet known about the circumstances of his life. He belongs to the large group of *Vanitas* painters: H. Andriessen, J. de Claeuw, J. Vermeulen, L. van der Vinne, P. van der Willigen. The symbolic documents, musical instruments, hour-glass, skull etc. are depicted in vivid colours; despite the precise drawing they have a painterly effect. The sense of space is enhanced by the skilful distribution of light and shade. There is a typical *Vanitas* of 1660 by him in the Rijksmuseum at Amsterdam. It is extraordinary that more pictures by this excellent artist have not been preserved.

Plattenberg, Matthieu van

b. Antwerp 1606, d. Paris 1660

915

Netherlandish sea-painter and copper-engraver, pupil of A. van Eertvelt. He worked in Paris, initially as a designer of embroidery patterns. His marines represent fantastic storms, generally in evening light; they are dark, but impressive in their effect. There are typical works by him at Antwerp, Augsburg, Bamberg, Nuremberg, Würzburg and Paris.

Pluym, Carel van der

b. Leiden 1625, d. 1672

916

Leiden painter and member of Rembrandt's circle; he was probably a cousin and pupil of the latter's. G. van den Eeckhout was his uncle. His studies of heads are in Rembrandt's broad, impasted manner, but he followed the master only in the externals of technique and lighting. He painted old men and women holding a book and a pair of spectacles, scholars in their studies, people reading or asleep, money-changers, rabbis and Biblical scenes with a few figures. His distinctive colours are a warm brown olive-green and a bright yellow; he avoided red shades. His pictures, which are rare, were often passed off as Rembrandt's by removing his signature.

Literature: A. Bredius, "K. van der Pluym," *Cicerone*, I, 1918, pp. 47–51; A. Bredius, "K. van der Pluym," *Oud Holland*, XLVIII, 1931, pp. 241–64.

Poel, Egbert van der

b. Delft 1621,
d. Rotterdam 1664

917, 918, 919

Dutch painter of peasant life: barns and kitchens with piles of household gear and a maid or farm hand, also a dog and poultry. The figures and the bright lateral sunlight show the influence of Adriaen van Ostade. The tone is a warm reddish-brown; local colour is strong, especially in the interiors. Occasionally he also painted stables or the outside corner of a house with pots, barrels and vegetables composed in still-life fashion. He is best known for his numerous pictures of the explosion of the powder-magazine at Delft, which usually bear the exact date of the catastrophe. In addition there are many pictures by him of fires and plundering, with peasant figures in a strong light. His effective, somewhat coarse figures also play an important part in his winter scenes, views of canals and beaches, showing fishermen selling their wares or ships with lofty sails on a calm sea. The pictures of barns and kitchens are generally signed in full and may be compared with similar works by Cornelis Saftleven,

H. M. Sorgh, Hubert van Ravesteyn and H. Potuijl; they are also sometimes ascribed to Adriaen van Ostade or W. Kalf. The pictures of the explosion at Delft were imitated by D. Vosmaer.

Literature: N. MacLaren, *National Gallery Catalogues, Dutch School*, London, 1960, p. 291; W. Stechow, *Dutch Landscape Painting of the Seventeenth Century*, London, 1968.

Poelenburgh, Cornelis van

b. Utrecht about 1586,
d. there 1667

920, 921, 922

Utrecht landscapist and historical painter, pupil of Abraham Bloemaert. His landscapes of woods and ruins are mostly small and are decorated with mythological or Biblical female nudes, painted with the smoothness and delicacy of a miniature. The Arcadian landscapes with ruins are of a Roman type; there is often a stream with bathers. His elegant Roman landscapes (Tivoli) are especially true to nature and show the influence of A. Elsheimer. Less often he painted small portraits and religious subjects with large figures of putti and angels. He also contributed figures to paintings by Jan Both, J. Hackaert, Willem de Heusch, A. Keirincx, Herman Saftleven and Hendrick Steenwijck. A. van Cuylenborch and J. van Haensbergen are close to him as regards style and material. Among his pupils and imitators were D. van der Lisse, D. Vertangen and F. Verwilt.

Literature: Th. von Frimmel, "C. van Poelenburgh und seine Nachfolger," *Studien und Skizzen zur Gemäldekunde*, I 102, II 101 and IV 20–45; G. J. Hoogewerff, *De Bentvueghels*, The Hague, 1952; E. Schaar, "Poelenburgh und Breenbergh," *Mitteilungen des Kunsthistorischen Institutes in Florenz*, IX, 1959; N. MacLaren, *National Gallery Catalogues, Dutch School*, London, 1960, p. 295; W. Stechow, *Dutch Landscape Painting of the Seventeenth Century*, London, 1968.

Pompe, Gerrit

b. ?Rotterdam 1655, d. 1705

923, 924

Dutch sea-painter, pupil of L. Backhuysen; active at Rotterdam between 1678 and 1691. His rare marine pieces and beach scenes are characterized by ships with skilfully rendered sails and tackling. As with his master, the depiction of the waves is somewhat hard. The light is variable, and there are long bright and dark stretches of sea; the skyline of a town is often seen in the distance. There is a typical picture of warships at Enkhuizen (1671) in the W. van der Vorm collection at Rotterdam.

Poorter, Willem de

b. Haarlem 1608, d. after 1648

925, 926

Haarlem painter, probably a pupil of Rembrandt, the work of whose Leiden period he imitated with strong contrasts of light

and dark. Groups of Biblical figures are seen against a dark background; the light usually falls in from the left at a sharp angle. A heavy impasto characterizes these pictures, which are often attributed to Rembrandt. His later allegorical works belong more to the school of L. Bramer and J. de Wet; the foreground is usually decorated with flashing gold and silver implements, weapons, armour, flags or sculpture.

Literature: N. MacLaren, *National Gallery Catalogues, Dutch School*, London, 1960, p. 296.

Porcellis, Jan

b. Ghent about 1584,
d. Zoeterwoude (near Leiden) 1632
927, 928

Flemish-Dutch sea-painter, father of Julius Porcellis. His pictures of silver-grey seas with heavy breakers are admirably drawn; as a rule there is no coast visible, the horizon is low and the scene is animated by fishing cutters, which sit well in the water. The movement of the waves is excellently observed, and the heavily clouded sky is convincingly rendered. His "painting of tone and atmosphere" set a standard for Dutch sea-painting: J. van Goyen himself was directly influenced by it. The monogram used by Jan Porcellis has led to confusion with his son Julius, who painted in a similar style, and also with the later, more cursory marine painter Jan Peeters. P. Mulier's range of subjects was similar.

Literature: A. Bredius, "Joh. Porcellis," *Oud Holland*, XXIII, 1905, II, 23 ff.; F. C. Willis, *Die Niederländische Marinemalerei*, Leipzig 1911; L. Preston, *Sea and River Painters of the Netherlands*, London, 1937; W. Stechow, *Dutch Landscape Painting of the Seventeenth Century*, London, 1968.

Porcellis, Julius

b. Rotterdam 1609, d. Leiden 1645
929

Dutch sea-painter, son and pupil of Jan Porcellis. He painted in a similar style to his father and also used his monogram. Their pictures are therefore hard to tell apart; but in the son's work the sea is calmer and more attention is paid to completing the picture with boats, houses or a strip of coast. He is often confused with the showier Jan Peeters.

Literature: F. C. Willis, *Die Niederländische Marinemalerei*, Leipzig, 1911.

Post, Frans

b. Leiden about 1612, d. Haarlem 1680
930, 931

Dutch painter of charming Brazilian landscapes with native villages under palm-trees; he often repeated these from sketches and from memories of his stay there in 1637–44. They are of ethnographical interest and reflect the native scene well, but are not to be regarded as topographically accurate. The earlier pictures, which are closer to reality, depend more on tones, the later ones on contrasting colours; the atmosphere is admirably rendered. He is characterized by a hard, prominent blue-green. His brother was the battle-painter P. Post.

Literature: J. de Sousa-Leão, *Frans Post*, Rio de Janeiro, 1948; E. Larsen, *Frans Post, interprète du Brésil*, Amsterdam and Rio de Janeiro, 1962; exhibition, Os Pintores de Mauricio de Nassau, Rio de Janeiro, 1968; W. Stechow, *Dutch Landscape Painting of the Seventeenth Century*, London, 1968.

Post, Pieter

b. Haarlem 1608, d. The Hague 1669
932

Haarlem painter of horses, battles and landscapes, brother of Frans Post. His cavalry fights, which are not often met with, belong to the Haarlem school, i. e. approximately that of J. Martsen de Jonge or J. van der Stoffe. He is characterized by sallow-grey tones and earthy colours. The horses and riders are well observed, but from this point of view and as regards colour he is excelled by Philips Wouverman. He may be confused with Palamedes Palamedesz.

Literature: S. J. Gudlaugsson, "P. Post," *Oud Holland*, LXIX, 1954, pp. 59–71.

Pot, Hendrick Gerritsz.

b. Haarlem about 1585, d. Amsterdam 1657
933, 934

Versatile Haarlem painter of genre, portraits and historical themes. In his early period he painted group portraits with fresh colours and large figures, and also genre pictures which recall Dirck Hals's lively interiors with cavaliers and fine ladies conversing; the setting itself is poorly rendered. Themes of dissolute carousing and card-playing are often repeated. Later the figures are drawn more sketchily; the tonality is cool black or violet, with white lights crudely superimposed. As time went on, he mostly painted small individual portraits in cool grey tones, of persons sitting at a table or standing in semi-profile in an almost empty room. The yellowish-brown tonality and elaborate detail recall T. de Keyser. He is often confused with the many other painters of soldiers indoors: Anthonie Palamedesz., P. Codde, J. Olis, J. Duck, S. Kick and J. van Velsen.

Literature: N. MacLaren, *National Gallery Catalogues, Dutch School*, London, 1960, p. 297.

Potheuck, Johann

b. Leiden 1626, d. 1669
935

Dutch still-life painter and portraitist; member of the guild at Leiden in 1652. His still lifes, which are rare, belong to the wider

circle around J. de Heem: breakfast pieces with costly vessels and carpets, in a style similar to B. Vermeer or P. de Ring. Apart from still lifes, the only picture by him at present known is a large group portrait of the governors of the Leiden plague hospital, dated 1658 (Lakenhal, Leiden).

Literature: A. P. A. Vorenkamp, *Het Hollandsche Stilleven*, Leiden, 1933, p. 68.

Potter, Paulus

b. Enkhuizen 1625,
d. Amsterdam 1654
936, 937, 938, 939

Important Dutch painter of animals and still lifes, son of the still-life artist Pieter Potter. He is famous for his lifelike painting of animals and the Dutch pasture landscape with its lonely oaks, flowers and plants growing on land or in water. Bullocks and cows, horses, sheep, goats and pigs stand in the quiet fields, with no human being to be seen, under a high, silver-grey sky. His bigger landscapes with life-size animal and human figures are inferior to the smaller cabinet pieces, which have a less posed look, are closer to nature and more accurate in perspective. He is fond of using a raised viewpoint, from a dyke or hillock which often conceals the foreground. He painted many portraits of horses and dogs to order; these are lighted to advantage and displayed against an attractive landscape. Less often and with less success he painted hunting pieces (e.g. bear-hunts) and Biblical or mythological themes. He influenced K. Dujardin and Adriaen van de Velde, and was imitated by A. Klomp and W. Romeyn in his pictures of animals and pasture. E. Murant's pictures of grazing animals occasionally resemble Potter but are fussier in technique. The best work of Govert Camphuysen used often to be attributed to him. His classic development of the art of painting animals in landscape served as a model throughout the eighteenth and nineteenth centuries.

Literature: C. Hofstede de Groot, *Catalogue raisonné*, vol. IV, Esslingen, 1911; R. von Arps-Aubert, *Die Entwicklung des Tierbildes bei Potter*, Halle, 1932; N. MacLaren, *National Gallery Catalogues, Dutch School*, London, 1960, p. 298.

Potter, Pieter Symonsz.

b. Enkhuizen 1597,
d. Amsterdam 1652
940, 941, 942

Amsterdam painter of genre, landscapes and still life, with some-what crude drawing and in light-brown tones; father of Paulus Potter. His genre pieces – soldiers eating, drinking and smoking in modest interiors with still-life accessories – belong to the group comprising J. Duck, P. Codde, Simon Kick and J. Olis. His well-

wooded landscapes with streams and his pastoral pictures contain skilfully painted grazing animals, which may have inspired his son Paulus Potter. As a painter of *Vanitas* still lifes he is close to Harmen van Steenwijck of Leiden and the early Jan Davidsz. de Heem. He has in common with Pieter Claesz warm tones, plastic effect and a broad style of painting. Most of his pictures are signed and dated, but unlike his son, who wrote the name Paulus in full, he always contracts Pieter to P.

Potuijl, Hendrik

b. in Holland about 1630,
d. 1670
943

Dutch painter of peasant interiors, barns, stables and rustic open-air scenes with a few figures. He had close links with the Rotterdam interior painters Cornelis Saftleven, E. van der Poel and H. M. Sorgh. His chiaroscuro and concentration of light on a still-life arrangement of farm implements, utensils and vege-tables derive from Adriaen van Ostade, to whom his pictures are often ascribed. His treatment of figures, which mostly occur in the background, is, however, crude. He often signed his work, sometimes with the addition of an owl. His barn interiors may be confused with those of F. Ryckhals.

Putter, Pieter de

b. The Hague about 1600,
d. Beverwijk 1659
944

Dutch painter of still lifes with fish, especially pike and perch, displayed somewhat naively side by side on earthenware dishes. The tonality is cool or brownish, harder and less painterly than that of his nephew and pupil A. van Beyeren. He painted fish-mongers' stalls with portrait-like studies of their owners or serving-maids. The still lifes of P. van Noort may be distin-guished from his by their more careful lighting, and the later ones of I. van Duynen by their less exact drawing. His hunting still lifes with dead hares or ducks are rare. Most of his pictures are signed.

Puytlinck, Christoffel

b. Roermond 1640
945, 946

Dutch still-life painter and draughtsman: he was at Reims in 1663, at Rome in 1667–8 and from 1670 at Roermond. His cousin, the miniaturist J. F. Douven, was his pupil. His still lifes

(Rijksmuseum, Amsterdam) depict live and dead poultry in a masterly fashion; the plumage is rendered with characteristic sweeping brush-strokes in fresh colours. His hunting still lifes with game, a cat or a dog (Landshut Gallery) resemble in theme those of his contemporary Jan Weenix. He often signed with the assumed name Trechter.

Pynacker, Adam

b. Pijnacker (near Delft) 1622,
d. Amsterdam 1673
947, 948

Dutch landscape painter of the Italianate school of N. Berchem and Jan Both; he is particularly close to the latter. His landscapes with herds of cattle may be recognized by the skilfully grouped clumps of trees (which have often darkened) beside quiet mountain streams with thistles or reeds in the foreground. Some of the landscapes are of large size. The trunks of birches and beeches glow in the evening sunlight. The foliage is sometimes of a peculiar metallic bluish colour. His small pictures of sailing boats on a Mediterranean coast, or mule-drawn carts being loaded and unloaded, are distinguished by clear lighting and the beauty of the reflections in still water. He was occasionally imitated by Frederick de Moucheron.

Literature: C. Hofstede de Groot, *Catalogue raisonné*, vol. IX, Esslingen, 1926; W. Stechow, *Dutch Landscape Painting of the Seventeenth Century*, London, 1968.

Pynas, Jacob

b. Haarlem, d. after 1648
949, 950, 951

Dutch landscapist and history painter, also a draughtsman. In 1605 he went with his brother to Italy, where he met P. Lastman and A. Elsheimer. His early landscapes with somewhat over-bright figures are executed with great care and recall Elsheimer's work. As a student he was also close to the Venetian C. Saraceni, who in turn derives from Elsheimer. In 1608 Pynas was back in Amsterdam; in 1622 he was at The Hague, and in 1632 at Delft. Together with his brother Jan, his brother-in-law J. Tengnagel and P. Lastman, he threw off Italian influence and founded the Dutch school of historical painting, from which Rembrandt derives among others. He painted chiefly Old and New Testament scenes with large, animated figures, with broad strokes and in a brownish tonality, and with less emphasis on landscape. At this period he was close to P. Lastman and C. Moyart from the point of view of theme, and also to L. Jacobsz. His landscape was at this time very close to nature, in the new Dutch style. His place in art history is with the pre-Rembrandtists. According to tradition, he taught Rembrandt for some months. His later work is cursory and less powerful. His pictures are hard to distinguish from his brother's. Numerous works are listed in old inventories

as by "Pynas," without any Christian name. A large number of his drawings, but only about fifteen of his pictures are known today.

Literature: K. Bauch, *Oud Holland*, LIII, 1936, p. 79; L. von Baldass, *Belvedere*, 1938–43, pp. 154–9.

Pynas, Jan

b. Haarlem 1583,
d. Amsterdam after 1631
952, 953

Rare Haarlem painter who, like L. Jacobsz., P. Lastman and N. Moyart, belonged to the pre-Rembrandt circle. His pictures of Old and New Testament and historical themes show Roman and Venetian influence. The landscape backgrounds with their cool, light green tones recall A. Elsheimer; but the novelty of his landscapes and figures lies in the Dutch narrative approach. His works are hard to distinguish from those of his younger brother Jacob Pynas and L. Jacobsz.; more of them are known from records than have been identified. R. van Troyen was a pupil of his.

Literature: K. Bauch, "Beiträge zum Werk der Vorläufer Rembrandts," *Oud Holland*, XXXV, 1952, pp. 145–58.

Quast, Pieter

b. Amsterdam 1606,
d. there 1647
954, 955, 956

Amsterdam genre painter. His figures, which are often coarse, have a personal touch. His backgrounds are often of a pale bluish lilac colour; hard folds of material are typical of his work. The element of caricature and the exaggerated movements are reminiscent of the pseudo-Van de Venne. His allegories are humorous in style. His pictures vary in quality; the better ones have often been ascribed to A. Brouwer. His well-painted interiors with soldiers resemble the work of P. Codde, J. Duck, J. Olis and Simon Kick. His linked monogram PQ was often removed for purposes of forgery.

Literature: A. Bredius, "P. Quast," *Oud Holland*, XX, 1902, pp. 65–82; N. MacLaren, *National Gallery Catalogues, Dutch School*, London, 1960, p. 300.

Quellinus, Erasmus

b. Antwerp 1607,
d. there 1678
957

Flemish figure painter, pupil and follower of Rubens. His Biblical, mythological and historical scenes with numerous figures show good powers of composition. The landscape is treated only as a background. His scenes from the New Testament and

the lives of saints are often surrounded by garlands of flowers and fruit painted by Daniel Seghers and J. P. van Thielen. Occasionally he contributed single figures, e.g. to a still life of birds by J. Fyt. His portraits are rare. Many of his better works are probably still attributed to Rubens.

Literature: F. C. Legrand, "E. Quellinus als Schlachtenmaler," *Bulletin du Musée Royal des Beaux-Arts,* 2, 1966, pp. 61–81.

Ravesteyn, Hubert van

b. Dordrecht 1638, d. there 1691

958

Dordrecht painter of stables and of breakfast still lifes with smoking implements. His tones are dark and elegant; details of the surface of material are accurately rendered. In its dark tonality and in the similarity of subject, his work resembles that of Jan van de Velde and Pieter Janssens Elinga. Less often he painted barns with animals, especially sheep, piles of farm implements, maids and children in the style of Cornelis Saftleven, H. M. Sorgh and E. van der Poel. His pictures usually bear the monogram HR; sometimes this was misread and they were taken for early works by W. Kalf. He may be confused with Dirck Wyntrack.

Ravesteyn, Jan Anthonisz. van

b. The Hague 1572, d. there 1657

959, 960

Hague painter of individual and group portraits in the style of M. J. van Mierevelt, though with less keenness of observation. He portrays distinguished persons, courtiers and warriors in an accurate but somewhat prosaic fashion. Their rich costumes and armour have a decorative effect thanks to successful combinations of colour. Strong reddish-brown flesh-tints are characteristic especially of his early work. His skilfully grouped militia pieces are rarer. Most of his pictures are monogrammed and dated. He may be confused with M. J. van Mierevelt, N. Elias and C. van der Voort.

Renesse, Constantyn van

b. Maarsen (near Utrecht) 1626, d. Eindhoven 1680

961

Dutch painter, draughtsman and etcher, son of a clergyman. He studied at Leiden University and was a pupil of Rembrandt's in 1649. He was chiefly a draughtsman, and his paintings are few. Only a handful of monogrammed pictures have come down to us; a *Satyr in a Peasant's Cottage,* signed and dated 1653, was in the Campe collection at Leipzig in 1827. Apart from genre pieces

he painted half-length portraits, which are close to the school of Rembrandt: for instance, two small oval likenesses of Rembrandt's father and mother, in the Schloss collection in Paris, were found to bear Renesse's monogram after the forged monogram of G. Dou had been removed. Clearly Renesse's was often removed altogether in order to ascribe his pictures to better-known pupils of Rembrandt.

Rietschoof, Jan Claesz.

b. Hoorn 1652, d. 1719

962, 963

Dutch sea-painter and draughtsman, pupil of L. Backhuysen at Amsterdam. His drawing of waves is somewhat weaker than the latter's, but the boats and the bright and dark stretches of water, reflecting a sky with lively cloud effects, are well composed and the atmosphere is especially well rendered. On the horizon beyond the light, fairly calm sea, a harbour town with breakwaters is sometimes seen. As with L. Backhuysen, dark figures often occupy the foreground in front of the light-coloured sea. The theme of a calm sea with large sailing boats at anchor is somewhat reminiscent of Abraham Storck. The ships' lines and rigging are those of the early eighteenth century. His son and pupil Hendrik Rietschoof was also a sea-painter.

Literature: L. Preston, *Sea and River Painters of the Netherlands,* London, 1937.

Ring, Pieter de

b. Leiden about 1615, d. there 1660

964

Dutch still-life painter, probably a pupil of Jan Davidsz. de Heem. Fruit, vessels and drinking-glasses, books and musical instruments are composed on the corner of a table. There is often a Persian carpet or a velvet cloth with gold fringes; the colouring is bright and full of contrast, the painting is executed with broad strokes. A ring is sometimes painted alongside the signature, and sometimes instead of it. Most of his pictures may still be attributed to the De Heems or their many pupils.

Literature: I. Bergström, *Dutch Still-Life Painting,* London, 1956.

Roepel, Conraet

b. The Hague 1678, d. 1748

965, 966

Dutch still-life painter, pupil of the portraitist Constantin Netscher; member of the guild at The Hague in 1724. As a flower painter he is close to Rachel Ruysch, and his work in general belongs to the beginning of the eighteenth century.

Rich bouquets of flowers are composed with taste and with much variety of colour against a dark grey background, less often in front of a niche. The light catches the middle of the bouquet, and the bluish-green leaves at the edge are lost in delicate shadows. The meticulous attention to detail is distinctive. The stone pedestals, putti reliefs and fantastically shaped vases reflect the taste of the period. As in the portraits of Netscher's circle, the background is formed by architecture or stone sculpture. He also painted fruit still lifes.

Roestraten, Pieter Gerritsz. van

b. Haarlem 1627,
d. London 1698
967, 968, 969

Dutch still-life and genre painter. Precious china, silver boxes, pewter jugs, ivory goblets and nautilus shells are arranged in a tasteful composition; the reproduction of the various substances is lifelike. The table is sometimes covered with a Persian carpet. He often painted *Vanitas* pieces with a candlestick, a clock, musical instruments and a skull. His early works are genre scenes of peasant life, less in the style of his father-in-law Frans Hals than in that of J. Steen or G. ter Borch; the warm tones and strong colouring bear witness to his skill and talent.

Roghman, Roeland

b. about 1620,
d. Amsterdam 1686
970

Rare Amsterdam landscape painter, a friend of Rembrandt and G. van den Eeckhout. He painted mountain landscapes with distant views of extensive plains, and romantic river-valleys with tall, isolated clumps of trees, sometimes with twisted trunks. The tone of these pictures is olive-green and brown. Strong contrasts of light and shade give the impression of Mediterranean evening sunshine. His work may be confused with the early paintings of Herman Saftleven and the followers of Hercules Seghers, Joost de Momper and their circle.

Literature: N. MacLaren, *National Gallery Catalogues, Dutch School*, London, 1960, p. 353.

Rombouts, Gillis

b. Haarlem 1630,
d. there about 1672
971, 972, 973

Dutch landscape painter of the Ruisdael circle, closest to Roelof van Vries and C. Decker. His beach scenes are similar to J.

Esselens', but the figures are smaller; his Norwegian mountain scenes, which are rarer, recall the style of Allaert van Everdingen. His pictures of large open spaces outside city walls, a village street with market-booths or rustics dancing exhibit a multitude of somewhat coarse figures, which at times recall the work of the artist's son, Salomon Rombouts. The style of the two is closely similar and they are sometimes hard to distinguish. Occasionally the father painted craftsmen, shoemakers or weavers in their cottages, which also recall C. Decker. In his full signature he generally, unlike his son, wrote the surname "Rombout" without the final S. He also used a monogram composed of J and R, which has led to the attribution of his work to Jakob van Ruisdael. He may also be confused with C. Beelt and W. Kool.

Rombouts, Salomon

active at Haarlem 1652–60,
d. Florence before 1702
974, 975, 976

Haarlem painter of forest landscapes in the style of the Ruisdael circle; son of Gillis Rombouts. He painted, in the style of C. Decker and Roelof van Vries, peasant cottages under tall trees beside a still expanse of water diversified with fishing-boats and anglers. In addition, like his father, he painted country fairs with quack doctors, kermesses, craftsmen (shoemakers, weavers, tinkers), also beach and winter scenes that recall Claes Molenaer. His village streets and winding forest paths with sunny patches in the foreground are animated by brightly coloured figures, such as he contributed to his father's pictures and probably to others' also. He sometimes signed with his full surname (cf. Gillis Rombouts) and sometimes with an intertwined S and R.

Rombouts, Theodor

b. Antwerp 1597,
d. there 1637
977, 978

Flemish painter of genre, history and church pictures in the style of his master Abraham Janssens and later of Rubens, by whom he was increasingly influenced. However, his singers, cardplayers, lute-players and allegories of the five senses are still painted with strongly contrasting light effects (Caravaggio); in this respect he is close to the Utrecht group around Gerard van Honthorst. He depicted Old Testament subjects or legends of the saints, using as background a free and sketchy version of the Flemish landscape. He sometimes contributed his large, pleasant figures to still lifes by Adriaen van Utrecht.

Literature: A. von Schneider, *Caravaggio und die Niederländer*, Marburg, 1933; G. Isarlo, *Le Caravage*, Aix-en-Provence, 1941.

PLATES

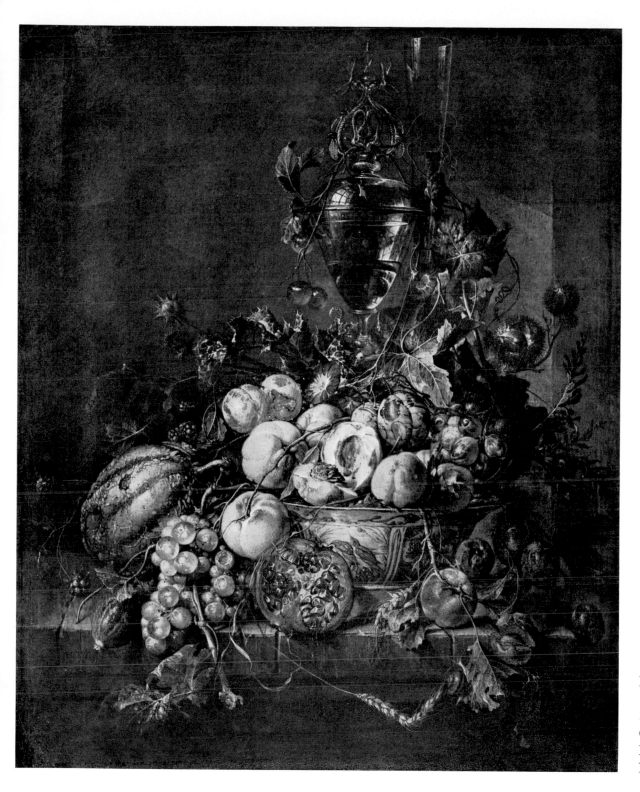

Cornelis de Heem

FLOWERS AND FRUIT

Signed and dated 1671
Canvas, 66×54 cm.
Brussels, Musée des Beaux-Arts
No. 204.

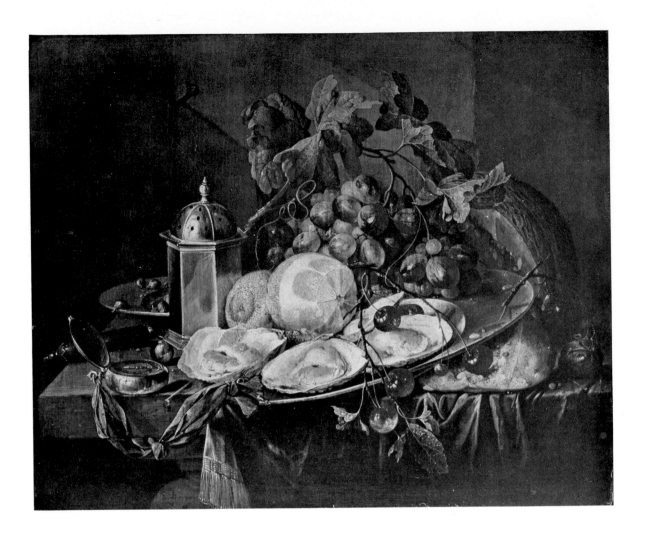

Cornelis de Heem

Breakfast Still Life

Signed
Wood, 34×41.5 cm.
Vienna,
Kunsthistorisches Museum
No. 567.

Jan Davidsz. de Heem

Table with Books

Signed and dated 1628
Wood, 36.1×48.5 cm.
The Hague, Mauritshuis
No. 613.

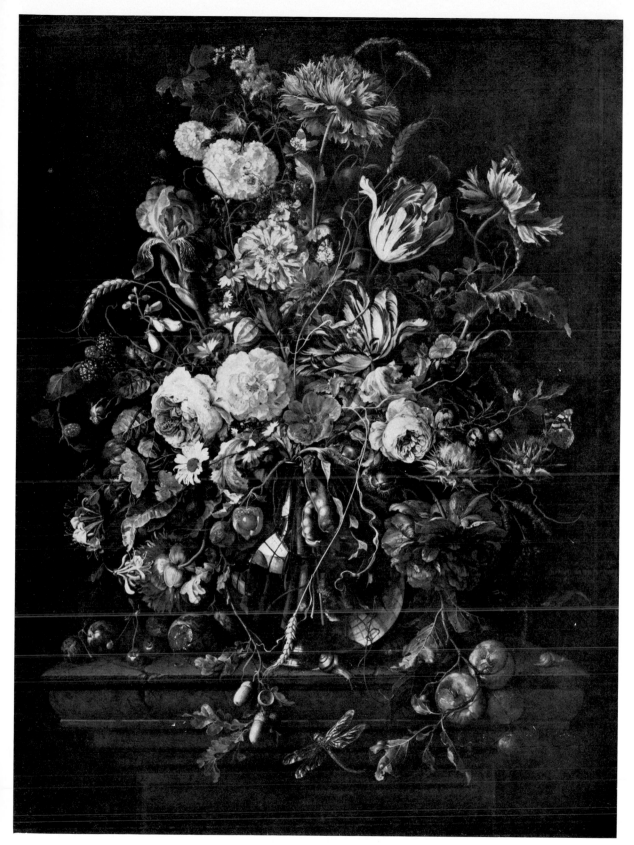

Jan Davidsz. de Heem

FLOWERS IN A GLASS
AND FRUIT

Signed
Canvas, 100×75.5 cm.
Dresden, Gallery
No. 1267.

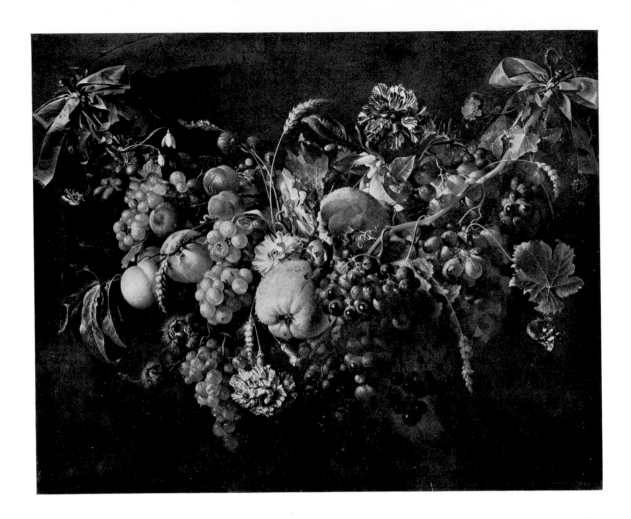

Jan Davidsz. de Heem

GARLAND OF FLOWERS
AND FRUIT

Signed
Canvas, 60 × 75 cm.
The Hague, Mauritshuis
No. 49.

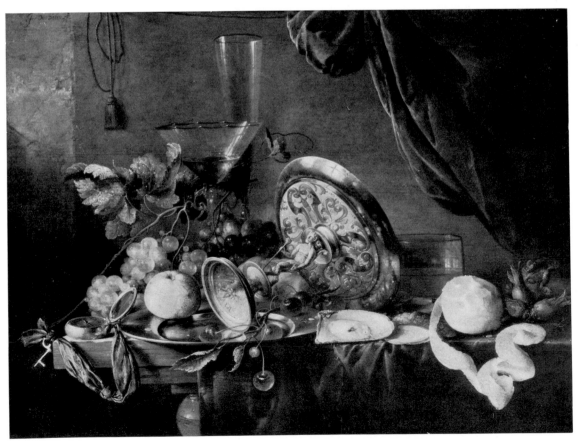

Jan Davidsz. de Heem

FRUIT STILL LIFE

Wood, 49 × 64 cm.
Madrid, Prado
No. 2090.

Egbert
van Heemskerck

TAVERN INTERIOR

With monogram
Wood, 58×83 cm.
Lausanne, art trade.

Egbert
van Heemskerck

GRACE BEFORE DINNER

Signed and dated 1667
Wood, 48×62 cm.
Frankfurt, Staedel Institute.

Thomas Heeremans

VILLAGE INN BESIDE A RIVER

Canvas, 55 × 75 cm.
Berlin, art trade.

Thomas Heeremans

ICE SPORT AT THE FOOT
OF A CITY WALL

Signed and dated 1677
Wood, 60.5 × 84 cm.
Dresden, Gallery
No. 1515C.

Hendrick Heerschop

THE ALCHEMIST

Signed
Wood, 55×45 cm.
Dresden, Gallery
No. 1490.

Gerrit van Hees

Cottage beside a Quiet Stream

Signed and dated 1659
Wood, 74×104 cm.
Haarlem, Frans Hals Museum
No. 159.

Daniel van Heil

The Burning of Troy

Wood, 70×109 cm.
Como, Restelli collection.

Daniel van Heil

IMAGINARY CITY BY A RIVER

With monogram
Canvas, 42.5 × 60 cm.
Munich, art trade.

Mattheus van Helmont

GUARD ROOM

Signed
Canvas, 47.5 × 63 cm.
Brunswick, Herzog-Anton-
Ulrich Museum
No. 149.

Mattheus van Helmont

THE MARKET

Signed
Canvas, 116 × 154 cm.
Budapest, Museum of Fine Arts
No. 564 (414).

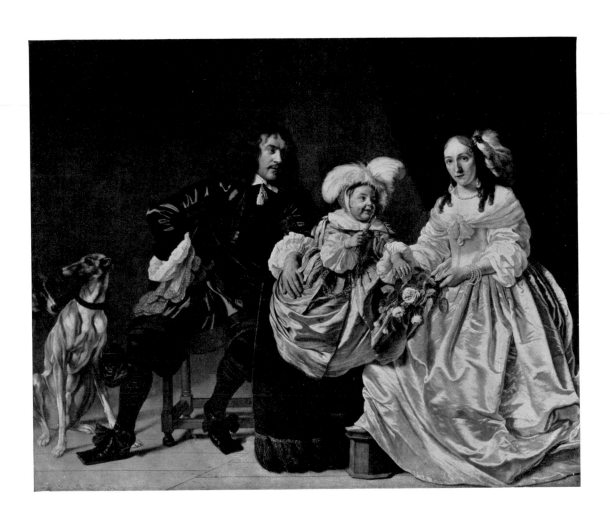

Bartholomeus van der Helst

FAMILY GROUP
Signed and dated 1652
Canvas, 188 × 227 cm.
Leningrad, Hermitage
No. 860.

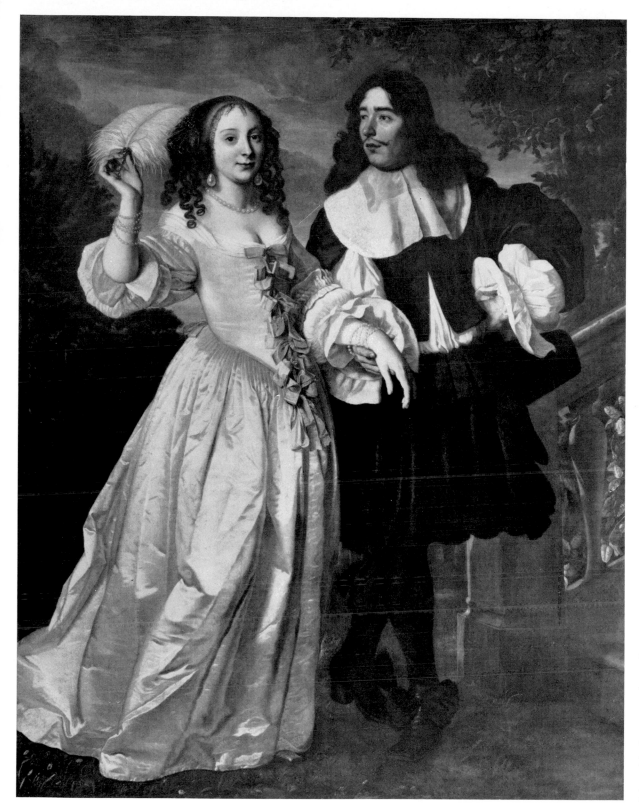

Bartholomeus van der Helst

YOUNG PATRICIAN COUPLE

Signed and dated 1661.
Canvas, 186×148.5 cm.
Karlsruhe,
Staatliche Kunsthalle
No. 235.

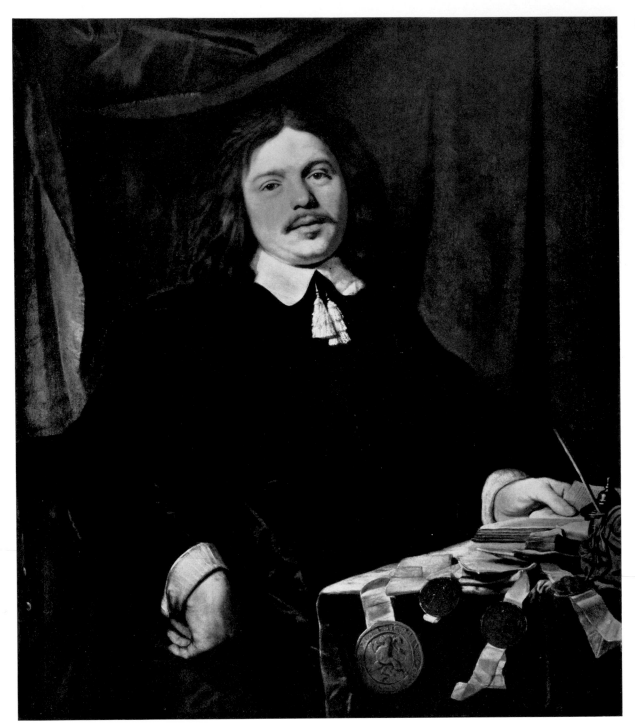

**Bartholomeus
van der Helst**

PORTRAIT OF A NOTARY

Canvas, 105 × 88 cm.
Lugano-Castagnola,
Thyssen collection
No. 186.

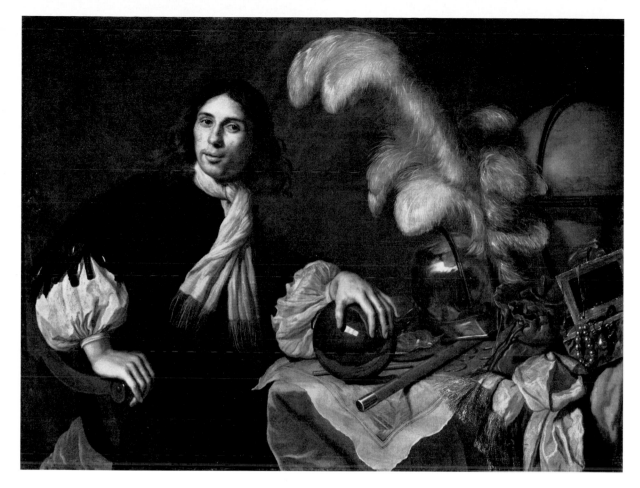

Lodewijk van der Helst

AUCKE STELLINGWERF

Signed and dated 1670
Canvas, 103 × 136 cm.
Amsterdam, Rijksmuseum
No. 1153.

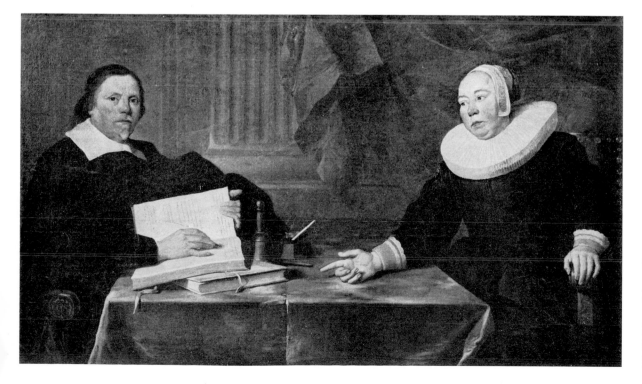

Nikolaes
de Helt-Stocade

DOUBLE PORTRAIT

Signed and dated 1647
Canvas, 105 × 177 cm.
Nijmegen, Old Men's Home.

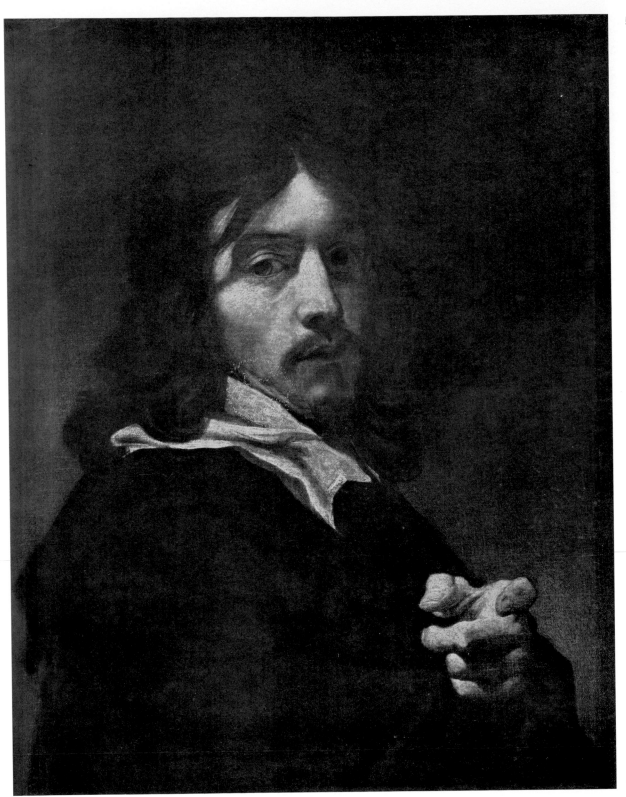

Nikolaes
de Helt-Stocade

PORTRAIT OF THE ARCHITECT
GEORG PFRÜND

Canvas, 60×43 cm.
Munich, Alte Pinakothek
No. 963.

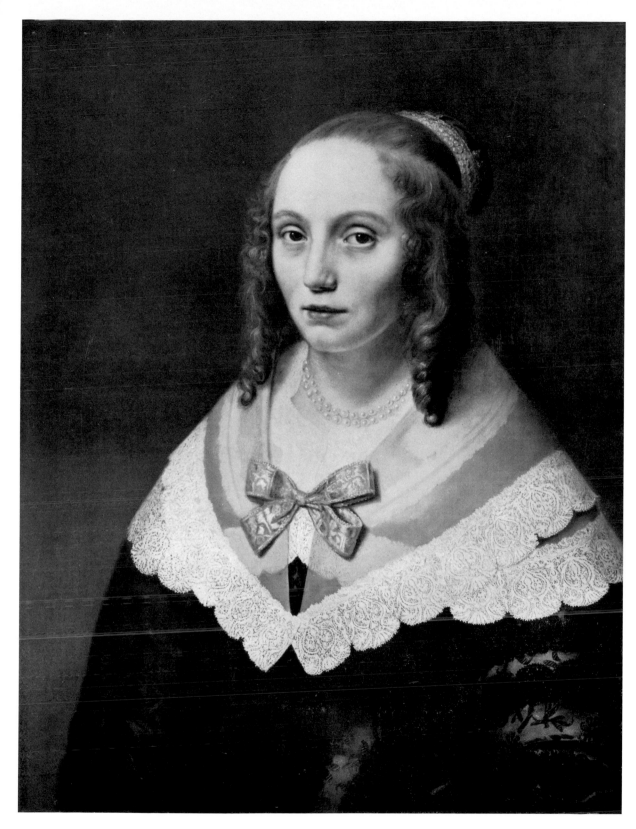

Paulus Hennekyn

PORTRAIT OF A LADY

Signed and dated 1645
Wood, 72 × 53 cm.
Munich, art trade.

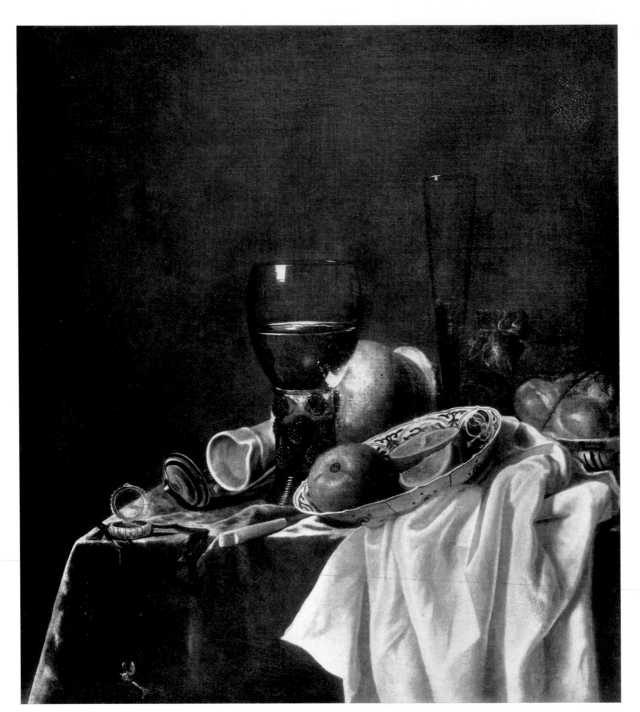

Paulus Hennekyn

BREAKFAST STILL LIFE

Signed
Canvas, 72.5×65.5 cm.
Hamburg, Kunsthalle
No. 414.

514

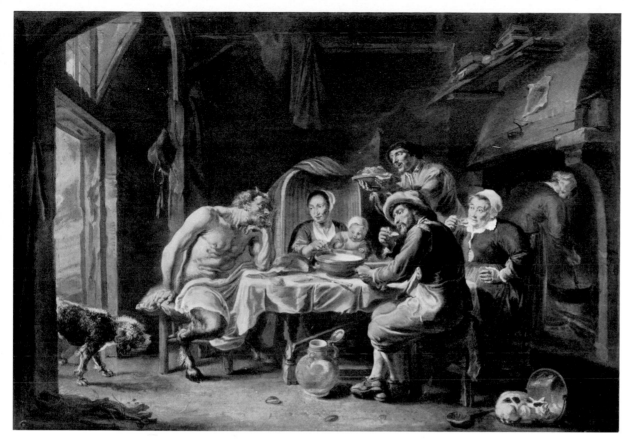

Willem van Herp

SATYR VISITING A
PEASANT FAMILY

Wood, 71 × 102 cm.
Formerly Berlin,
Kaiser-Friedrich Museum
No. 945.

515

Jakob de Heusch

CLASSICAL LANDSCAPE WITH
LATONA AND THE FROGS

Signed and dated 1697
Canvas, 140 × 187 cm.
Munich, art trade.

Jakob de Heusch

THE PONTE ROTTO IN ROME

Signed and dated 1696.
Canvas, 60×106 cm.
Brunswick,
Herzog-Anton-Ulrich Museum
No. 410.

Willem de Heusch

LANDSCAPE WITH HUNTSMEN
(Figures by J. Lingelbach)

Signed
Canvas, 85×107 cm.
Cassel, Gallery
No. 409.

Jan van der Heyden

STILL LIFE

Signed
Canvas, 75×63.5 cm.
Budapest, Museum of Fine Arts
No. 201 (391).

Jan van der Heyden

A VIEW IN COLOGNE

With monogram
Wood, 33 × 43 cm.
London, National Gallery
No. 866.

Jan van der Heyden

THE BEER QUAY BY THE
OUDE KERK, AMSTERDAM

Signed
Wood, 41.5 × 52.5 cm.
Leningrad, Hermitage
No. 1211.

Jan van der Heyden

COUNTRY HOUSE BY A CANAL
(figures by
Adriaen van de Velde)

Wood, 46.2 × 57.5 cm.
London, Buckingham Palace
No. 102.

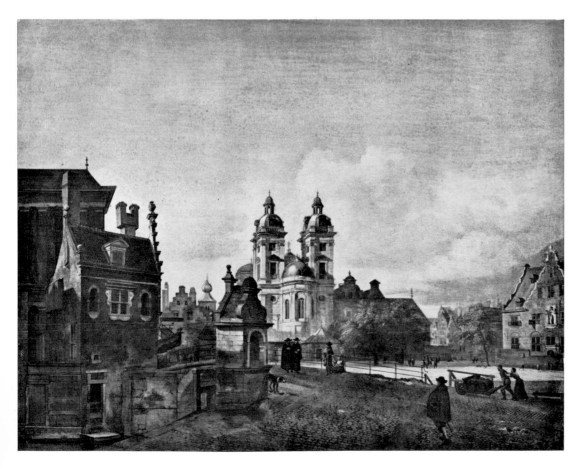

Jan van der Heyden

THE JESUIT CHURCH
AT DÜSSELDORF
(figures by A. van de Velde)

Signed and dated 1667
Wood, 51 × 63.5 cm.
The Hague, Mauritshuis
No. 53.

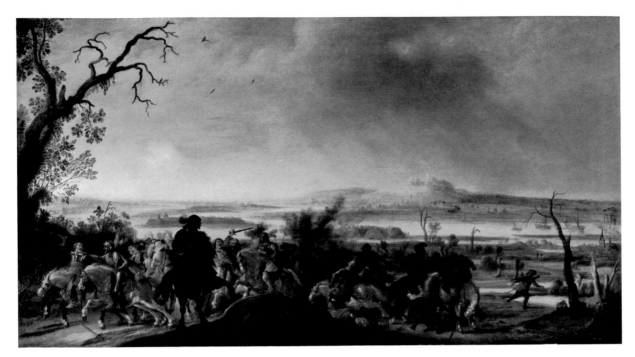

Pauwels van Hilligaert

CAVALRY FIGHT BY THE
TAVERN BULWARK

Signed and dated 1629.
Wood, 41.5 × 76.5 cm.
Arnhem, Municipal Museum
No. 5653.

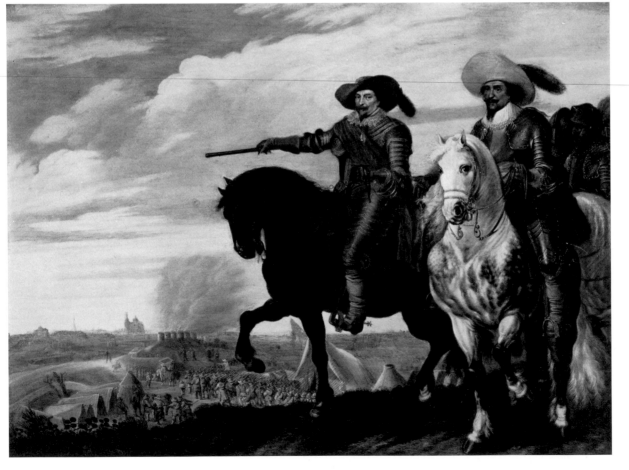

Pauwels van Hilligaert

PRINCE FREDERICK HENRY
AND COUNT ERNEST CASIMIR
AT 'S-HERTOGENBOSCH, 1629

Wood, 48 × 64 cm.
Amsterdam, Rijksmuseum
No. 1178.

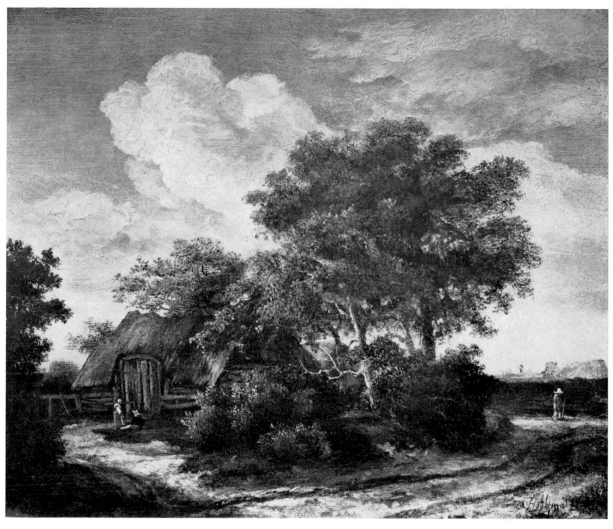

Meindert Hobbema

ROADSIDE COTTAGE

Signed and dated 1659
Wood, 30×35 cm.
Frankfurt, Staedel Institute
No. 1083.

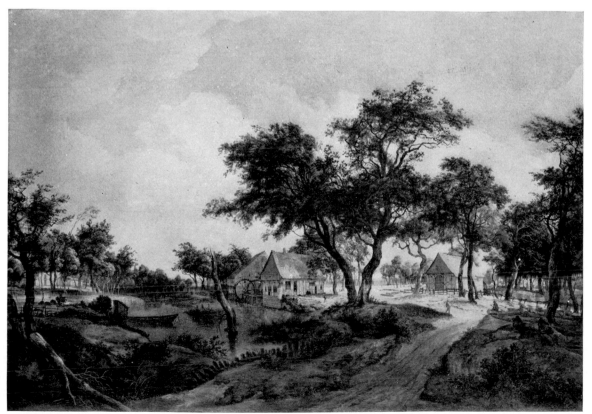

Meindert Hobbema

TWO WATER-MILLS

Signed
Canvas, 92×128 cm.
The Hague, Mauritshuis
No. 743.

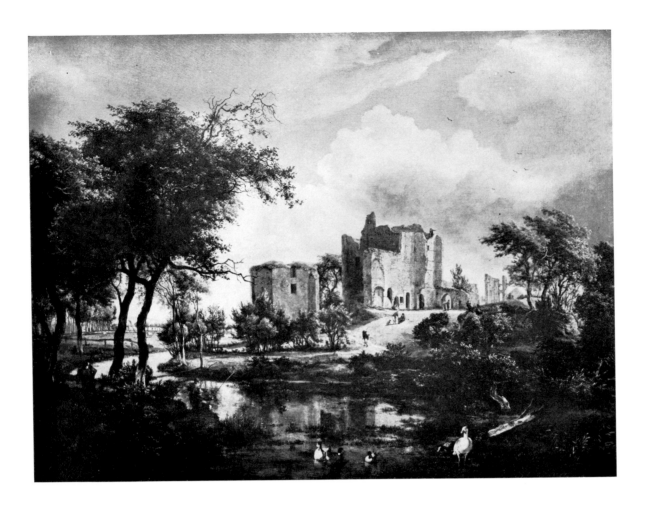

Meindert Hobbema

The Ruins of Brederode

Signed and dated 1671
Canvas, 82 × 106 cm.
London, National Gallery
No. 831.

Meindert Hobbema

The Water-Mill

Signed
Wood, 51.2 × 67.5 cm.
London, Buckingham Palace
No. 128.

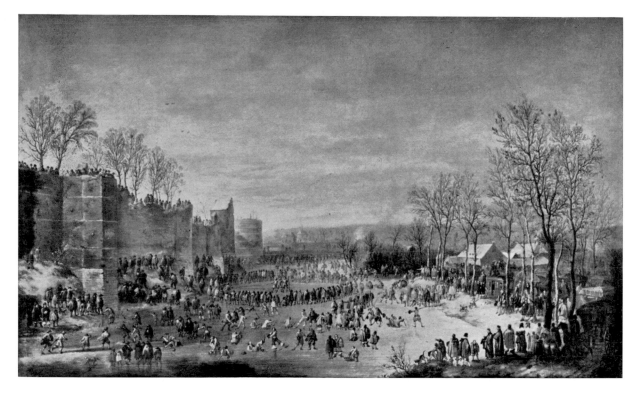

529

Robert van den Hoecke

SKATING ON THE MOAT
AT BRUSSELS

Signed and dated 1649
Wood, 58×92 cm.
Vienna,
Kunsthistorisches Museum
No. 656.

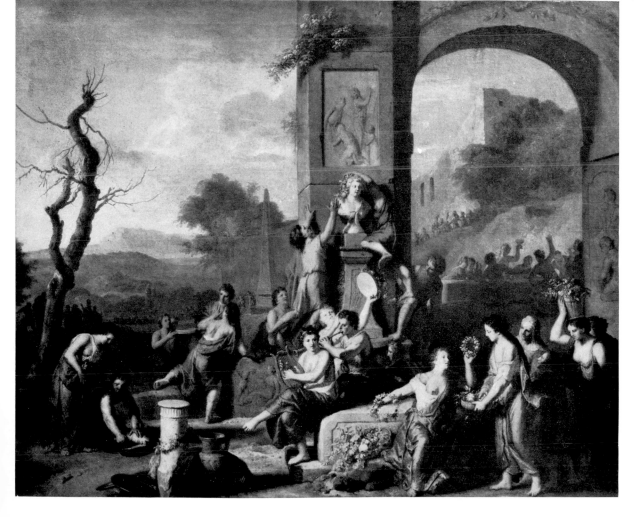

530

Gerard Hoet

SACRIFICIAL FEAST
AMONG ANTIQUE RUINS

Canvas, 51×60.5 cm.
Munich, art trade.

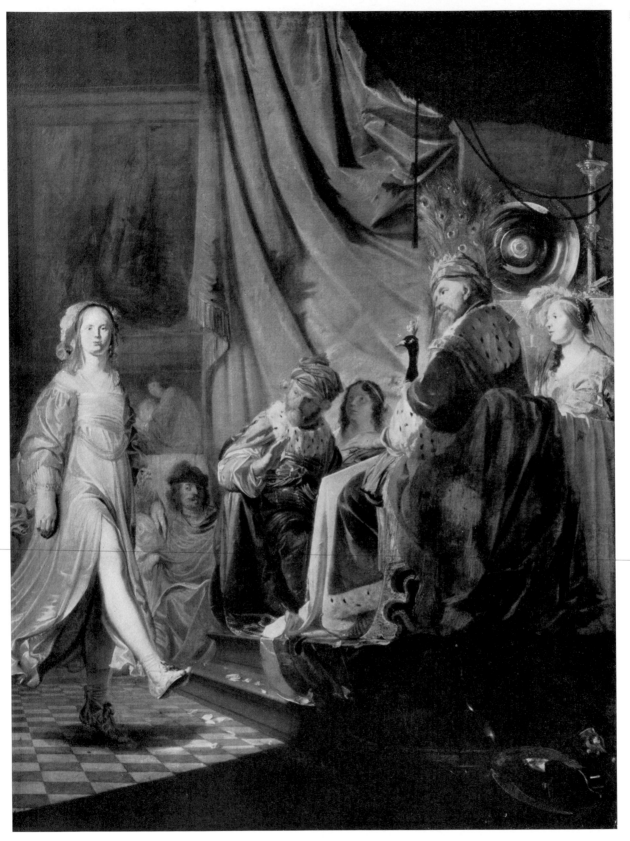

Jakob Hogers

SALOME DANCING
BEFORE HEROD

Canvas, 176×133 cm.
Amsterdam, Rijksmuseum.

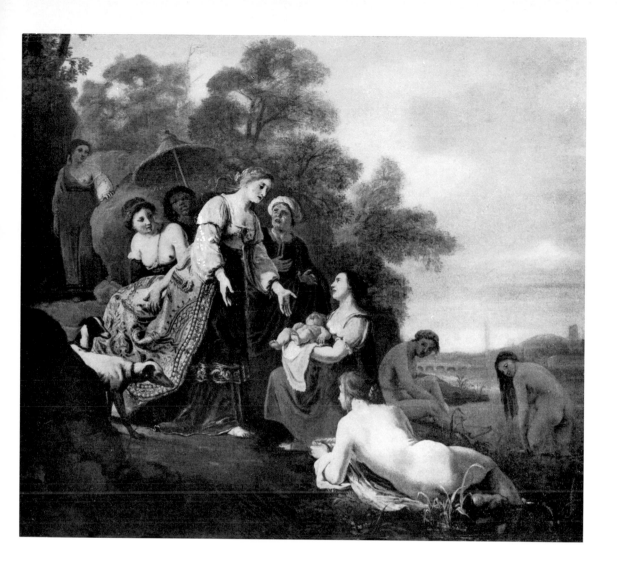

Cornelis Holsteyn

THE FINDING OF MOSES

With monogram
Canvas, 119×135 cm.
Amsterdam,
Frederik Muller sale,
26 May 1914
No. 103.

Gillis Claesz.
de Hondecoeter

LANDSCAPE WITH DIANA
AND ACTAEON

Signed and dated 1619
Wood, 32.5×65 cm.
Munich, private collection.

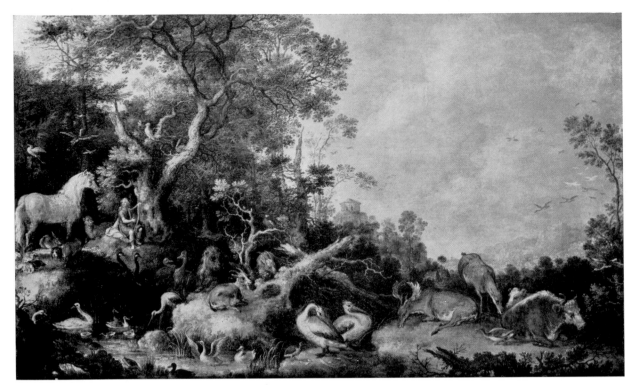

Gillis Claesz. de Hondecoeter

ORPHEUS PLAYING TO THE ANIMALS

With monogram; dated 1624
Wood, 51×82.5 cm.
Utrecht, Central Museum
No. 143.

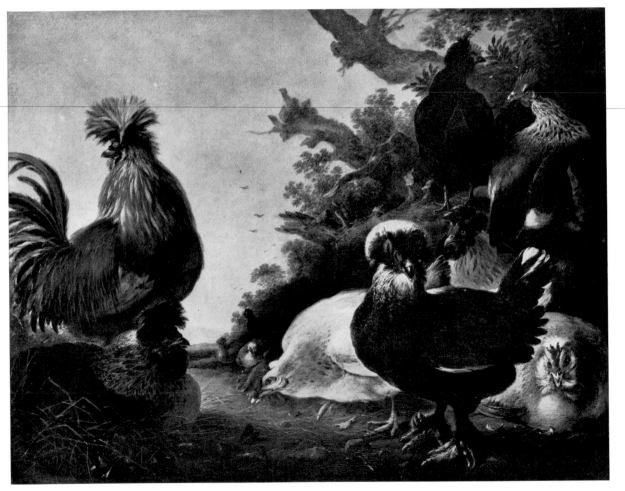

Gysbert de Hondecoeter

COCK AND HENS

Signed and dated 1652
Canvas, 71×84 cm.
Rotterdam,
Boymans-Van-Beuningen
Museum
No. 1327.

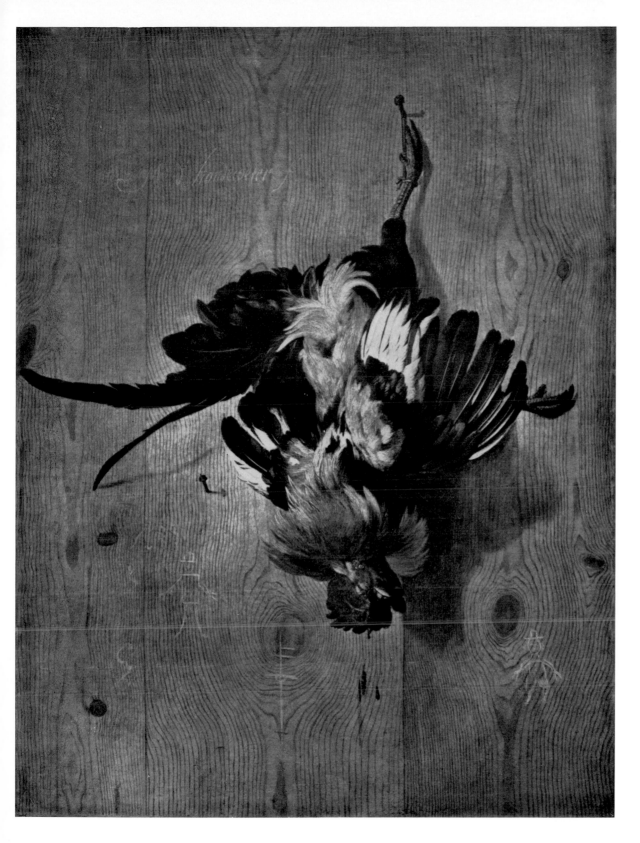

Melchior
de Hondecoeter

DEAD ROOSTER

Signed
Canvas, 111×83 cm.
Brussels,
Musée des Beaux-Arts
No. 224.

Melchior
de Hondecoeter

BARNYARD

Signed
Canvas, 97×123 cm.
Leipzig,
Museum of Fine Arts
No. 406.

Abraham Hondius

BEAR-BAITING

Signed and dated 1655
Wood, 107×133 cm.
Paris, Hôtel Drouot sale,
25 May 1925
No. 51.

Lambert de Hondt

Riders
in a River Landscape

Signed
Canvas, 86.5 × 118 cm.
Vevey, art trade.

Lambert de Hondt

Attack

Signed
Copper, 20 × 30 cm.
Frankfurt, Staedel Institute.

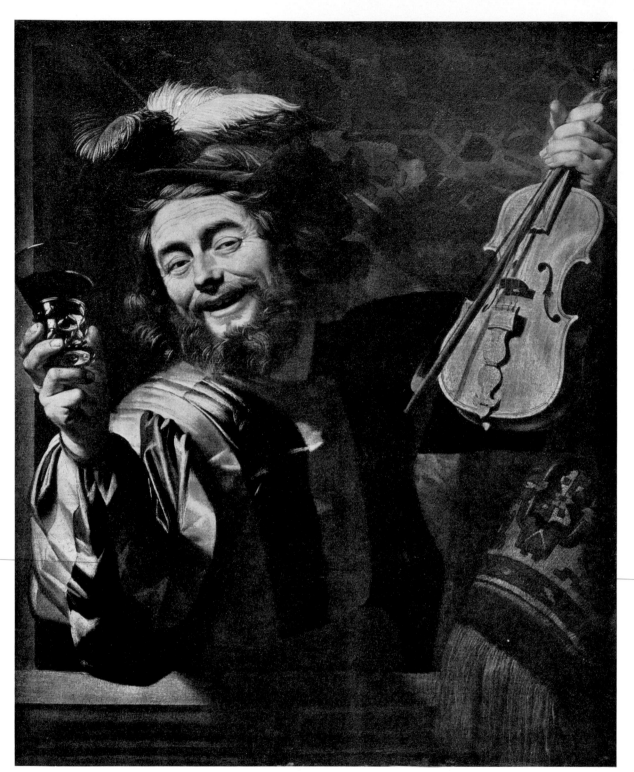

Gerard van Honthorst

THE MERRY FIDDLER

Signed and dated 1623
Canvas, 108 × 89 cm.
Amsterdam, Rijksmuseum
No. 1233.

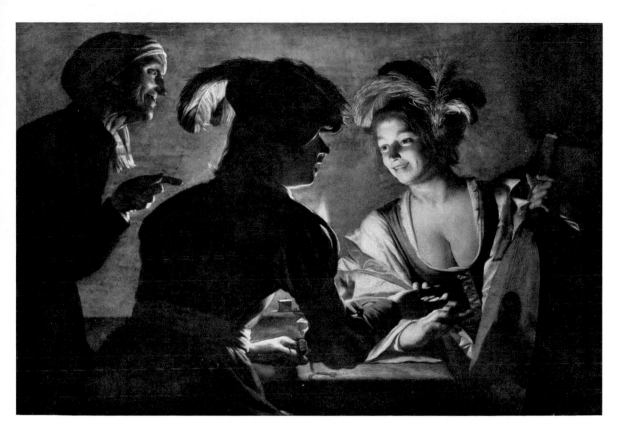

Gerard van Honthorst

AT THE PROCURESS'S

Signed and dated 1625
Wood, 71 × 106 cm.
Formerly The Hague,
Steengracht collection
No. 15.

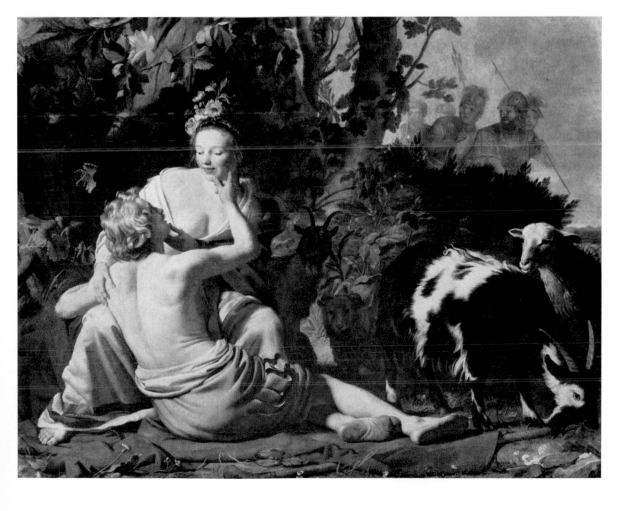

Gerard van Honthorst

GRANIDA AND DAIFILO

Signed and dated 1625
Canvas, 145 × 178.5 cm.
Utrecht, Central Museum
No. 151.

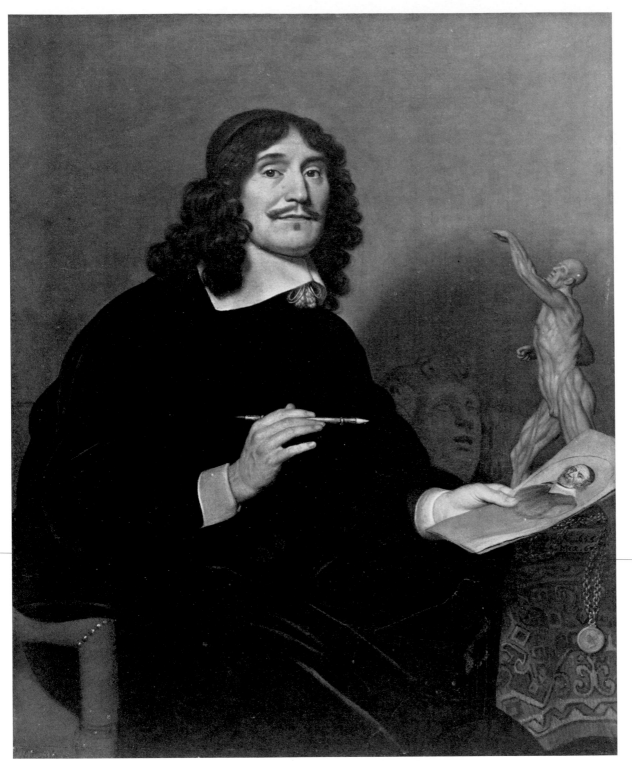

Gerard van Honthorst

SELF-PORTRAIT

Dated 1655
Canvas, 117×95 cm.
Amsterdam, Rijksmuseum
No. 1231.

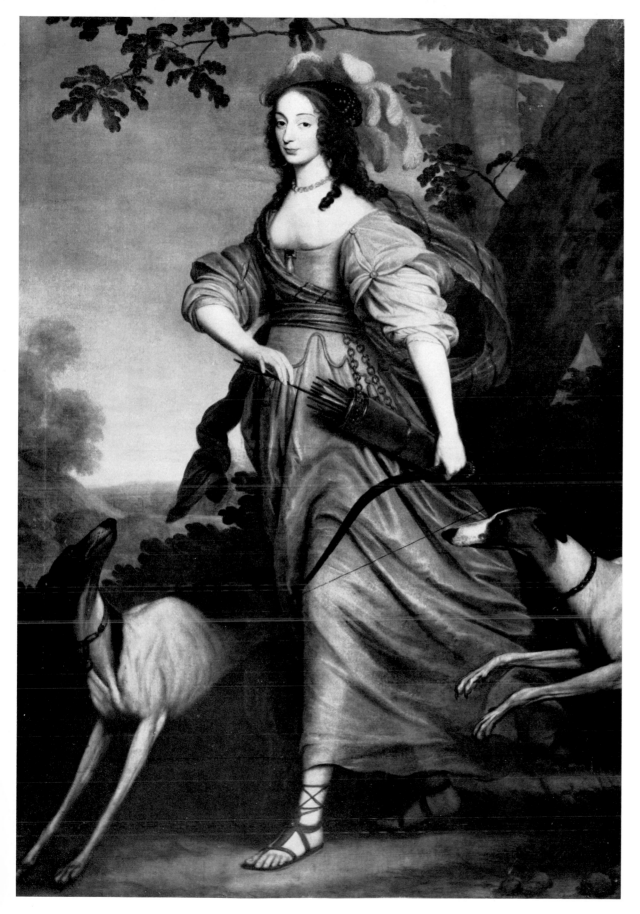

Willem van Honthorst

LOUISA HENRIETTA OF NASSAU

Signed and dated 1643
Canvas, 205 × 141 cm.
Utrecht, Central Museum
No. 156.

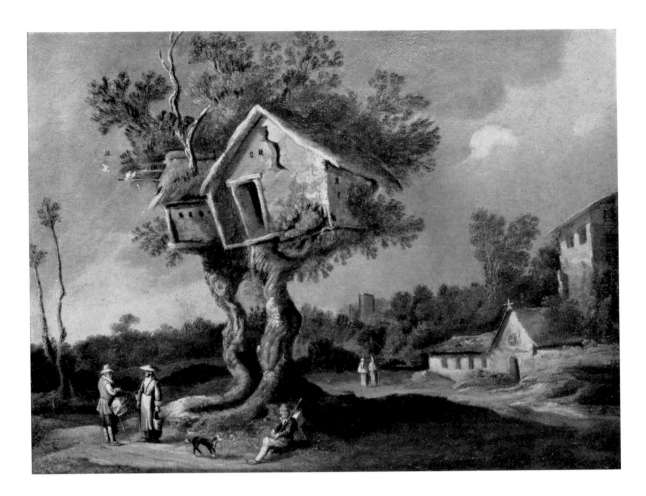

Carel de Hooch

THE DOVECOTE

Signed
Canvas, 35.6×47 cm.
London, Christie's sale,
10 July 1939
No. 45.

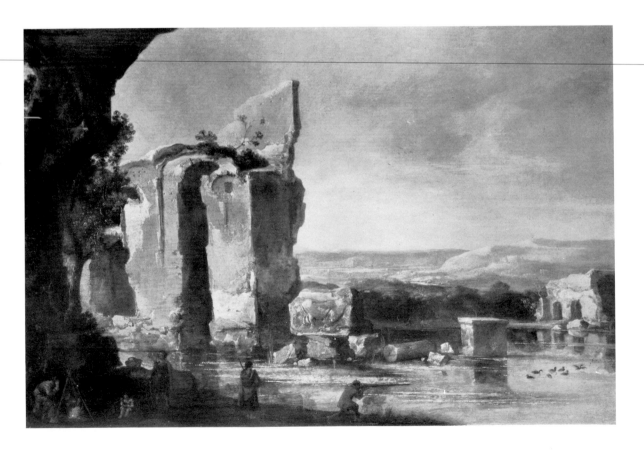

Carel de Hooch

ROMAN LANDSCAPE WITH RUIN

Wood, 42×63 cm.
Utrecht, Central Museum.

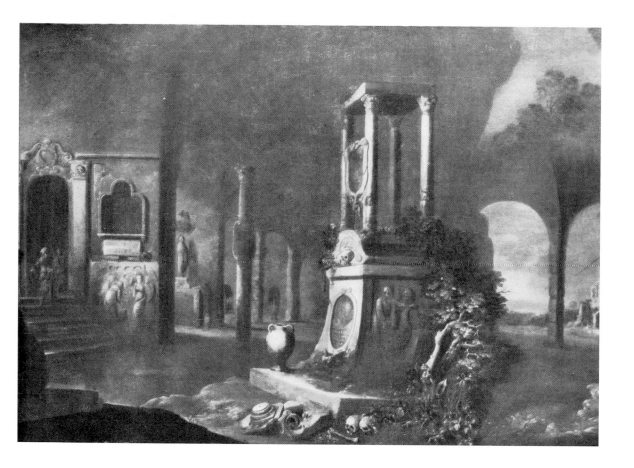

Carel de Hooch

GROTTO WITH MONUMENTS

Signed
Brussels, Arenberg sale
15 November 1926
No. 50.

Horatius de Hooch

LANDSCAPE WITH RUINS

Signed and dated 1652
Canvas, 100.5 × 151.5 cm.
Copenhagen,
Royal Museum of Fine Arts
No. 326.

Pieter de Hooch

The Spoilt Parrot

Canvas, 77.5 × 67.5 cm.
London,
Lord Northbrook.

Pieter de Hooch

COURTYARD OF A HOUSE
IN DELFT

Canvas, 73 × 60 cm.
London, National Gallery
No. 835.

Pieter de Hooch

GALLERY IN THE CITY HALL,
AMSTERDAM

Signed
Canvas, 112.5 × 99 cm.
Amsterdam,
W. J. R. Dreesman collection.

Samuel van Hoogstraten

Young Lady in a Vestibule

With monogram
Canvas, 242 × 179 cm.
The Hague, Mauritshuis
No. 66.

Samuel van Hoogstraten

Vanitas Self-Portrait

Signed and dated 1644
Wood, 58×74 cm.
Rotterdam,
Boymans-Van Beuningen
Museum
No. 1386.

Gerrit Willemsz. Horst

The Blessing of Jacob

Canvas, 155×218 cm.
Formerly Berlin,
Kaiser-Friedrich Museum
No. 807.

Gerrit Willemsz. Horst

BREAKFAST STILL LIFE

Signed and dated 1651
Canvas, 103 × 79 cm.
Berlin, Staatliche Museen
No. 824B.

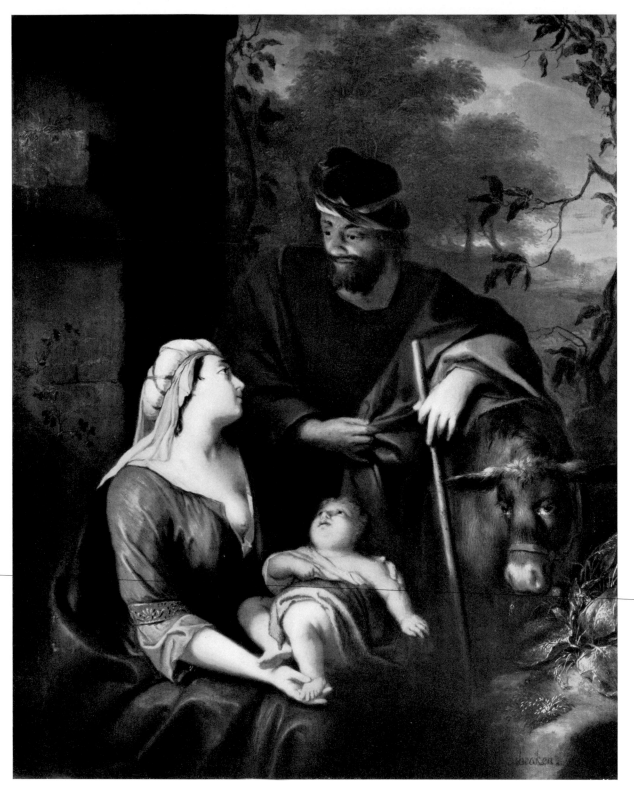

Arnold Houbraken

REST ON THE FLIGHT

Signed
Wood, 36 × 29 cm.
The Hague, 1946 exhibition
No. 27.

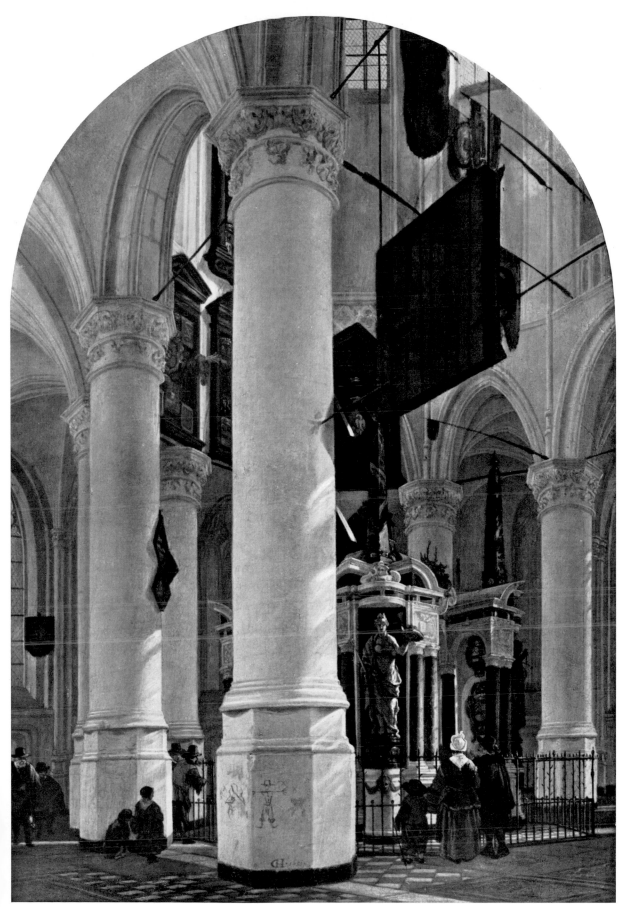

Gerrit Houckgeest

TOMB OF WILLIAM THE SILENT
IN THE NIEUWE KERK AT DELFT

Signed and dated 1651
Wood, 56×38 cm.
The Hague, Mauritshuis
No. 58.

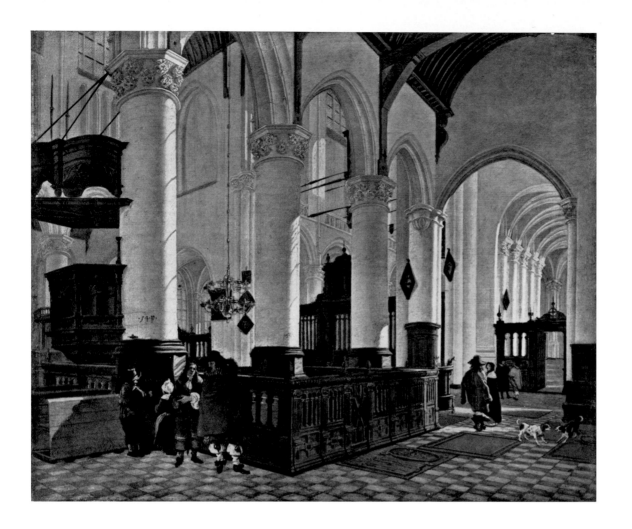

Gerrit Houckgeest

INTERIOR OF THE NIEUWE
KERK AT DELFT

Signed and dated 1653
Wood, 43 × 52 cm.
Brussels,
Musée des Beaux-Arts
No. 225.

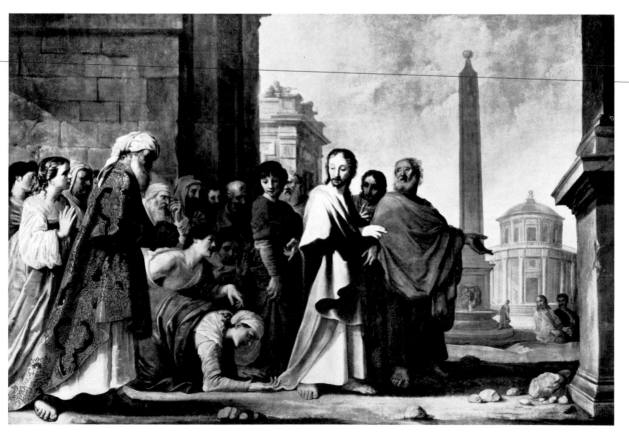

Joachim Houckgeest

CHRIST AND THE SICK WOMAN

Signed and dated 1625.
Canvas, about 160 × 200 cm.
Berlin, art trade.

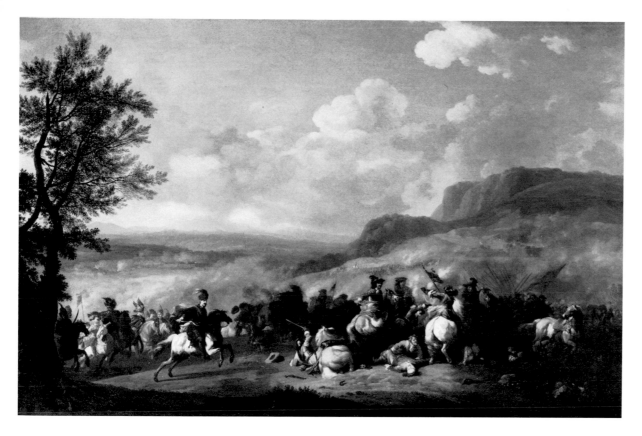

Jan van Huchtenburgh

CAVALRY BATTLE

Signed and dated 1673
Wood, 56×84 cm.
Recklinghausen,
private collection.

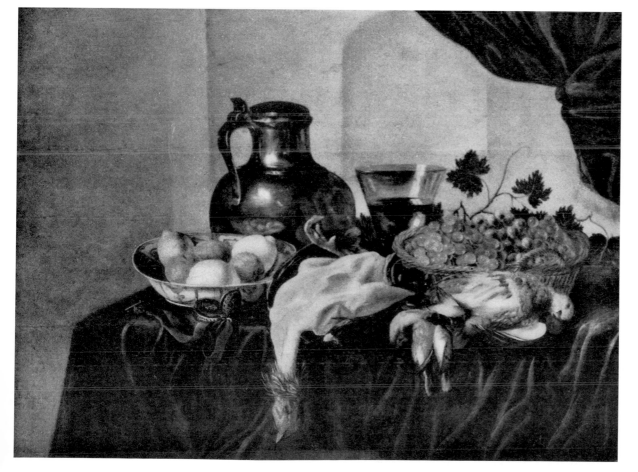

Carel van Hullegarden

STILL LIFE

Signed and dated 1648
Wood, 84×113 cm.
Amsterdam, Petri sale,
30 November 1924
No. 69.

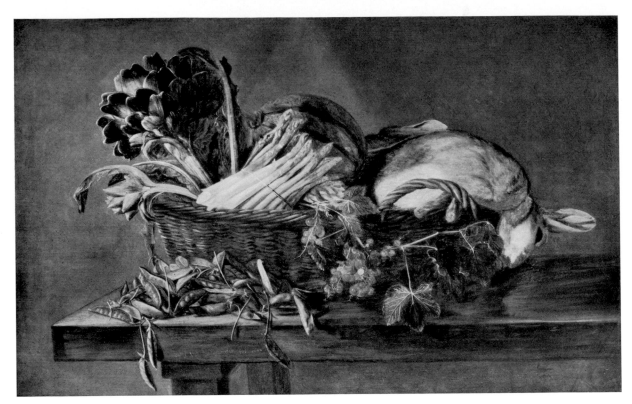

Carel van Hullegarden

VEGETABLE STILL LIFE

Signed and dated 1647
Wood, 55.5 × 86 cm.
Gavno, Denmark,
private collection.

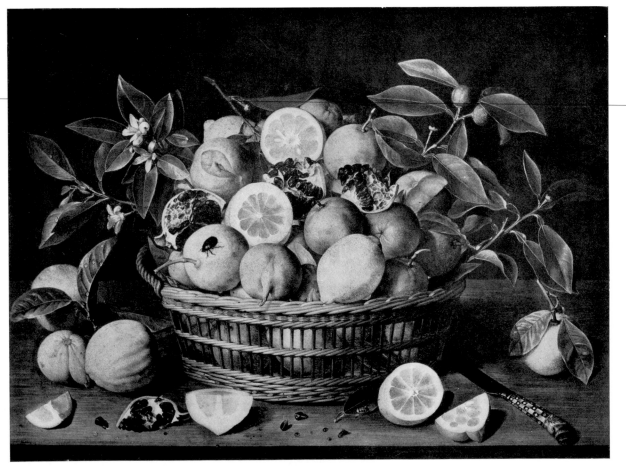

Jakob van Hulsdonck

BASKET OF POMEGRANATES
AND LEMONS

Signed
Wood, 50 × 64 cm.
Bonn,
Rheinisches Landesmuseum

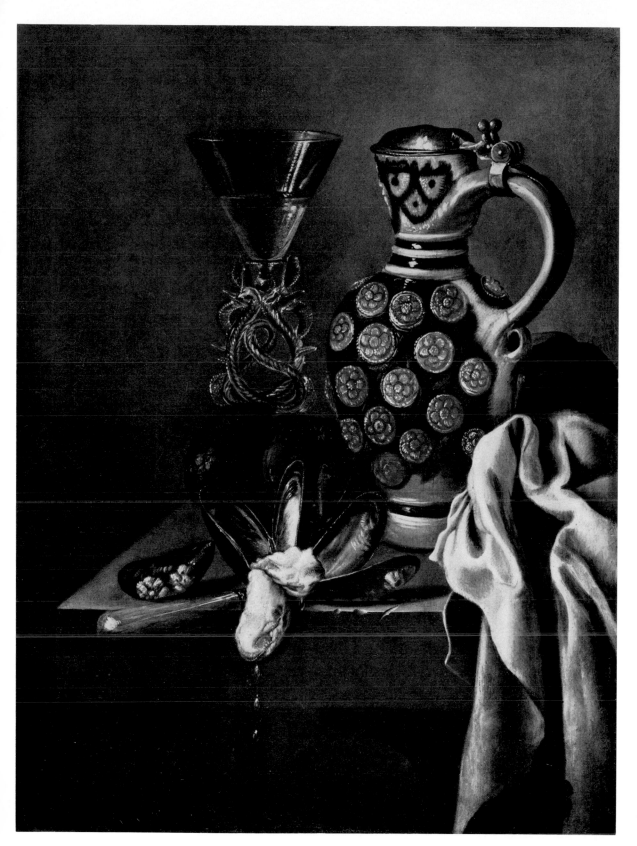

Jakob van Hulsdonck

Still Life

With monogram
Wood, 45 × 36 cm.
Brunswick,
Herzog-Anton-Ulrich Museum
No. 437.

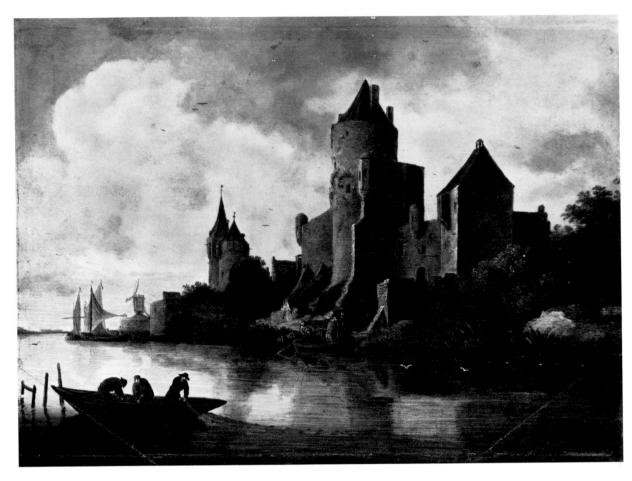

Frans de Hulst

CASTLE BY A RIVER

Signed
Wood, 29×39 cm.
Karlsruhe,
Staatliche Kunsthalle
No. 326.

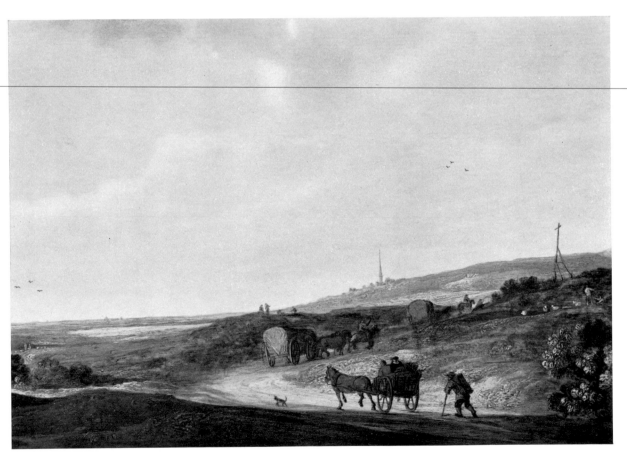

Maerten Fransz. van der Hulst

DUNE LANDSCAPE

With monogram; dated 1641
Wood, 35×48 cm.
Leiden, Lakenhal
No. 1041.

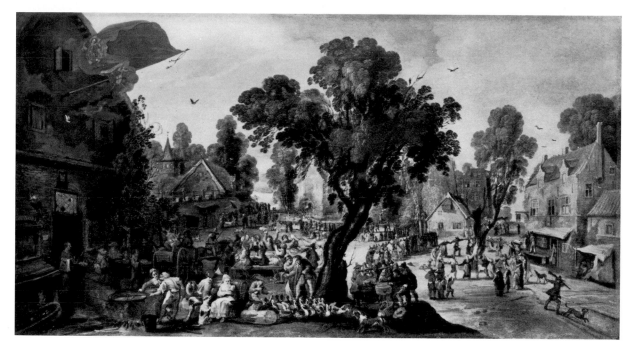

Pieter van der Hulst I.

FLEMISH KERMESSE

Signed and dated 1628
Wood, 49×93 cm.
Brunswick,
Herzog-Anton-Ulrich Museum
No. 107.

Cornelis Huysmans

FOREST LANDSCAPE

Canvas, 133×168 cm.
Brussels,
Musée des Beaux-Arts
No. 228.

Jan Baptist Huysmans

RUINED TEMPLE
ON THE SHORE OF A BAY

Signed and dated 1695
Wood, 54.5 × 94 cm.
Munich, Alte Pinakothek
No. 947.

Jan Baptist Huysmans

LANDSCAPE WITH ANIMALS

Signed and dated 1697
Canvas, 166.5 × 215 cm.
Brussels,
Musée des Beaux-Arts
No. 229.

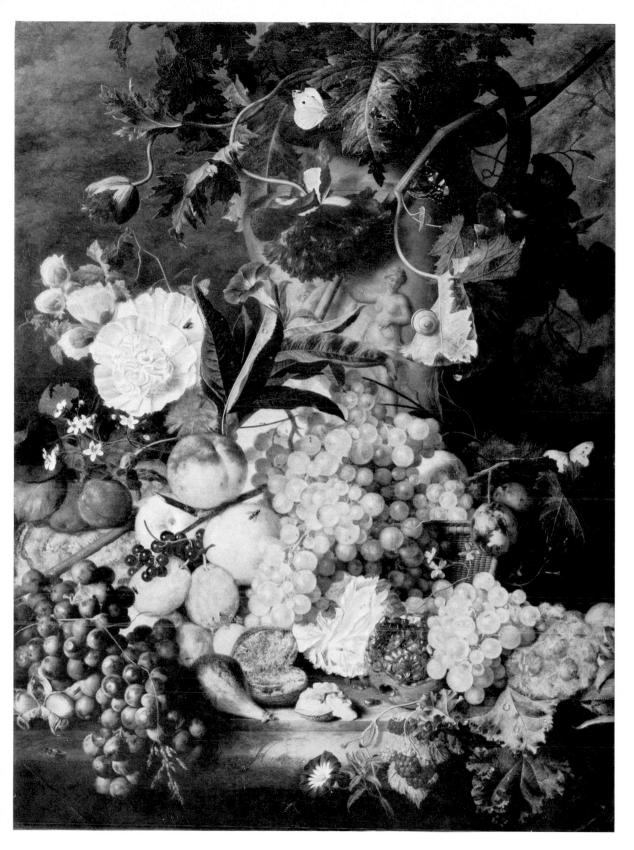

Jan van Huysum

FRUIT, FLOWERS AND INSECTS

Signed and dated 1735
Wood, 81×61 cm.
Munich, Alte Pinakothek
No. 2077.

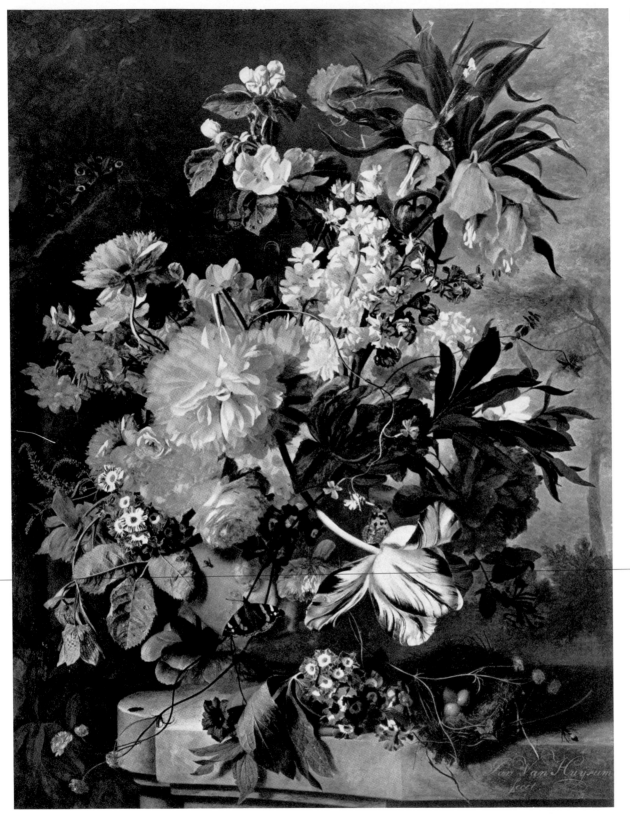

Jan van Huysum

FLOWERS IN A VASE

Signed and dated 1726
Wood, 80×60 cm.
London, Wallace Collection
No. 149.

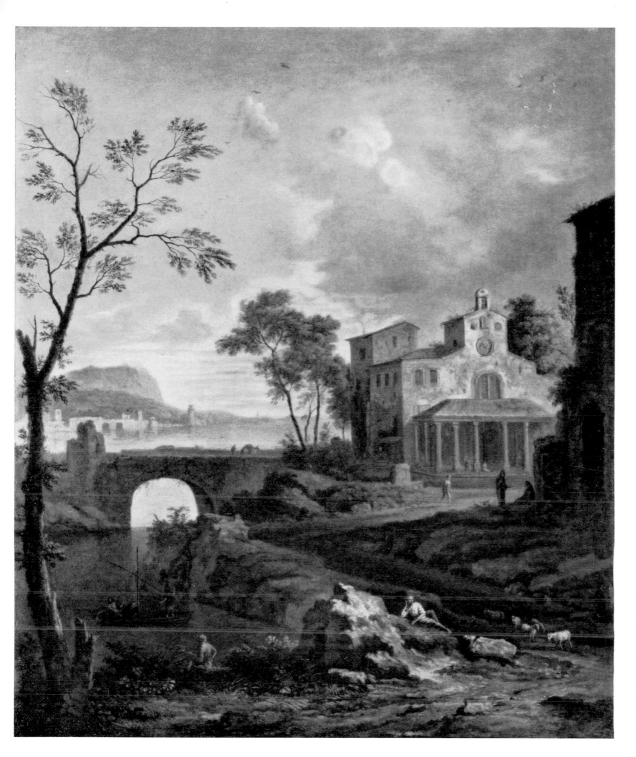

Jan van Huysum

ITALIAN LANDSCAPE

Signed
Canvas, 59 × 49.5 cm.
Amsterdam, art trade
(Goudstikker catalogue 37
No. 17).

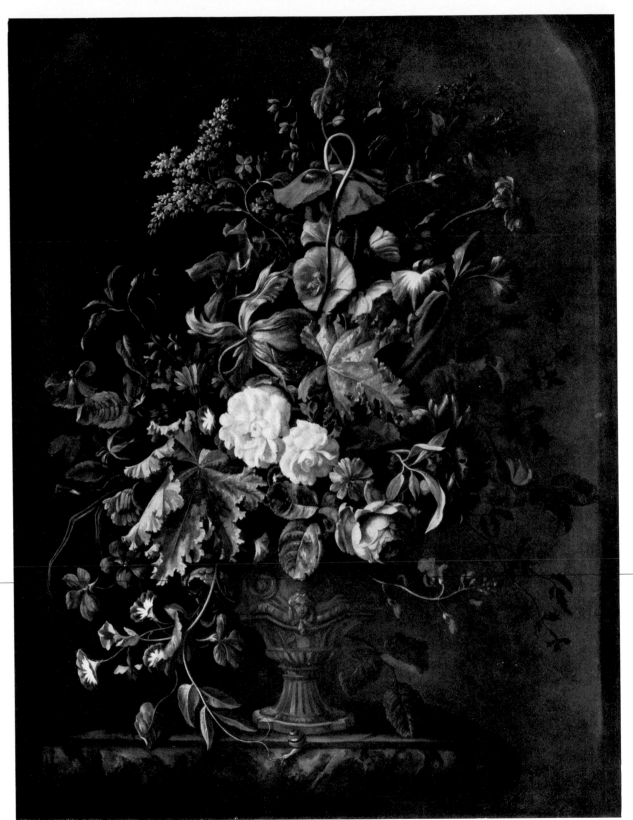

Justus van Huysum

Bouquet of Flowers

Signed
Canvas, 120×91 cm.
Munich, H. Helbing sale,
16 June 1931
No. 51.

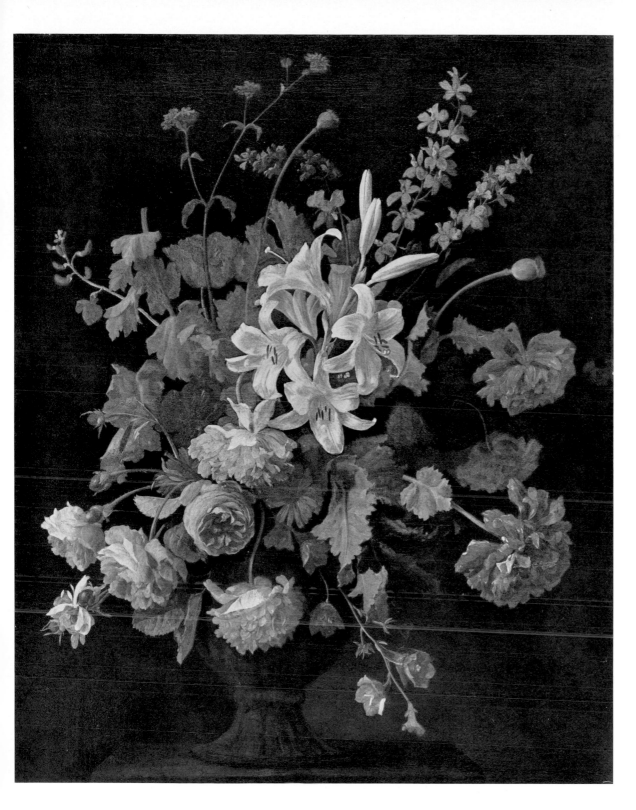

Justus van Huysum

BOUQUET OF FLOWERS

Signed
Canvas, 86.5 × 69.5 cm.
Schwerin, Gallery
No. 531.

Philipp Augustyn Immenraet

ITALIAN LANDSCAPE
WITH ANTIQUE ARENA

Signed
Canvas, 47.5 × 63.2 cm.
Munich, art trade, 1942.

Isaac Isaacsz.

BANQUET

Signed and dated 1622
Canvas, 245 × 316 cm.
Copenhagen,
Royal Museum of Fine Arts
No. 342.

Isaac Isaacsz.

ABIMELECH AND SARAH

Signed and dated 1640
Canvas, 98 × 131 cm.
Amsterdam, Rijksmuseum
No. 1281.

Isaac Isaacsz.

BIBLICAL SCENE

Signed and dated 1632
Wood, 45 × 76 cm.
London, collection of
Dr. E. Schapiro.

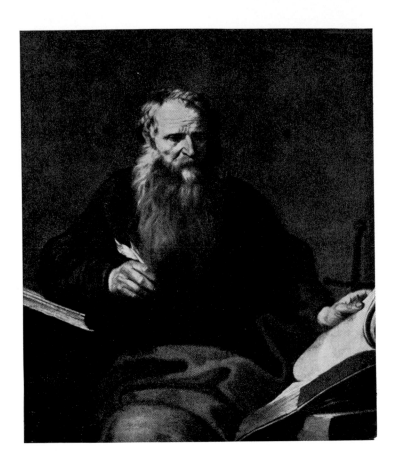

Lambert Jacobsz.

St. Paul in Prison

Signed and dated 1629
Canvas, 114×101 cm.
Leeuwarden, Frisian Museum.

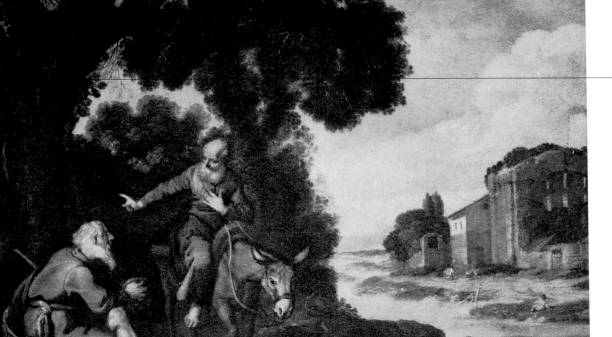

Lambert Jacobsz.

The Prophet Inviting
the Man of God

Signed and dated 1629
Canvas, 82.5×111 cm.
Amsterdam, Rijksmuseum
No. 1293A1.

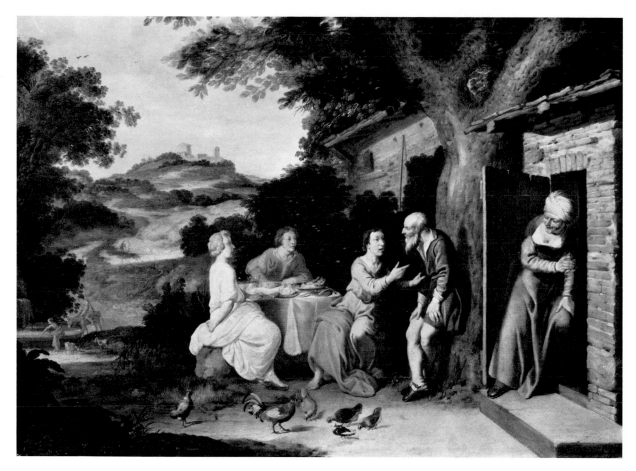

Lambert Jacobsz.

THE ANGELS VISITING
ABRAHAM

Signed and dated 1628
Wood, 59×82 cm.
Munich, private collection.

584

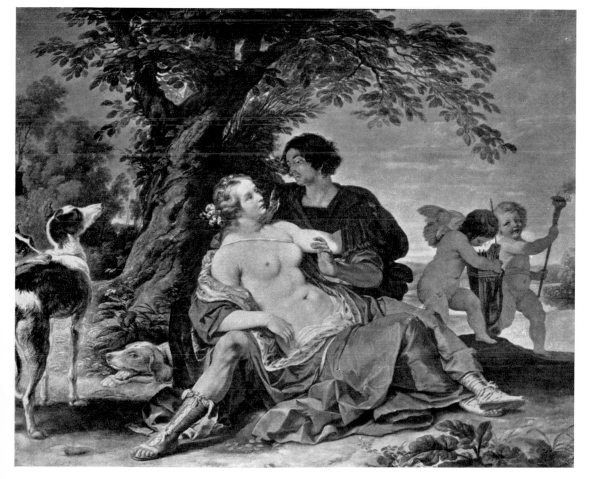

Abraham Janssens

VENUS AND ADONIS

Canvas, 200×240 cm.
Vienna,
Kunsthistorisches Museum
No. 728.

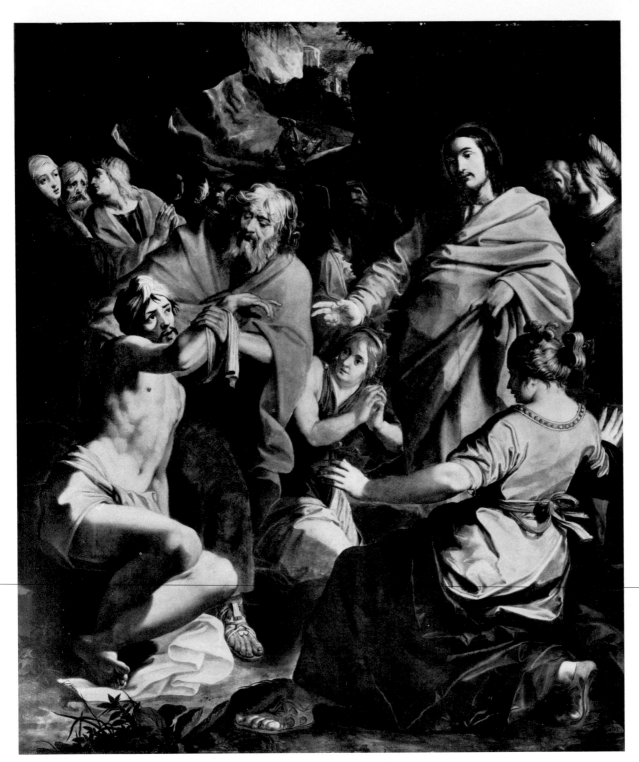

Abraham Janssens

THE RAISING OF LAZARUS

Dated 1607
Wood, 223 × 183 cm.
Munich, Alte Pinakothek
No. 153.

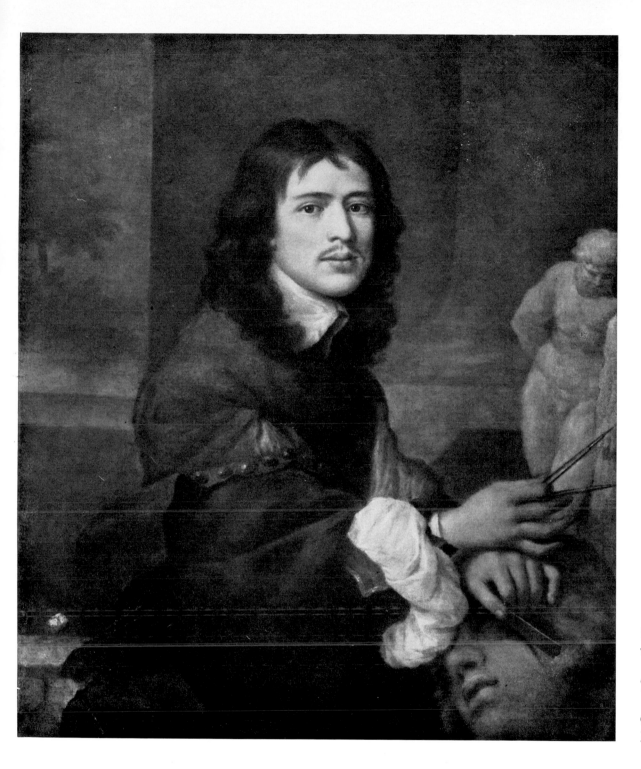

Cornelis Janssens
van Ceulen

The Sculptor

Canvas, 92×78 cm.
Hollywood, Calif., M. Rozsa.

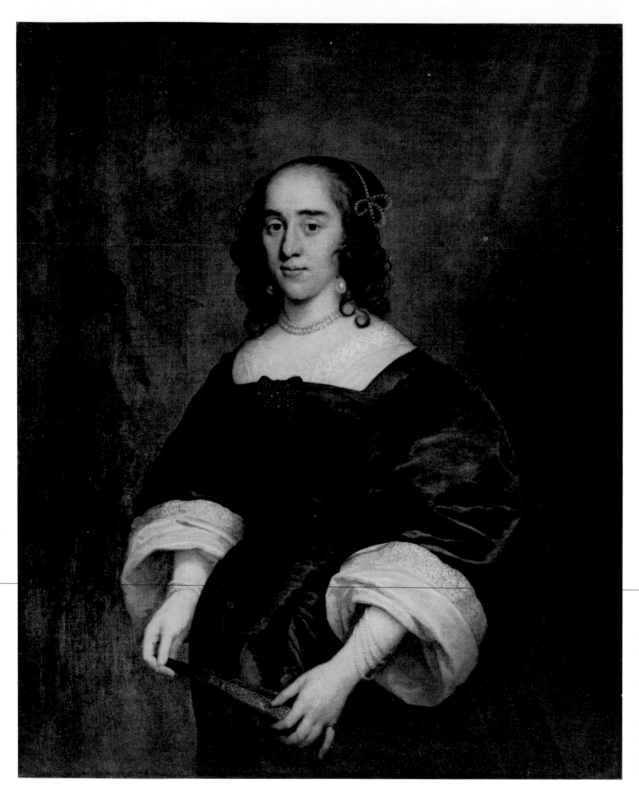

Cornelis Janssens van Ceulen

Portrait of a Lady

Signed and dated 1651
Canvas, 112×90 cm.
Dresden, Gallery
No. 1542.

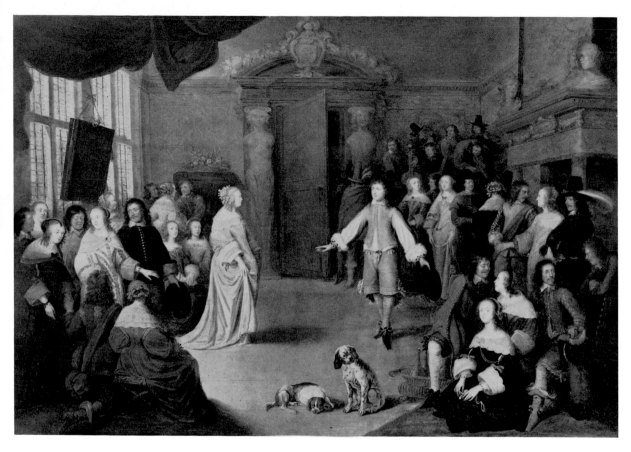

Hieronymus Janssens

DANCING PARTY

Signed
Wood, 74×106 cm.
Munich, Stroefer-Böhler sale
28 October 1937
No. 57.

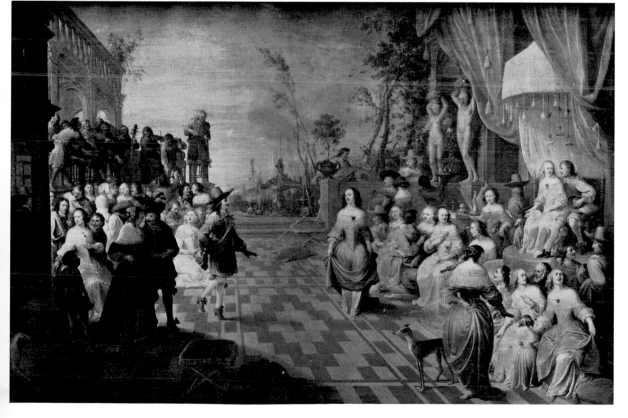

Hieronymus Janssens

OPEN-AIR DANCE

Signed and dated 1658
Canvas, 112×168 cm.
Lille, Musée des Beaux-Arts.

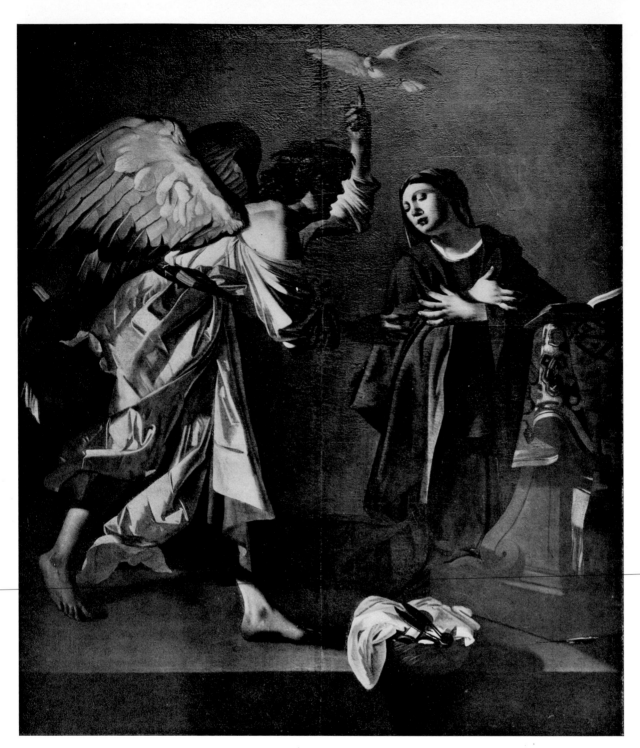

Jan Janssens

THE ANNUNCIATION

Signed
Canvas, 258×222 cm.
Ghent, Musée des Beaux-Arts
No. S-91.

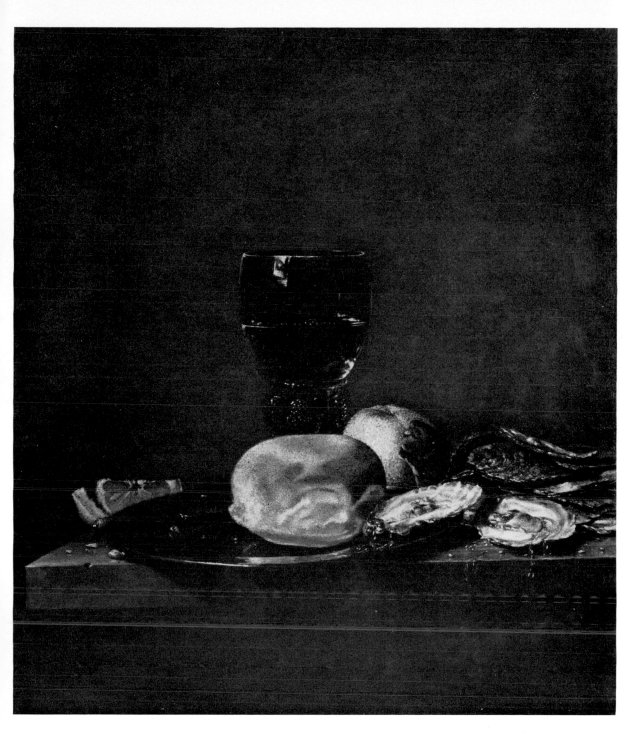

Pieter Janssens Elinga

BREAKFAST STILL LIFE

Signed
Canvas
Berlin, art trade.

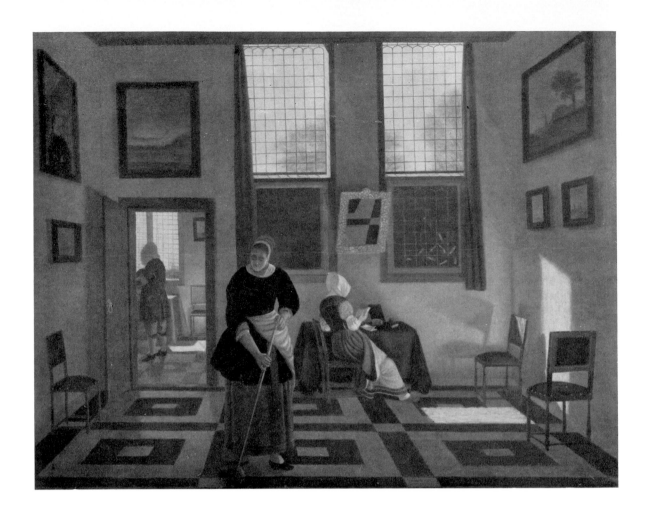

Pieter Janssens Elinga

INTERIOR

Canvas, 82×105 cm.
Munich, art trade.

Claude de Jongh

ITALIAN LANDSCAPE

Signed and dated 1633
Wood, 43×69 cm.
Utrecht, Central Museum
No. 117.

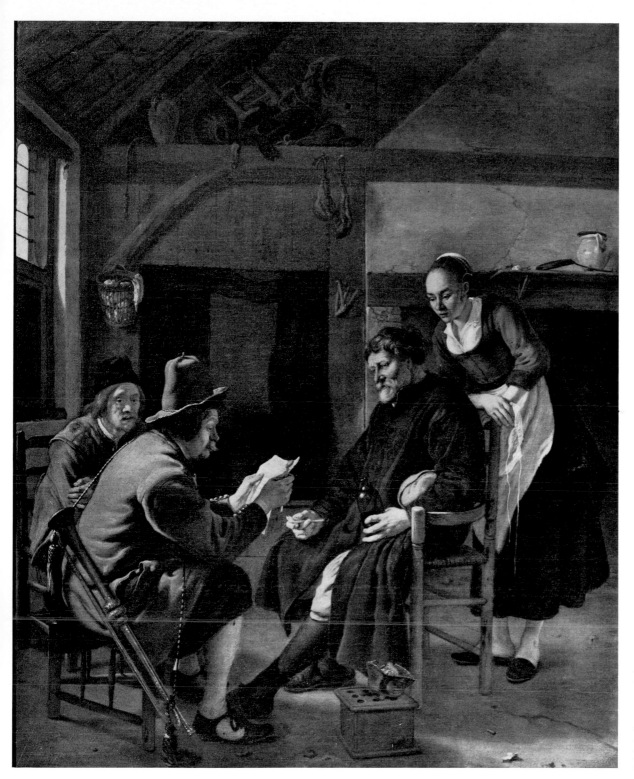

Ludolf de Jongh

MAN READING A LETTER

Signed and dated 1657
Canvas, 66×54 cm.
Mainz, Museum
No. 800.

Ludolf de Jongh

PORTRAIT OF A WOMAN
WITH HER DAUGHTER

Signed and dated 1653
Canvas, 110×97 cm.
Dresden, Gallery
No. 1805.

Ludolf de Jongh

LANDSCAPE WITH DIANA
RESTING

Signed and dated 1644
Wood, 75 × 107 cm.
Berlin, Lepke sale
27 February 1917
No. 44.

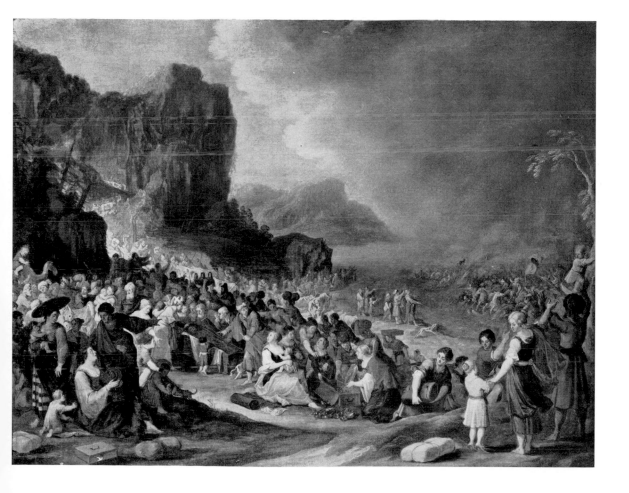

Hans Jordaens

PASSAGE OF THE ISRAELITES
THROUGH THE RED SEA

Signed
Canvas, 66 × 85 cm.
The Hague, Mauritshuis
No. 434.

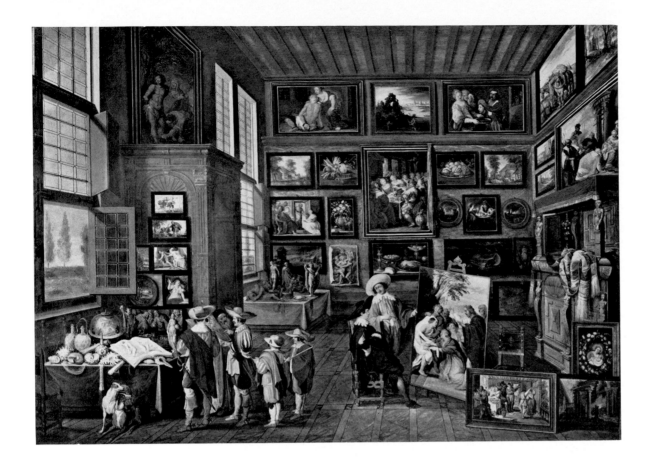

Hans Jordaens

AN ART-COLLECTOR'S
CABINET

Signed
Wood, 86×120 cm.
Vienna,
Kunsthistorisches Museum
No. 964.

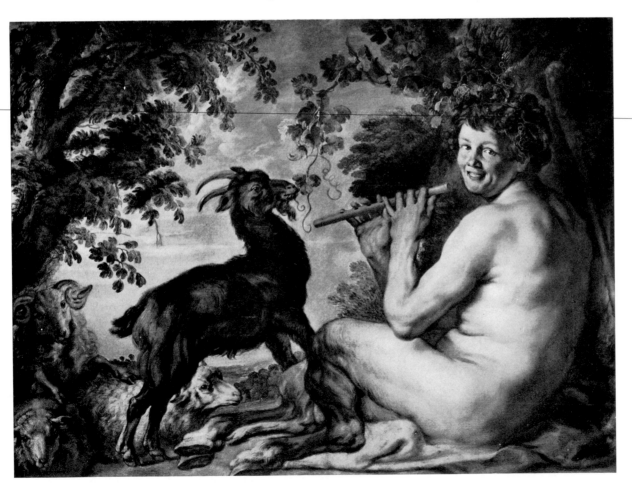

Jacob Jordaens

SATYR PLAYING THE FLUTE

Canvas, 135×176 cm.
Amsterdam, Rijksmuseum
No. 1315.

Jacob Jordaens

St Peter Finding the
Tribute Money in the
Mouth of the Fish

Signed
Canvas, 119 × 197.5 cm.
Amsterdam, Rijksmuseum
No. 1316.

Jacob Jordaens

Family Group in a Garden

Canvas, 181 × 187 cm.
Madrid, Prado
No. 1549.

Jacob Jordaens

THE PRODIGAL SON

Canvas, 236×369 cm.
Dresden, Gallery
No. 1011.

Jacob Jordaens

ALLEGORY OF FERTILITY
(Fruit and vegetables
by F. Snyders)

Signed
Canvas, 180×241 cm.
Brussels,
Musée des Beaux-Arts
No. 235.

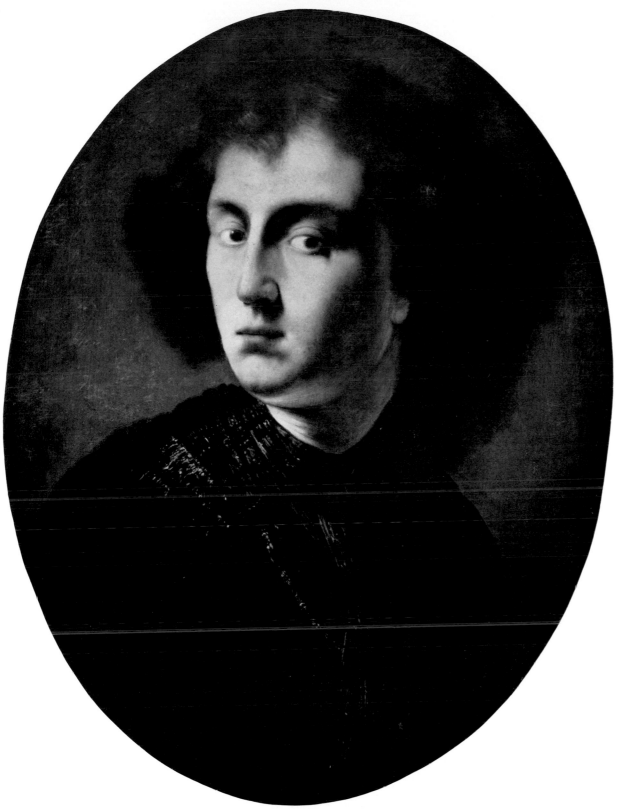

Isaac de Jouderville

PORTRAIT OF A YOUNG MAN

Signed
Wood, 48 × 37 cm.
Dublin,
National Gallery of Ireland
No. 433.

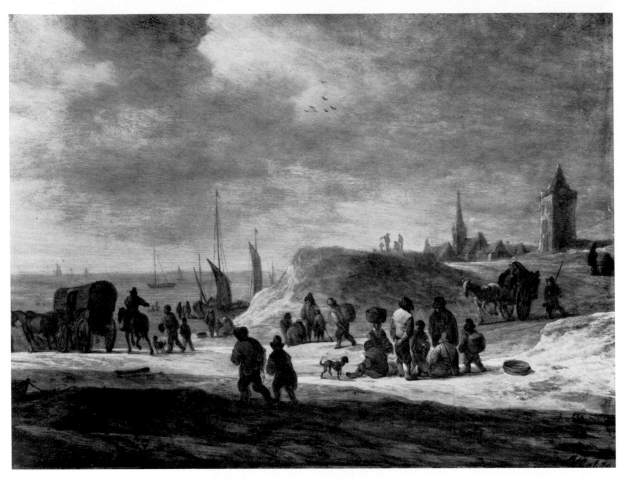

Adriaen van der Kabel

BEACH LANDSCAPE

Signed
Wood, 35 × 49 cm.
New York, art trade.

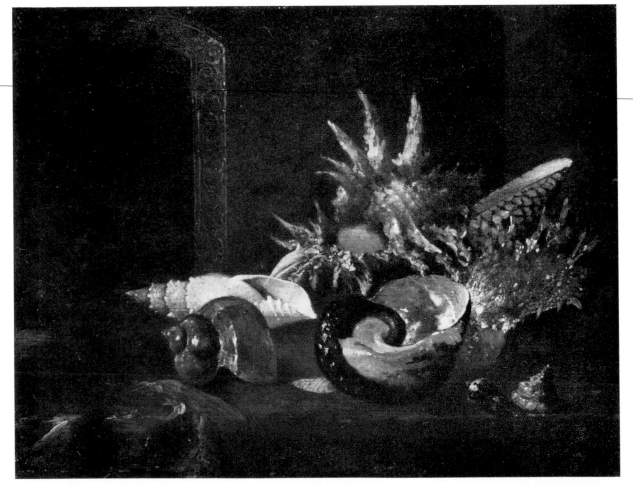

Willem Kalf

STILL LIFE WITH SHELLS

Wood, 26.5 × 34.5 cm.
Formerly Berlin,
Goldschmidt collection.

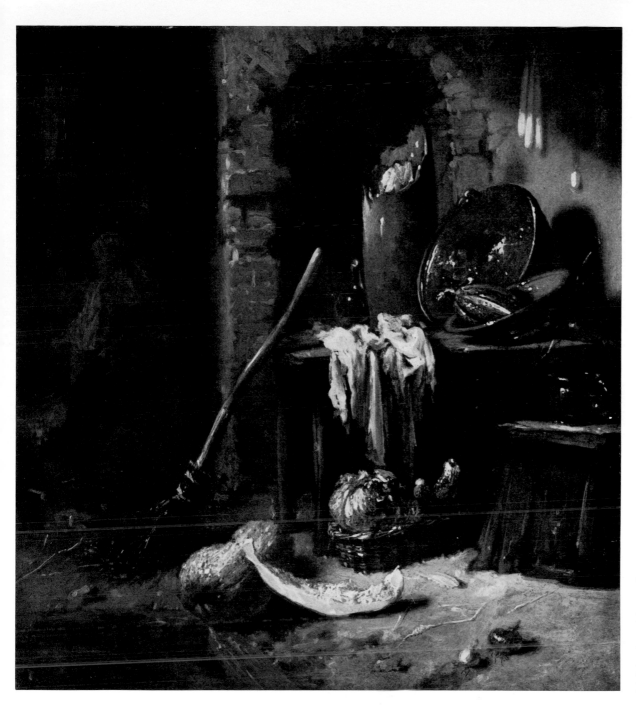

Willem Kalf

KITCHEN INTERIOR

Wood, 20×18 cm.
Berlin, Staatliche Museen
No. 948H.

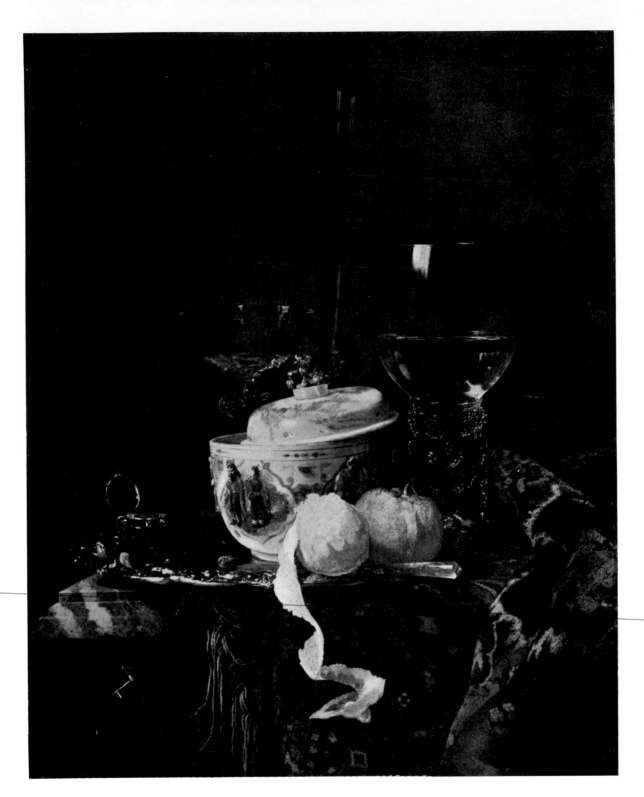

Willem Kalf

STILL LIFE

Canvas, 65 × 56 cm.
Berlin, Staatliche Museen
No. 948D.

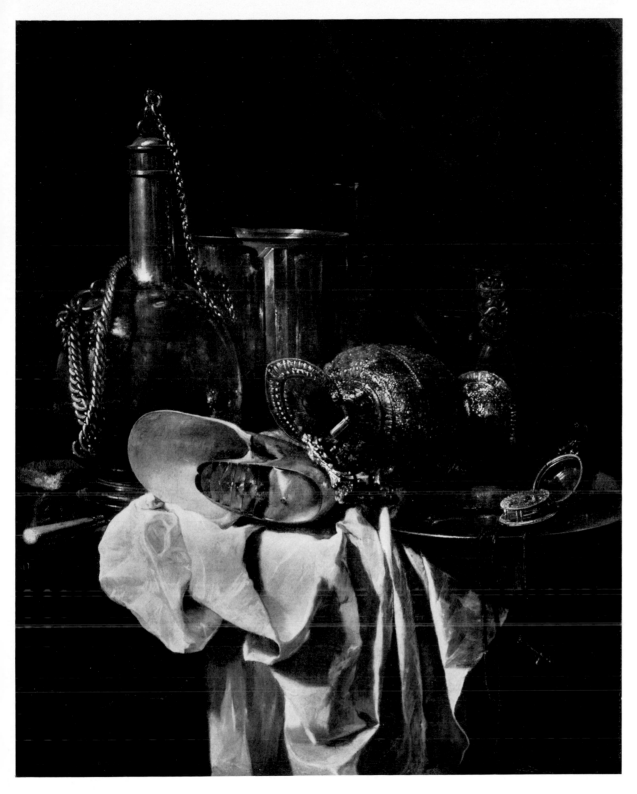

Willem Kalf

STILL LIFE WITH
SILVER AND GOLD VESSELS
AND NAUTILUS SHELL

Canvas, 67 × 53.5 cm.
Munich, art trade.

Godaert Kamper

THE CELLO PLAYER

Signed and dated 1646
Wood, 54.5 × 42.7 cm.
Düsseldorf, Art Museum.

Godaert Kamper

PORTRAIT OF A LADY

Signed and dated 1656
Wood, 89×69 cm.
Amsterdam, Rijksmuseum
No. 1321.

Alexander Keirincx

RIVER FLOWING THROUGH
A FOREST

Wood, 44.5 × 70.5 cm.
Dresden, Gallery
No. 1146.

Alexander Keirincx

FOREST
(figures by
C. van Poelenburgh)

Signed
Wood, 64 × 92 cm.
The Hague, Mauritshuis
No. 79.

Jan van Kessel

TEN INSECTS

Signed and dated 1660
Wood, 17×23 cm.
Strasbourg,
Musée des Beaux-Arts.

Jan van Kessel

ART CABINET

Signed and dated 1659
Copper, 68×90 cm.
Antwerp, private collection.

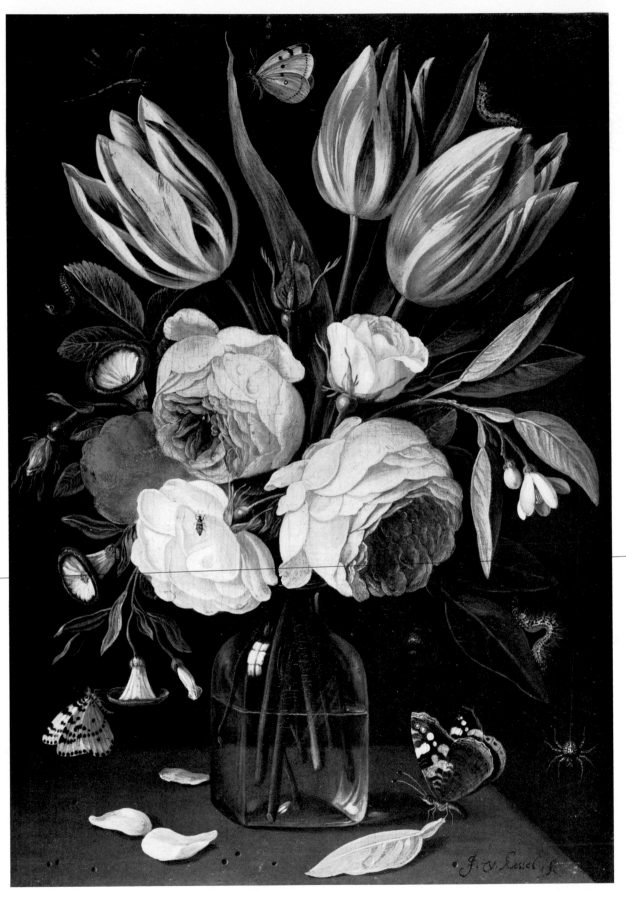

Jan van Kessel

FLOWERS IN A GLASS BOTTLE

Signed
Wood, 35 × 24 cm.
Munich, art trade.

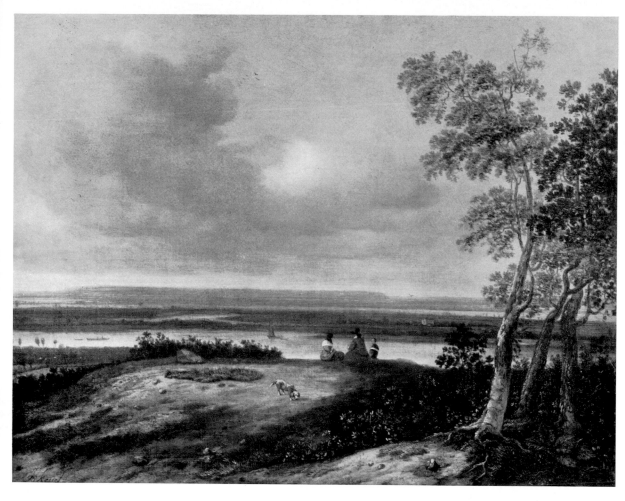

Jan van Kessel

FLAT LANDSCAPE

Signed
Canvas, 48×57 cm.
Munich, art trade.

618

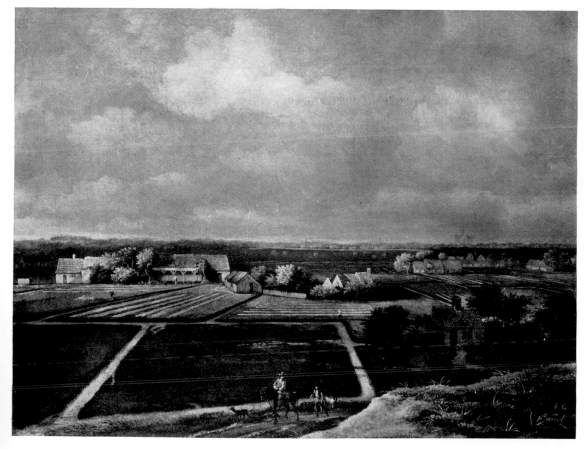

Jan van Kessel

LINEN-BLEACHING GROUND
NEAR HAARLEM

Signed
Canvas, 54×65 cm.
Sarasota, Fla.,
John and Mable Ringling
Museum of Art.

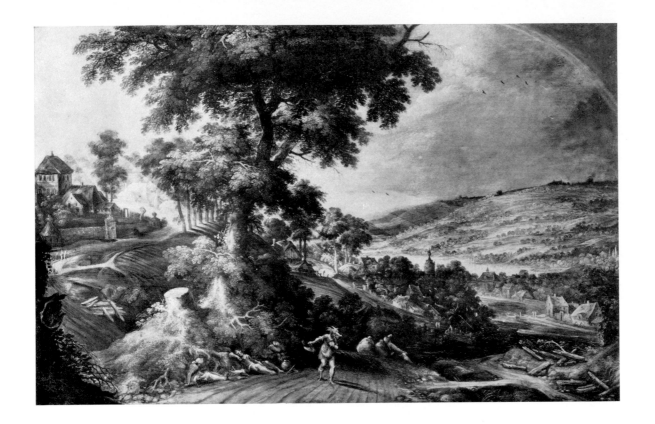

Kerstiaen de Keuninck

LANDSCAPE WITH THE
DEVIL SOWING WEEDS

Wood, 69×105 cm.
Formerly Berlin,
Kaiser-Friedrich Museum
No. 1998.

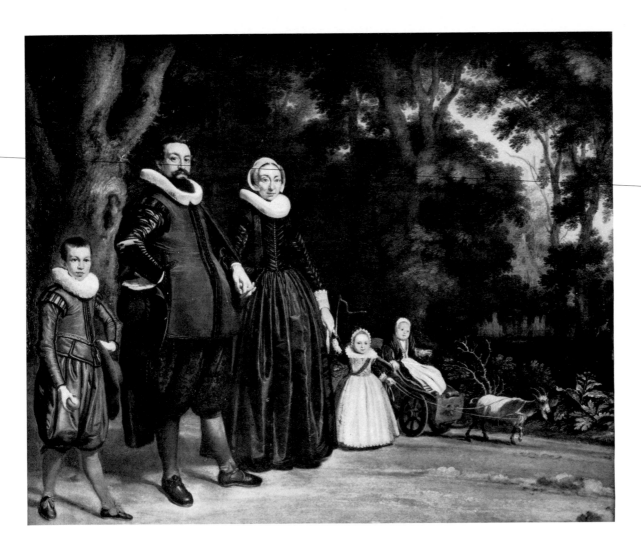

Thomas de Keyser

FAMILY GROUP
IN A LANDSCAPE

Wood, 59×71 cm.
Gotha, Ducal Gallery
No. 246.

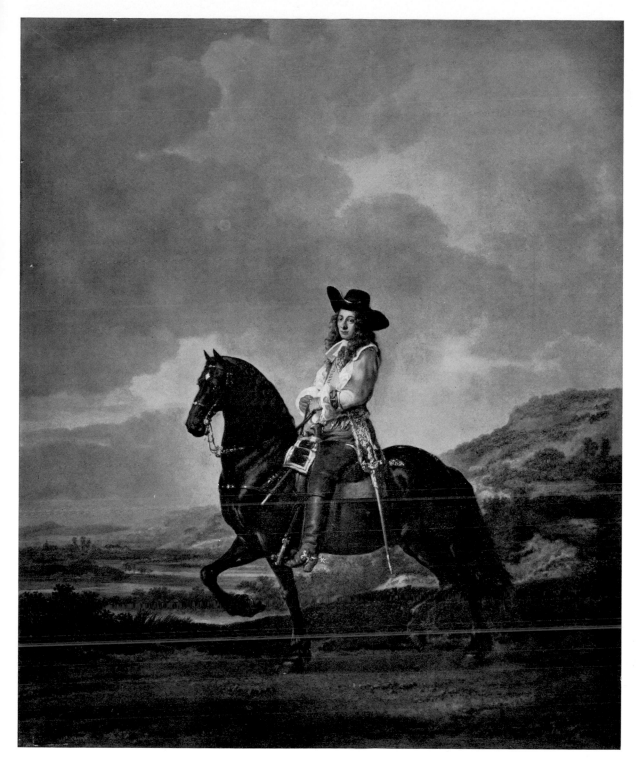

Thomas de Keyser

PIETER SCHOUT ON HORSEBACK

With monogram: dated 1660
Copper, 86×69.5 cm.
Amsterdam, Rijksmuseum
No. 1350.

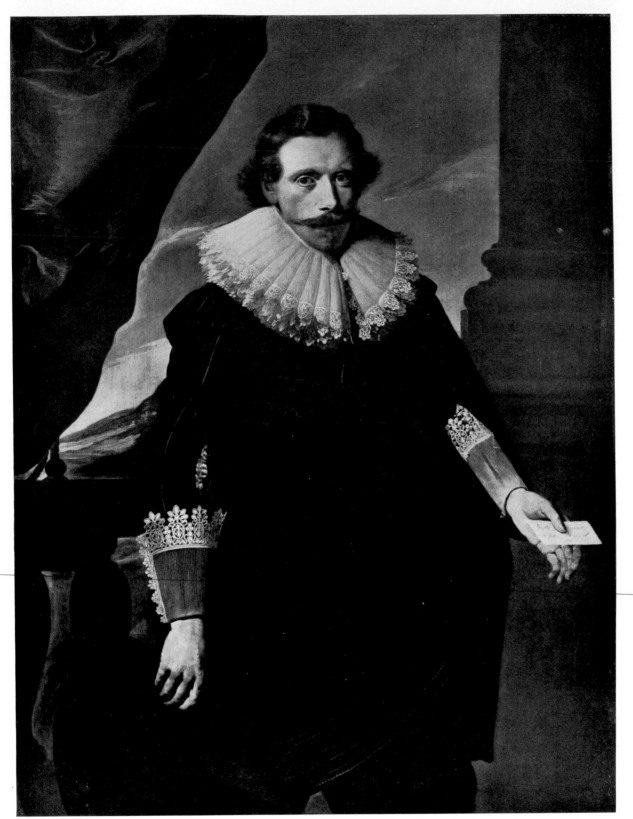

Thomas de Keyser

PORTRAIT OF A GENTLEMAN

With monogram: dated 1631
Wood, 121×89 cm.
The Hague,
portrait exhibition, 1903
No. 66.

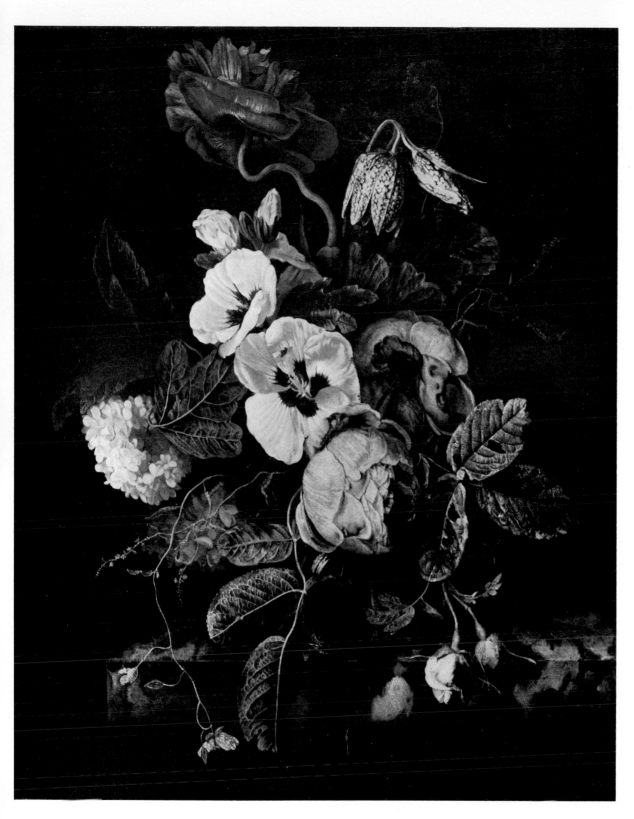

Cornelis Kick

FLOWER STILL LIFE

Signed
Canvas, 49×38 cm.
Düsseldorf, art trade.

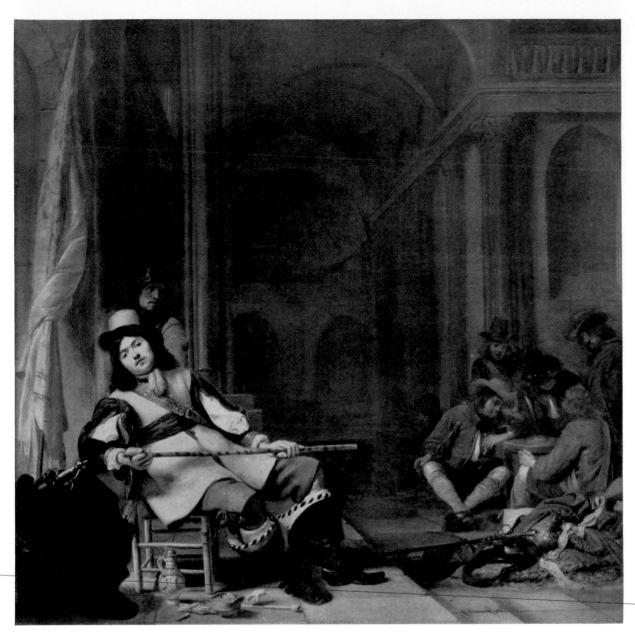

Simon Kick

GUARD-ROOM

Wood, 72 × 71 cm.
Basle, Kunstmuseum
No. 387.

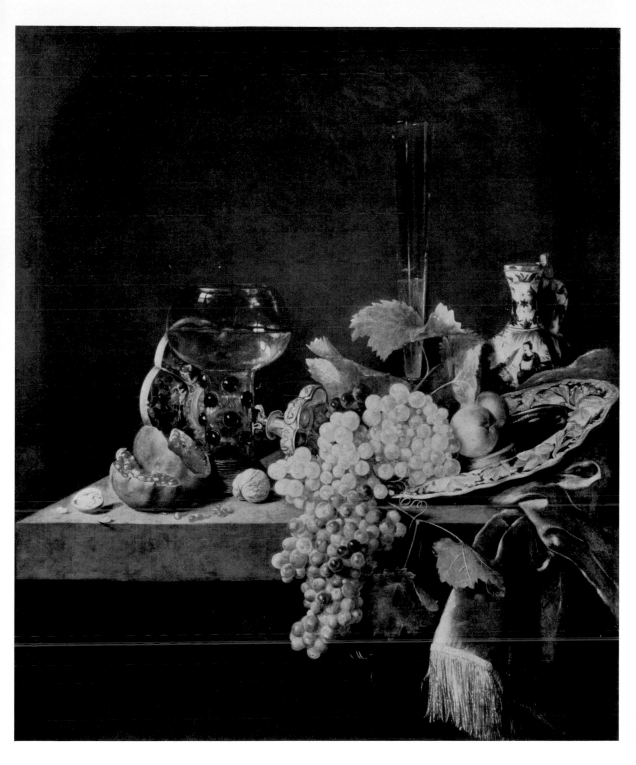

Isaac van Kipshaven

STILL LIFE

Signed and dated 1661
Canvas, 84×73 cm.
The Hague, Mauritshuis
No. 814.

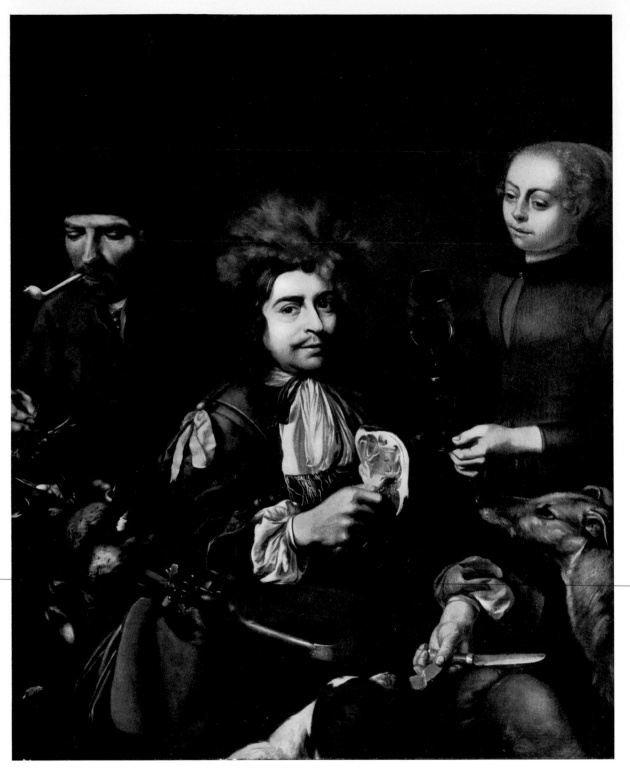

Isaac van Kipshaven

HUNTSMAN BREAKFASTING

Signed and dated 1665
Canvas, 122,5 × 105 cm.
Munich, art trade, 1949.

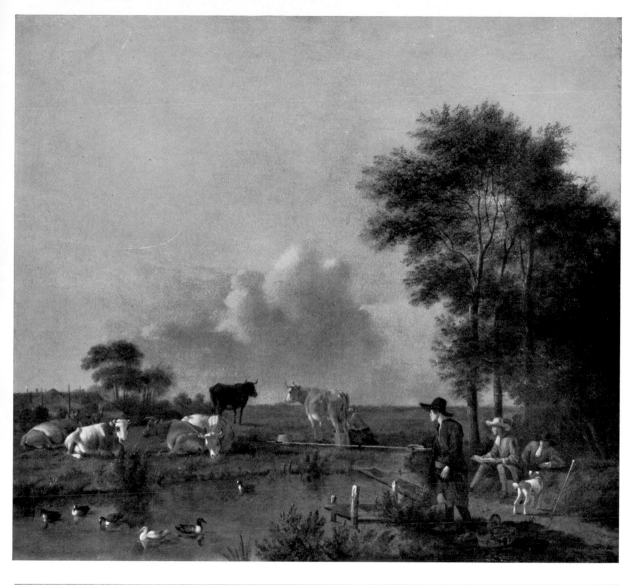

Albert Klomp

LANDSCAPE WITH ANGLER
AND COWS

Signed and dated 1684
Canvas, 66.5 × 73 cm.
Munich, art trade.

628

Catharina
van Knibbergen

LANDSCAPE

With monogram
Oak wood, 18 × 26 cm.
Amsterdam,
W. M. J. Russell collection.

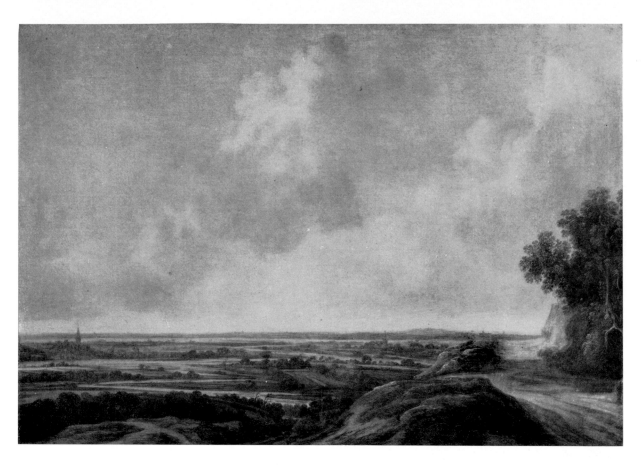

François
van Knibbergen

PANORAMIC LANDSCAPE

Signed
Canvas, 97×140 cm.
Amsterdam, Rijksmuseum
No. 1356a.

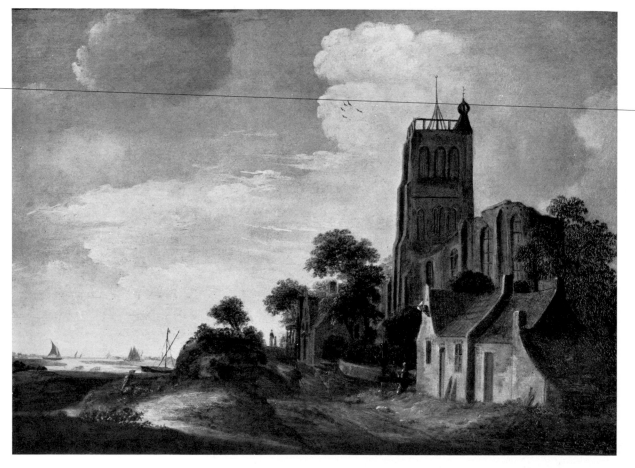

Wouter Knijff

EGMOND AAN ZEE

Signed and dated 1652
Wood, 48×64 cm.
Formerly The Hague,
Bredius collection.

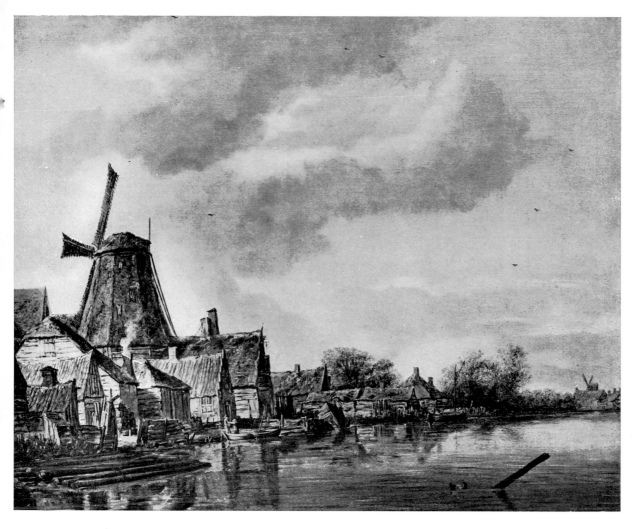

Wouter Knijff

DUTCH CANAL LANDSCAPE

Signed and dated 1644
Canvas, 94 × 105 cm.
Leipzig, Museum of Fine Arts
No. 507.

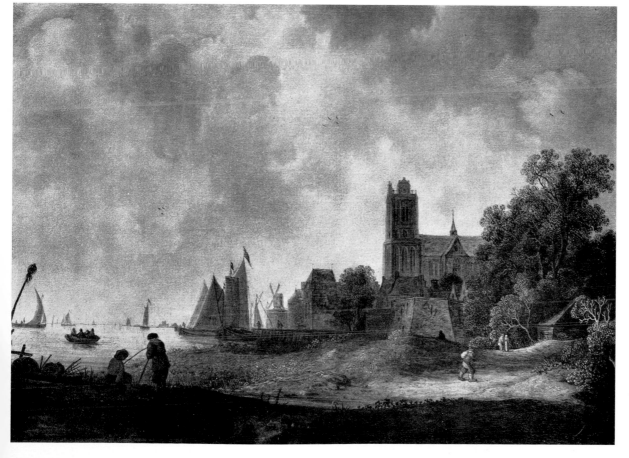

Wouter Knijff

VIEW OF DORDRECHT

Signed and dated 1644
Canvas, 98.5 × 132 cm.
Amsterdam, Rijksmuseum
No. 993.

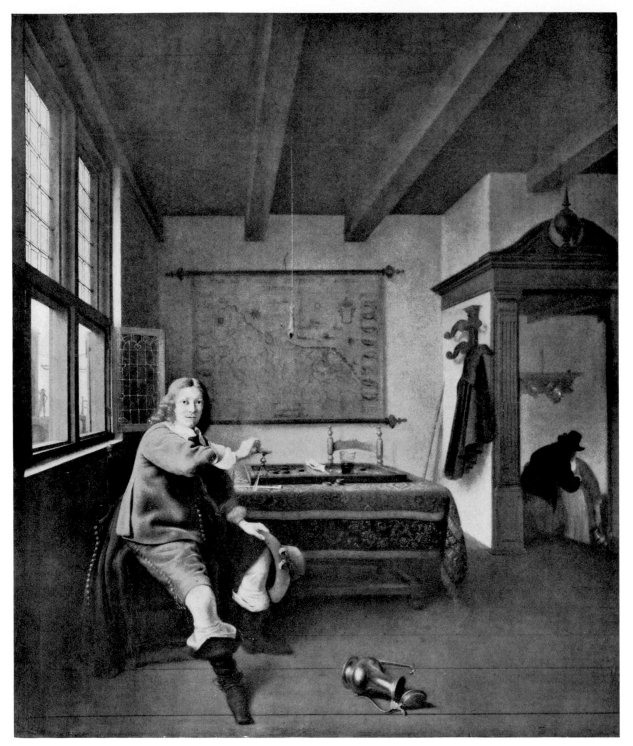

Isaac Koedyck

THE EMPTY BEAKER

Signed and dated 1648
Wood, 65.5 × 55 cm.
Amsterdam,
Frederik Muller sale,
26 April 1927
No. 60.

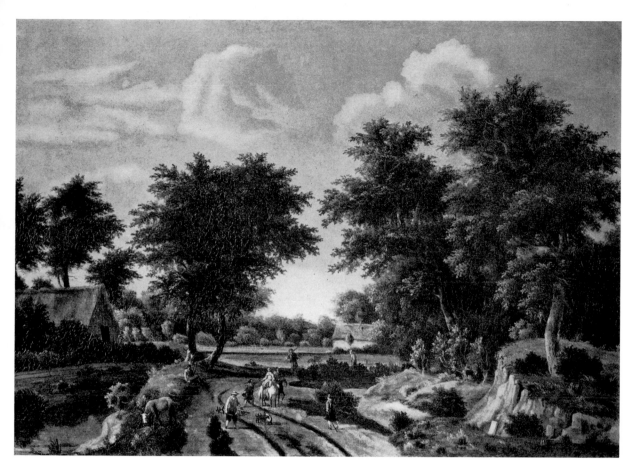

Isaac Koene

FOREST LANDSCAPE
AND BUSY ROAD

Signed
Wood, 59×83 cm.
Stockholm, Hallwyl Museum
B 54.

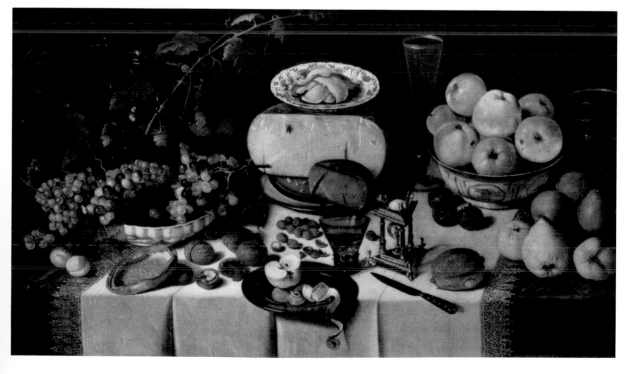

Roelof Koets

BREAKFAST STILL LIFE

Signed and dated 1625
Wood, 80×135 cm.
Antwerp,
Musée Mayer van den Bergh
No. 929.

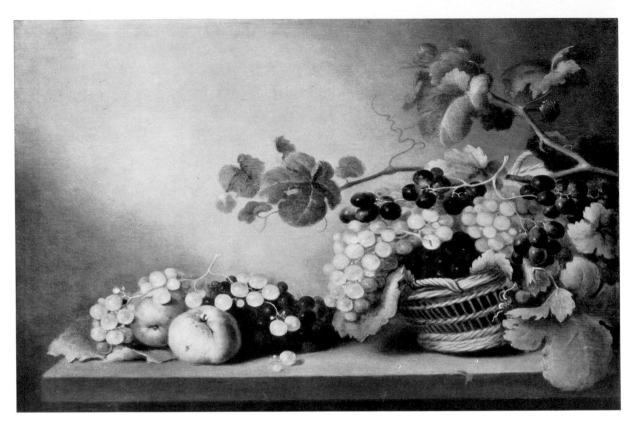

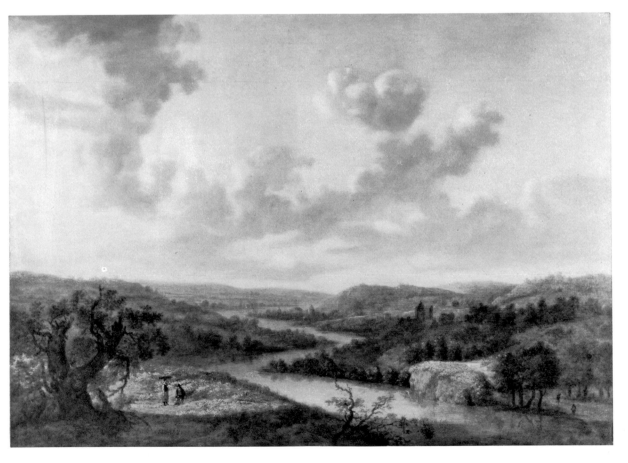

Roelof Koets

STILL LIFE

Signed and dated 1632
Wood, 45.5 × 68.5 cm.
Munich, art trade.

Jakob Koninck

RIVER LANDSCAPE

Signed
Wood, 61 × 84.5 cm.
Basle, Kunstmuseum
No. 1384.

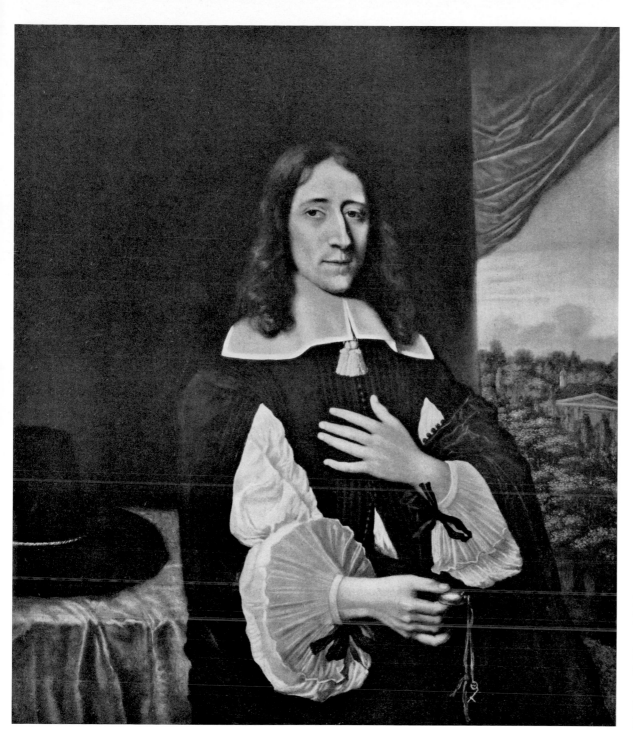

Philips Koninck

Portrait of
Professor Schooten

Signed and dated 1656
Canvas, 102 × 88 cm.
Amsterdam, art trade
(Goudstikker, catalogue 35
No. 20).

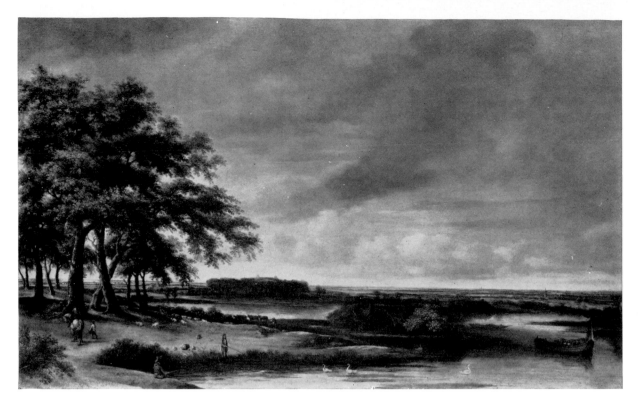

Philips Koninck

FLAT LANDSCAPE

Signed
Wood, 72×117 cm.
Frankfurt, Staedel Institute
No. 864.

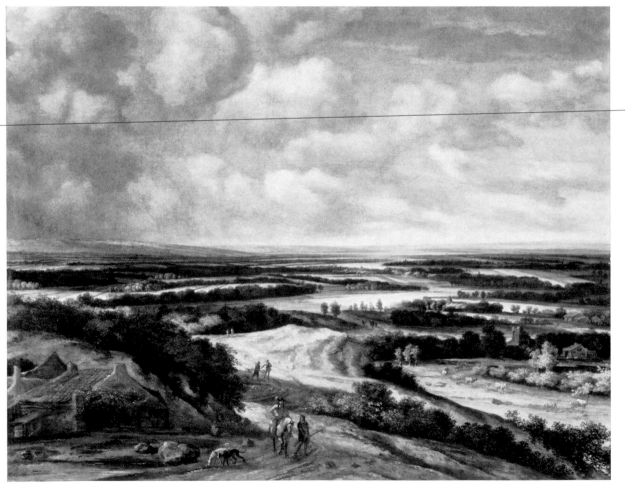

Philips Koninck

LARGE FLAT LANDSCAPE

Canvas, 105×135 cm.
Schweinfurt,
private collection.

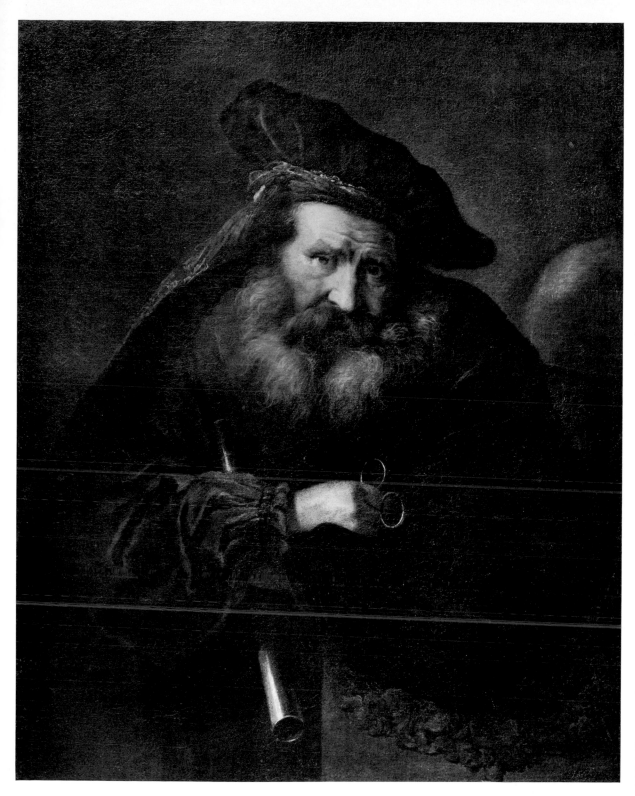

Salomon Koninck

THE ASTRONOMER

Signed
Canvas, 108.5 × 87 cm.
Dresden, Gallery
No. 1589a.

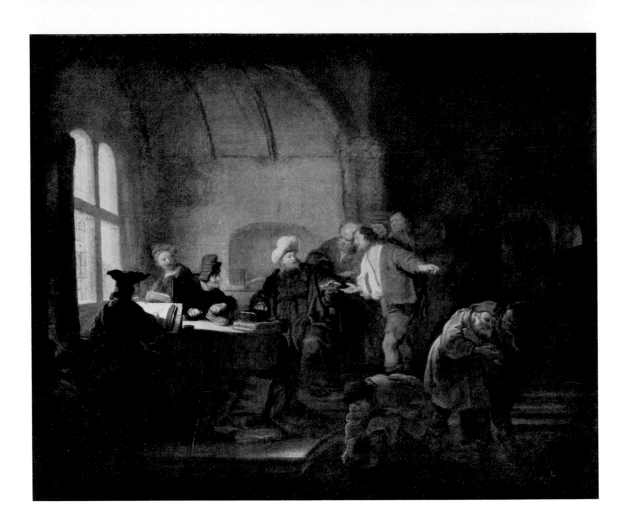

Salomon Koninck

The Parable
of the Vineyard

Canvas, 48 × 57 cm.
Leningrad, Hermitage
No. 2157.

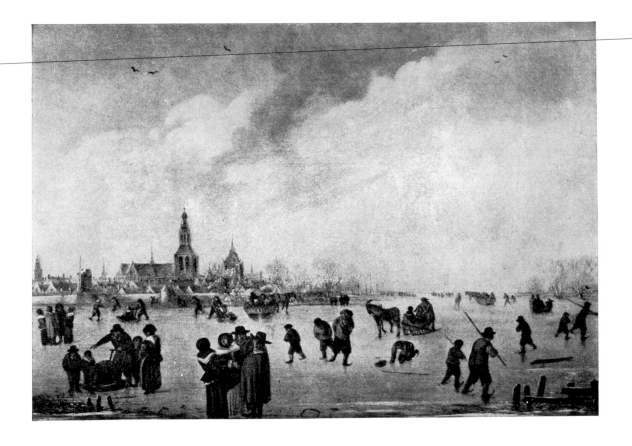

Willem Kool

Winter Landscape

Signed
Wood, 39.5 × 55.5 cm.
Amsterdam,
Frederik Muller sale
26 May 1914
No. 115.

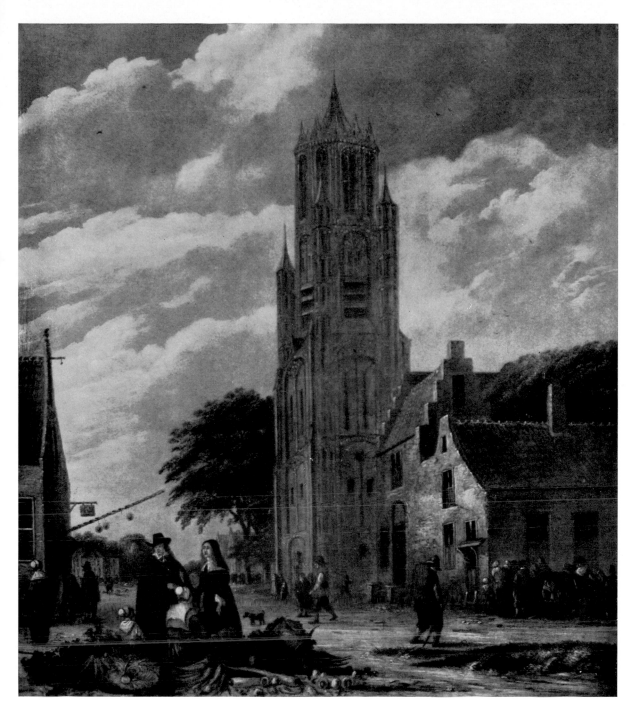

Willem Kool

Village Street in Front of a Church

Signed and dated 1654
Wood, 60×53 cm.
Munich, art trade.

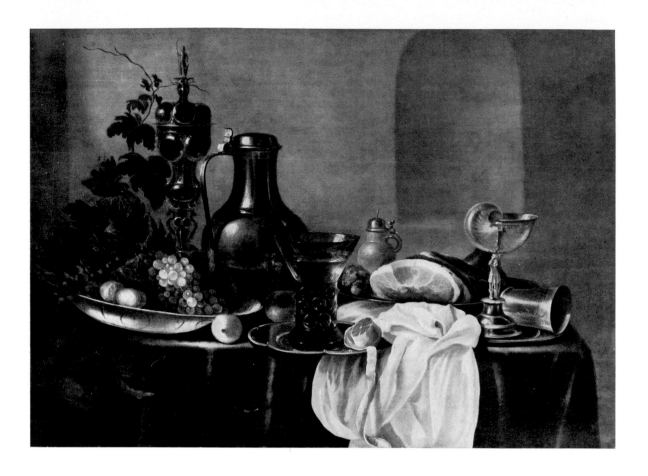

Cornelis Kruys

BREAKFAST STILL LIFE

Signed
Wood, 90.5 × 123 cm.
Amsterdam, art trade.

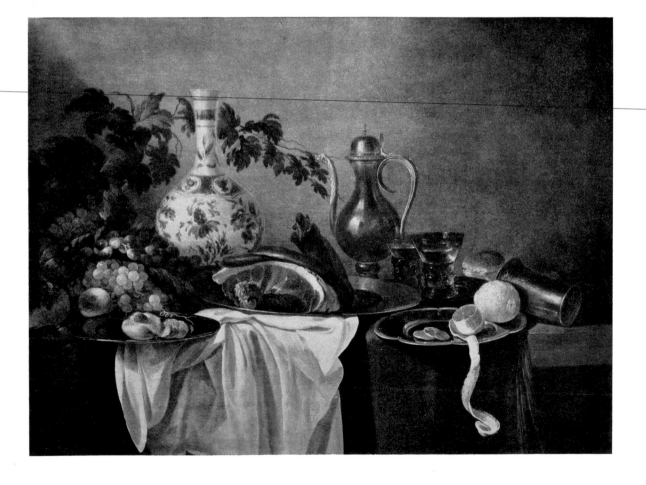

Cornelis Kruys

BREAKFAST STILL LIFE

Signed
Wood, 87 × 115 cm.
Amsterdam, art trade.

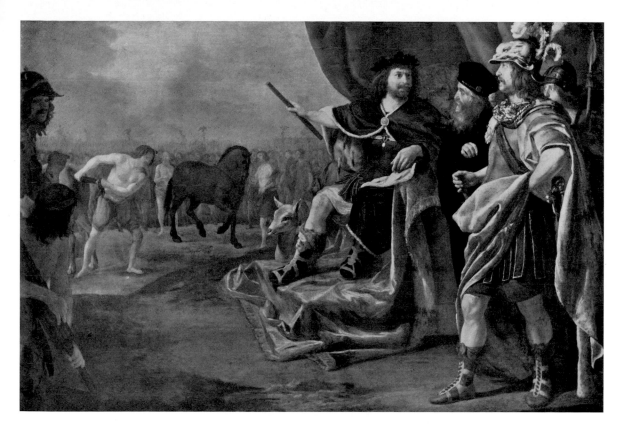

Gysbert van der Kuyl

GUILE OVERCOMING FORCE

With monogram; dated 1638
Canvas, 167×238 cm.
Amsterdam, Rijksmuseum
No. 1398.

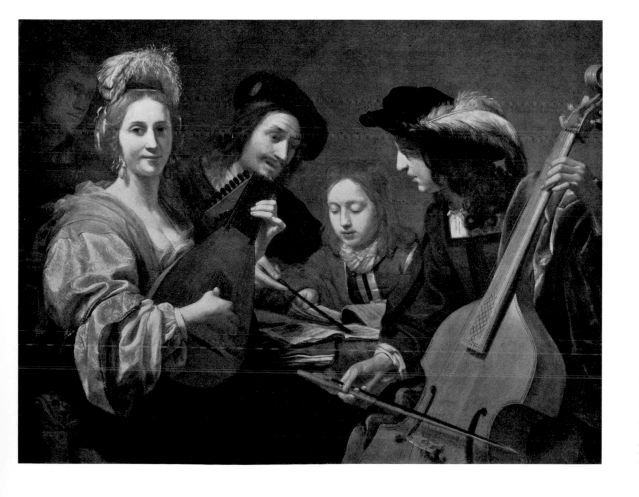

Gysbert van der Kuyl

MUSICAL COMPANY

With monogram; dated 1651
Canvas, 99×130 cm.
Amsterdam, Rijksmuseum
No. 1399.

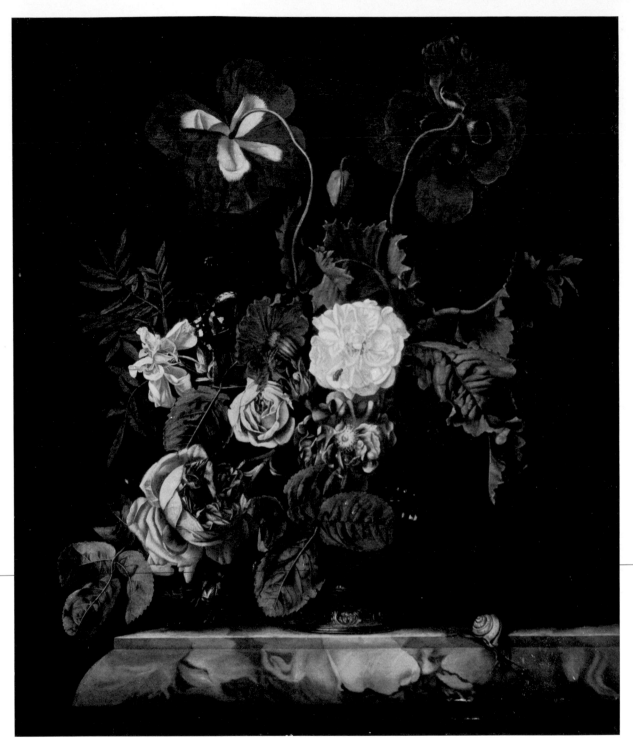

Nicolaes Lachtropius

BOUQUET OF FLOWERS

Signed and dated 1667
Canvas, 63 × 52 cm.
Amsterdam, Rijksmuseum
No. 1400.

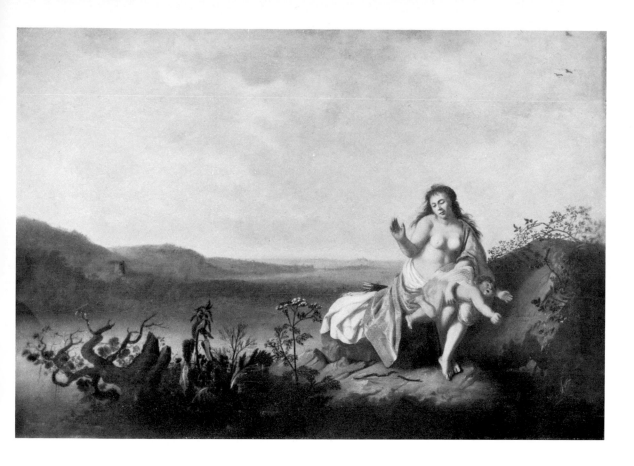

Reinier van der Laeck

Venus Chastising Cupid

Signed and dated 1640
Wood, 39×56 cm.
Göttingen University
No. 99.

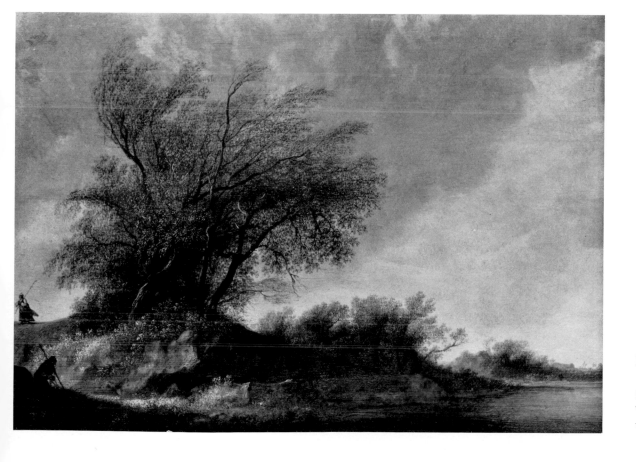

Reinier van der Laeck

River Landscape

Signed
Wood, 43×61 cm.
Vienna, private collection.

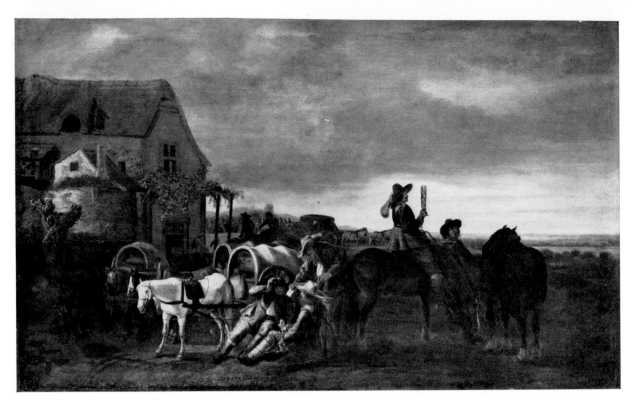

Pieter van Laer

HALT AT AN INN

Signed
Wood, 49×78 cm.
Brunswick,
Herzog-Anton-Ulrich Museum
No. 297.

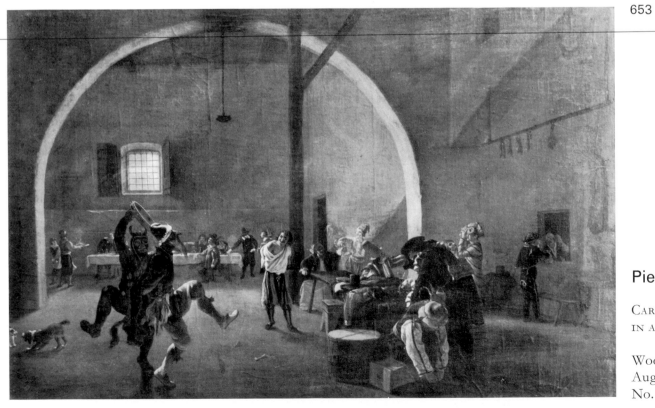

Pieter van Laer

CARNIVAL DANCE
IN A CELLAR TAVERN

Wood, 52×79 cm.
Augsburg, Gallery
No. 581.

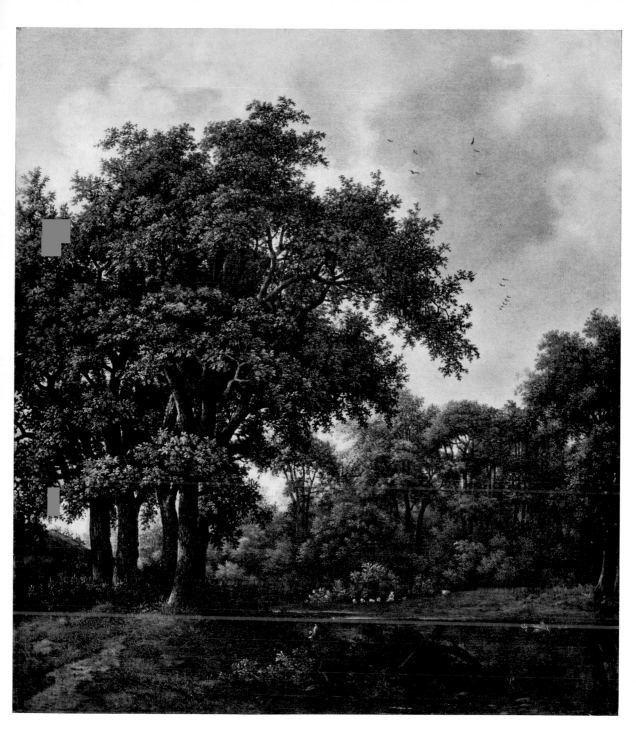

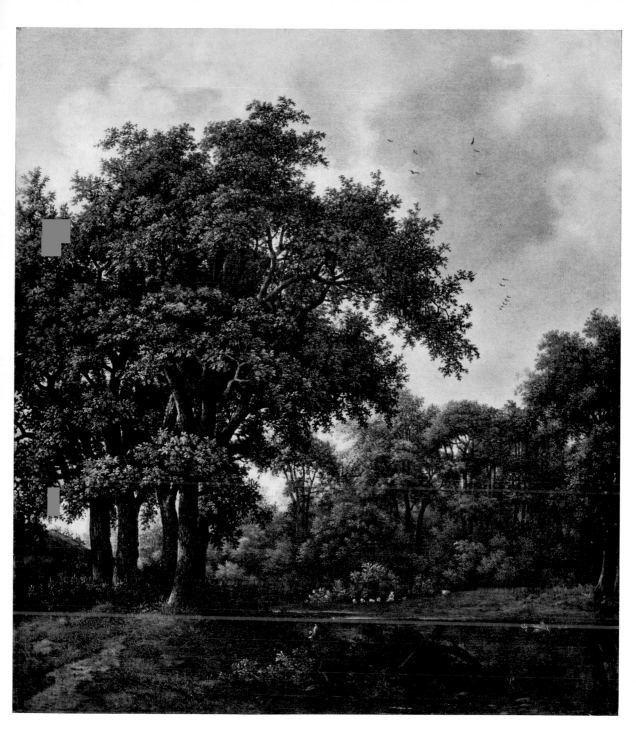

Jan Lagoor

FOREST LANDSCAPE

Signed
Canvas, 77×69 cm.
Budapest,
Museum of Fine Arts
No. 261 (516).

Gerard de Lairesse

DESIGNATION OF THE
EMPEROR ALEXANDER SEVERUS

Canvas, 93 × 159 cm.
Berlin, Staatliche Museen
No. 480.

Gerard de Lairesse

BACCHANAL

Signed
Canvas, 130 × 157 cm.
Cassel, Gallery
No. 462.

Christoph Jacobsz.
van der Lamen

MUSIC PARTY AT TABLE

With monogram
Wood
Berlin, art trade.

Christoph Jacobsz.
van der Lamen

MUSIC PARTY

Wood, 48×63 cm.
Berlin, Lepke sale
27 February 1917
No. 3.

Jasper van der Lanen

BALAAM AND HIS ASS

Signed and dated 1624
Wood
London, art trade, 1955.

Jasper van der Lanen

LANDSCAPE WITH GIPSIES

Signed
Wood, 53 × 73.5 cm.
Zurich, art trade, 1958.

Rutger van Langevelt

CHURCH INTERIOR

Signed and dated 1669
Canvas, 86.5 × 72 cm.
Copenhagen,
Royal Museum of Fine Arts
No. 381.

Jan Lapp

ITALIAN INN

Signed
Copper, 29 × 38 cm.
Kiel, private collection.

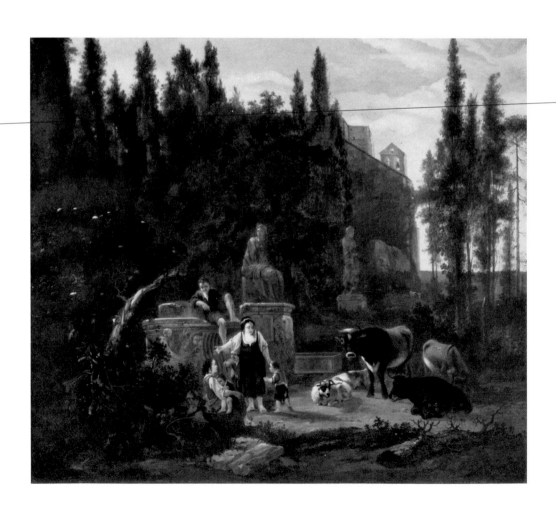

Jan Lapp

PARK WITH
ANTIQUE MONUMENTS

Signed
Canvas, 55 × 63 cm.
London,
Dulwich College Art Gallery
No. 330.

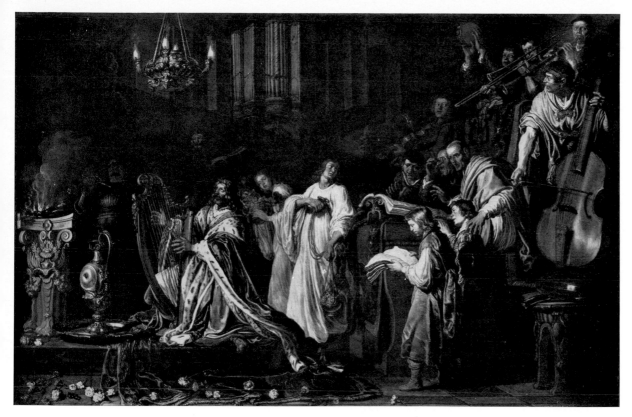

Pieter Lastman

DAVID IN THE TEMPLE

Signed and dated 1618
Wood, 79×117 cm.
Brunswick,
Herzog-Anton-Ulrich Museum
No. 208.

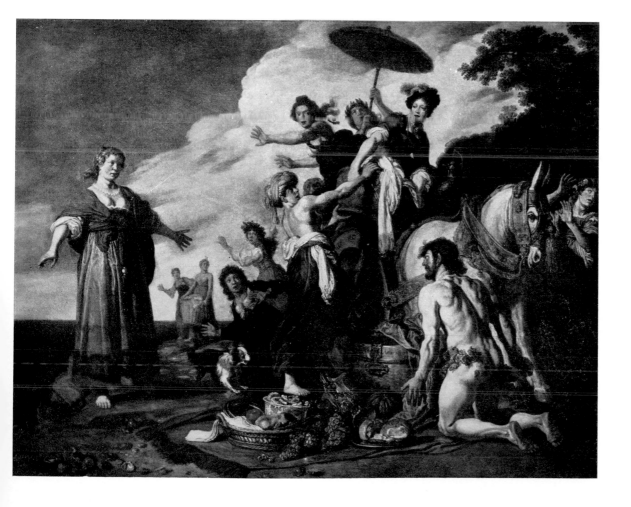

Pieter Lastman

ODYSSEUS AND NAUSICAA

With monogram; dated 1619
Wood, 92×117 cm.
Munich, Alte Pinakothek
No. 4947.

Anthonie Leemans

VANITAS STILL LIFE

Signed and dated 1655
Canvas, 78 × 72 cm.
Amsterdam, Rijksmuseum
No. 1429.

Johannes Leemans

STILL LIFE WITH
HUNTING GEAR

Signed and dated 1665
Canvas, 85 × 167 cm.
The Hague, restitution.

Pieter Leermans

The Hermit

Signed
Wood, 42×33 cm.
Dresden, Gallery
No. 1779.

Pieter Leermans

THE GREAT ELECTOR
OF BRANDENBURG

Signed and dated 1681
Copper, 35 × 28.7 cm.
Winterthur, exhibition
of the Bryner collection,
1960.

Pieter van der Leeuw

Bull being Shown

Canvas, 78.5 × 112 cm.
Wiesbaden, art trade.

Pieter van der Leeuw

Cattle Market

Signed
Wood, 42 × 62 cm.
Formerly Frankfurt,
Staedel Institute
No. 316.

Cornelis van Lelienberg

DEAD POULTRY

Signed and dated 1654
Wood, 56×45.5 cm.
Dresden, Gallery
No. 1339.

Paulus Lesire

Portrait of a Councillor

Signed and dated 1643
Wood, 71 × 58 cm.
Dordrecht, Museum.

Paulus Lesire

Portrait of a Lady

Signed and dated 1638
Wood
Nijmegen, private collection.

Jacobus Levecq

PORTRAIT OF A YOUNG MAN

Wood, 90 × 70 cm.
Polesden Lacey, National Trust.

Jacobus Levecq

PORTRAIT OF A LADY

Signed and dated 1665
Canvas, 91 × 73 cm.
Paris, J. Porgès collection
before 1925.

Jacobus Levecq

PORTRAIT OF MATTH. ELIASZ
VAN DEN BROUCKE

Signed and dated 1665
Canvas, 89.5 × 72 cm.
Munich, art trade, 1942.

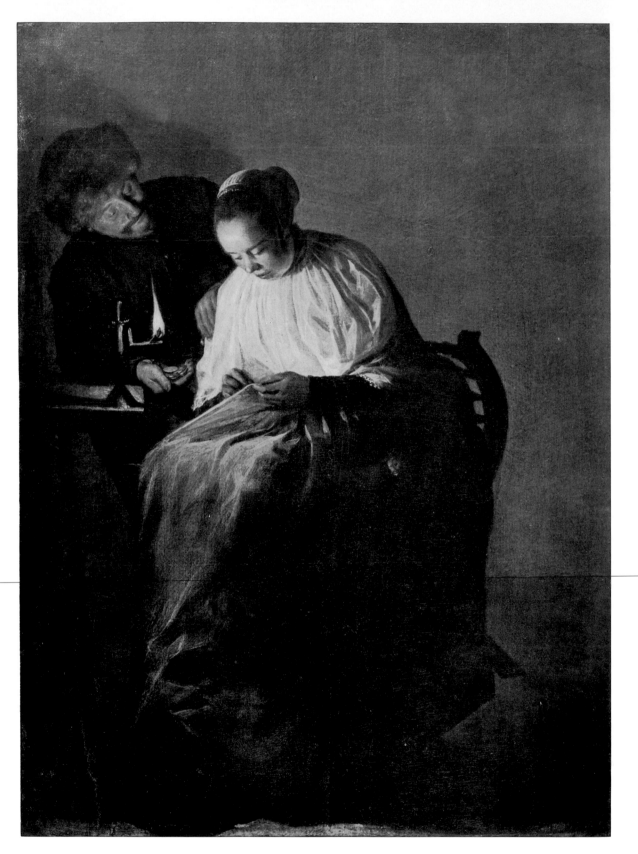

Judith Leyster

The Rejected Offer

With monogram; dated 1631
Wood, 30.9 × 24.2 cm.
The Hague, Mauritshuis
No. 564.

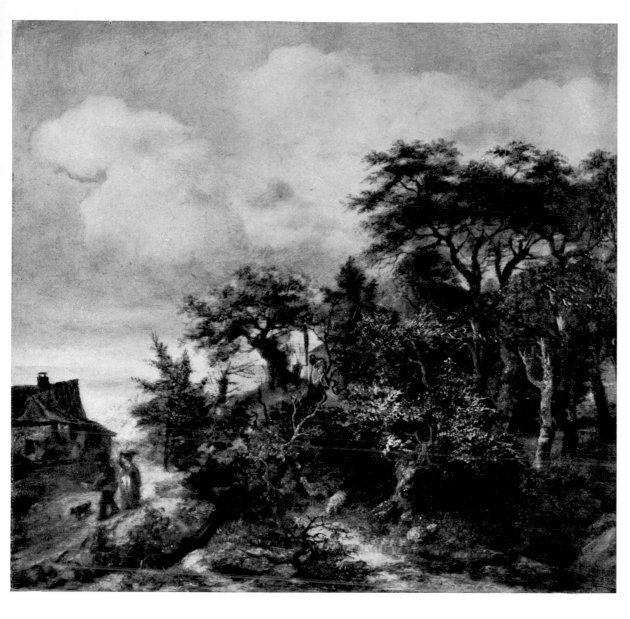

Jan Lievens

COTTAGE BY THE SEA

Wood, 38×41 cm.
Leipzig, Museum of Fine Arts
No. 994.

Jan Lievens

HAGAR AND ISHMAEL

Signed and dated 1669
Canvas, 84×163.5 cm.
Arnhem, private collection.

Hendrik van Limborch

THE JUDGMENT OF PARIS

Signed
Wood, 61×83 cm.
Budapest,
Museum of Fine Arts
No. 253 (478).

Herman van Lin

CAVALRY ENGAGEMENT

Signed and dated 1664
Canvas, 162×180 cm.
Vienna,
Kunsthistorisches Museum
No. 1223.

Herman van Lin

RIDERS RESTING

Signed and dated 1668
Wood, 30 × 36.5 cm.
Zurich, art trade, 1959.

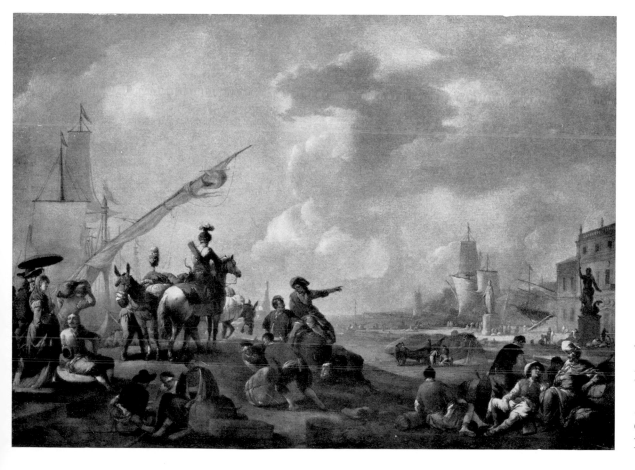

Johannes Lingelbach

MEDITERRANEAN PORT

Signed
Canvas, 63.5 × 88 cm.
Frankfurt, Staedel Institute.

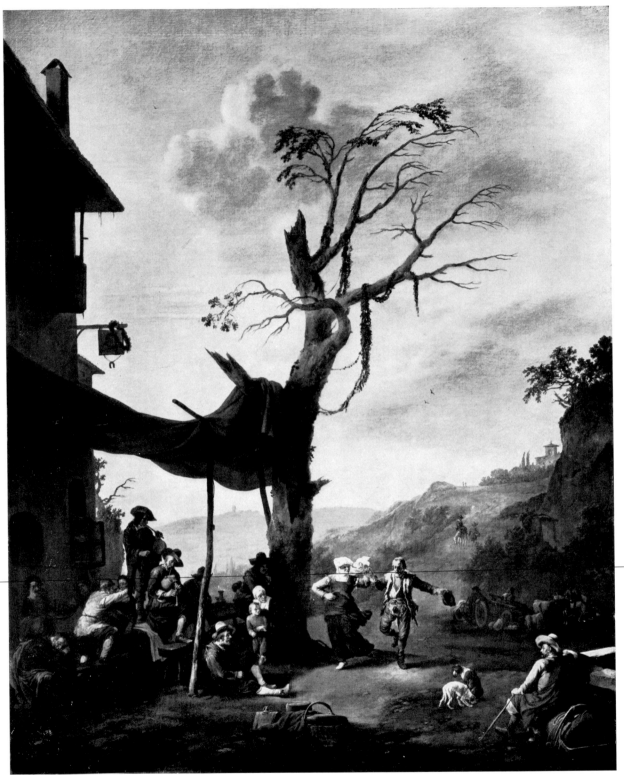

Johannes Lingelbach

DANCE OUTSIDE AN INN

London,
Lord Northbrook.

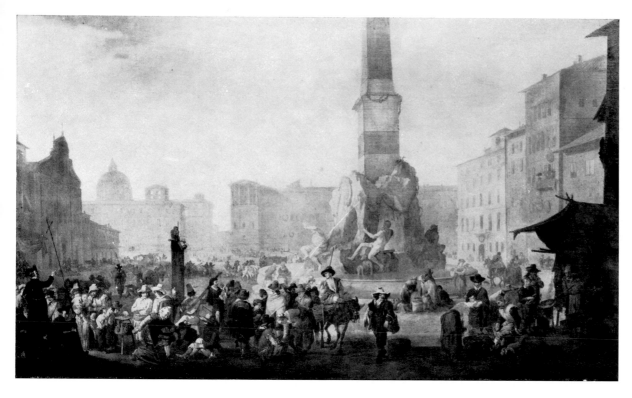

691

Johannes Lingelbach

ROMAN MARKET

Canvas, 86×140 cm.
Frankfurt, Staedel Institute.

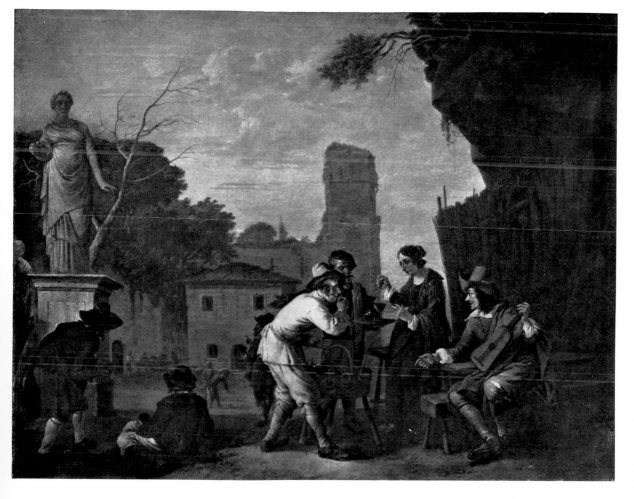

692

Johannes Lingelbach

HUNTSMEN AT AN OSTERIA

Signed
Wood, 37×47 cm.
Formerly The Hague,
Steengracht Gallery
No. 20.

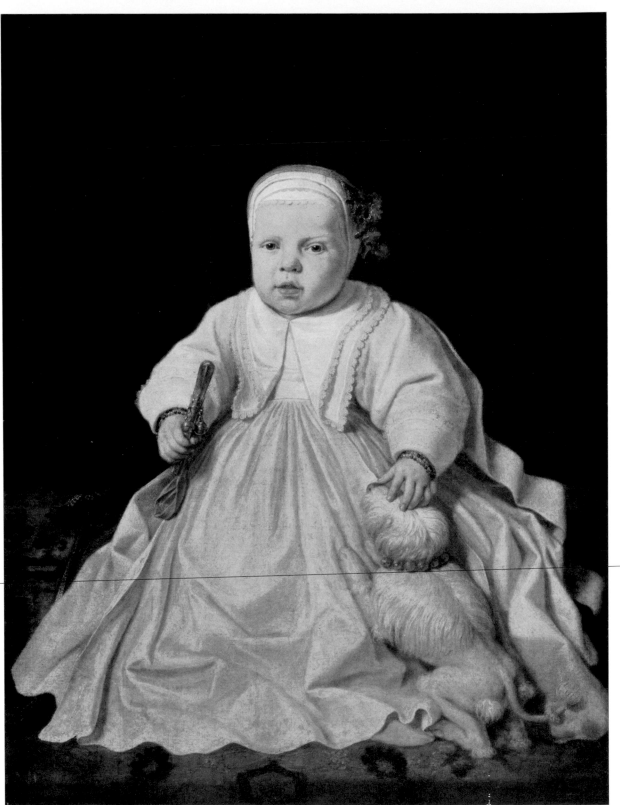

Peter van Lint

<small>PORTRAIT OF A SMALL GIRL</small>

Signed and dated 1645
Canvas, 87×66 cm.
Antwerp,
Musée des Beaux-Arts
No. 884.

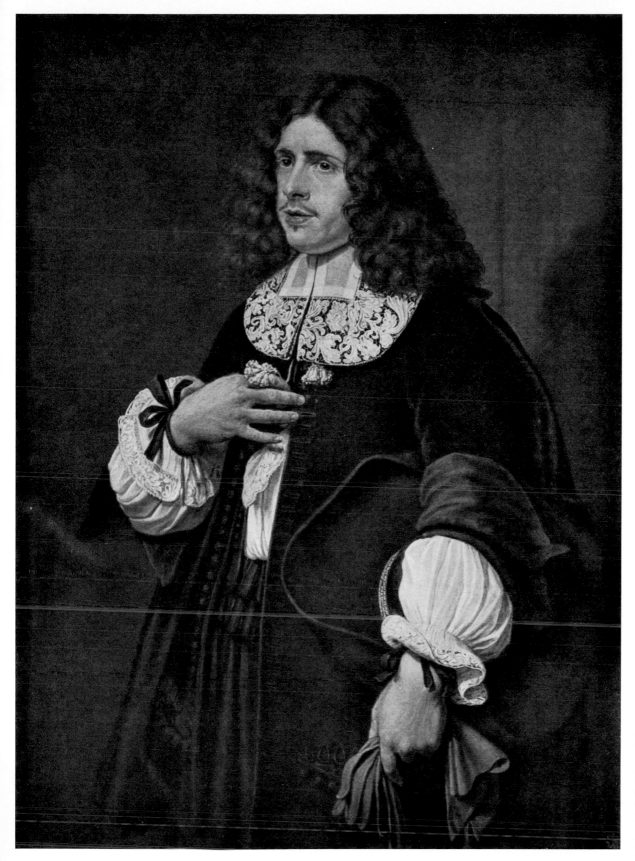

Peter van Lint

PORTRAIT OF A GENTLEMAN

Signed
Canvas, 109×78 cm.
Budapest,
Museum of Fine Arts
No. 717 (448).

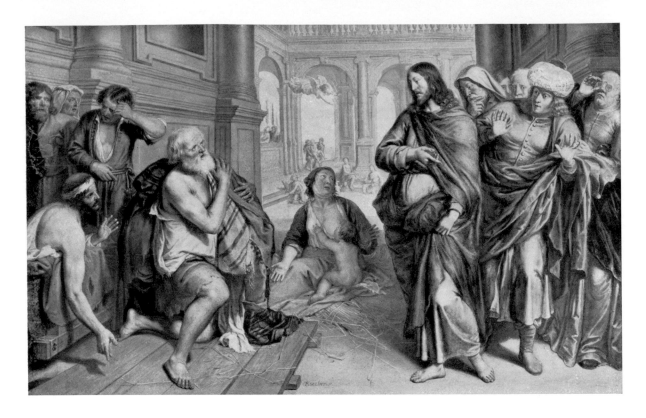

Peter van Lint

CHRIST HEALING THE SICK

Signed
Wood, 50×81 cm.
Vienna,
Kunsthistorisches Museum
No. 1068.

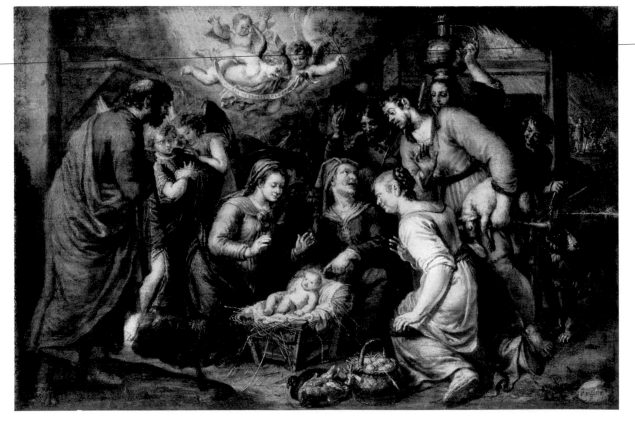

Peter van Lint

THE ADORATION OF
THE SHEPHERDS

Signed
Wood, 31×48 cm.
Berlin, Staatliche Museen
No. 1856.

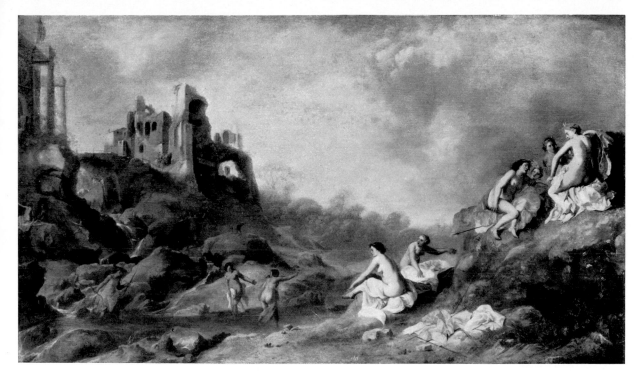

Dirck van der Lisse

Diana Bathing

With monogram
Wood, 49 × 83 cm.
Berlin, Staatliche Museen
No. II 463.

Dirck van der Lisse

Italian Mountain
Landscape with Ruins

With monogram
Canvas, 152 × 227 cm.
Brunswick,
Herzog-Anton-Ulrich Museum
No. 195.

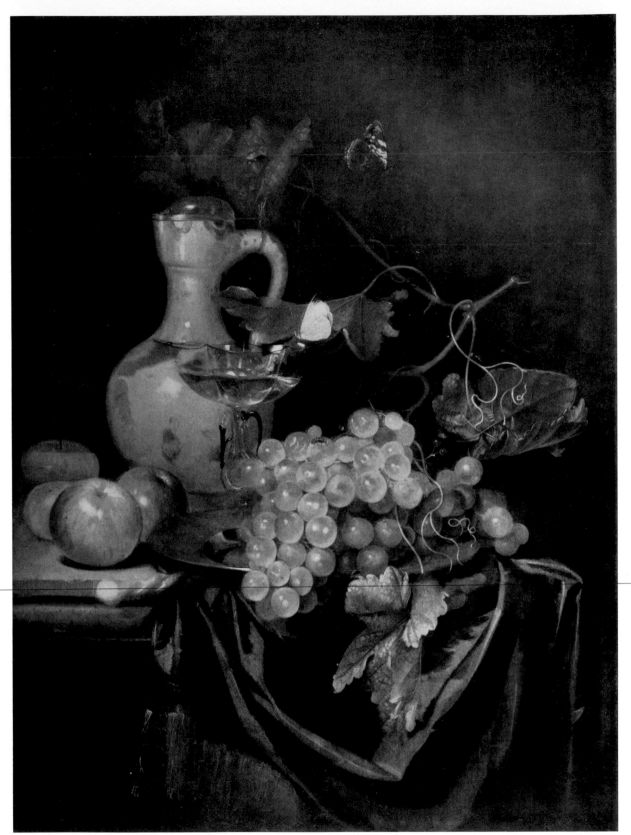

Harmen Loeding

STILL LIFE

Signed
Wood, 49×36 cm.
Paris,
Adolphe Schloss collection
No. 121.

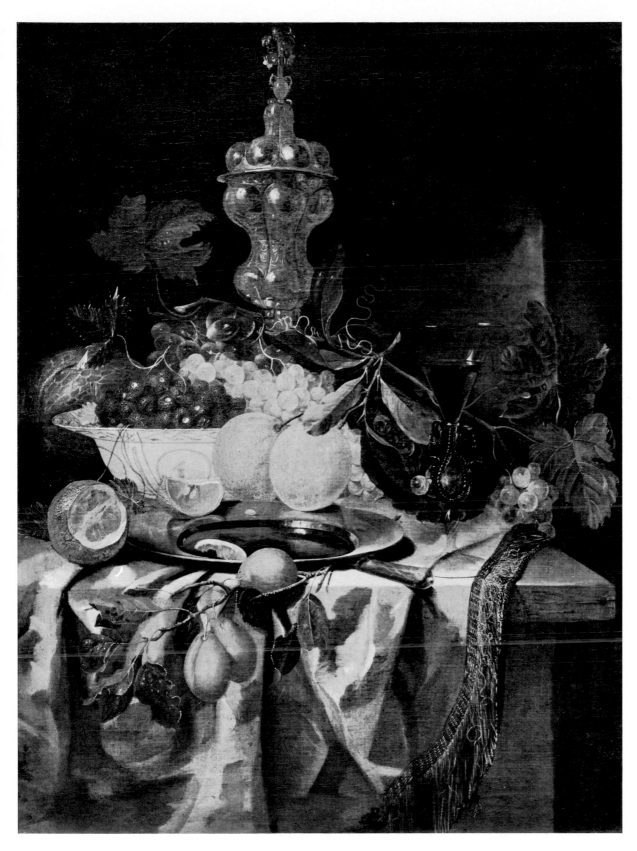

Harmen Loeding

STILL LIFE

Canvas, 78 × 59 cm.
form. Cassel, Gallery
No. 448.

Jacob van Loo

FEMALE NUDE

Canvas, 103 × 80 cm.
Paris, Louvre
No. 2452.

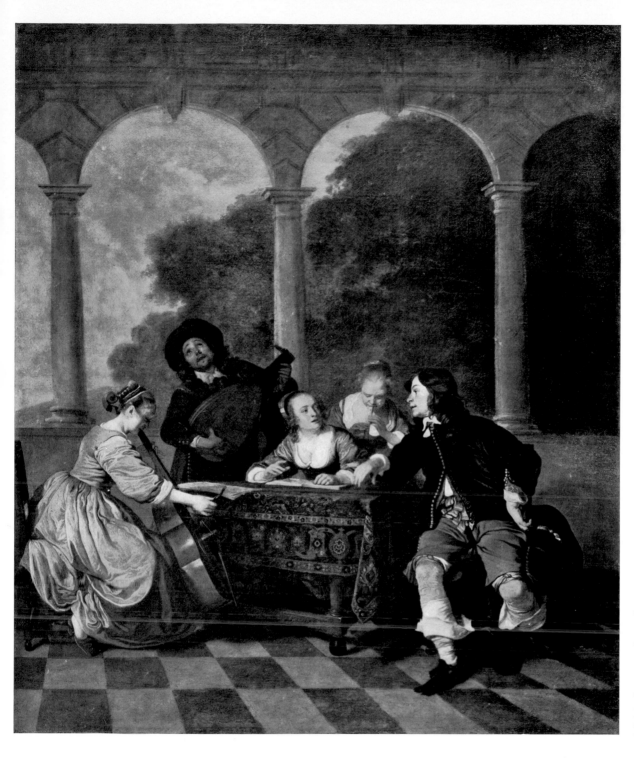

Jacob van Loo

CONCERT

Signed
Canvas, 76×65 cm.
Leningrad, Hermitage
No. 1092.

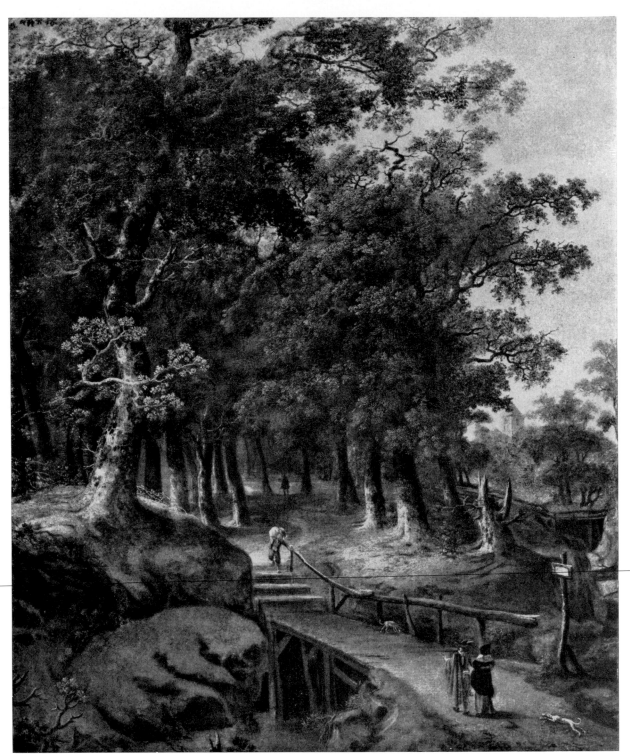

Jan Looten

Path through an Oak-Wood

Signed 1650
Canvas, 126×103 cm.
Munich, H. Helbing sale
17 October 1907
No. 21.

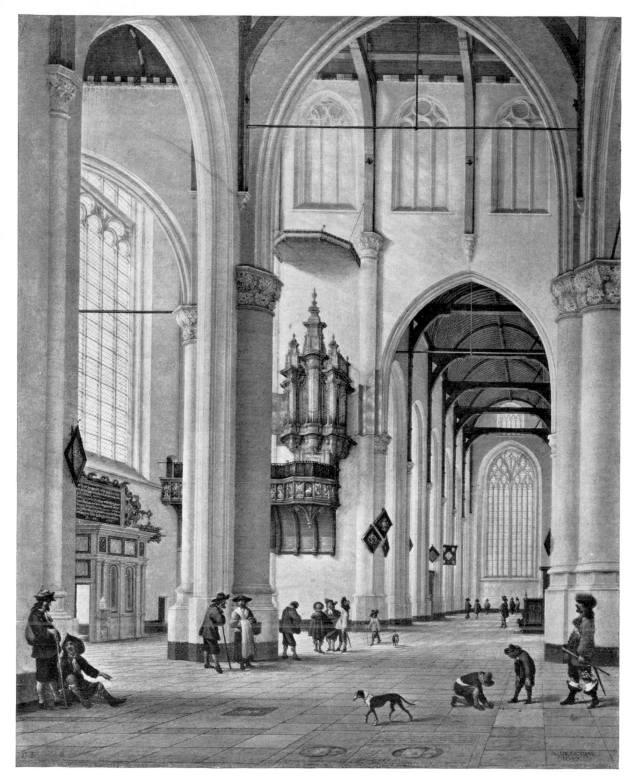

Anthonic de Lorme

THE GREAT CHURCH OF
ST LAURENCE AT ROTTERDAM

Signed and dated 1657
Canvas, 74×59,5 cm.
Amsterdam,
Six sale
16 October 1928
No. 20.

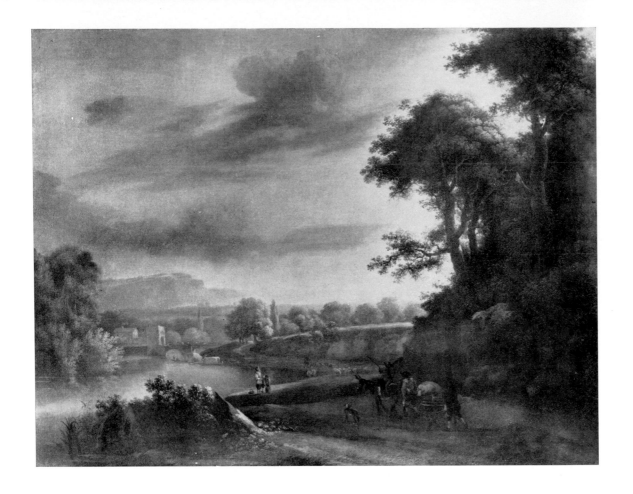

Lodewijck van Ludick

ITALIAN LANDSCAPE

Signed
Canvas, 82×103 cm.
Munich, Alte Pinakothek
No. 591.

Gerrit Lundens

COUPLE AT AN INN

Signed
Wood, 32×43 cm.
Hanover, Landesgalerie

Antoni dc Lust

FLOWER-PIECE

Signed
Canvas, 52.1 × 41.5 cm.
Brunswick,
Herzog-Anton-Ulrich Museum
No. 438.

Isaac Luttichuys

PORTRAIT OF A GENTLEMAN

Signed and dated 1651
Wood, 115 × 85 cm.
Munich, art trade.

Isaac Luttichuys

Portrait of a Lady

Signed and dated 1656
Canvas, 99 × 82 cm.
Muller sale, Amsterdam
December 1930.

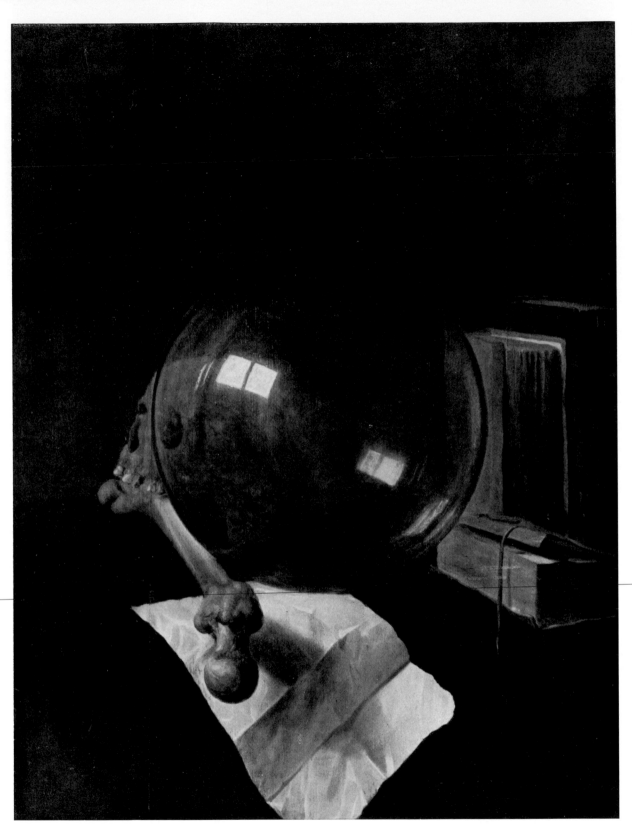

Simon Luttichuys

VANITAS STILL LIFE

Signed and dated 1645
Wood, 71 × 55 cm.
Berlin, private collection.

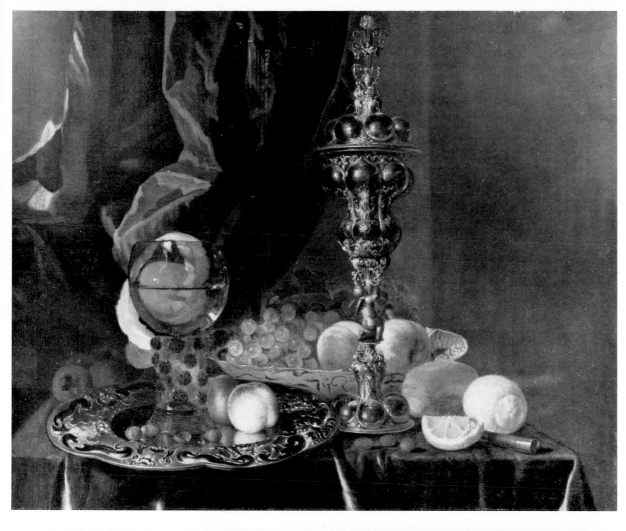

Simon Luttichuys

STILL LIFE

Canvas, 62×75 cm.
Recklinghausen,
private collection.

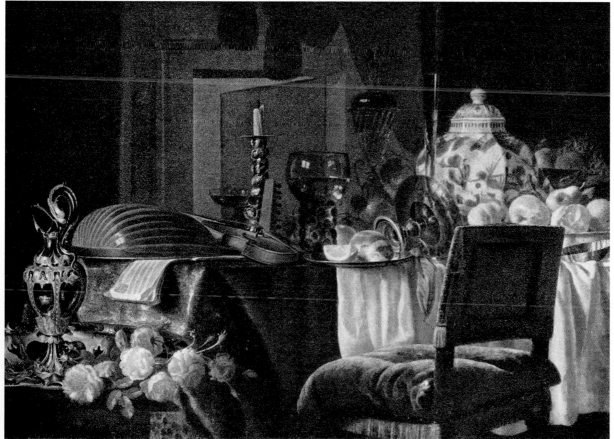

Simon Luttichuys

STILL LIFE

Signed and dated 1657
Canvas, 43×60 cm.
London,
A. De Casseres collection.

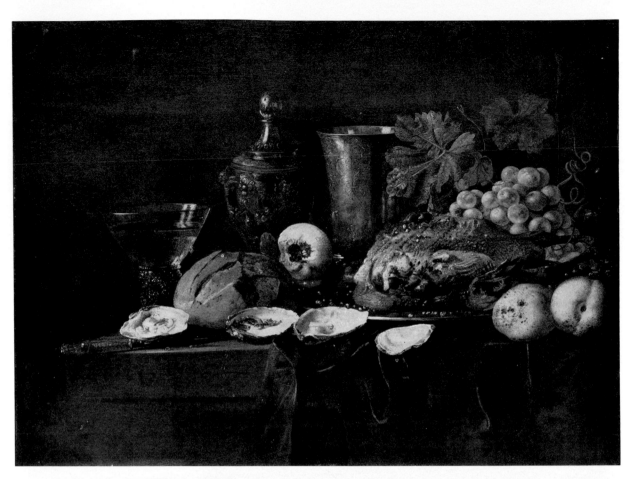

Christiaan Luycks

STILL LIFE

Signed
Wood, 48×64.5 cm.
Brunswick,
Herzog-Anton-Ulrich Museum
No. 147.

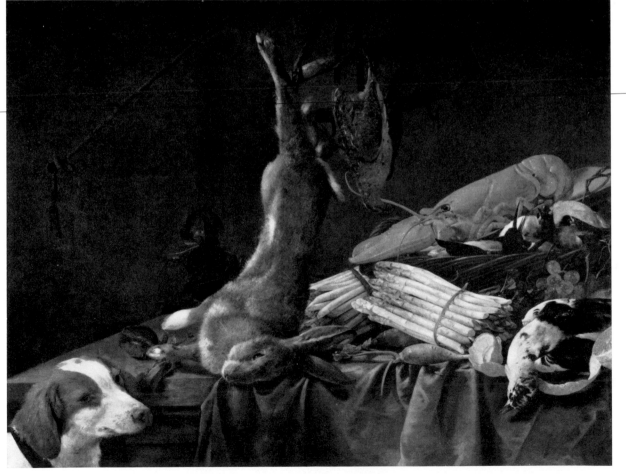

Christiaan Luycks

STILL LIFE

Signed
Canvas, 66×84 cm.
St Gilgen (Austria),
F. C. Butôt collection.

Frans Luycks

PORTRAIT OF THE ARCHDUKE
LEOPOLD WILLIAM OF AUSTRIA

Signed
Canvas, 201 × 140 cm.
Vienna,
Kunsthistorisches Museum
No. 1890.

Dirck Maas

VILLAGE HORSE MARKET

Canvas, 75 × 114 cm.
Formerly Vienna,
Liechtenstein Gallery
No. 392.

Nicolaes Maes

LANDSCAPE WITH MERCURY
AND ARGUS

Canvas, 75 × 85 cm.
Munich, art trade.

Nicolaes Maes

OLD WOMAN SAYING GRACE

Signed
Canvas, 134×113 cm.
Amsterdam, Rijksmuseum
No. 1501.

Nicolaes Maes

St. John the Evangelist

Canvas, 93×76 cm.
Munich, art trade.

Nicolaes Maes

WILLIAM SIX AS A BOY,
WITH BOW AND DOG

Signed and dated 1670
Canvas, oval, 42.5 × 30 cm.
Amsterdam, Six collection
No. 38.

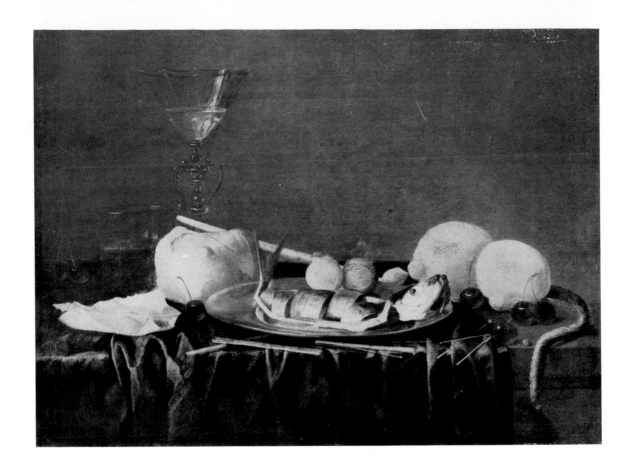

Cornelis Mahu

BREAKFAST STILL LIFE

Wood, 40.5 × 54 cm.
Berlin, Staatliche Museen
No. 944A.

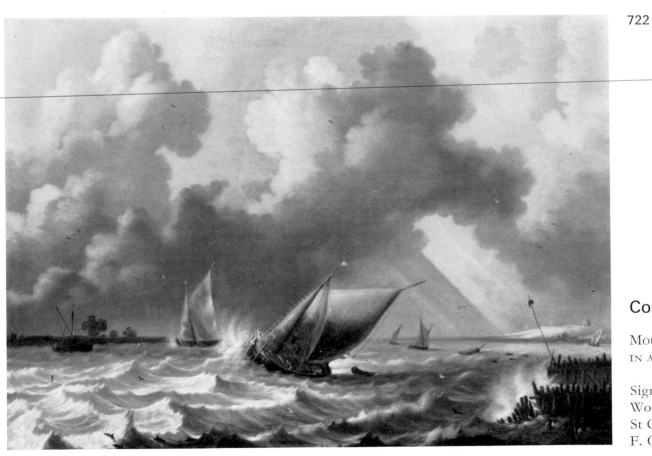

Cornelis Mahu

MOUTH OF THE SCHELDT
IN A STORM

Signed
Wood, 41.4 × 57 cm.
St Gilgen (Austria),
F. C. Butôt collection.

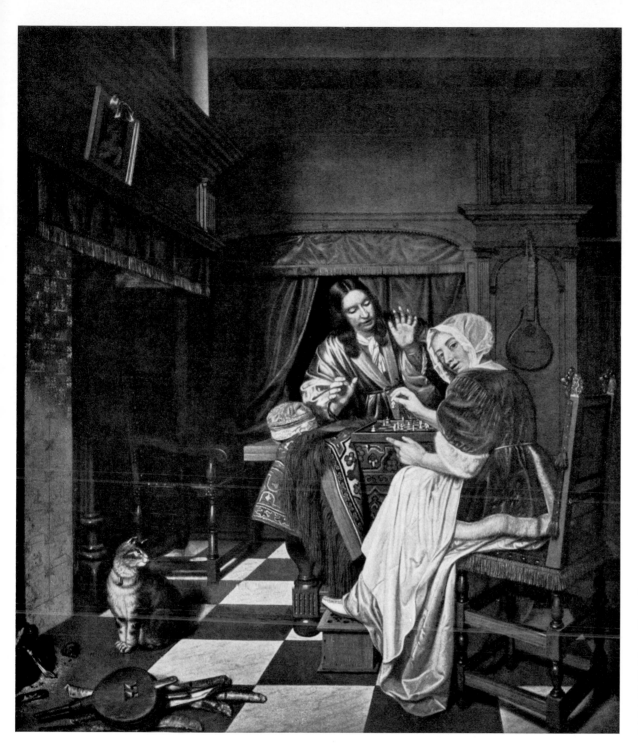

Cornelis de Man

CHESS-PLAYERS

Signed
Canvas, 98 × 85 cm.
Budapest,
Museum of Fine Arts
No. 320 (464).

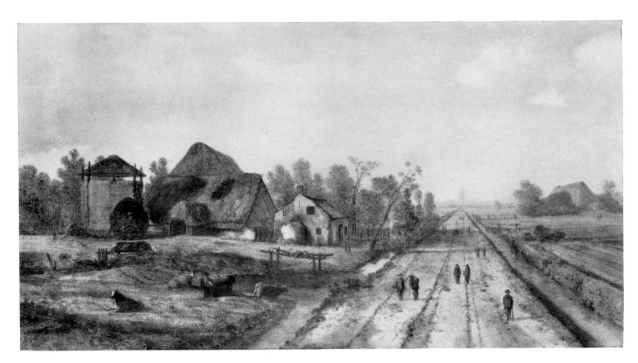

Jacobus Mancadan

FLAT LANDSCAPE

Wood, 40×71 cm.
The Hague,
private collection.

Jacobus Mancadan

MOUNTAIN LANDSCAPE
WITH CATTLE AND SHEEP

With monogram
Canvas, 104×151 cm.
Berlin,
Union sale, 10 June 1942
No. 82.

Jacobus Mancadan

MOUNTAIN LANDSCAPE

Signed
Wood, 45 × 37.5 cm.
Bonn, Landesmuseum
No. 528.

Karel van Mander

JESUS IN THE TEMPLE

With monogram; dated 1598
Wood, 95 × 66 cm.
Vienna,
Kunsthistorisches Museum
No. 797.

Karel van Mander

THE DANCE AROUND
THE GOLDEN CALF

With monogram, dated 1602
Canvas, 101 × 217 cm.
Haarlem, Frans Hals Museum.

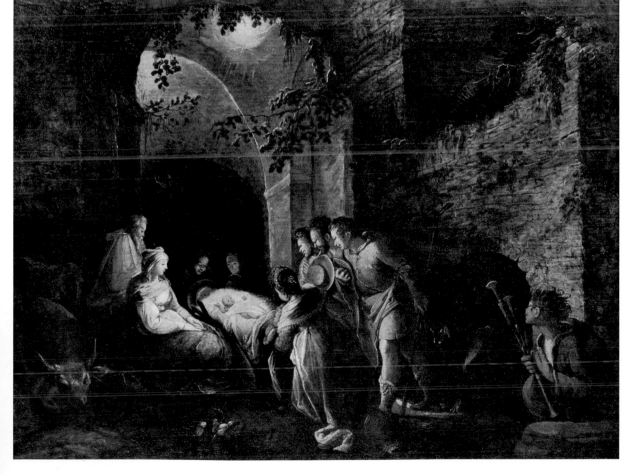

Karel van Mander

THE NATIVITY

With monogram; dated 1598
Wood, 36 × 46.5 cm.
Haarlem,
Frans Hals Museum,
permanent loan.

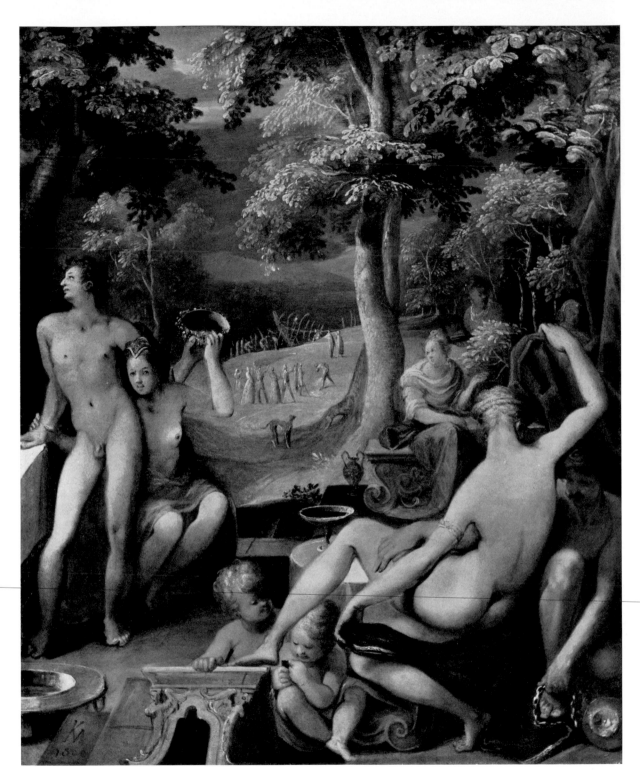

Karel van Mander

Noah's Ark

With monogram; dated 1600
Copper, 35 × 25 cm.
Cologne, art trade, 1938.

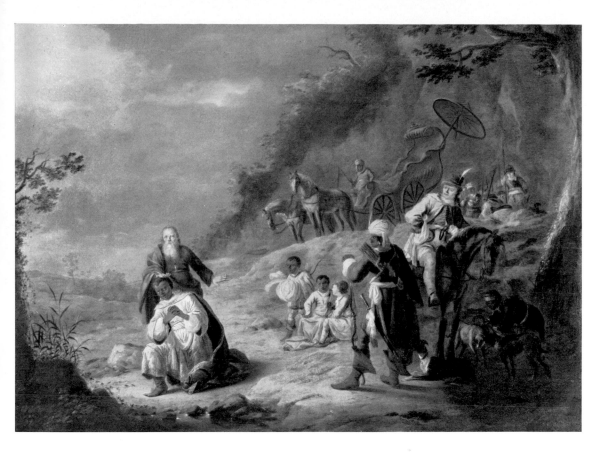

Jan Marienhof

The Baptism of the Eunuch

Signed
Wood, 69.5 × 94 cm.
Karlsruhe,
Staatliche Kunsthalle
No. 1813.

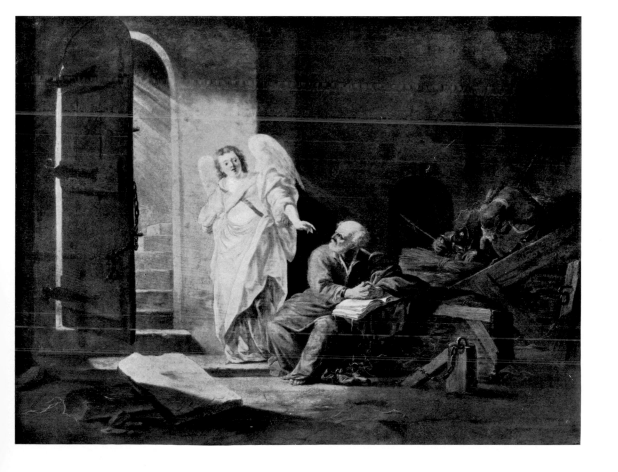

Jan Marienhof

The Liberation of St. Peter

Signed and dated 1649
Wood, 47 × 58.5 cm.
Cassel, Gallery
No. 265.

Jan Marienhof

THE BROKEN JUG

Signed and dated 1649
Wood, 48×60 cm.
Cologne, Lempertz sale,
26 November 1958.

Jan Marienhof

THE ARCHITECT BEFORE
THE RULER

Signed and dated 1649
Wood, 48×64 cm.
Dresden, Gallery
No. 1314.

Philippe de Marlier

GARLAND OF FLOWERS AND
FRUIT WITH ST. ROSALIE

Signed and dated 1640
Wood, 72 × 52 cm.
Antwerp,
Musée des Beaux-Arts
No. 5058.

Evert Marseus van Schrieck

LANDSCAPE WITH RUINS

Signed
Wood, 51.5×67 cm.
Vienna, art trade.

Otto Marseus van Schrieck

SNAKES AND MUSHROOMS

Signed and dated 1662
Canvas, 50.7×68.5 cm.
Brunswick,
Herzog-Anton-Ulrich Museum
No. 431.

Otto Marseus van Schrieck

STILL LIFE OF THISTLES WITH ANIMALS

Canvas, 132 × 90 cm.
Landshut, Gallery.

Jan Martsen de Jonge

GUSTAF ADOLF IN THE
BATTLE OF LÜTZEN

Signed and dated 1636
Wood, 54.2×98 cm.
Brunswick,
Herzog-Anton-Ulrich Museum
No. 417.

Jan Martsen de Jonge

BATTLEFIELD

Signed and dated 1632
Wood, 33.6×54.7 cm.
Paris, art trade.

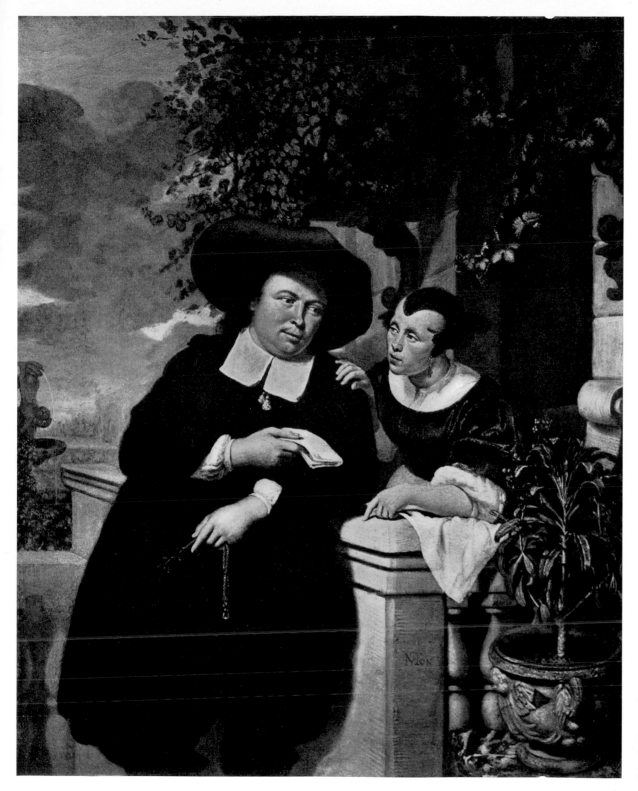

Bartholomäus Maton

THE BAILIFF

Signed
Wood, 39.2 × 31.6 cm.
London, art trade, 1950.

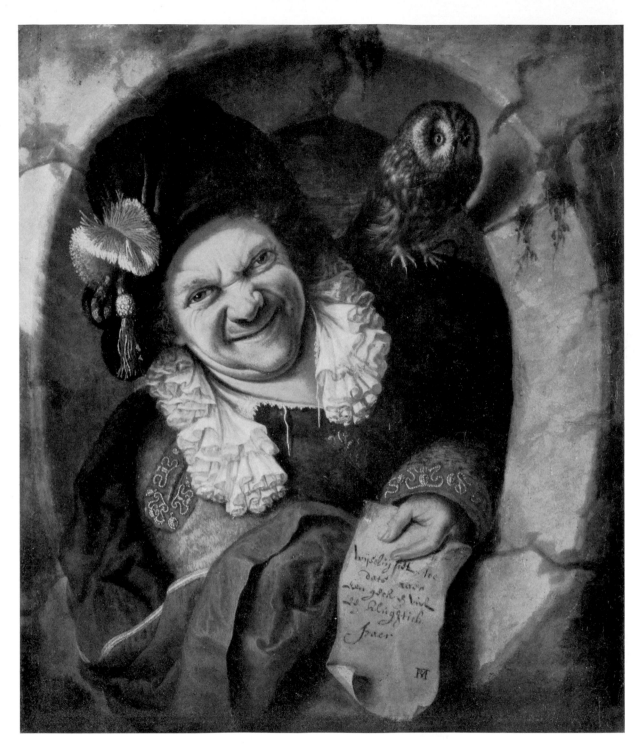

Bartholomäus Maton

Allegory

With monogram
Copper, 35 × 26 cm.
Stuttgart, private collection.

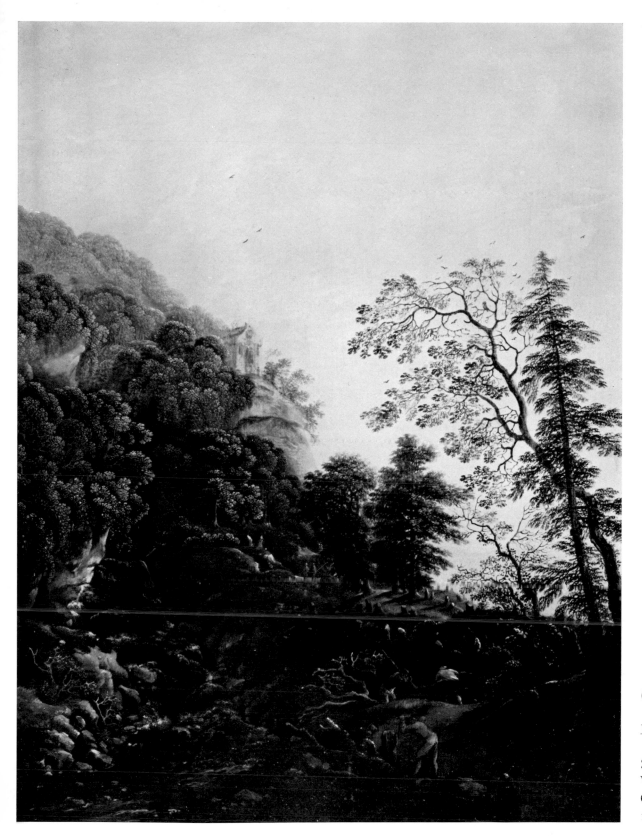

Cornelis Matthieu

LANDSCAPE WITH TREES

Signed
Wood, 45 × 35 cm.
Constance, art trade
1961.

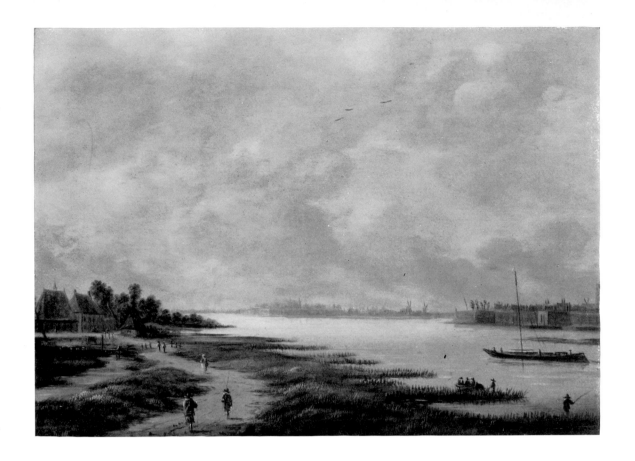

Jan Meerhoud

River Landscape

Signed and dated 1663
Wood, 29 × 40 cm.
Dessau, Amalienstift
No. 111.

Jan Meerhoud

View of Gorkum

Wood, 27 × 38 cm.
Munich, private collection.

Jacob van der Merck

PORTRAIT OF CL. H. DE MUNT

Signed
Canvas, 201 × 111 cm.
Leiden, Lakenhal
No. 298.

Jacob van der Merck

MUSIC PARTY

Signed
Wood, 61×79.5 cm.
Amsterdam,
private collection.

Jacob van der Merck

GROUP POSING AS
VENUS AND ADONIS

Signed and dated 1647
Canvas, about 180×200 cm.
Basle, private collection.

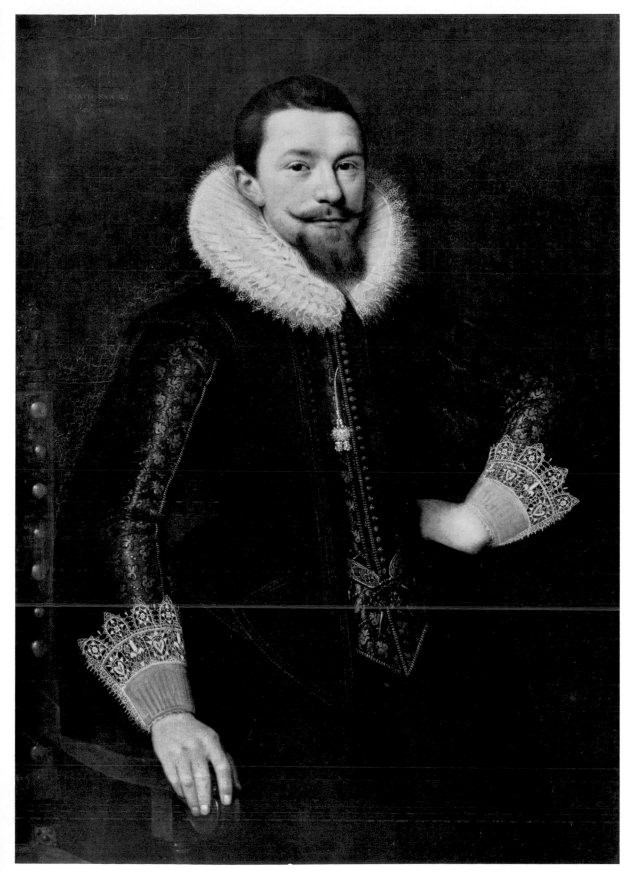

Salomon Mesdach

PIETER BOUDAEN COURTEN

Dated 1619
Wood, 105 × 74 cm.
Amsterdam, Rijksmuseum
No. 1545.

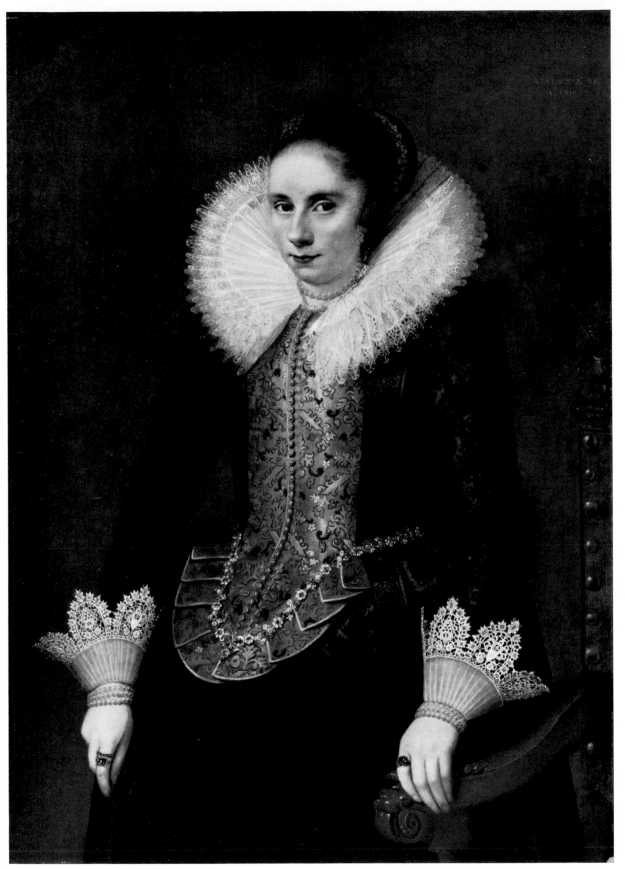

Salomon Mesdach

MARGARETHA COURTEN

Dated 1625
Wood, 102,5 × 74 cm.
Amsterdam, Rijksmuseum
No. 1544.

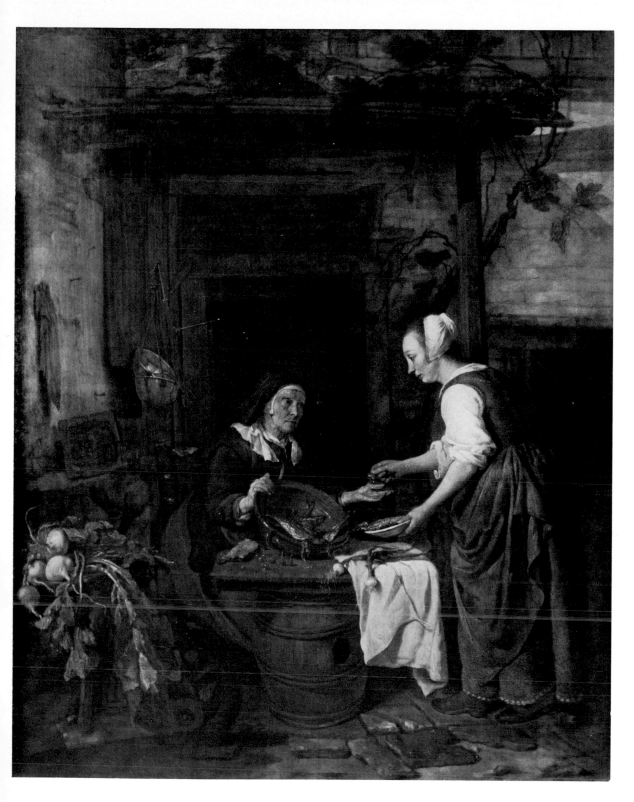

Gabriel Metsu

AN OLD WOMAN SELLING FISH

Signed
Wood, 49×39 cm.
London, Wallace Collection
No. 234.

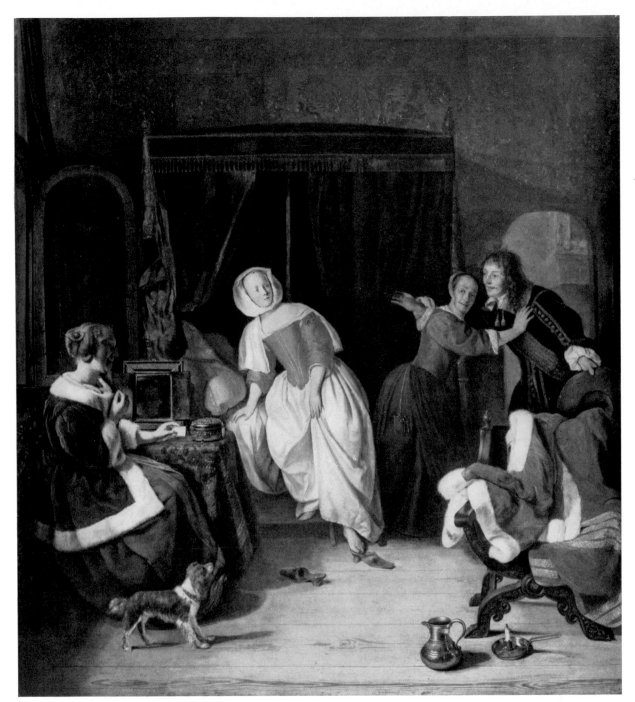

Gabriel Metsu

A Gallant
Surprising Young Ladies
at Their Toilet

Signed
Wood, 65 × 58 cm.
London, Lord Northbrook.

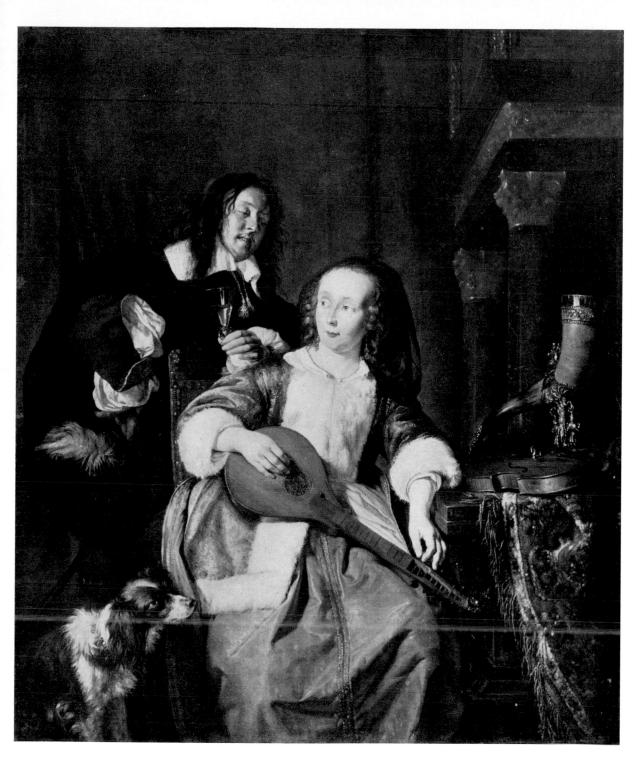

Gabriel Metsu

WOMAN PLAYING THE LUTE

Wood, 36×30 cm.
Cassel, Gallery
No. 301.

**Adam Frans
van der Meulen**

LOUIS XIV SETTING OUT
FOR VINCENNES

Canvas, 60×85 cm.
Dresden, Gallery
No. 1114.

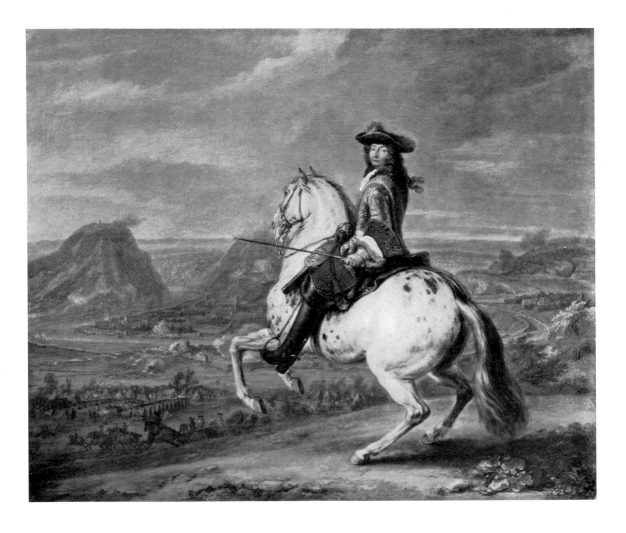

**Adam Frans
van der Meulen**

LOUIS XIV BESIEGING
A TOWN

Canvas, 55×67 cm.
Leningrad, Hermitage
No. 675.

Pieter Meulener

SKIRMISH NEAR ANTWERP

Signed and dated 1646
Canvas, 122 × 167 cm.
Brunswick,
Herzog-Anton-Ulrich Museum
No. 132.

Hendrik de Meyer

LARGE BEACH LANDSCAPE

Signed
Wood, 92 × 155 cm.
Munich,
Stroefer sale, J. Böhler
28 October 1937
No. 66.

Hendrik de Meyer

WINTER LANDSCAPE
WITH GAMES ON THE ICE

Canvas.
Dessau, Gallery.

Aelbert Meyeringh

IMAGINARY LANDSCAPE
WITH A YOUTH
BY THE WATER-SIDE

Signed and dated 1686
Canvas, 83 × 104 cm.
Brunswick,
Herzog-Anton-Ulrich Museum
No. 397.

Theobald Michau

RIVER-BANK

Signed
Copper, 36×49.5 cm.
Budapest,
Museum of Fine Arts
No. 569 (632).

Theobald Michau

LANDSCAPE WITH MARKET

Signed
Wood, 27×38 cm.
Brunswick,
Herzog-Anton-Ulrich Museum
No. 155.

Jan Miel

MAN PLAYING THE BAGPIPES

Copper, 14.5 × 24.5 cm.
Dresden, Gallery
No. 1842.

Jan Miel

COBBLER'S STALL

Signed
Canvas.
London,
Buckingham Palace
No. 114.

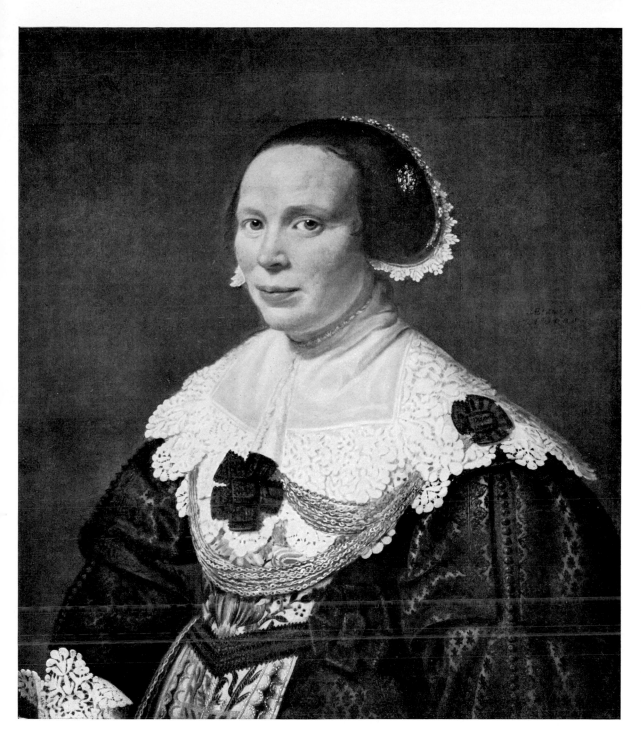

Michiel van Mierevelt

PORTRAIT OF A LADY

Signed and dated 1635
Wood.
Amsterdam, Six collection
No. 50.

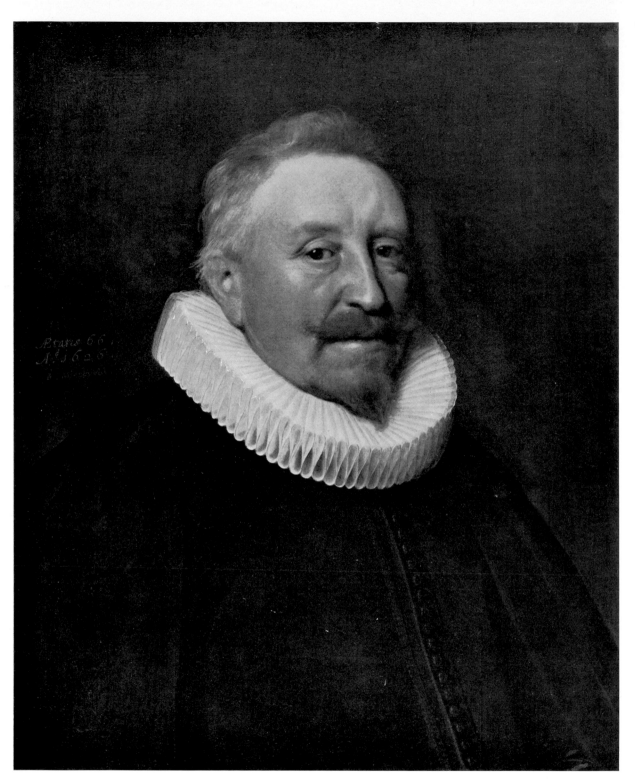

Michiel van Mierevelt

SELF-PORTRAIT (?)

Signed and dated 1626
Wood, 64×53 cm.
Karlsruhe,
Staatliche Kunsthalle
No. 230.

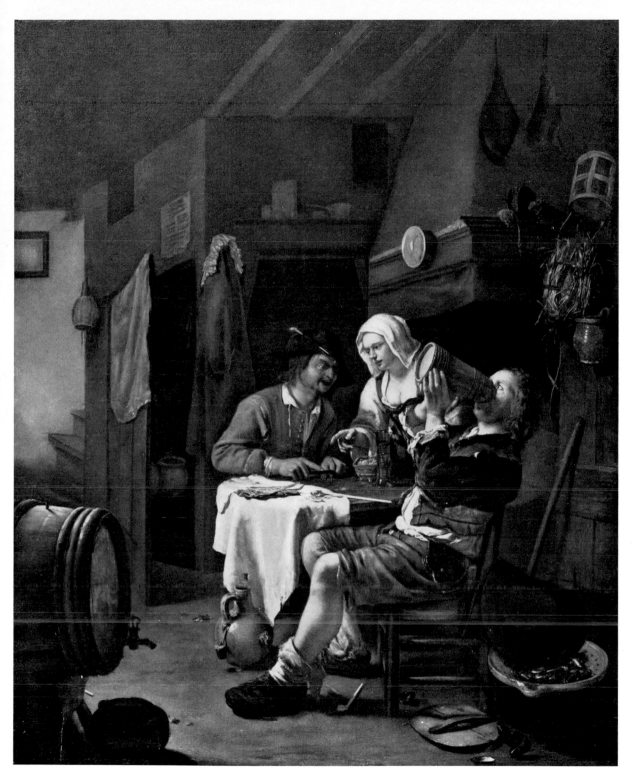

Frans van Mieris
the Elder

INTERIOR
OF A PEASANT COTTAGE

Signed
Wood, 38×30 cm.
Leiden, Lakenhal.

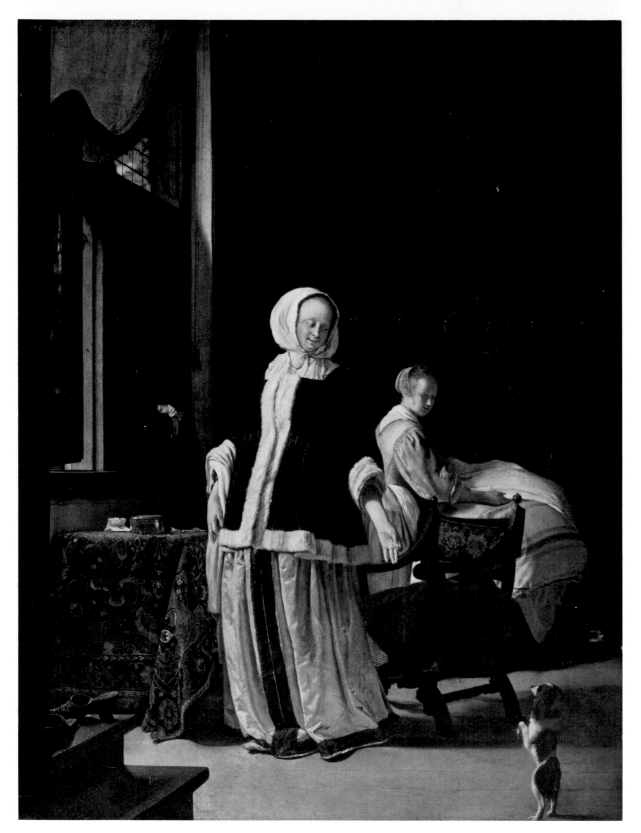

Frans van Mieris
the Elder

THE PUPPY

Wood, 51 × 40 cm.
Leningrad, Hermitage
No. 915.

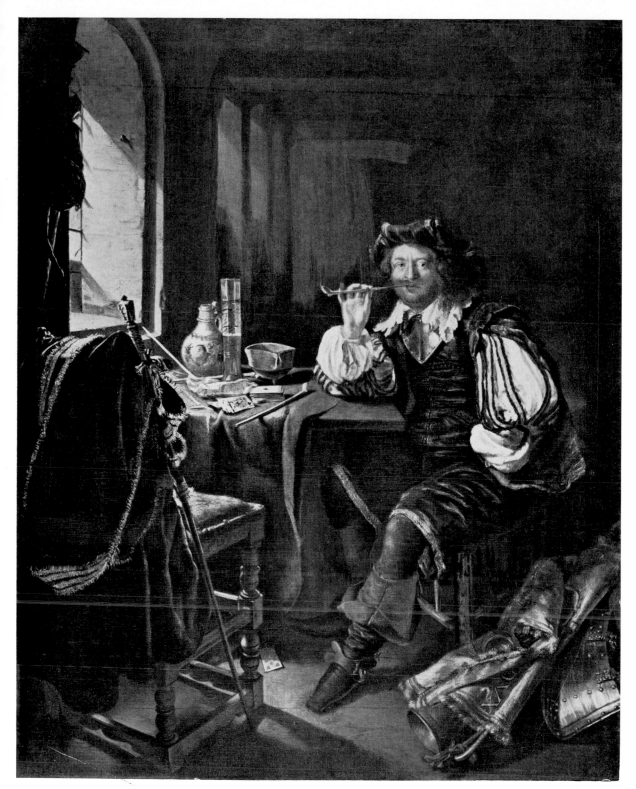

Frans van Mieris
the Elder

SOLDIER SMOKING

Signed
Wood, 32 × 25.5 cm.
Dresden, Gallery
No. 1747.

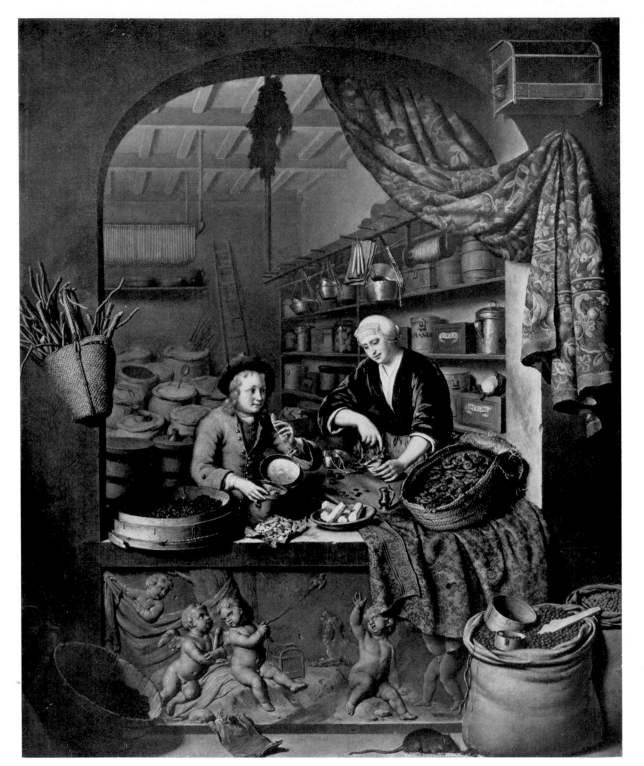

Willem van Mieris

The Grocer's Shop

Signed and dated 1717
Wood, 49.5 × 41 cm.
The Hague, Mauritshuis
No. 109.

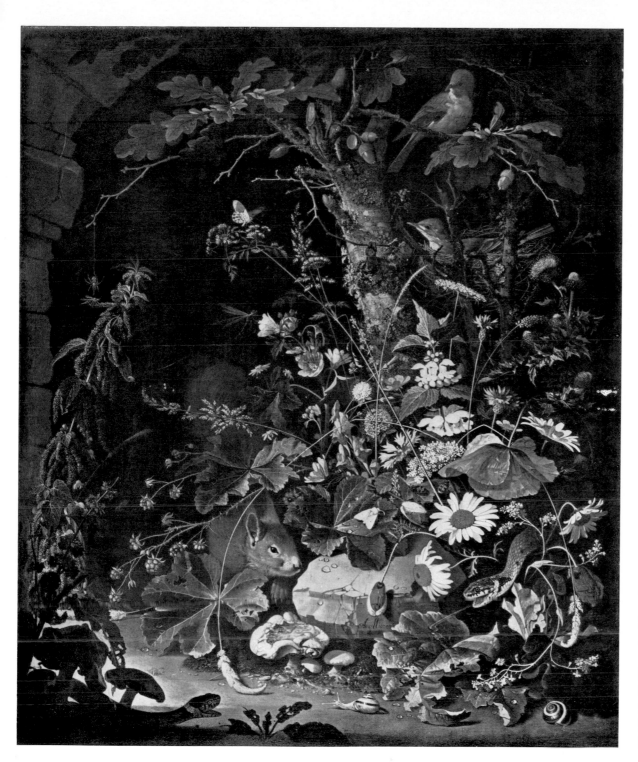

Abraham Mignon

FLOWERS, ANIMALS
AND INSECTS

Signed
Canvas, 60×50 cm.
Brussels,
Musée des Beaux-Arts
No. 306.

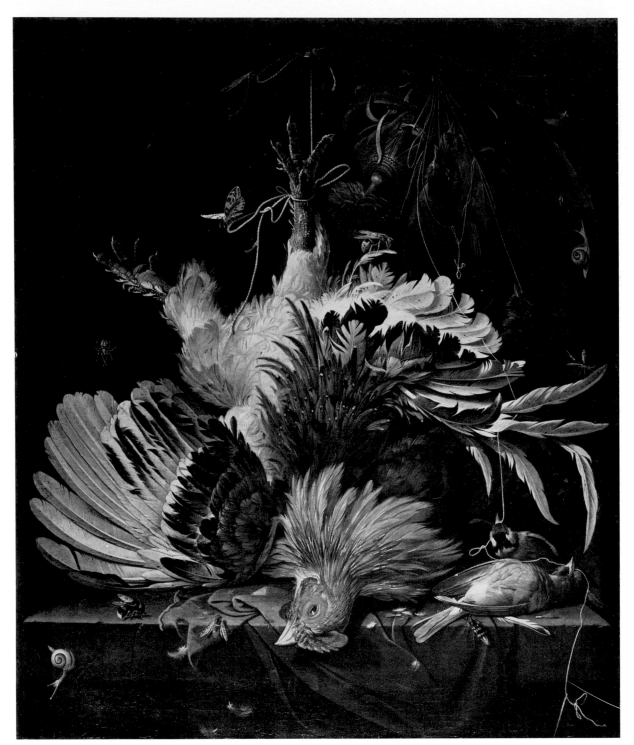

Abraham Mignon

DEAD ROOSTER AND
OTHER BIRDS

Signed
Canvas, 60× 50 cm.
Frankfurt, Staedel Institute
No. 722.

Jan Miense Molenaer

LADY PLAYING
THE HARPSICHORD

Wood, 38.5 × 29.5 cm.
Amsterdam, Rijksmuseum
No. 1635.

Jan Miense Molenaer

YOUTH PLAYING THE LUTE

With monogram
Wood, 28×23.5 cm.
Formerly Paris,
Adolphe Schloss collection.

Jan Miense Molenaer

GAME OF HOT COCKLES

Signed
Wood, 66×82 cm.
Budapest,
Museum of Fine Arts
No. 264 (504).

Jan Miense Molenaer

THE HALF-MOON TAVERN
AT HAARLEM

Signed
Canvas, 88×102 cm.
Budapest,
Museum of Fine Arts
No. 288 (339).

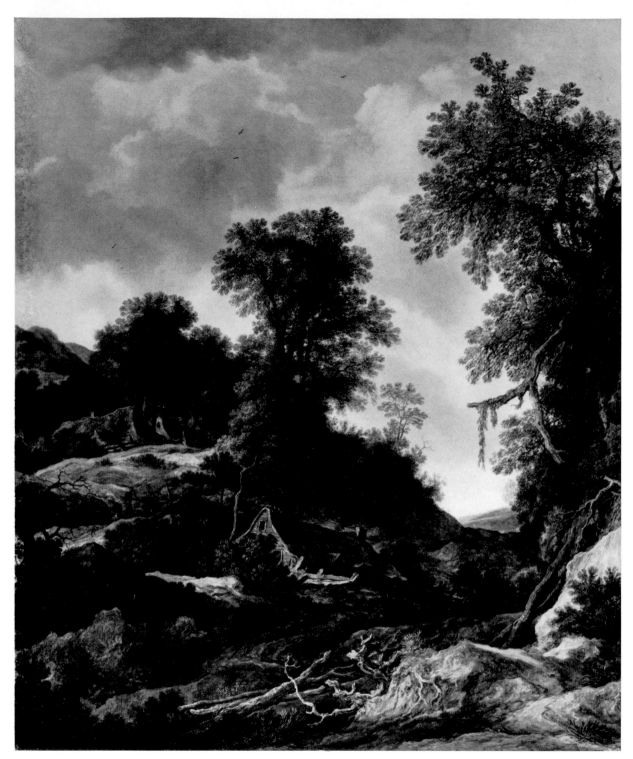

Pieter de Molijn

HILLY LANDSCAPE
WITH TALL TREES

Wood, 91 × 76 cm.
Ebersteinburg (Baden),
private collection.

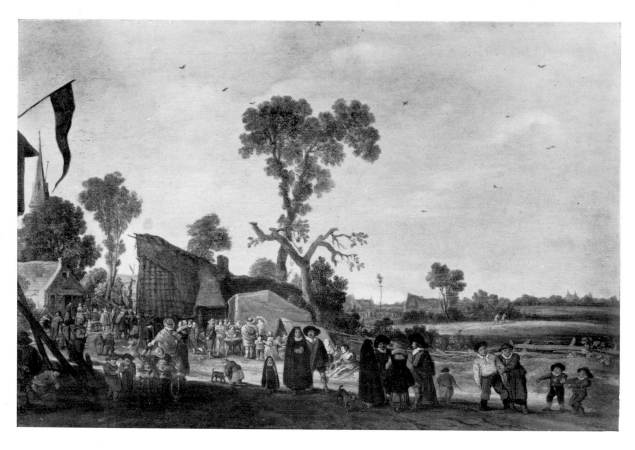

Pieter de Molijn

LANDSCAPE WITH KERMESSE

Signed and dated 1626
Wood, 28×42 cm.
Dessau, Amalienstift
No. 99.

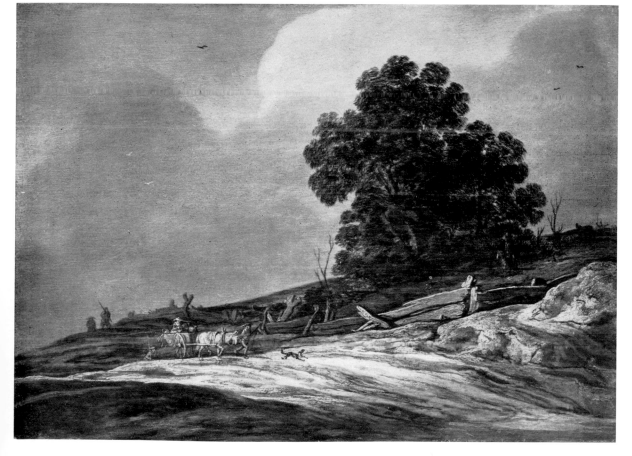

Pieter de Molijn

DUNE LANDSCAPE
WITH A CLUMP OF TREES

Signed and dated 1626
Wood, 26×36 cm.
Brunswick,
Herzog-Anton-Ulrich Museum
No. 338.

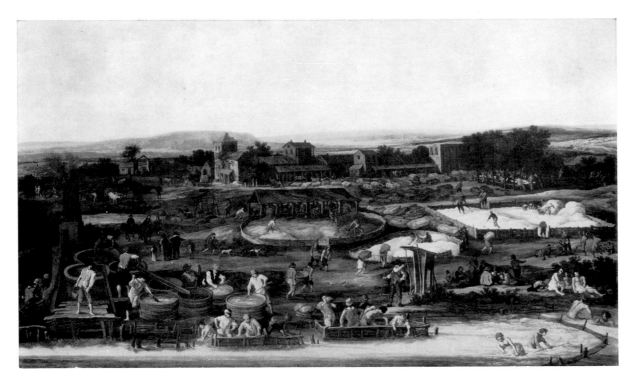

Pieter de Molijn

Wool-Washing

Signed
Canvas, 112×193 cm.
Berlin, H. W. Lange sale,
12 March 1941
No. 65.

Pieter de Molijn

Landscape

Signed and dated 1647
Canvas, 74.5×93 cm.
London, art trade.

Hendrick Mommers

MARKET IN AN ITALIAN TOWN

Signed
Canvas, 59×49 cm.
Brussels,
Musée des Beaux-Arts
No. 315.

Hendrick Mommers

PASTORAL LANDSCAPE

Signed
Wood, 61 × 80 cm.
Munich, Alte Pinakothek
No. 2203.

Frans de Momper

VILLAGE STREET IN WINTER

Wood, 42 × 64 cm.
Berlin, art trade.

Frans de Momper

RIVER LANDSCAPE

Wood, 45 × 91 cm.
Bremen,
C. Schünemann collection.

Joost de Momper

MOUNTAIN LANDSCAPE
WITH GLACIERS

Wood, 47 × 76 cm.
Munich, private collection.

Joost de Momper

SUMMER

Wood, 55.5 × 97 cm.
Brunswick,
Herzog-Anton-Ulrich Museum
No. 65.

Joost de Momper

MOUNTAIN LANDSCAPE
WITH GIPSIES RESTING

Wood, 39 × 53 cm.
Berlin, H. W. Lange sale,
27 January 1943
No. 61.

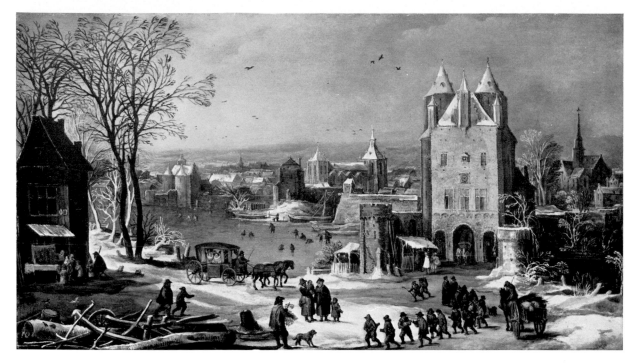

Joost de Momper

WINTER

Wood, 55 × 97 cm.
Brunswick,
Herzog-Anton-Ulrich Museum
No. 67.

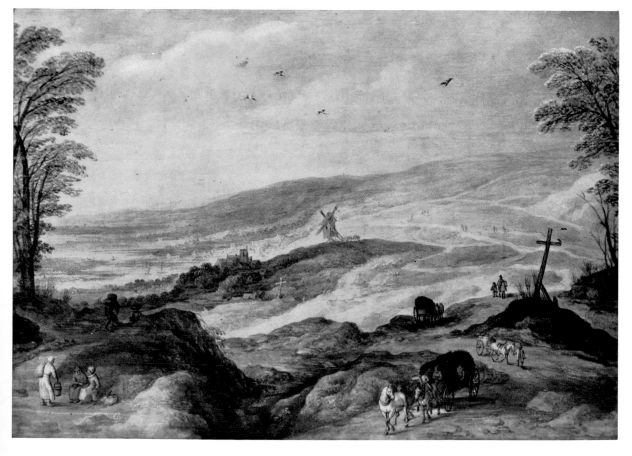

Joost de Momper

HILLY LANDSCAPE
WITH CART AND WAYFARERS

Wood, 51 × 72 cm.
Pommersfelden,
Schönborn Gallery
No. 365.

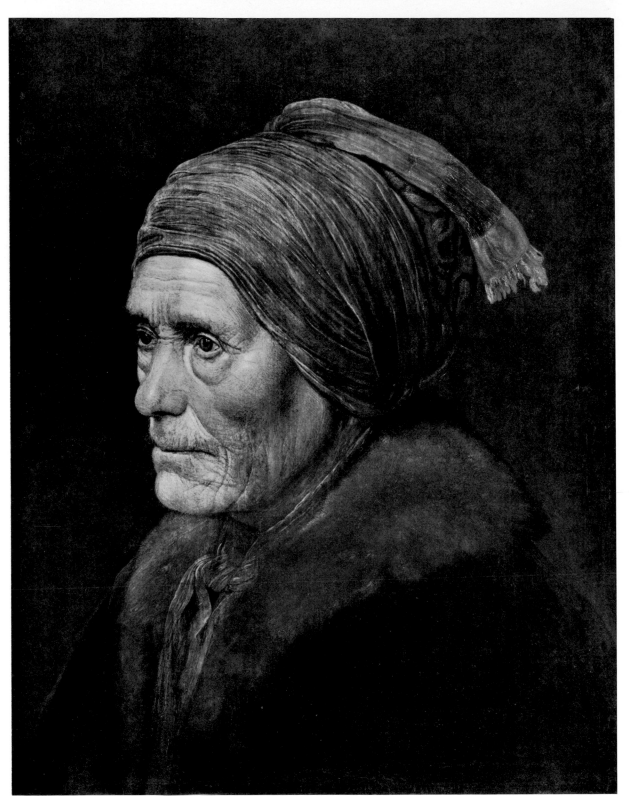

Monogrammist I. S.

OLD WOMAN

Formerly monogrammed
and dated 1651
Wood, 41×33 cm.
Vienna,
Kunsthistorisches Museum
No. 1288.

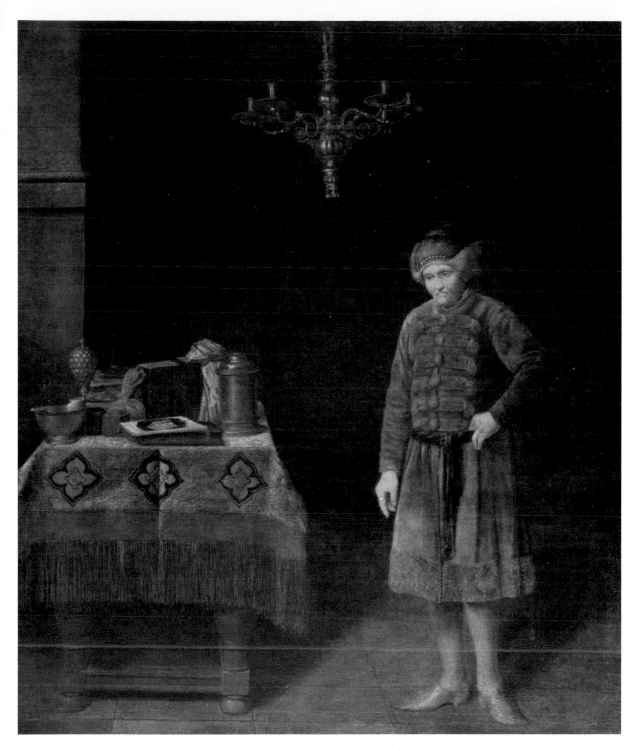

Monogrammist I. S.

INTERIOR WITH
AN OLD MAN STANDING
(AVARICE)

Monogrammed and dated 1652
Canvas, 54×46 cm.
Formerly Paris,
Adolphe Schloss
collection
No. 149.

Monogrammist I. S.

Old Lady Reading a Letter

Monogrammed and dated 1658
Wood, 50×35 cm.
Stockholm, National Museum
No. 1117.

Karel van Moor

Nymph and Faun

Signed
Wood, 31 × 26 cm.
Munich, art trade.

Karel de Moor

<small>Portrait of a Gentleman</small>

Signed
Canvas, 122.5 × 96 cm.
Copenhagen,
Royal Museum of Fine Arts
No. 478.

Paulus Moreelse

YOUNG WOMAN

Signed and dated 1627
Wood, 72×55 cm.
The Hague,
portrait exhibition of 1903
No. 94.

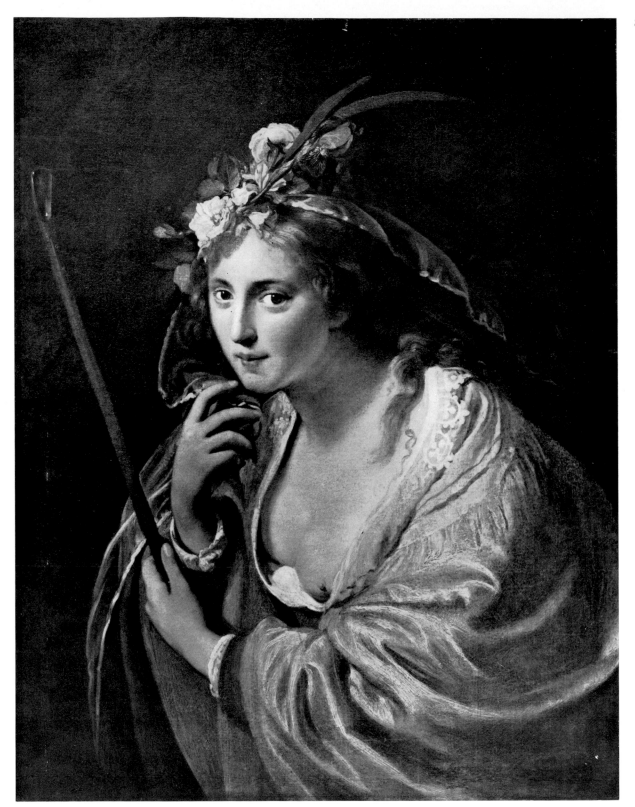

Paulus Moreelse

The Pretty Shepherdess

Signed and dated 1630
Canvas, 82 × 66 cm.
Amsterdam, Rijksmuseum
No. 1661.

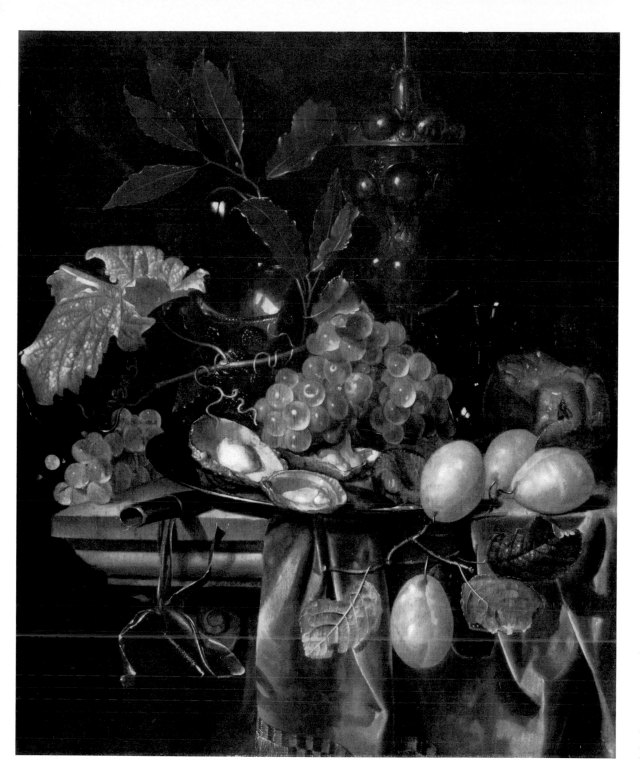

Jan Mortel

FRUIT STILL LIFE

Signed and dated 1680
Wood, 51 × 42 cm.
Munich, art trade.

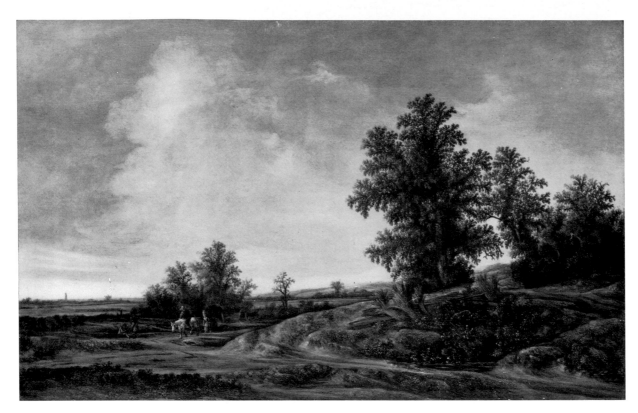

Jakob van Moscher

PATH THROUGH THE FIELDS

Signed
Wood, 53×85 cm.
Munich, Alte Pinakothek
No. 532.

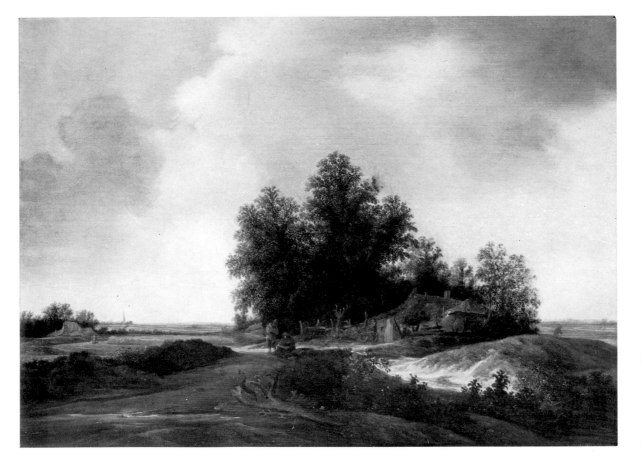

Jakob van Moscher

FARM HOUSE
UNDER TALL TREES

Signed
Wood, 50×70 cm.
Munich, private collection.

Frederick de Moucheron

LANDSCAPE

Signed
Canvas, 61 × 58 cm.
Munich, Alte Pinakothek
No. 602.

Isaac de Moucheron

ITALIAN LANDSCAPE
WITH AN ELEGANT COMPANY

Signed
Canvas, 37 × 41 cm.
Berlin, private collection.

Nicolaes Moyart

THE CUP FOUND
IN BENJAMIN'S SACK

Signed and dated 1627
Canvas, 94.5 × 138.4 cm.
Budapest,
Museum of Fine Arts
No. 1048 (330).

Nicolaes Moyart

ALLEGORY OF SPRING

Signed and dated 1624
Wood, 44.5 × 80.5 cm.
Nuremberg,
Germanisches Museum
No. 389.

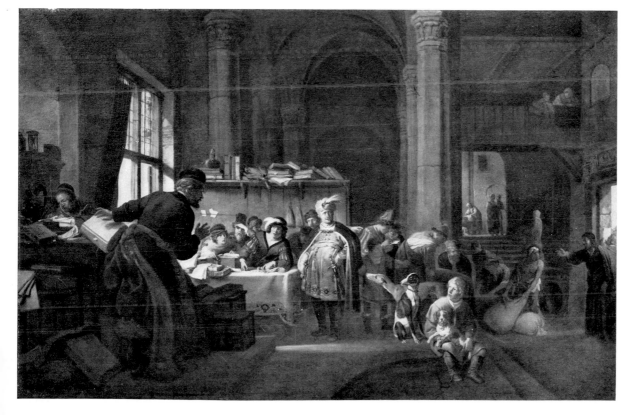

Nicolaes Moyart

THE CALLING
OF ST. MATTHEW

Signed and dated 1639
Canvas, 153 × 231 cm.
Brunswick,
Herzog-Anton-Ulrich Museum
No. 228.

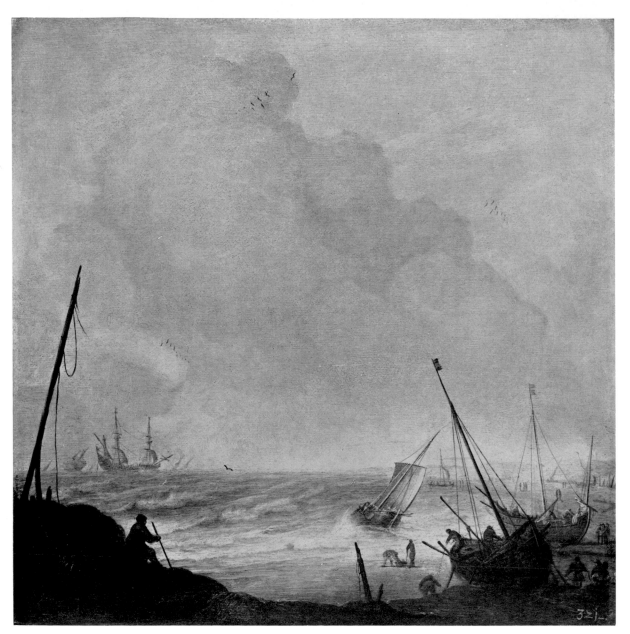

Pieter Mulier

BEACH SCENE

With monogram
Wood, 34.5 × 34.5 cm.
Dresden, Gallery
No. 1378.

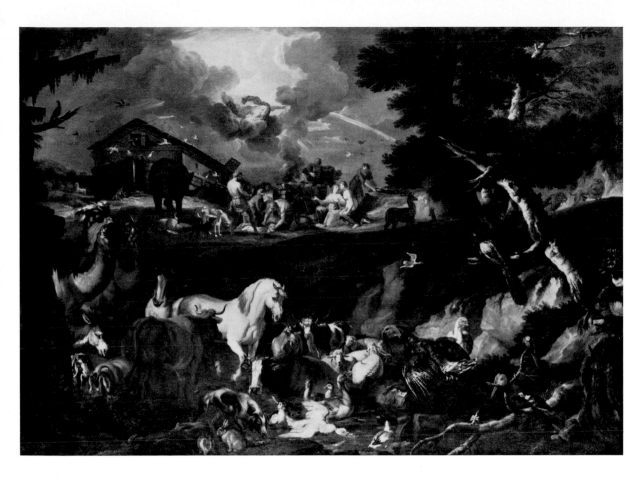

**Pieter Mulier,
called Tempesta**

NOAH'S THANK-OFFERING

Canvas, 91 × 122 cm.
Cassel, Gallery
No. 414.

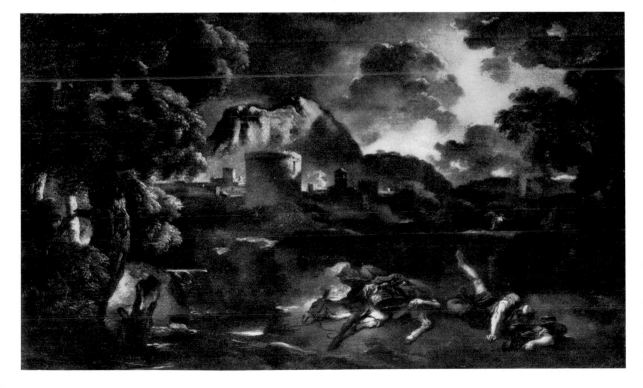

**Pieter Mulier,
called Tempesta**

LANDSCAPE IN A STORM

Canvas, 35.5 × 59.5 cm.
Dresden, Gallery
No. 1518.

Emanuel Murant

VILLAGE STREET

Signed and dated 1652
Canvas, 62×85 cm.
Berlin, H. W. Lange sale
3 December 1940
No. 132.

Emanuel Murant

A VILLAGE

Signed and dated 1652
Canvas, 50×57 cm.
Berlin, H. W. Lange sale
3 December 1940
No. 131.

Michiel van Musscher

A Painter in his Studio

Signed
Canvas.
London, Lord Northbrook

Michiel van Musscher

PORTRAIT OF A WOMAN

Signed and dated 1686
Canvas, 57×50 cm.
Budapest,
Museum of Fine Arts
No. 1046 (567).

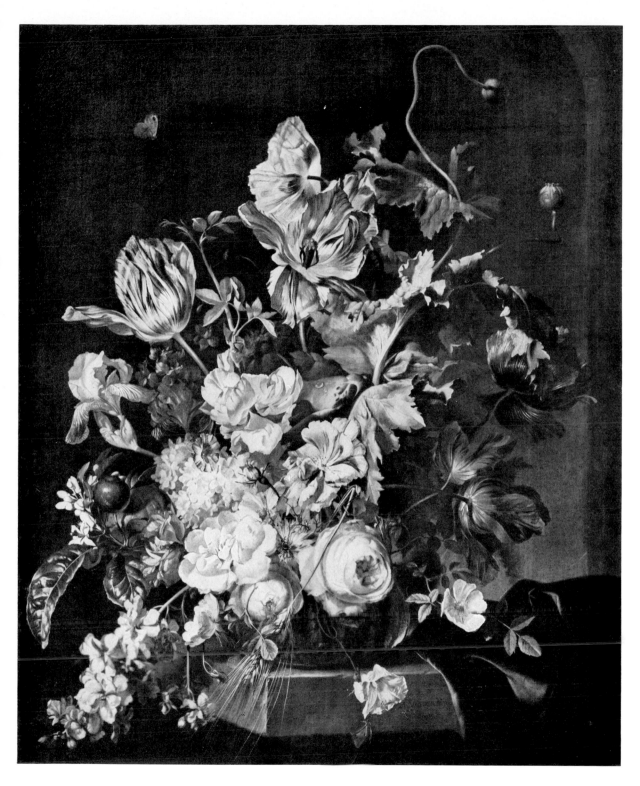

Herman van der Myn

GARDEN FLOWERS
IN A GLASS VASE

Signed
Canvas, 78×64 cm.
Munich, Alte Pinakothek
No. 904.

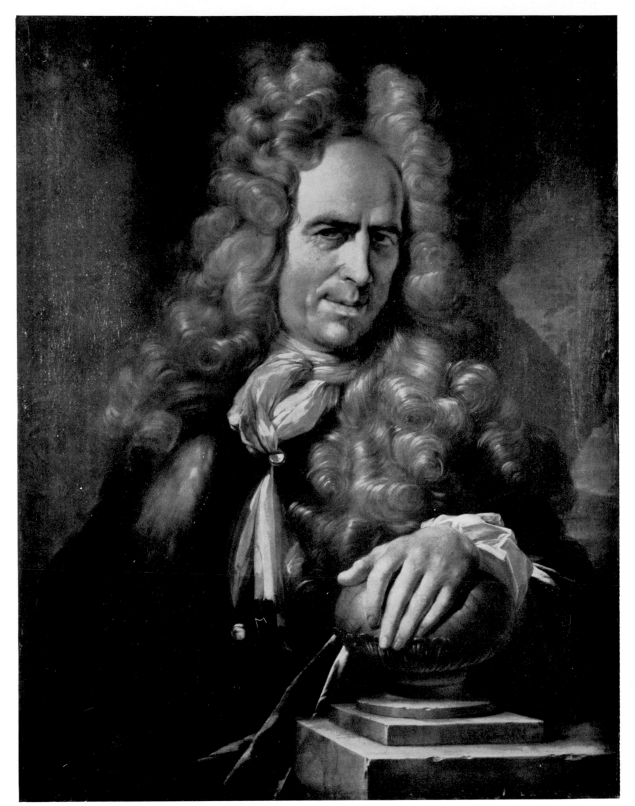

Herman van der Myn

PORTRAIT
OF THE FLOWER-PAINTER
JAN VAN HUYSUM

Signed and dated 1716
Canvas, 88×69 cm.
Munich, private collection.

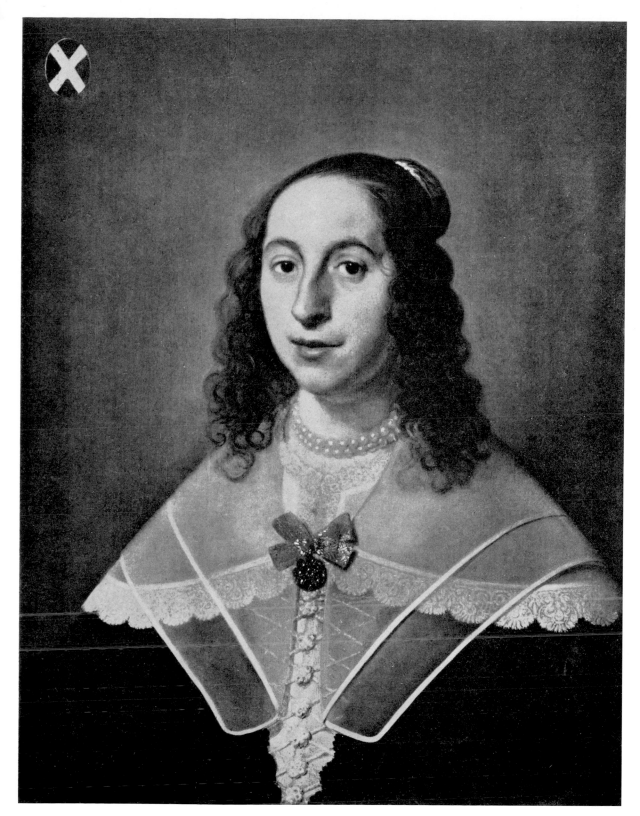

Daniel Mytens the Elder

PORTRAIT OF ANNA HOEUFFT

Signed and dated 1643
Wood, 71.5 × 55 cm.
Amsterdam,
Muller-Mensing sale,
30 November 1920
No. 1064

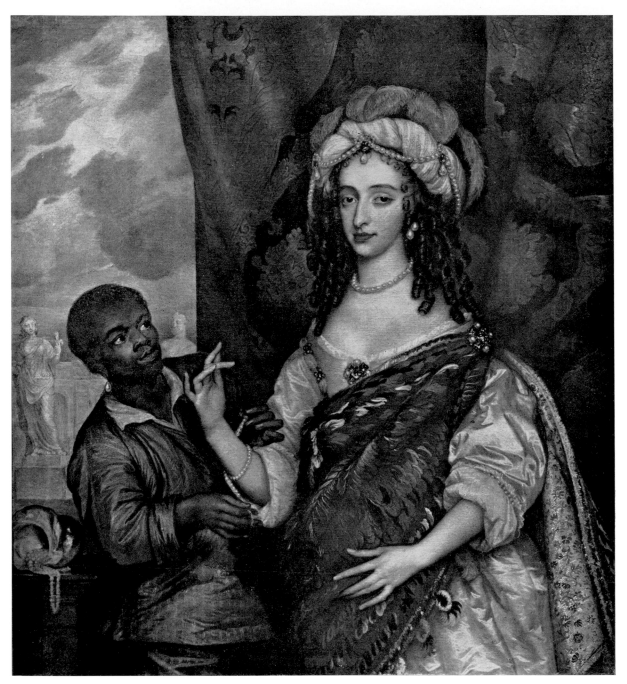

Jan Mytens

QUEEN HENRIETTA MARIA
OF ENGLAND

Canvas, 133 × 123 cm.
The Hague, Mauritshuis
No. 429.

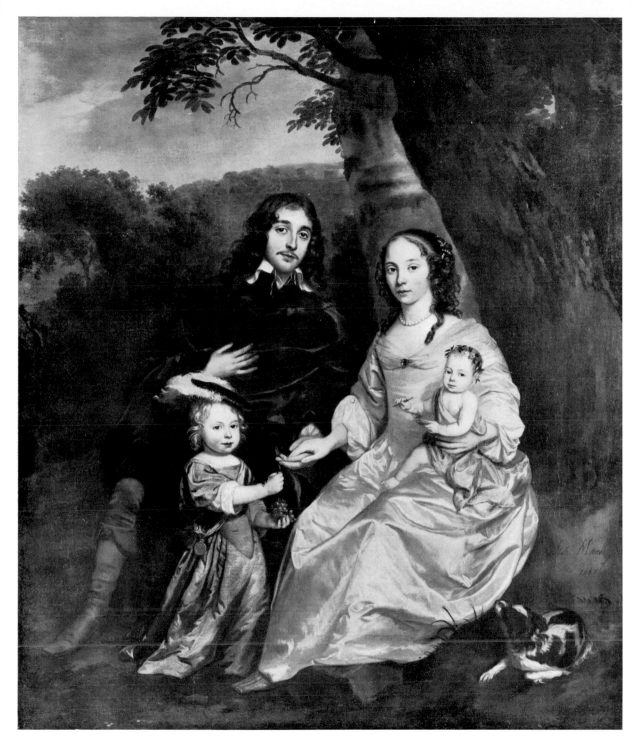

Jan Mytens

FAMILY GROUP

Signed and dated 1657
Canvas, 100 × 86 cm.
Amsterdam, Mak sale,
22 December 1924
No. 22.

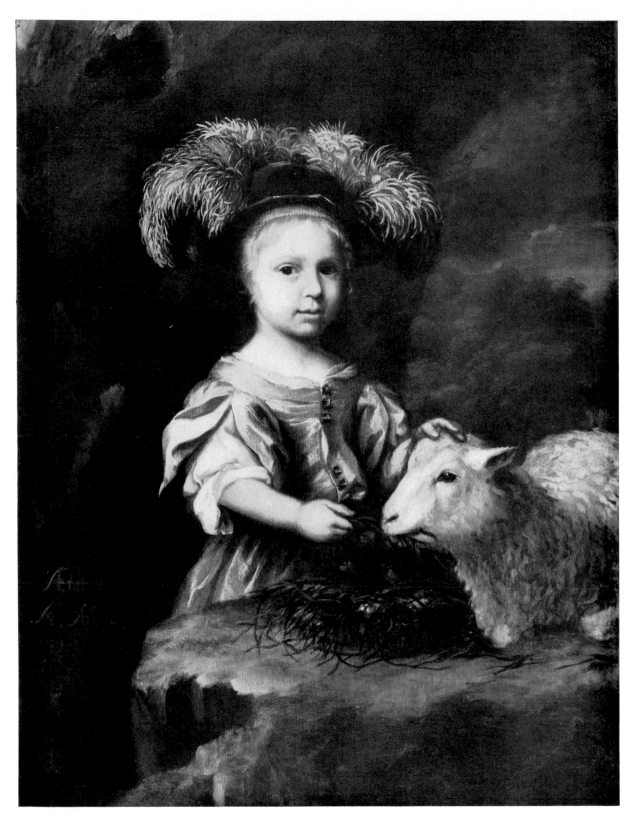

Martin Mytens the Elder

PORTRAIT OF A SMALL GIRL

Signed and dated 1669
Wood, 42 × 32.2 cm.
Munich, art trade.

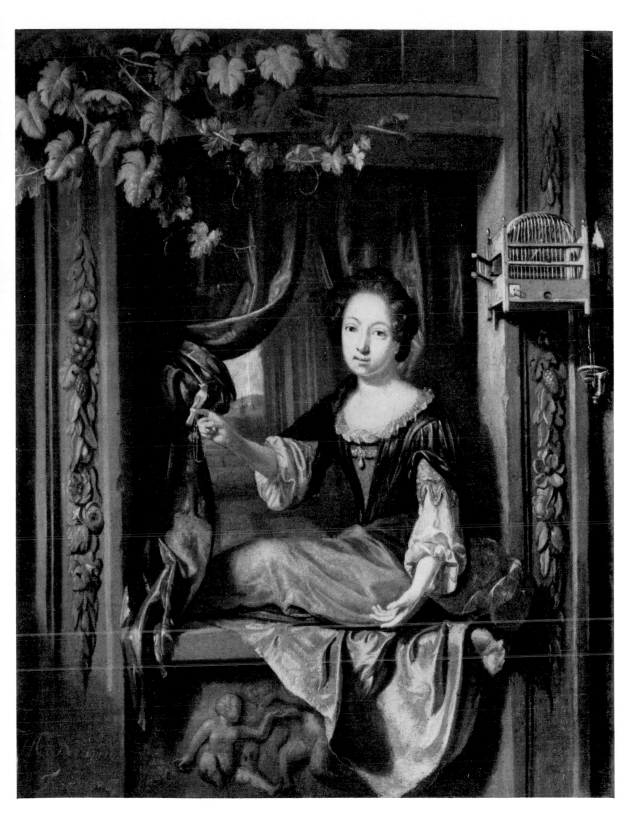

Matthys Naiveu

GIRL BY A WINDOW

Signed and dated 1686
Canvas, 28 × 22 cm.
Berlin, art trade.

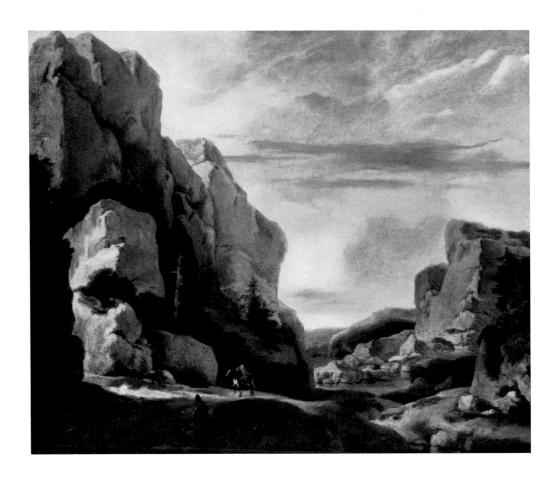

Herman Naiwincx

Rocky Landscape

Signed
Canvas, 58.5 × 70 cm.
New York, private collection.

Herman Naiwincx

Picture of a Rocky
Scandinavian Landscape,
with a Red Curtain

Canvas, 75 × 90 cm.
Munich, private collection.

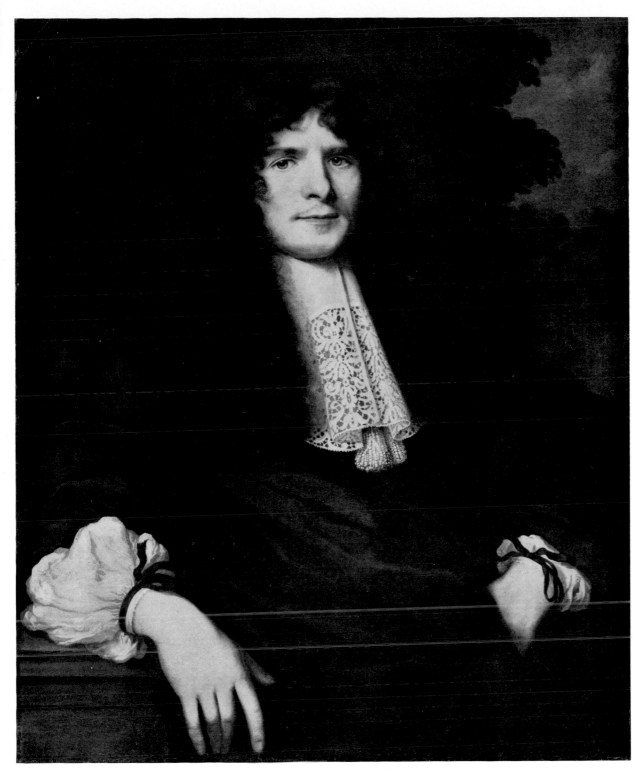

Pieter Nason

PORTRAIT OF A YOUNG MAN

Signed and dated 1668
Canvas, 83×67 cm.
Berlin, Staatliche Museen
No. 1007A.

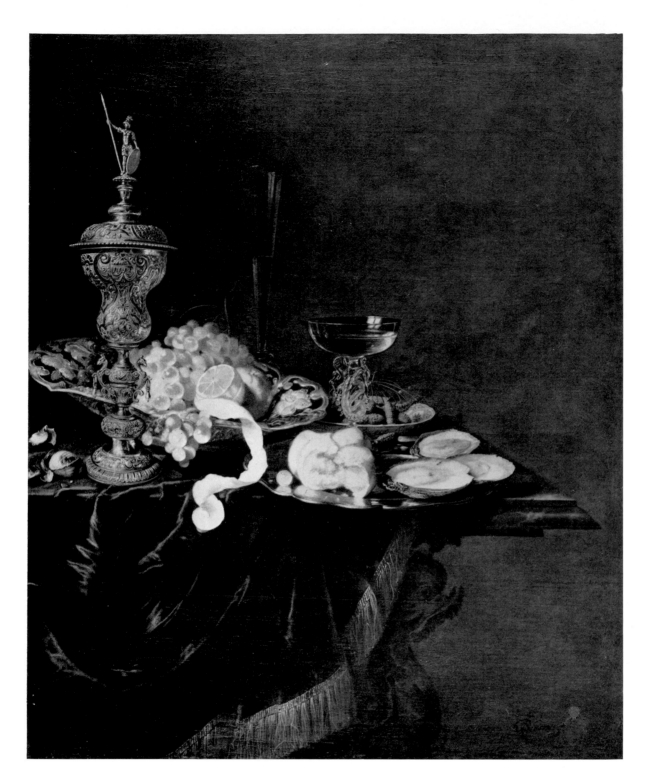

Pieter Nason

STILL LIFE

Signed
Canvas, 84 × 70 cm.
Berlin, Staatliche Museen
No. 977.

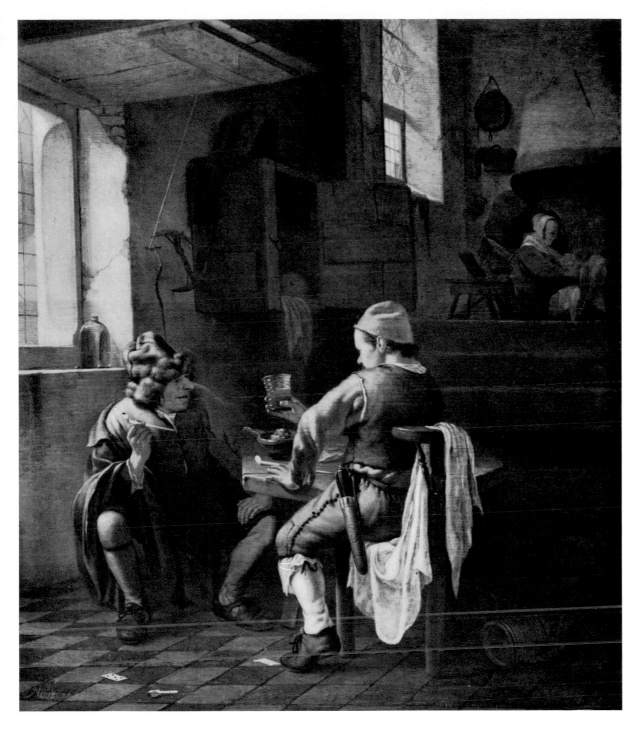

Johannes Natus

INTERIOR WITH A SMOKER
AND A DRINKER

Signed
Wood, 51.5 × 48 cm.
St Gilgen (Austria),
F. C. Butôt collection.

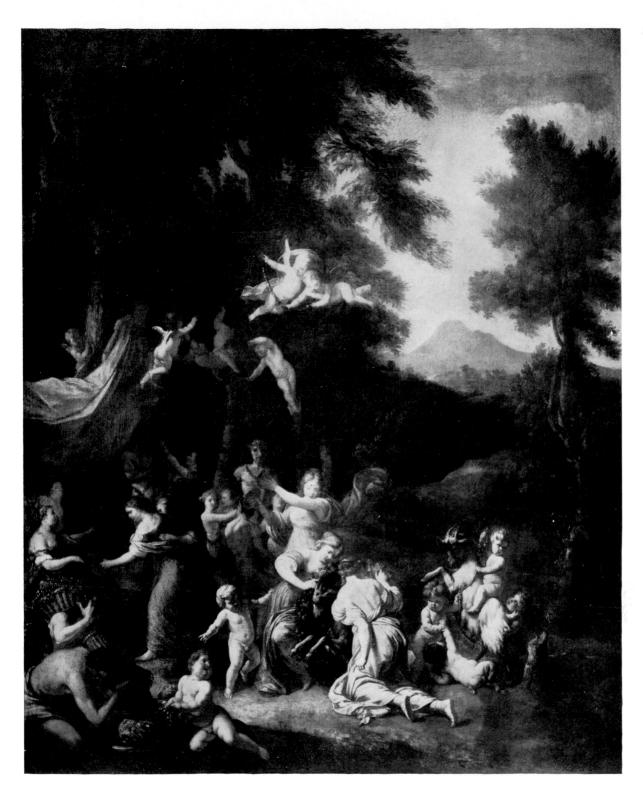

Jan van Neck

SACRIFICE TO PAN
NEAR A FOREST

Signed
Canvas, 82 × 68 cm.
Dresden, Gallery
No. 1654.

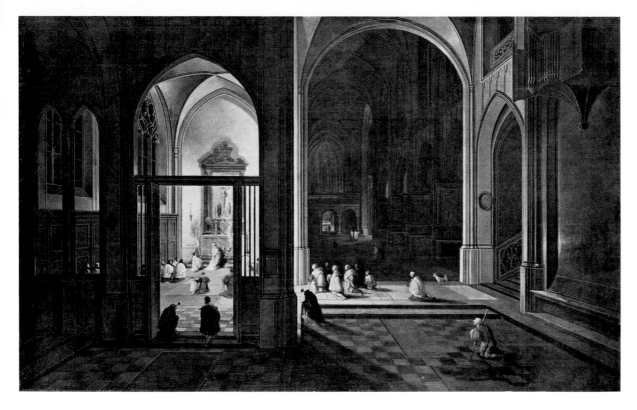

Pieter Neeffs the Elder

INTERIOR
OF A GOTHIC CHURCH

Wood, 35×55 cm.
Vienna,
Kunsthistorisches Museum
No. 946.

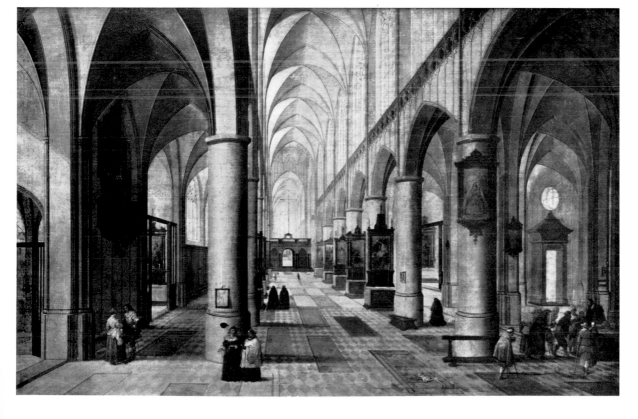

Pieter Neeffs the Elder

INTERIOR OF A CATHEDRAL

Wood, 54.6×85.7 cm.
London,
Dulwich College Art Gallery
No. 141.

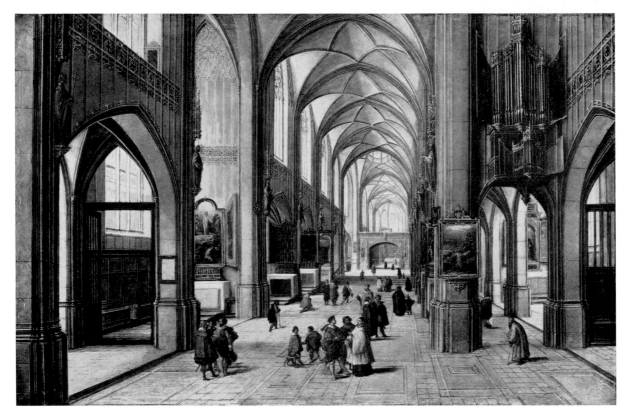

Pieter Neeffs the Elder

INTERIOR OF ANTWERP
CATHEDRAL
(figures by F. Francken)

Signed
Wood, 34×48 cm.
The Hague, Mauritshuis
No. 248.

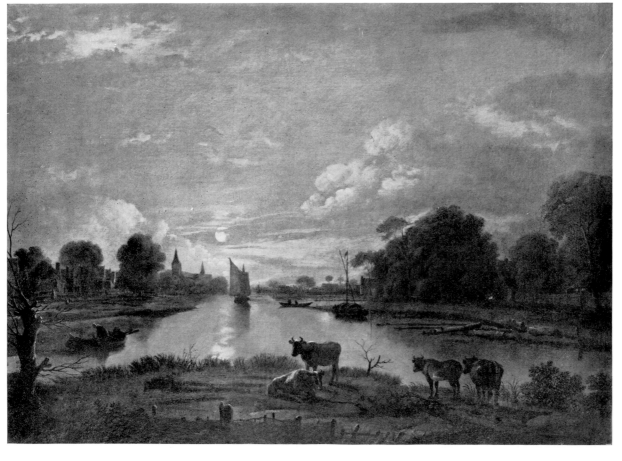

Aert van der Neer

RIVER LANDSCAPE
BY MOONLIGHT

With monogram
Canvas, 63×85 cm.
Munich, private collection.

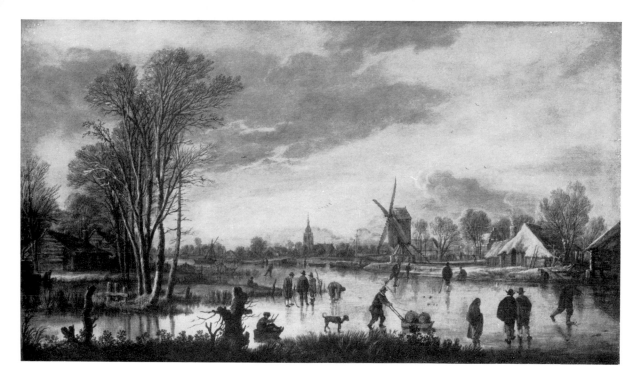

Aert van der Neer

FROZEN CANAL

With monogram
Wood, 35.5 × 62 cm.
Leningrad, Hermitage
No. 923.

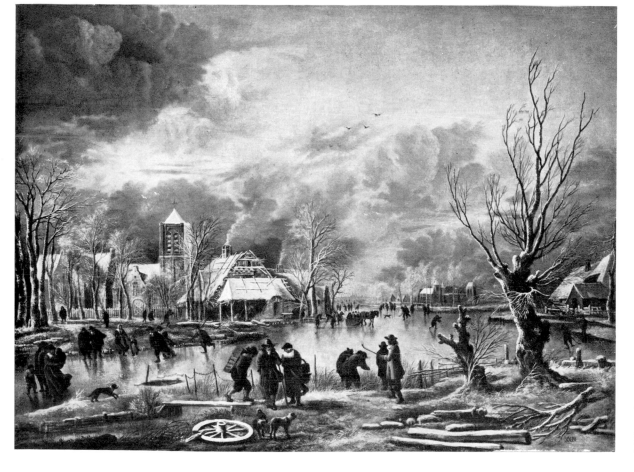

Aert van der Neer

WINTER LANDSCAPE

With monogram
Canvas, 97 × 128 cm.
Brunswick,
Herzog Anton-Ulrich Museum
No. 360.

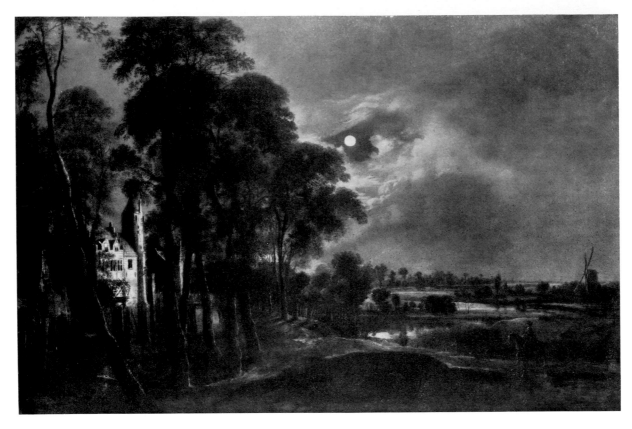

Aert van der Neer

MOONLIGHT LANDSCAPE

With monogram
Wood, 81 × 122 cm.
Berlin, H. W. Lange sale,
3 December 1940
No. 133.

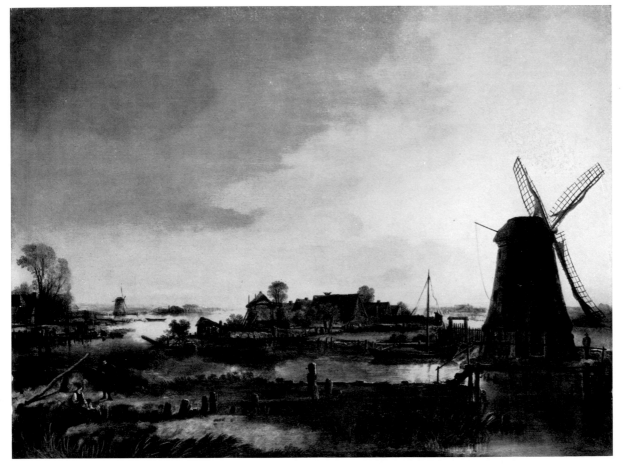

Aert van der Neer

EVENING LANDSCAPE
ON AN ISLAND
IN THE MEUSE

Wood, 69.5 × 92.5 cm.
Leningrad, Hermitage
No. 927.

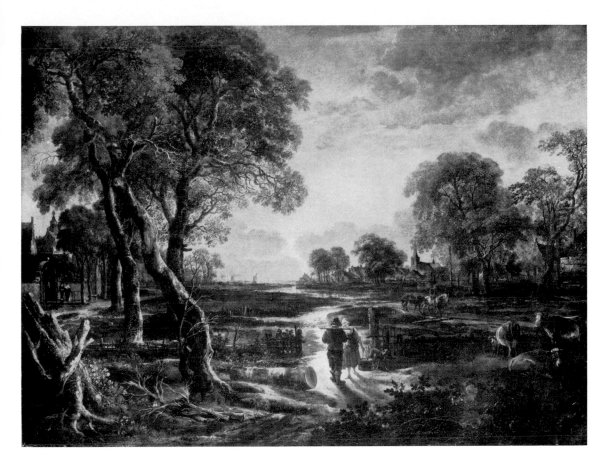

Aert van der Neer

Evening View
near a Village

With monogram
Canvas, 121 × 162 cm.
London, National Gallery
No. 152.

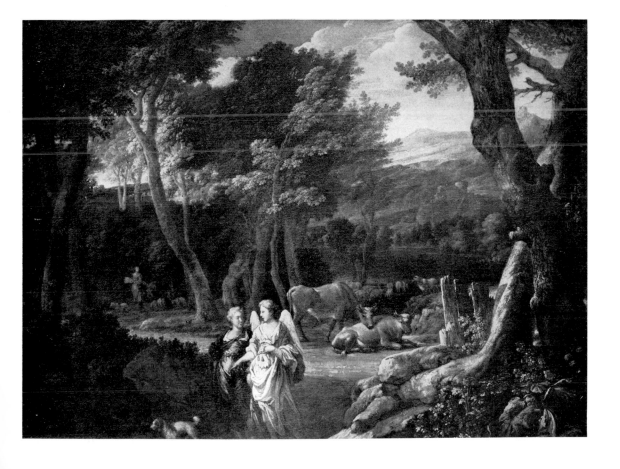

Eglon Hendrik
van der Neer

Tobias with
the Archangel Raphael

Signed
Wood, 22 × 28.5 cm.
Karlsruhe,
Staatliche Kunsthalle
No. 277.

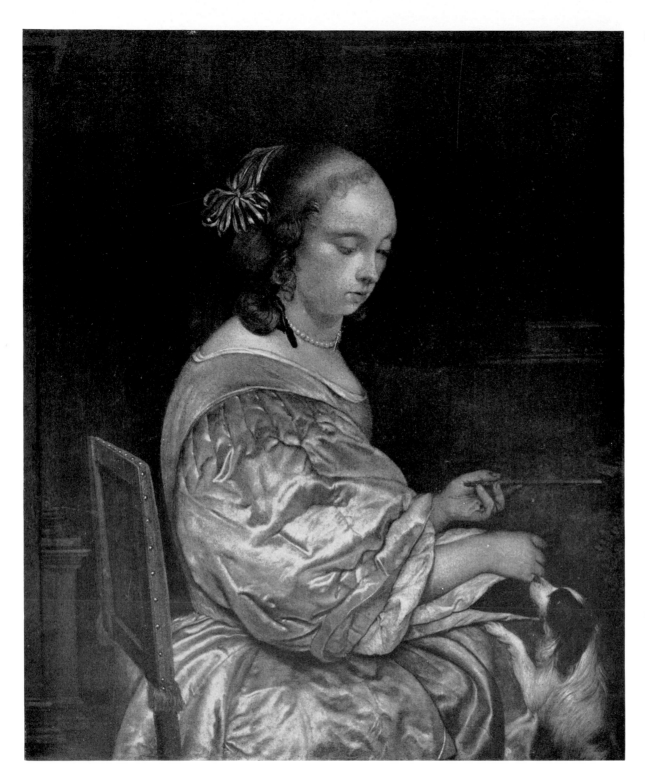

**Eglon Hendrik
van der Neer**

Young Lady with a Lapdog

Signed
Wood, 26.5 × 22 cm.
Karlsruhe,
Staatliche Kunsthalle
No. 278.

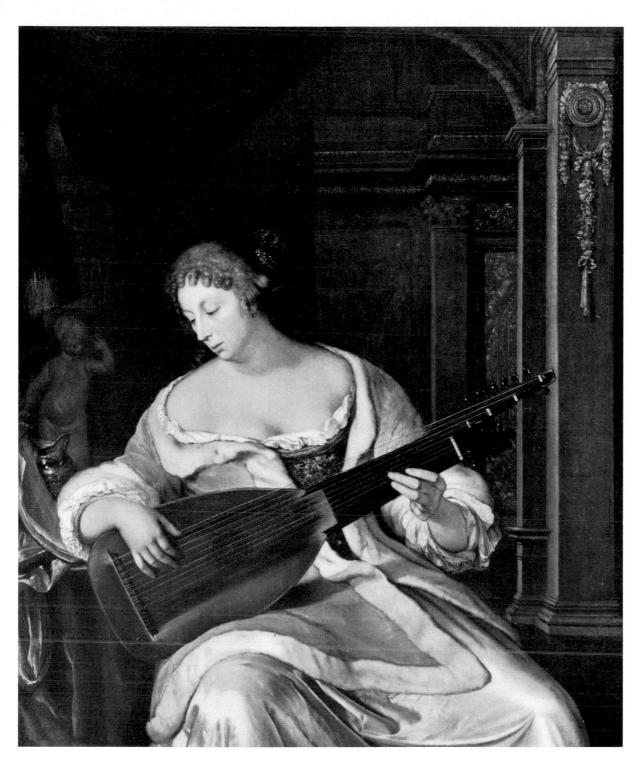

**Eglon Hendrik
van der Neer**

WOMAN PLAYING THE LUTE

Signed and dated 1695
Wood, 39.5 × 33 cm.
Munich, art trade.

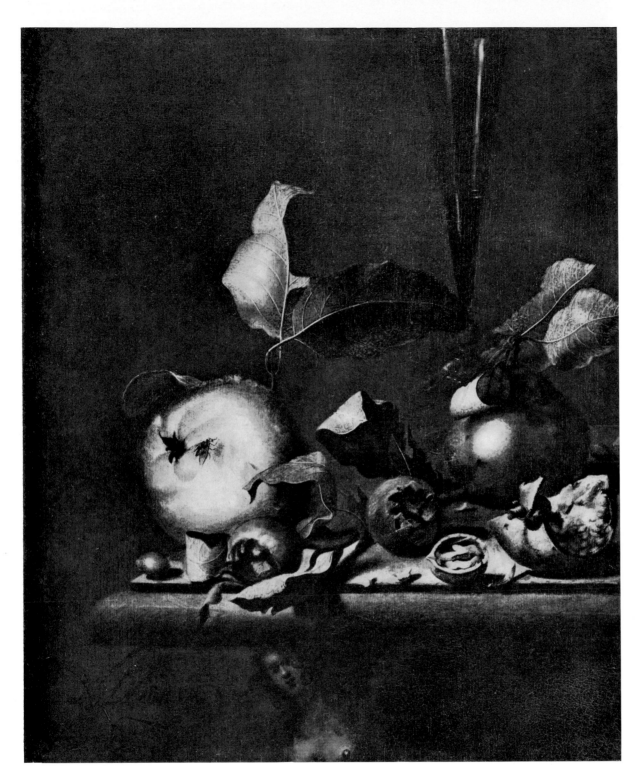

Martinus Nellius

FRUIT STILL LIFE

Signed
Wood, 41.5 × 34.5 cm.
Amsterdam, Rijksmuseum
No. 1723.

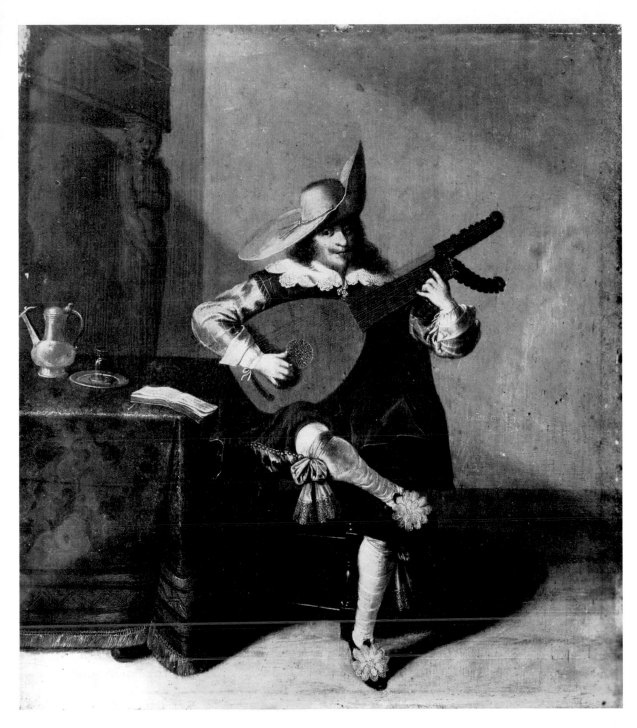

Laurentius de Neter

LUTE-PLAYER

Signed and dated 1631.
Wood, 27.5 × 24 cm.
Bielefeld, private collection.

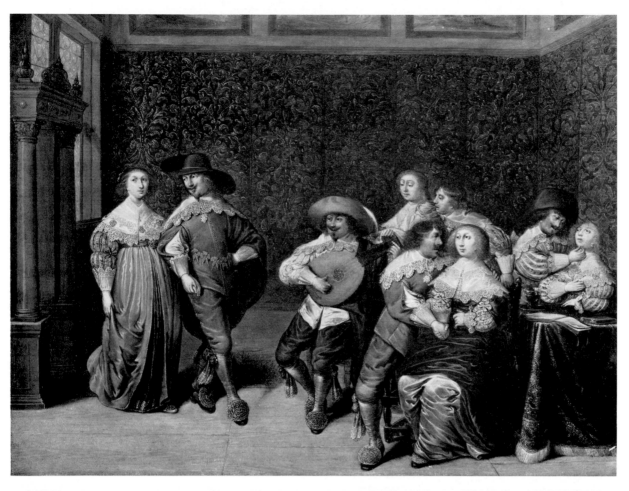

Laurentius de Neter

MUSIC PARTY

Signed and dated 1635
Wood, 31.3×41 cm.
Paris, art trade.

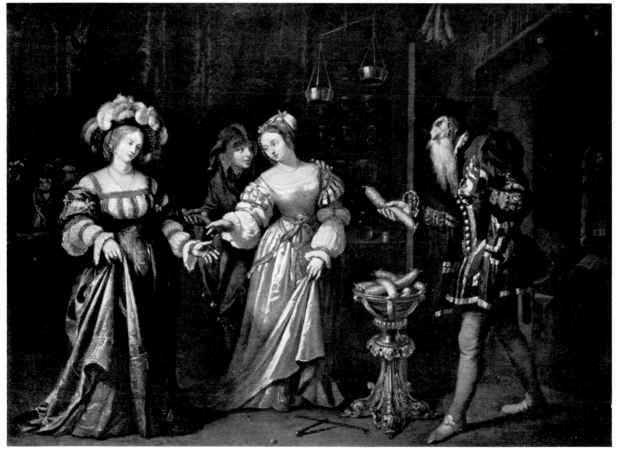

847

Caspar Netscher

SCENE WITH MASQUES

Signed and dated 1668
Wood, 47×63.5 cm.
Cassel, Gallery
No. 292.

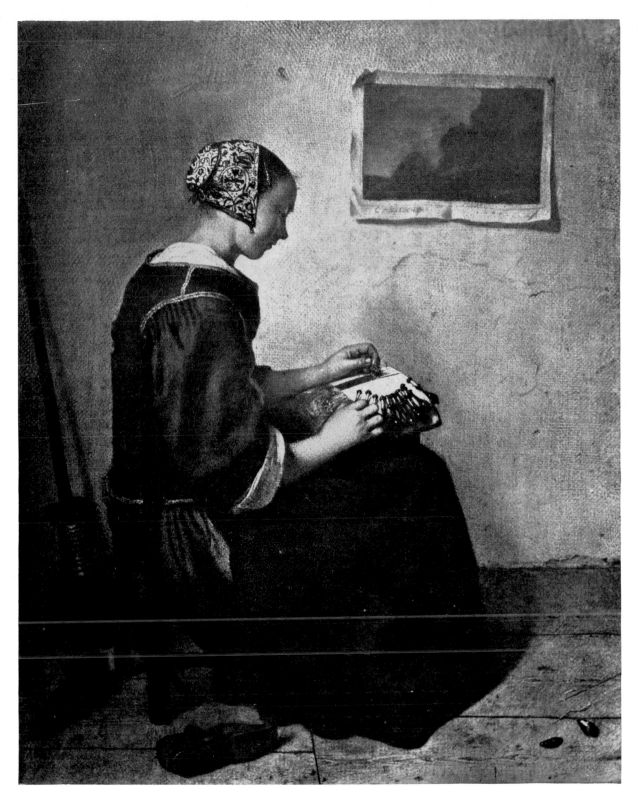

Caspar Netscher

THE LACE-MAKER

Signed and dated 1664
Canvas, 34×28 cm.
London,
Wallace Collection
No. 237.

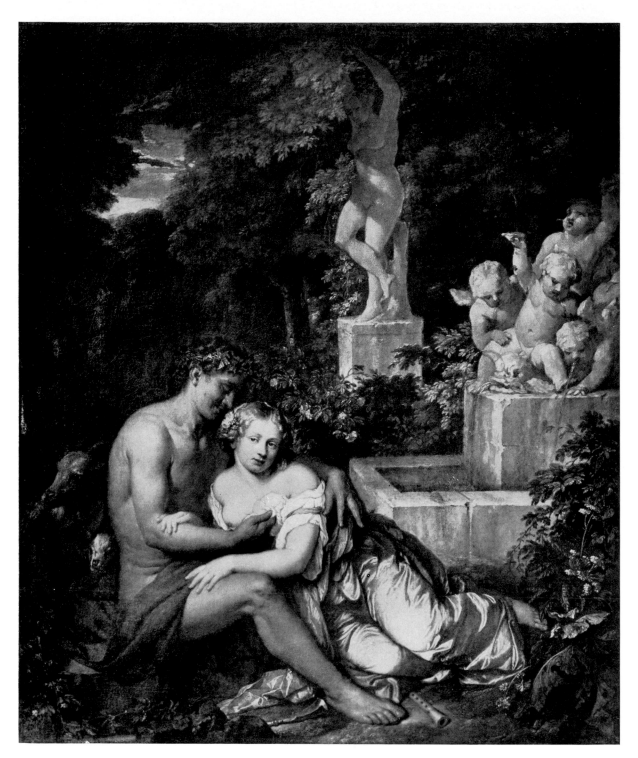

Caspar Netscher

PASTORAL IDYLL

Signed and dated 1681
Canvas, 54×45 cm.
Munich, Alte Pinakothek
No. 1402.

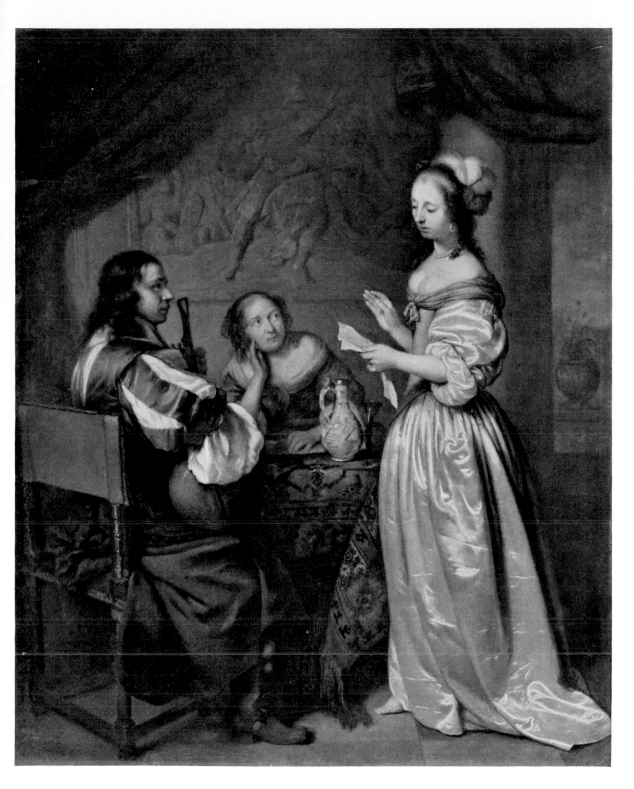

Caspar Netscher

SINGING LESSON

Signed and dated 1665
Wood, 44×36 cm.
The Hague, Mauritshuis
No. 125.

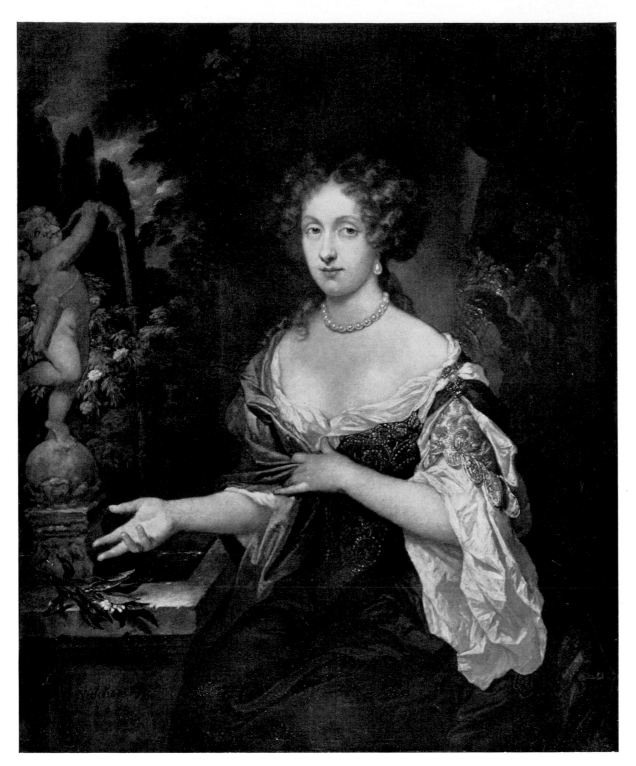

Caspar Netscher

PORTRAIT OF
MARIA TIMMERS

Signed and dated 1683
Canvas, 48×39 cm.
The Hague, Mauritshuis
No. 127.

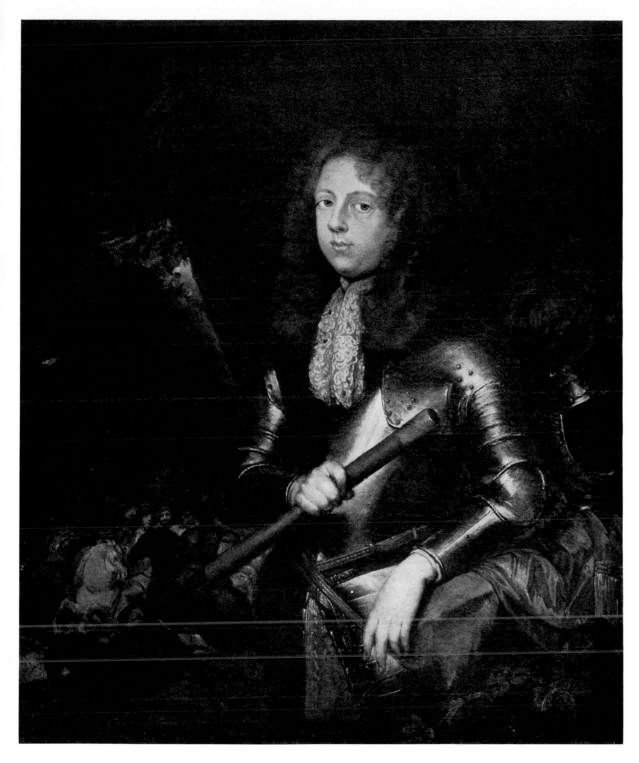

Constantin Netscher

PORTRAIT OF A PRINCE
IN ARMOUR

Canvas, 53 × 44 cm.
Schleissheim, Gallery
No. 3296.

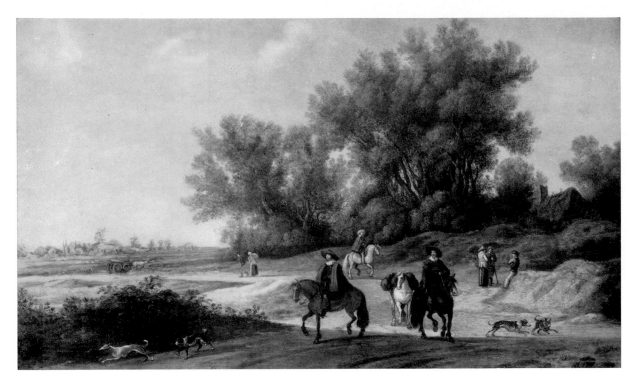

853

Pieter de Neyn

LANDSCAPE WITH DUNES

Signed and dated 1628
Wood.
Berlin, art trade.

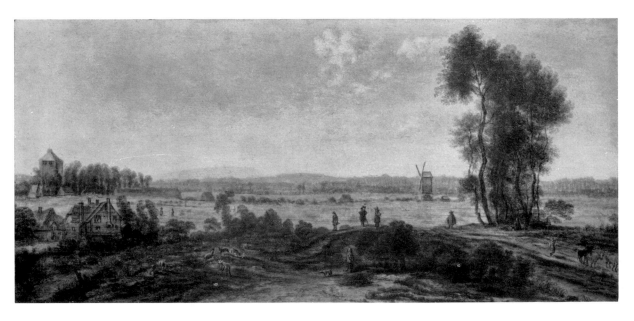

854

Gillis Neyts

FLAT LANDSCAPE

With monogram
Wood.
Berlin, art trade.

Gillis Neyts

RUINED CASTLE
IN A LANDSCAPE

Signed and dated 1666
Wood, 53.5 × 85 cm.
Lucerne, art trade.

Isaac van Nickele

THE NIEUWE KERK AT DELFT

Canvas, 99 × 121 cm.
Brunswick,
Herzog-Anton-Ulrich Museum
No. 428.

Isaac van Nickele

ST BAVO'S CHURCH
AT HAARLEM

Signed
Canvas, 136×121 cm.
Amsterdam,
Frederik Muller sale,
28 November 1911
No. 58.

Jan van Nickelen

ITALIAN LANDSCAPE

Signed
Canvas, 68×92.3 cm.
Karlsruhe,
Staatliche Kunsthalle
No. 1841.

Jan van Nickelen

THE OLD CASTLE OF
BENRATH

Signed and dated 1714
Canvas, 74×95 cm.
Schleissheim, Gallery
No. 3878.

Adriaen van Nieulandt

LARGE KITCHEN-PIECE

Signed and dated 1616
Canvas, 194 × 247 cm.
Brunswick,
Herzog-Anton-Ulrich Museum
No. 212.

Willem van Nieulandt

THE FORUM AT ROME

Signed and dated 1628
Wood, 49.5 × 76 cm.
Budapest,
Museum of Fine Arts
No. 207 (357).

Jan Rutgersz van Niwael

Young Woman
with a Goblet

Signed and dated 1646
Wood, 75 × 59.5 cm.
Utrecht, Central Museum
No. 205.

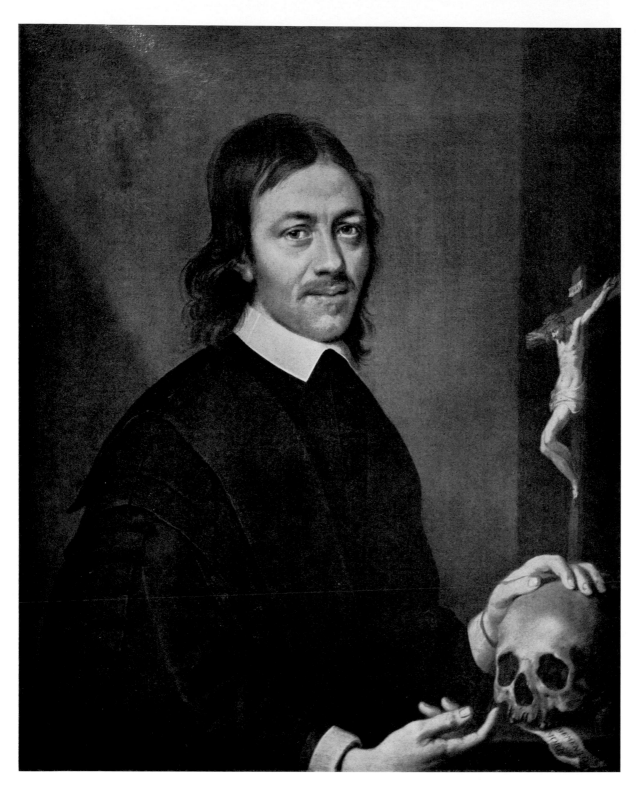

Jan Rutgersz. van Niwael

PORTRAIT OF A CLERGYMAN
WITH A SKULL

Signed and dated 1654
Canvas, 80×66.5 cm.
Utrecht, Central Museum
No. 206.

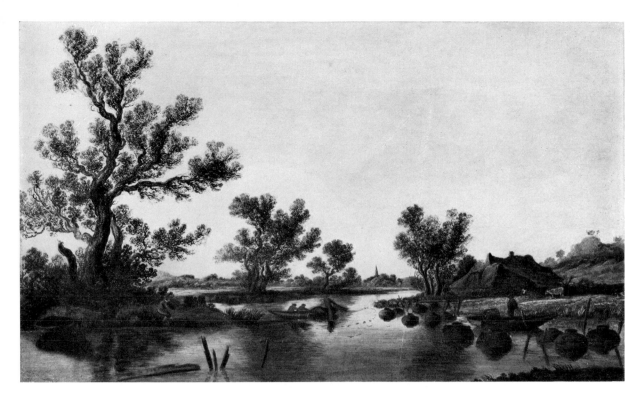

Pieter Nolpe

CANAL LANDSCAPE

With monogram; dated 1633
Wood, 46×70.5 cm.
Munich, Alte Pinakothek
No. 538.

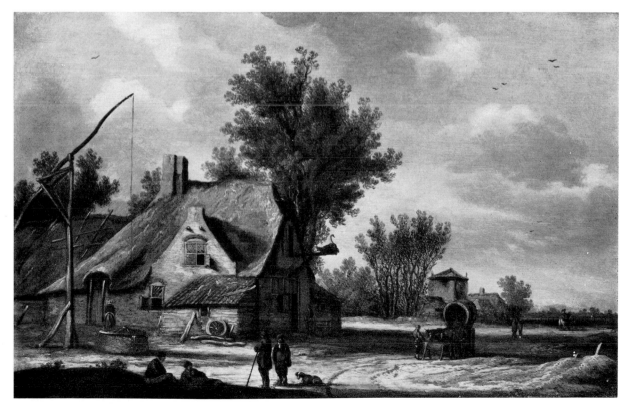

Pieter Nolpe

VILLAGE LANDSCAPE

Wood, 29×46 cm.
Cassel, Gallery
No. 386.

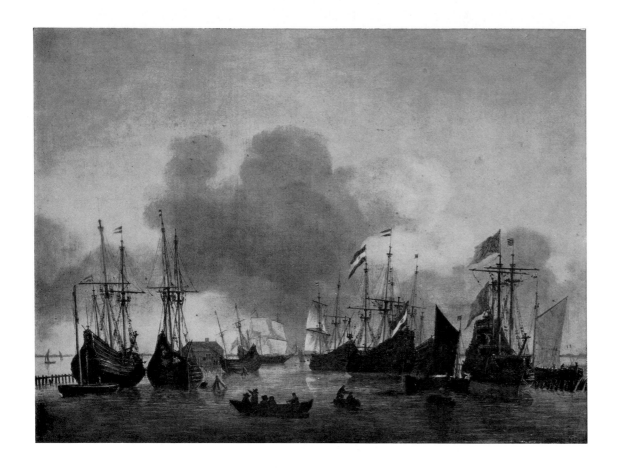

Reinier Nooms, called Zeeman

FRIGATES IN PORT
WITH A CALM SEA

Signed
Canvas, 43.5 × 58 cm.
Munich, art trade.

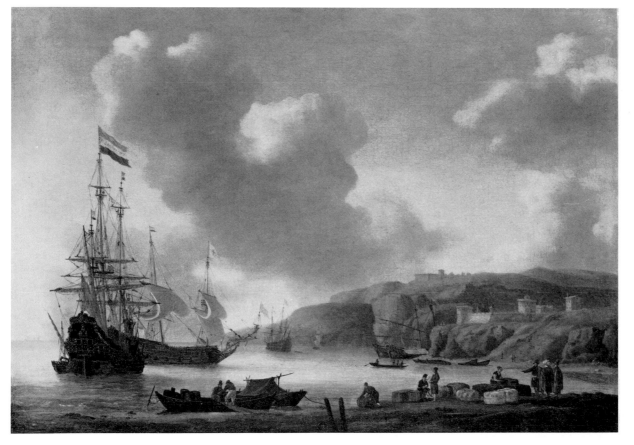

Reinier Nooms, called Zeeman

MEDITERRANEAN HARBOUR

Canvas, 41 × 57 cm.
Amsterdam, art trade.

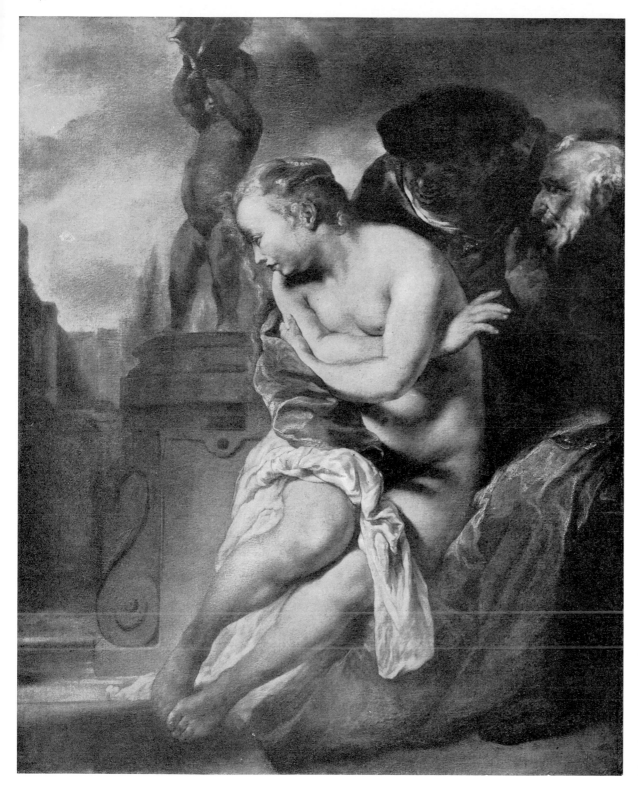

Jan van Noordt

SUSANNA AND THE ELDERS

Canvas, 127×102 cm.
Munich, Hoech sale,
19 September 1892
No. 192.

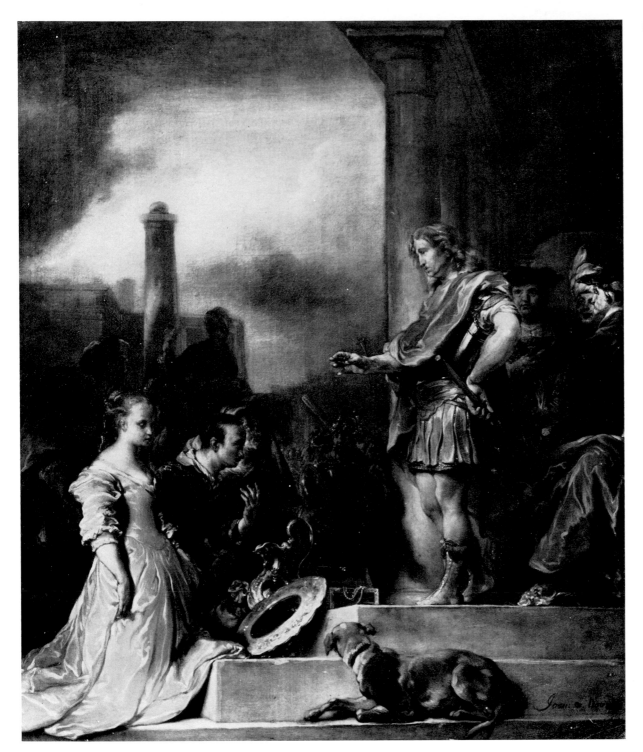

Jan van Noordt

THE MAGNANIMITY
OF SCIPIO

Signed and dated 1672
Canvas, 103×88 cm.
Amsterdam, Rijksmuseum
No. 1762.

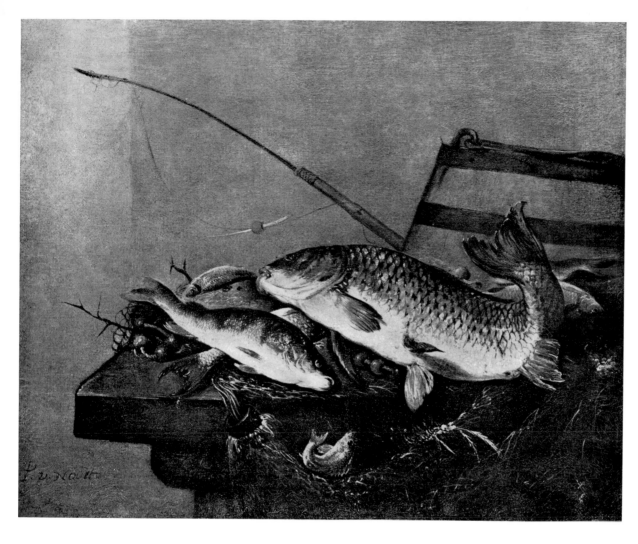

Pieter van Noort

FISH STILL LIFE

Signed
Canvas, 66×79 cm.
Amsterdam, Rijksmuseum
No. 1763.

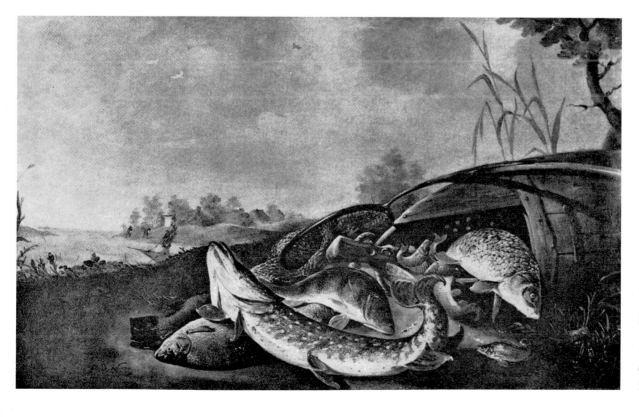

Pieter van Noort

FISH STILL LIFE

Signed
Canvas, 98×154 cm.
Stockholm, art trade.

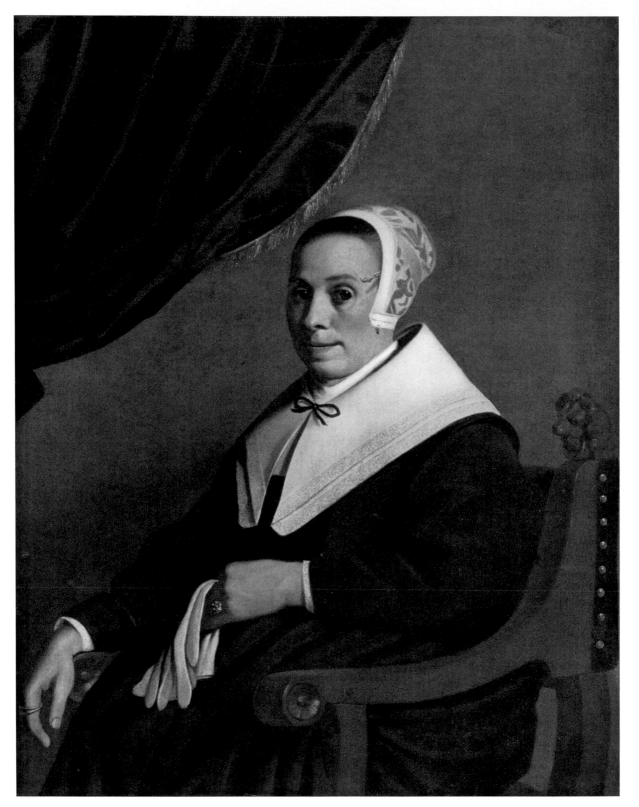

Michiel Nouts

PORTRAIT OF A LADY

Signed and dated 1656
Canvas, 108×85.5 cm.
Amsterdam, Rijksmuseum
No. 1768.

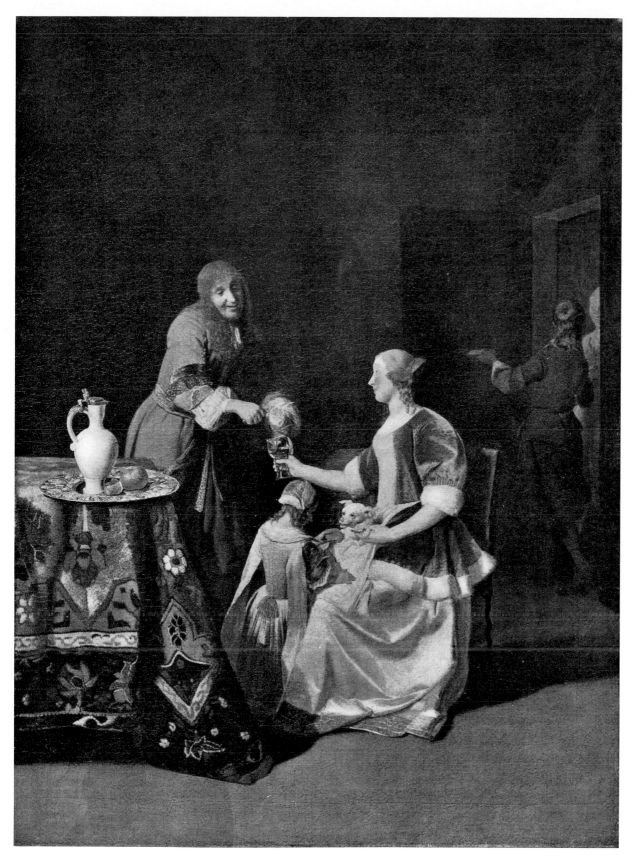

Jacob Ochtervelt

THE GALLANT

Signed and dated 1669
Canvas, 81.5 × 60.5 cm.
Dresden, Gallery
No. 1811.

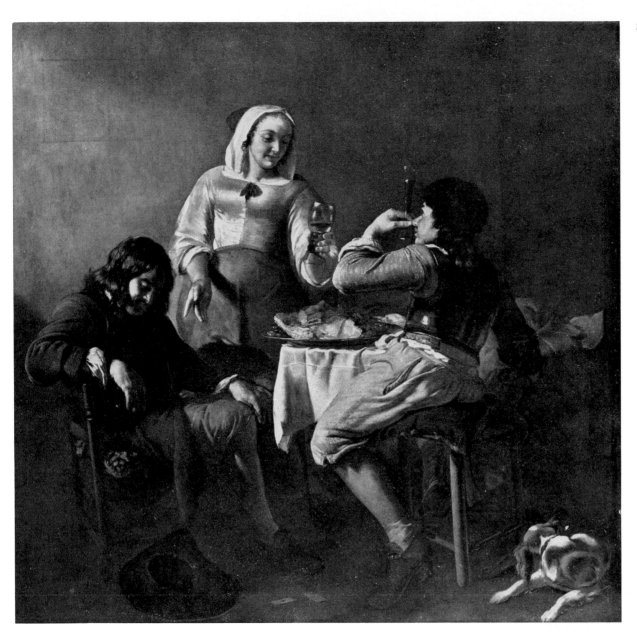

Jacob Ochtervelt

THE TOPERS

Canvas, 75 × 74 cm.
Stockholm, Bukowski sale,
25 September 1929.

Jacob Ochtervelt

WOMAN SELLING GRAPES

Signed and dated 1669
Canvas, 81 × 67 cm.
Leningrad, Hermitage
No. 951.

Hendrick ten Oever

A Vendor's Stall beside the Heerengracht, Amsterdam

Signed
Wood, 37 × 42 cm.
The Hague, Mauritshuis
No. 681.

Jan Olis

Musical Party

With monogram
Wood, 54 × 63 cm.
Amsterdam,
Frederik Muller sale,
25 November 1924
No. 56.

Jan Olis

MAN WRITING AT A TABLE

Signed
Wood, 26 × 21 cm.
The Hague, Mauritshuis
No. 537.

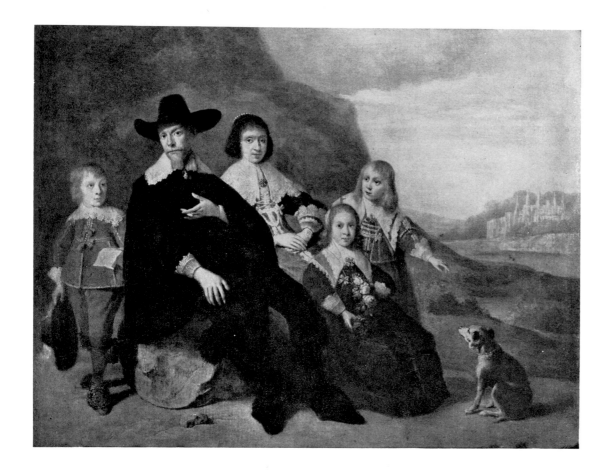

Jan Olis

FAMILY GROUP

Signed and dated 1640
Wood, 35 × 44 cm.
Budapest,
Museum of Fine Arts
No. 1290 (548).

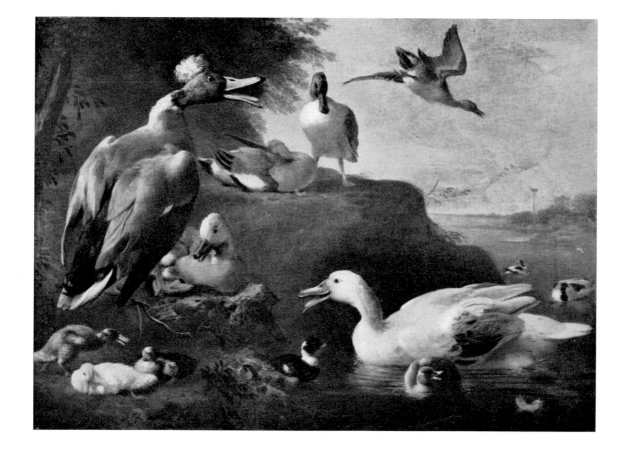

Adriaen van Oolen

DUCKS

Canvas, 72 × 101 cm.
Amsterdam,
sale of 24 June 1959
No. 282.

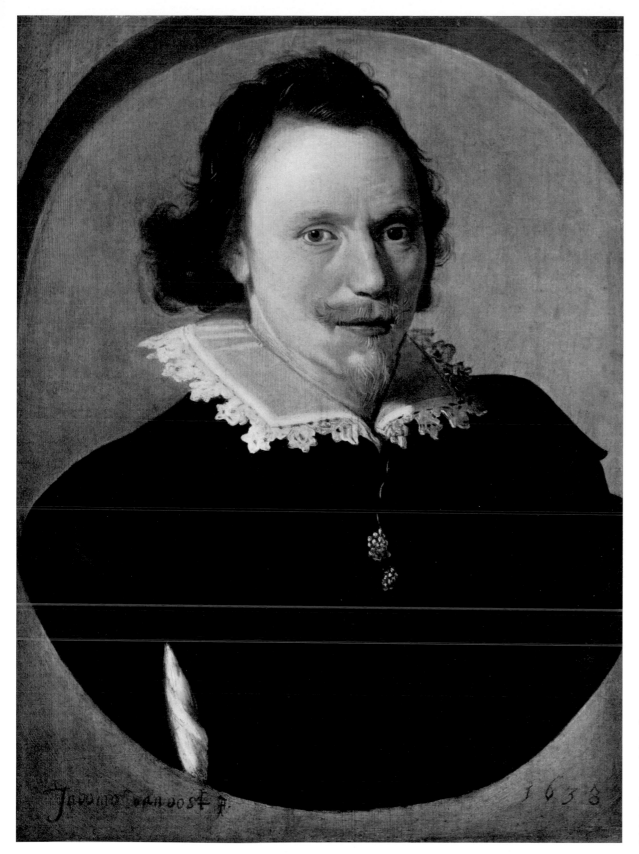

Jakob van Oost

PORTRAIT OF A GENTLEMAN

Signed and dated 1638
Wood, 61×45 cm.
Berlin, Staatliche Museen
No. 1469.

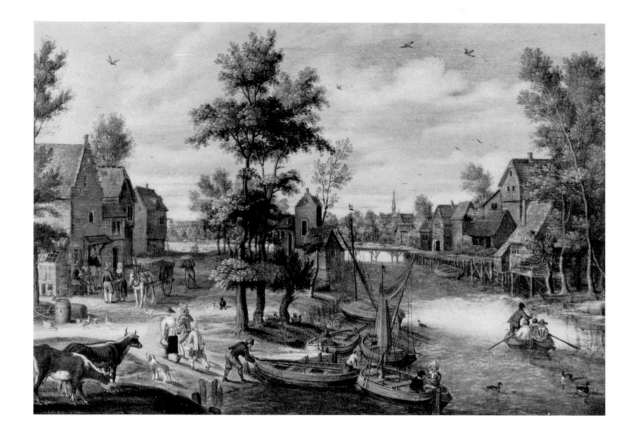

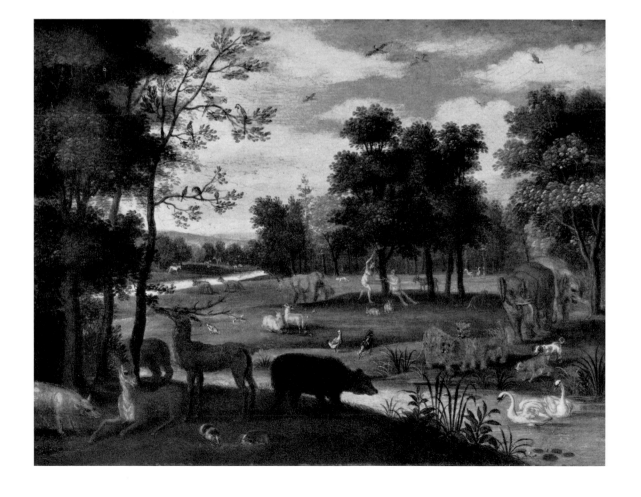

Isaak van Oosten

VILLAGE BY A RIVER

Signed
Wood, 30.5 × 43.5 cm.
Zurich, Bryner collection
No. 42.

Isaak van Oosten

PARADISE AND THE FALL

Signed
Wood, 18 × 24 cm.
Como, private collection.

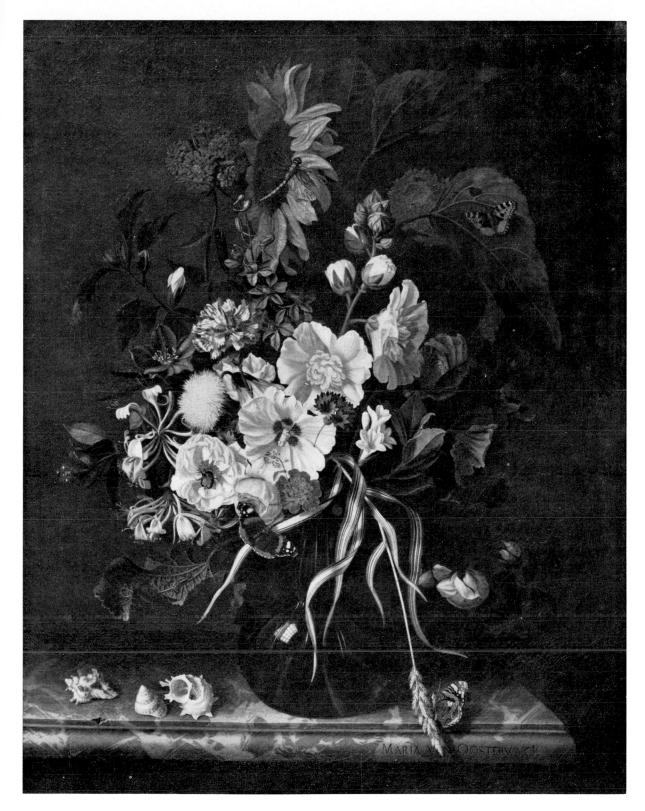

Maria van Oosterwyck

FLOWERS AND SHELLS

Signed
Canvas, 72 × 56 cm.
Dresden, Gallery
No. 1334.

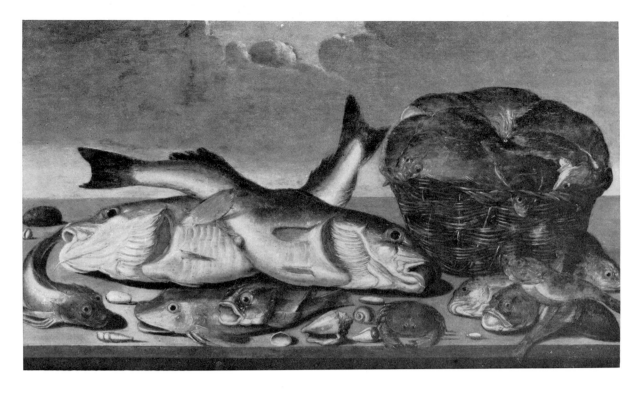

885

Willem Ormea

FISH-STALL

Signed and dated 1638
Wood, 54.5 × 92 cm.
Amsterdam, Rijksmuseum
No. 1794.

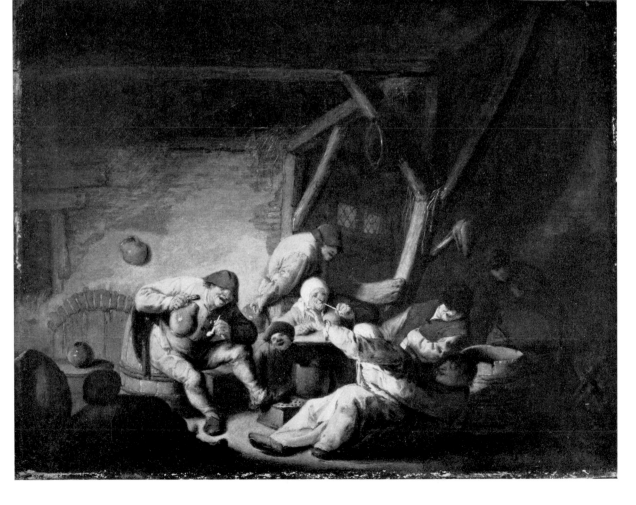

886

Adriaen van Ostade

MEN AND WIFES IN A BARN

Signed
Wood, 29,1 × 36,3 cm.
Munich, Alte Pinakothek,
No. 133.

Adriaen van Ostade

HURDY-GURDY PLAYER
OUTSIDE A PEASANT COTTAGE

Signed
Wood, 31.8 × 26.5 cm.
London, Lord Northbrook

Adriaen van Ostade

PEASANTS
OUTSIDE A COTTAGE

Signed
Canvas, 61 × 51 cm.
Cassel, Gallery
No. 275.

Adriaen van Ostade

A Slaughtered Pig

Signed and dated 1643
Wood, 61 × 49 cm.
Frankfurt, Staedel Institute
No. 1153.

Adriaen van Ostade

BOORS MAKING MERRY

Signed and dated 1647
Wood, 26.5 × 21.5 cm.
London, Dulwich College
Art Gallery
No. 115.

Isaac van Ostade

WOMAN WINDING YARN,
WITH A BOY,
OUTSIDE A COTTAGE

Signed
Wood, 44×37 cm.
Brussels,
Musée des Beaux-Arts
No. 343.

Isaac van Ostade

MAN PLAYING
A BARREL-ORGAN

Signed and dated 1641
Wood, 48×64.5 cm.
Bielefeld, private collection.

Isaac van Ostade

HALT AT A VILLAGE INN

Wood, 82.5×107.5 cm.
London, Buckingham Palace.

Isaac van Ostade

WINTER LANDSCAPE

Signed
Wood, 49 × 40 cm.
London, National Gallery
No. 848.

Adriaen Oudendijk

WAYFARERS AT A FOUNTAIN

Signed and dated 1700
Canvas, 67×83 cm.
Karlsruhe,
Staatliche Kunsthalle
No. 293.

Johannes Dircksz. Oudenrogge

WEAVER'S WORKSHOP

Signed and dated 1652
Wood, 41×56 cm.
Amsterdam, Rijksmuseum
No. 1824.

Johannes Dircksz. Oudenrogge

CANAL LANDSCAPE

Signed and dated 1649
Wood, 82×63.5 cm.
Formerly Paris,
Adolphe Schloss collection
No. 169.

Pieter van Overschee

STILL LIFE WITH FRUIT
AND DEAD BIRDS

Signed
Wood.
New York, private collection.

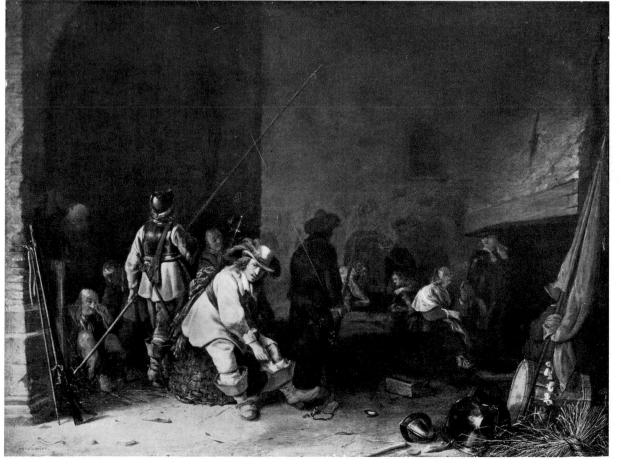

Anthonie Palamedesz.

GUARD-ROOM

Signed
Wood, 48 × 63 cm.
Formerly Vienna,
Liechtenstein Gallery
No. 512.

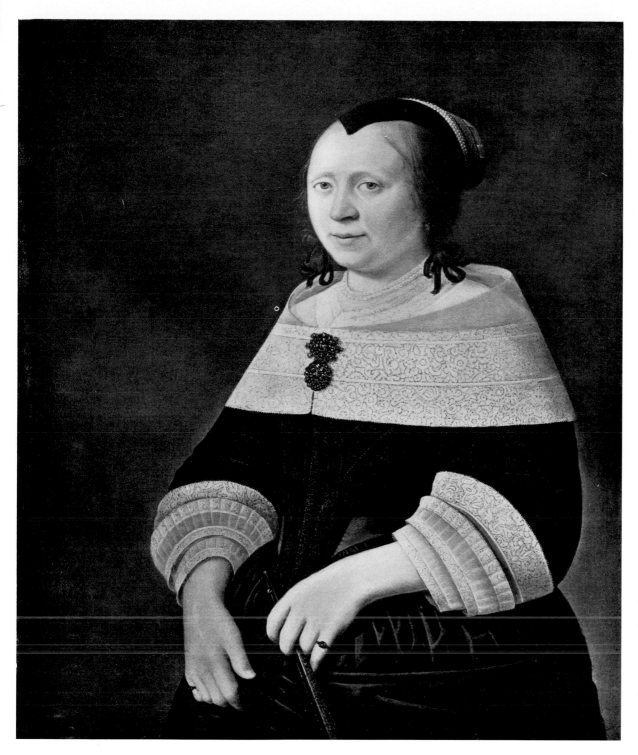

Anthonie Palamedesz.

PORTRAIT OF A WOMAN

Signed and dated 1655
Canvas, 84×70.5 cm.
Budapest,
Museum of Fine Arts
No. 1334 (343).

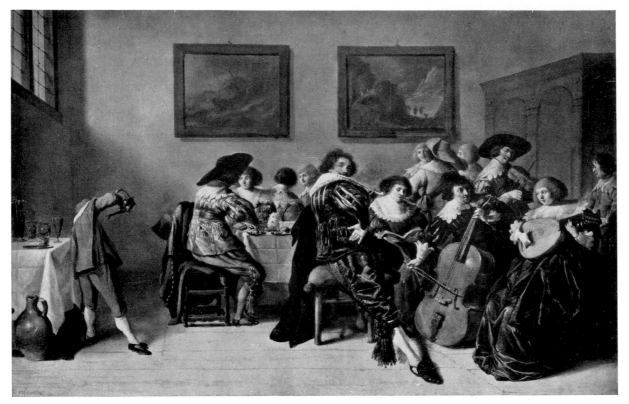

Anthonie Palamedesz.

MUSICAL COMPANY

Signed and dated 1632
Wood, 47.4×72.6 cm.
The Hague, Mauritshuis
No. 615.

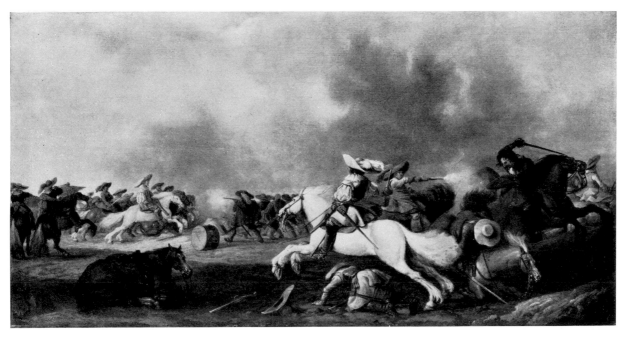

902

Palamedes Palamedesz.

CAVALRY SKIRMISH

Signed and dated 1638
Wood, 42×78.5 cm.
Vienna,
Kunsthistorisches Museum
No. 1306.

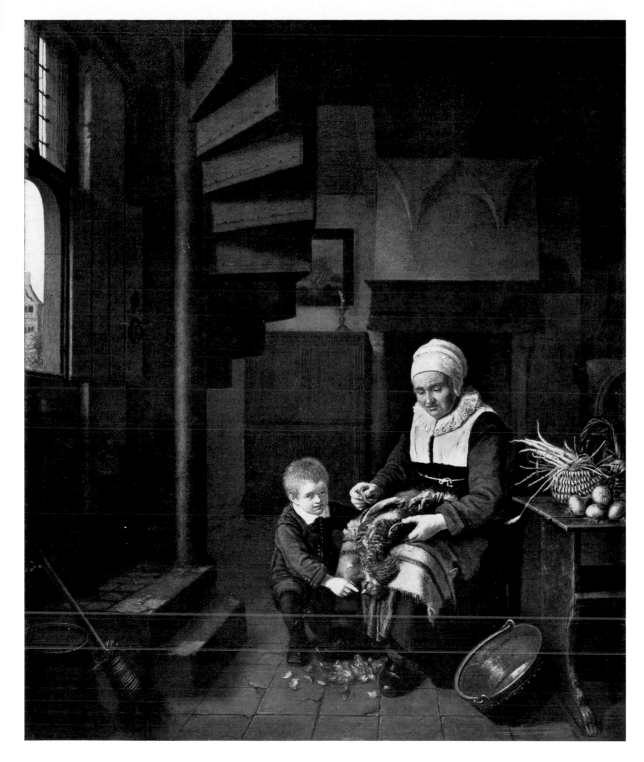

Abraham de Pape

OLD WOMAN
PLUCKING A FOWL

Signed
Wood, 49×41 cm.
The Hague, Mauritshuis
No. 130.

Horatius Paulyn

<small>Vanitas Still Life</small>

Signed
Canvas.
London, art trade.

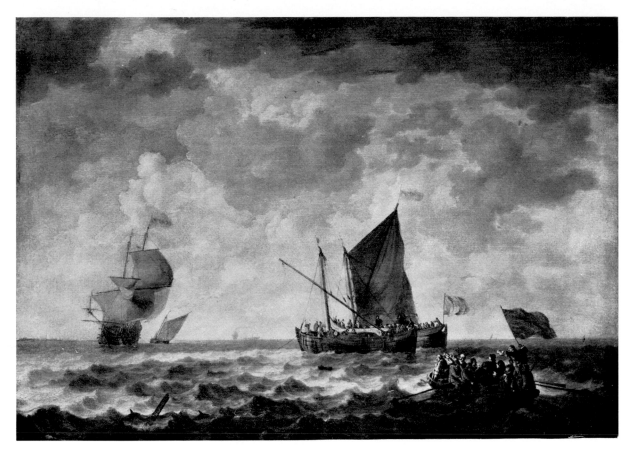

Bonaventura Peeters

SEASCAPE

With monogram
Wood, 40×56 cm.
Dresden, Gallery
No. 1150B.

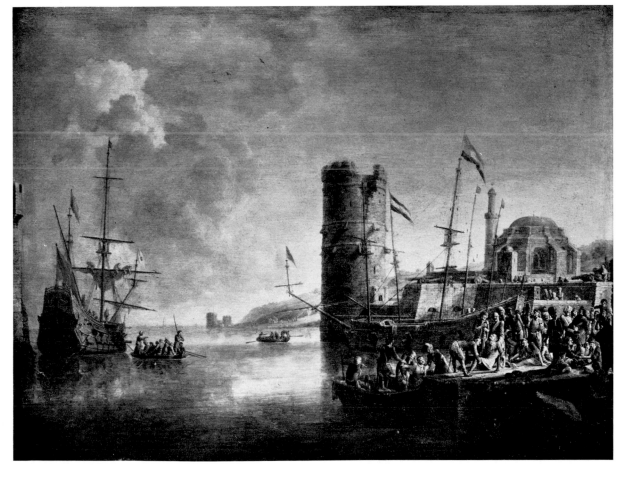

Bonaventura Peeters

MEDITERRANEAN HARBOUR

With monogram
Wood, 47×63 cm.
Vienna,
Kunsthistorisches Museum
No. 1001.

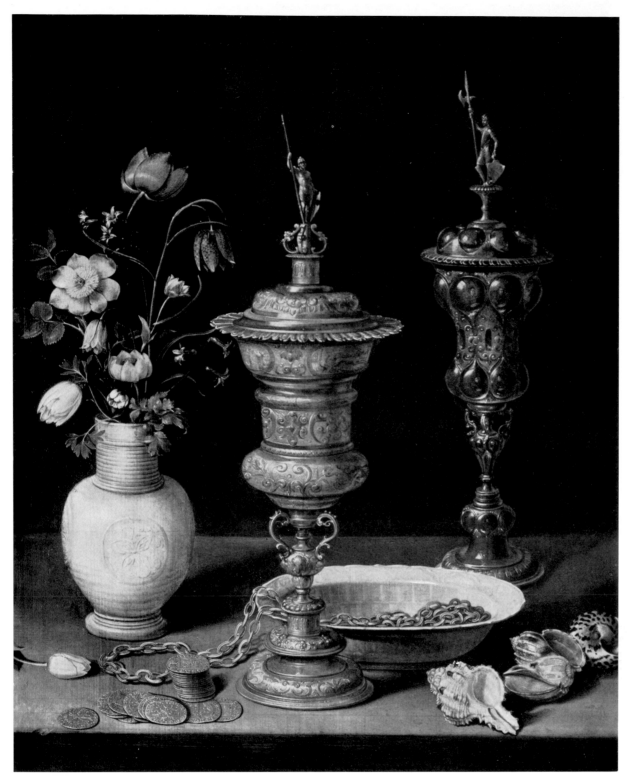

Clara Peeters

Still Life with
Gold Goblets

Signed and dated 1612
Wood, 60×49 cm.
Karlsruhe,
Staatliche Kunsthalle
No. 2222.

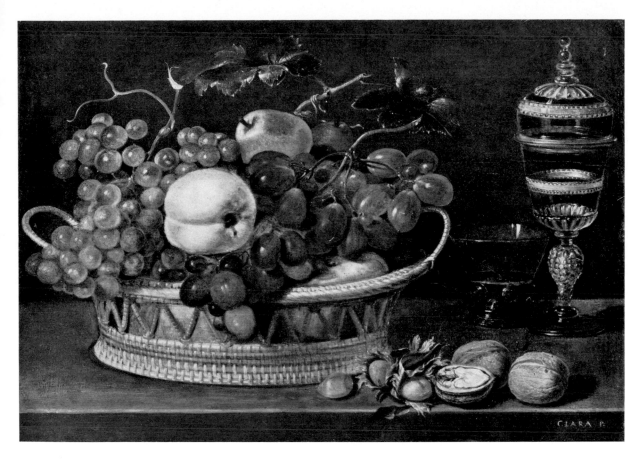

Clara Peeters

Fruit Still Life and
Glass Goblets

Signed
Wood, 32 × 50 cm.
Berlin, art trade.

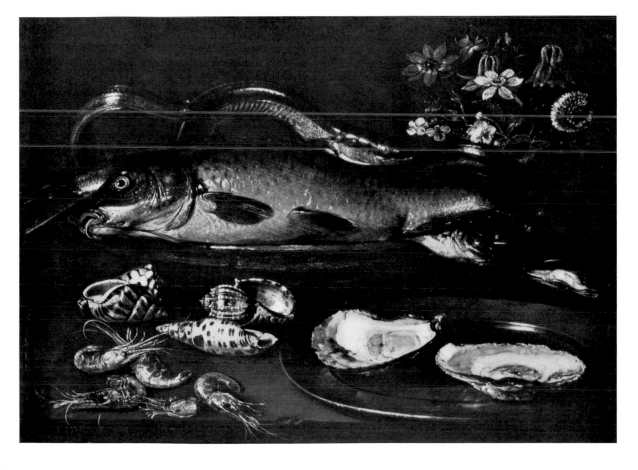

Clara Peeters

Fish Still Life

Signed
Wood, 25 × 35 cm.
Amsterdam, Rijksmuseum
No. 1848.

Gillis Peeters

Rocky Landscape
with Water-Mill

Signed and dated 1633
Wood, oval, 43 × 57.5 cm.
Amsterdam, Rijksmuseum
No. 1849.

Gillis Peeters

Landscape with Chapel

Signed
Wood, 42 × 62 cm.
Ebersteinburg (Baden),
private collection.

Jan Peeters

SEA BATTLE

With monogram; dated 1667
Canvas, 28×41 cm.
Cassel, Gallery
No. 167.

Jan Peeters

STORMY SEA

With monogram
Canvas, 86×102 cm.
Vienna,
Kunsthistorisches Museum
No. 1003.

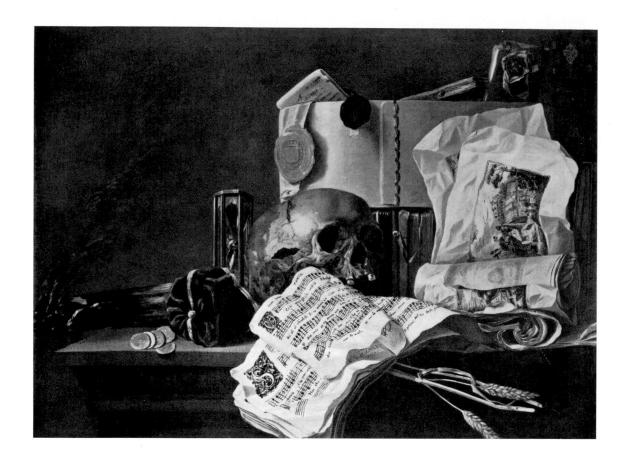

N. L. Peschier

Vᴀɴɪᴛᴀѕ Sᴛɪʟʟ Lɪꜰᴇ

Signed and dated 1659
Canvas, 63.5 × 86.5 cm.
(C. D. Rotch exhibited
London, Royal Academy, 1952,
No. 598.)

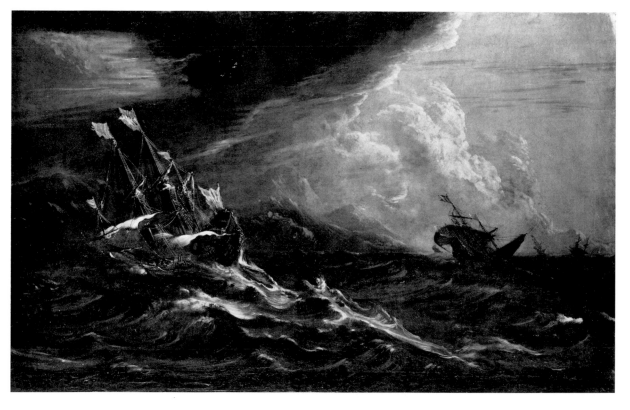

Matthieu van
Plattenberg

Sᴛᴏʀᴍʏ Sᴇᴀ

Canvas, 136 × 209 cm.
Augsburg, Gallery
No. 547.

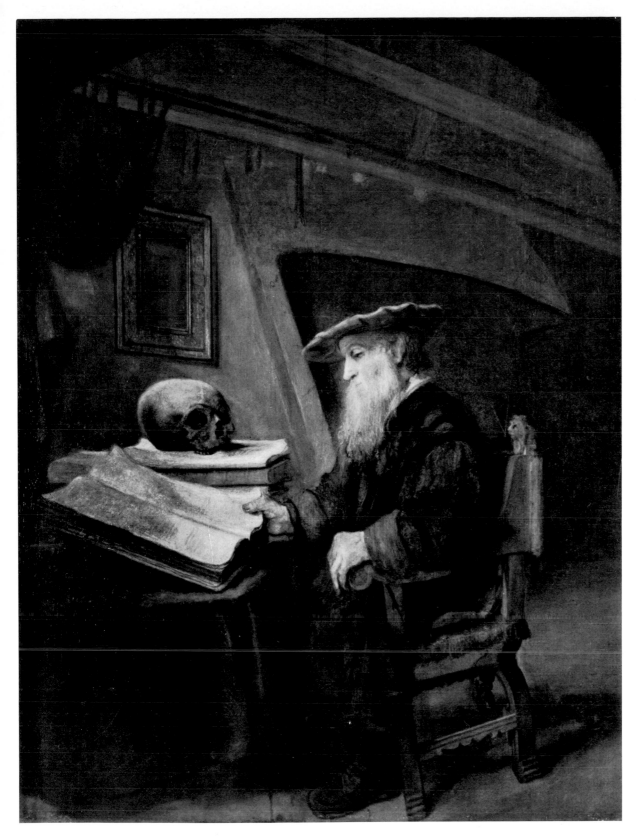

Carel van der Pluym

THE PHILOSOPHER

Signed and dated 1655
Wood, 54.9×42 cm.
Leiden, Municipal Museum
No. 357.

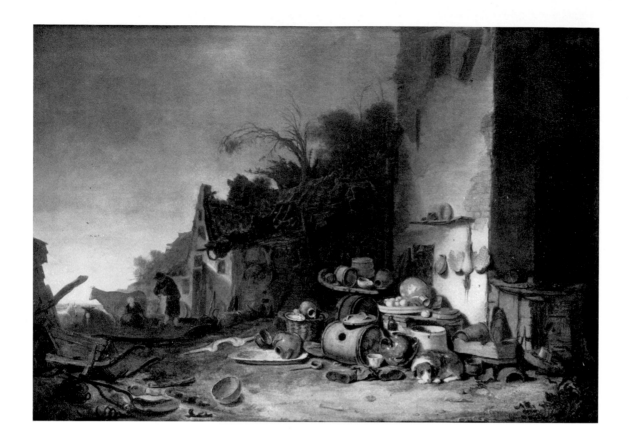

Egbert van der Poel

COURTYARD OF A
PEASANT HOUSE

Signed and dated 1646
Wood, 75 × 106 cm.
Nuremberg,
private collection.

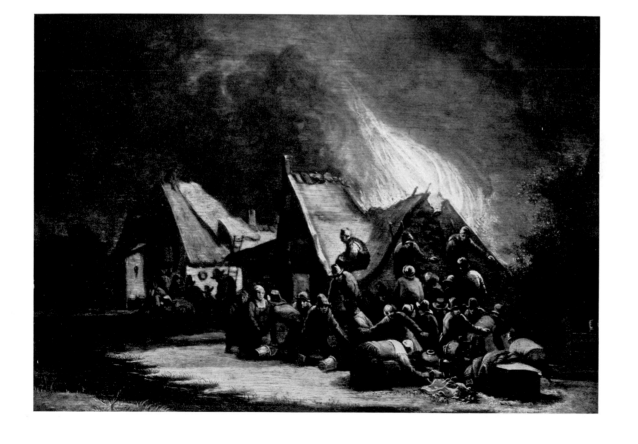

Egbert van der Poel

PEASANT COTTAGES ON FIRE

With monogram
Wood.
Berlin, art trade.

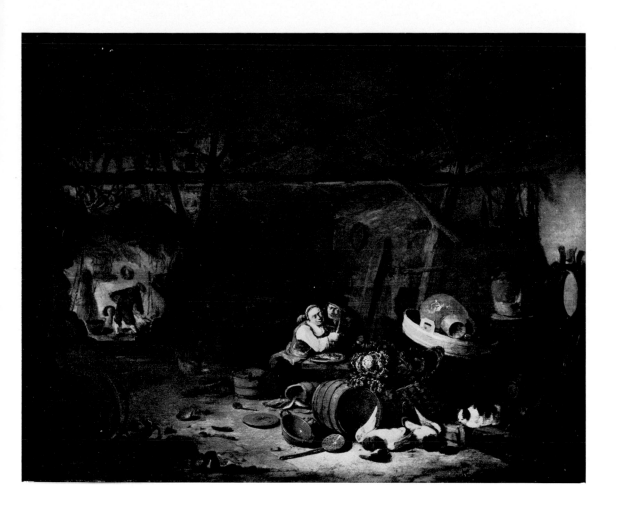

919

Egbert van der Poel

COUPLE IN A COTTAGE

Signed and dated 1648
Wood, 59.5 × 75.5 cm.
Dresden, Gallery
No. 1328.

920

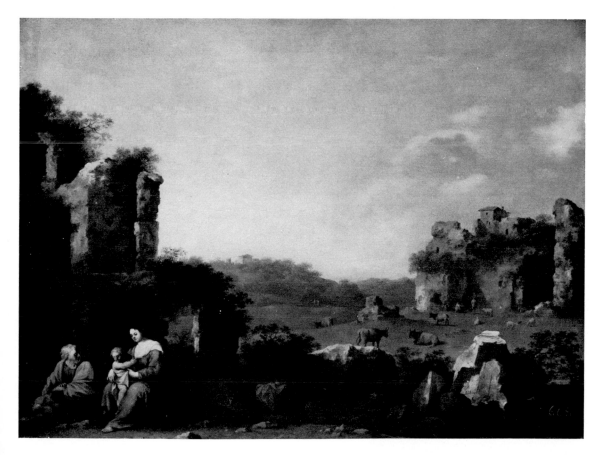

Cornelis van Poelenburgh

REST ON THE FLIGHT
INTO EGYPT

With monogram
Wood, 26 × 34.5 cm.
Dresden, Gallery
No. 1239.

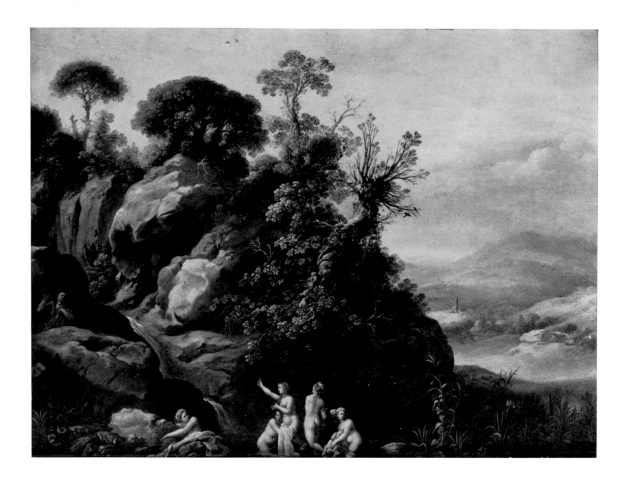

Cornelis
van Poelenburgh

DIANA AND ACTAEON

Copper, 44×56 cm.
Madrid, Prado
No. 2129.

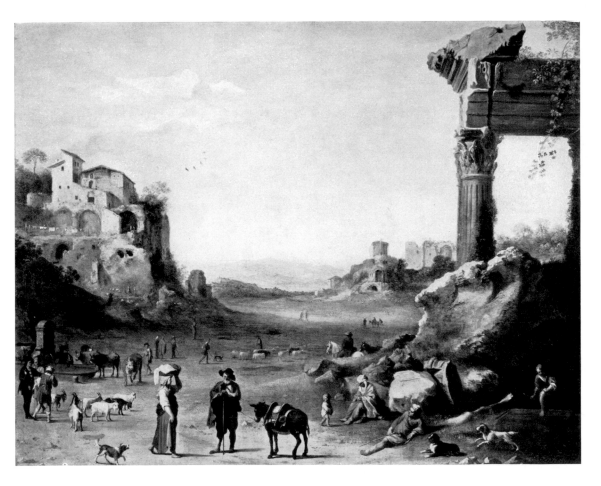

Cornelis
van Poelenburgh

PASTORAL SCENE AMONG
RUINS AND CASTLES

Signed
Wood.
London, Buckingham Palace.

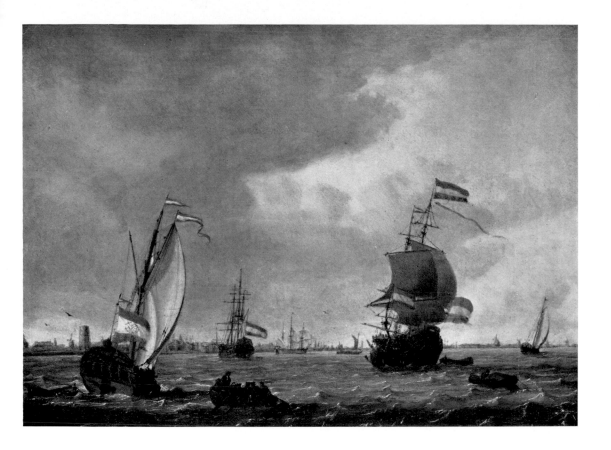

Gerrit Pompe

SEASCAPE WITH ROTTERDAM
IN THE BACKGROUND

Signed
Copper, 30×41 cm.
Rotterdam,
Boymans-Van Beuningen
Museum
No. 1671.

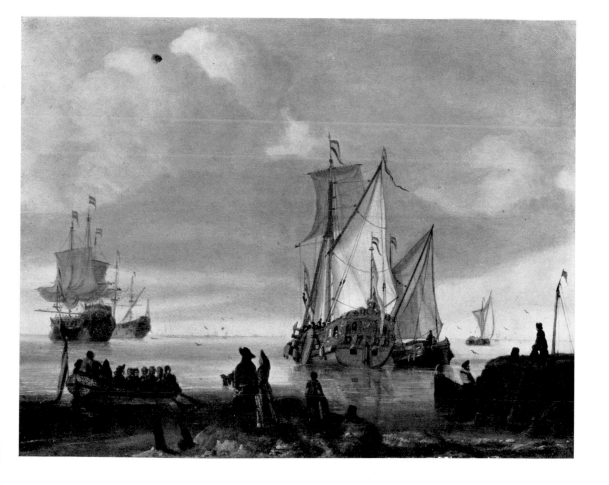

Gerrit Pompe

BEACH SCENE WITH A
CALM SEA

Signed and dated 1690
Wood, 38×47 cm.
Dublin,
National Gallery of Ireland.
No. 850.

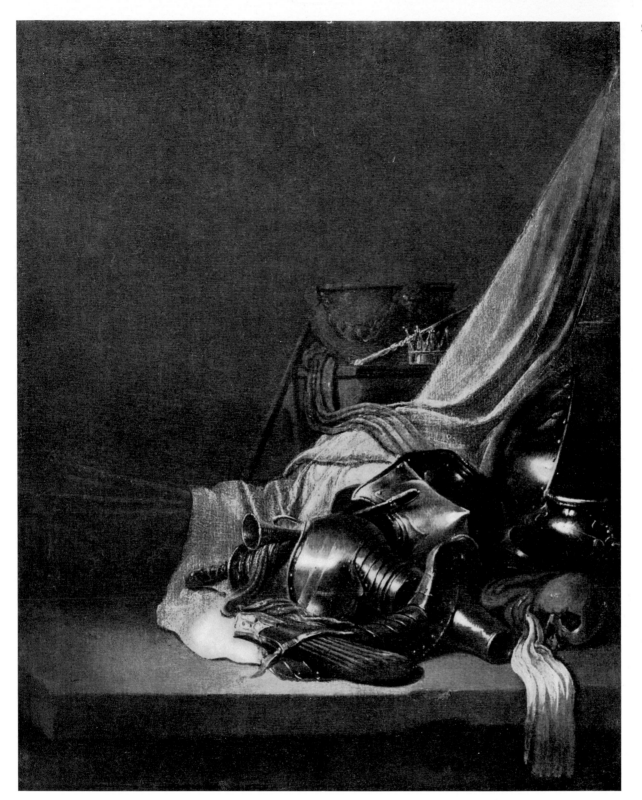

Willem de Poorter

STILL LIFE WITH WEAPONS

With monogram
Wood, 23.4 × 18.4 cm.
Brunswick,
Herzog-Anton-Ulrich Museum
No. 430.

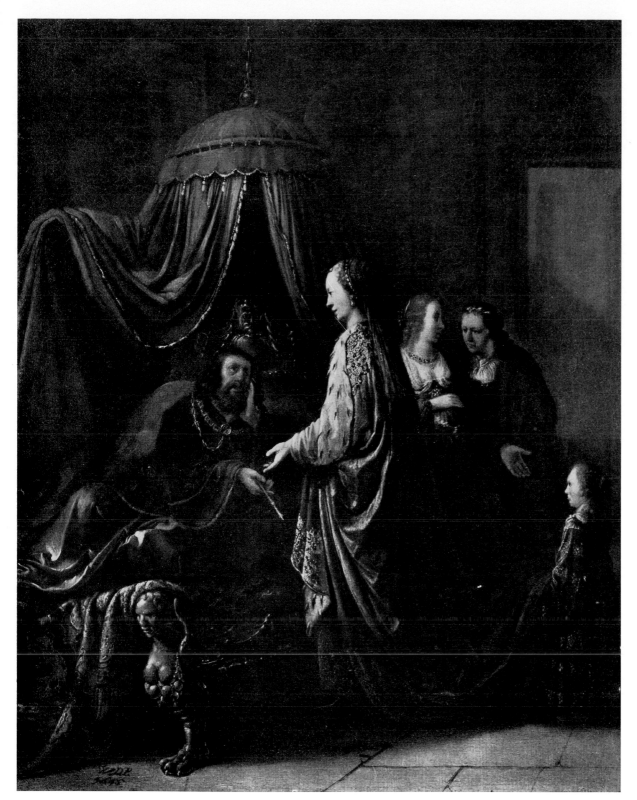

Willem de Poorter

ESTHER BEFORE AHASUERUS

With monogram; dated 1645
Wood, 40×32 cm.
Dresden, Gallery
No. 1389.

Jan Porcellis

WHALING-SHIPS

With monogram; dated 1624
Wood, 33 × 56 cm.
Dessau, Amalienstift
No. 75.

Jan Porcellis

FISHING-BOATS IN A
CHOPPY SEA

Wood, 34 × 40 cm.
Berlin, Staatliche Museen
No. 832B.

929

Julius Porcellis

CALM SEA

With monogram
Canvas, 32×57 cm.
Darmstadt, Landesmuseum
No. 303.

930

Frans Post

BRAZILIAN LANDSCAPE

Signed and dated 1664
Wood, 34.2×41 cm.
Sarasota, Fla., John and
Mable Ringling Museum
of Art.

Frans Post

WATERFALL IN A BRAZILIAN
LANDSCAPE

Signed and dated 1647
Wood, 59×46 cm.
Frankfurt, Staedel Institute
No. 1794.

Pieter Post

CAVALRY ENGAGEMENT

Signed and dated 1631
Wood, 34.7 × 53 cm.
The Hague, Mauritshuis
No. 765.

Hendrick Gerritsz. Pot

A FLIRTATIOUS COMPANY

With monogram
Wood, 41 × 56 cm.
The Hague, Mauritshuis
No. 475.

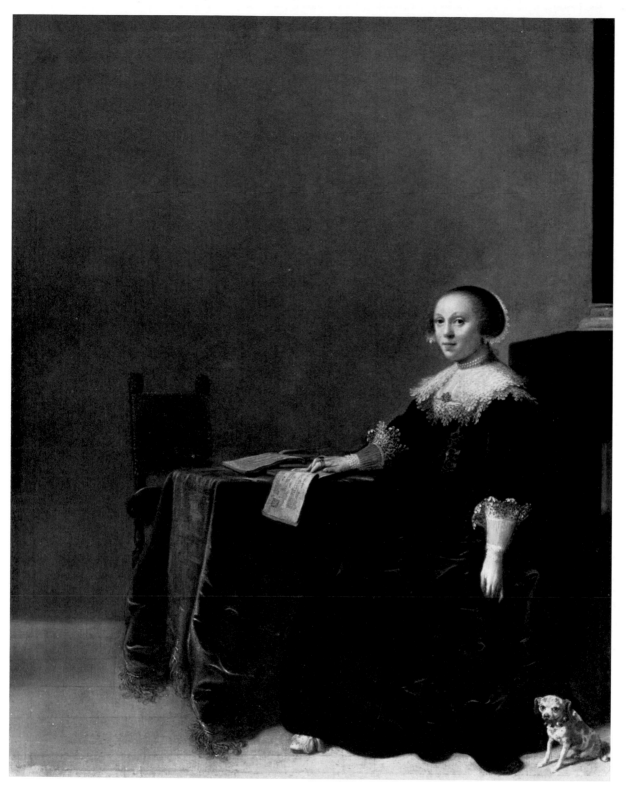

Hendrick Gerritsz. Pot

PORTRAIT OF A LADY

Wood, 43 × 34 cm.
Formerly Vienna,
Liechtenstein Gallery

Hendrick Gerritsz. Pot

PORTRAIT OF
J. VAN DEN VONDEL

With monogram
Wood, 34×26.5 cm.
Amsterdam, Rijksmuseum
No. 1907a.

Johann Potheuck

STILL LIFE WITH FRUIT

Signed and dated 1667
Canvas, 67×60 cm.
Formerly Hanover,
Cumberland collection.

Paulus Potter

Two Huntsmen
outside an Inn

Signed and dated 1650
Wood, 53.6×41 cm.
Leningrad, Hermitage
No. 1053.

Paulus Potter

COWS REFLECTED
IN THE WATER

Signed and dated 1648
Wood, 44×61.5 cm.
The Hague, Mauritshuis
No. 137.

Paulus Potter

ORPHEUS CHARMING
THE ANIMALS

Signed and dated 1650
Canvas, 67×89 cm.
Amsterdam, Rijksmuseum
No. 1912.

Paulus Potter

CATTLE GRAZING

Signed and dated 1648
Wood, 50×74 cm.
Cassel, Gallery
No. 369.

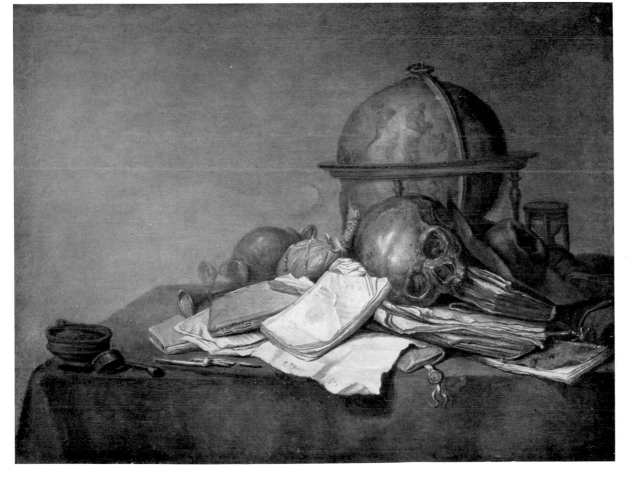

Pieter Symonsz. Potter

VANITAS STILL LIFE

Signed and dated 1636
Wood, 27×35 cm.
Berlin, Staatliche Museen
No. 921A.

Pieter Symonsz. Potter

LANDSCAPE WITH BRIDGE

Signed
Wood, 80.8 × 54.8 cm.
Munich, art trade.

Pieter Symonsz. Potter

INTERIOR WITH SOLDIERS

Signed and dated 1632
Wood, 33×42 cm.
Formerly Linz Museum.

Hendrik Potuijl

RUSTIC INTERIOR

Signed
Wood, 56.3×82.5 cm.
Budapest,
Museum of Fine Arts
No. 1972 (460).

944

Pieter de Putter

FISH STILL LIFE

Signed
Wood, 44×99 cm.
Karlsruhe,
Staatliche Kunsthalle
No. 1043.

945

Christoffel Puytlinck

CAT, DOG AND POULTRY

Signed
Canvas, 98×116 cm.
Schleissheim, Gallery
No. 4114.

Adam Pynacker

ITALIAN FOREST LANDSCAPE
WITH SHEPHERDS

Canvas, 126 × 106.5 cm.
Munich, art trade.

Jacob Pynas

THE TOMB OF VIRGIL

Signed and dated 1628
Wood, 47×62 cm.
London, Dr E. Schapiro.

Jacob Pynas

THE DREAM OF
NEBUCHADNEZZAR

Signed
Wood, 75×121 cm.
Munich, Alte Pinakothek.

Jacob Pynas

THE SACRIFICE AT LYSTRA

Signed and dated 1628
Wood, 64×105 cm.
Amsterdam, Rijksmuseum
No. 1931.

Jan Pynas

THE DEPARTURE OF HAGAR

Signed and dated 1614
Wood, 78×106 cm.
Paris, art trade.

Jan Pynas

CHRIST ON THE CROSS

Signed
Wood, 116 × 84.5 cm.
The Hague, Mauritshuis
No. 131.

Pieter Quast

Couple Making Music

Signed and dated 1636
Wood, 22.5 × 19 cm.
Budapest,
Museum of Fine Arts
No. 8533.

Pieter Quast

AT THE DENTIST'S

Signed
Wood, 37.5 × 54 cm.
Munich, Alte Pinakothek.

Pieter Quast

MEN DRINKING
AND SMOKING

With monogram
Wood, 20.5 × 20.5 cm.
Munich, art trade.

Erasmus Quellinus

THE ADORATION
OF THE SHEPHERDS

Signed
Canvas, 59×82 cm.
Augsburg, Gallery
No. 481.

Hubert van Ravesteyn

IN THE COWSHED

Signed
Canvas, 87×108.5 cm.
Amsterdam,
Frederik Muller sale,
26 May 1914
No. 341.

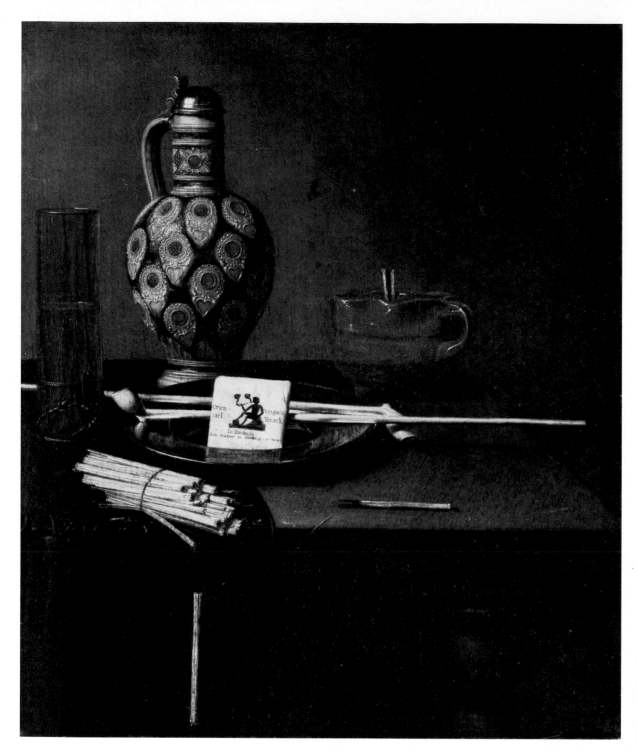

Hubert van Ravesteyn

STILL LIFE WITH
SMOKING IMPLEMENTS

With monogram and
dated 1664
Wood, 42 × 34 cm.
Amsterdam, Rijksmuseum,
No. 1974.

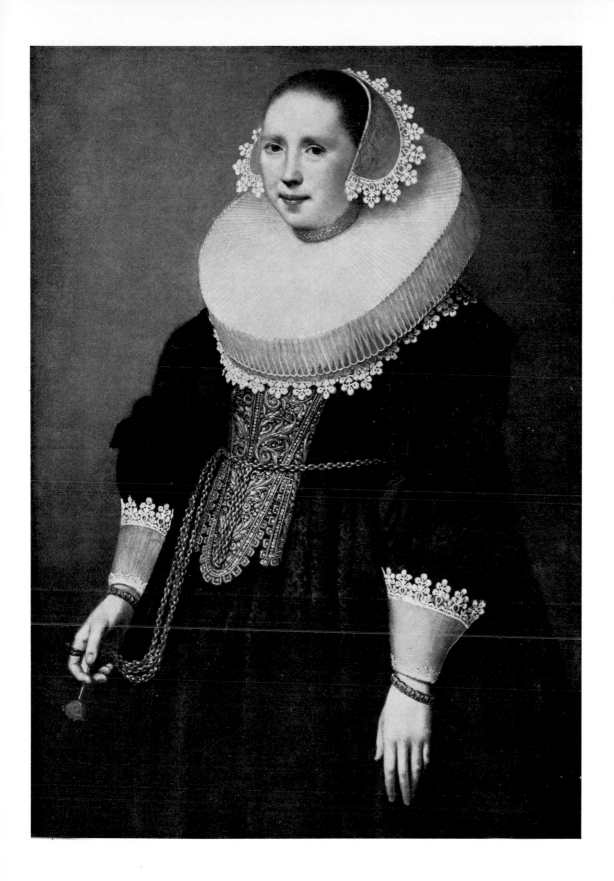

Jan Anthonisz. van Ravesteyn

PORTRAIT OF A LADY IN BLACK

Signed
Wood, 102 × 73 cm.
Munich, Alte Pinakothek
No. 320.

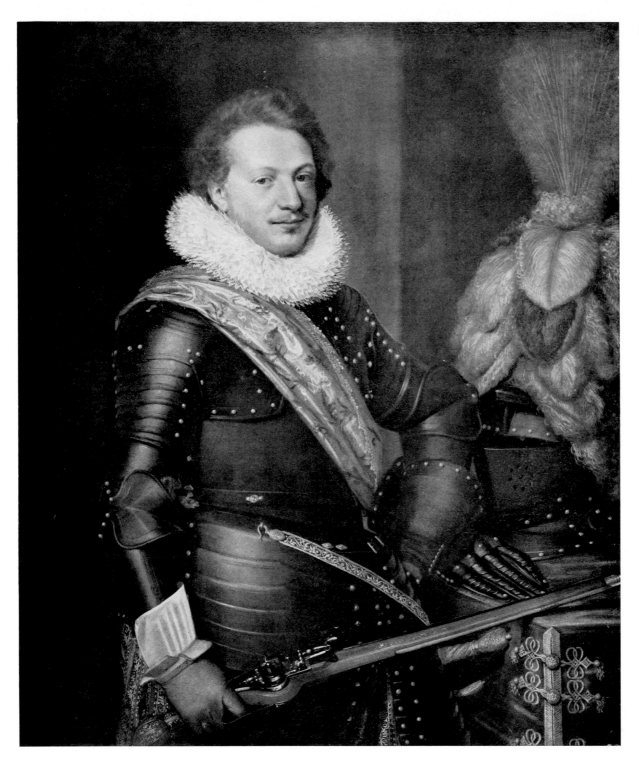

Jan Anthonisz.
van Ravesteyn

PORTRAIT OF AN OFFICER

Canvas, 110×92 cm.
The Hague, Mauritshuis
No. 438.

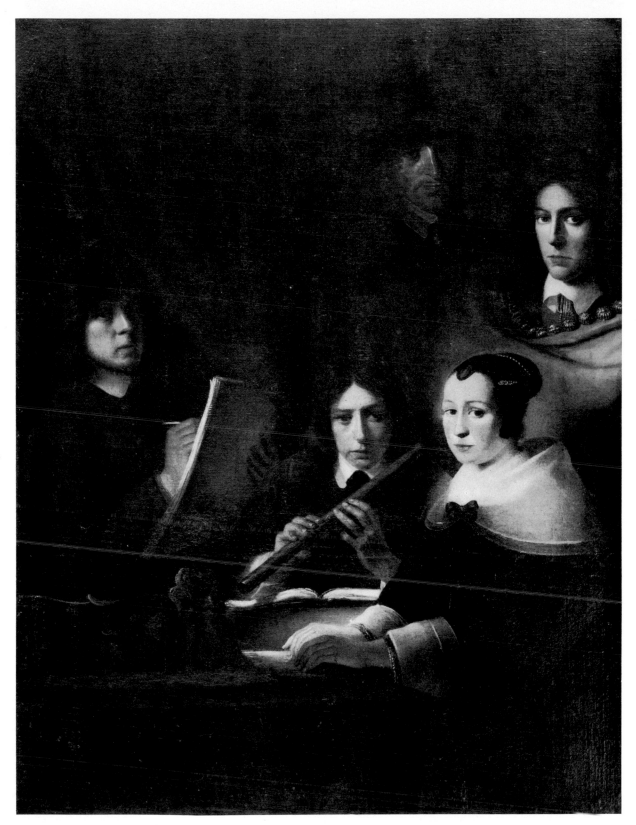

Constantyn van Renesse

A FAMILY CONCERT

Signed and dated 1651
Canvas, 152.5 × 116.5 cm.
Salzburg, Residenzgalerie
No. 102.

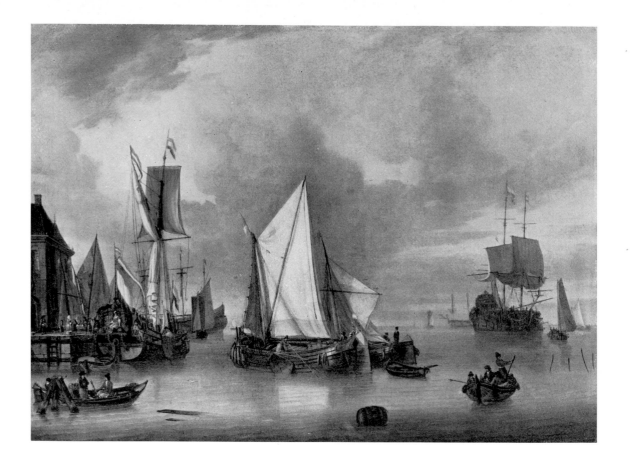

Jan Claesz. Rietschoof

Calm Sea

With monogram
Canvas, 60 × 81 cm.
Amsterdam, Rijksmuseum
No. 2032.

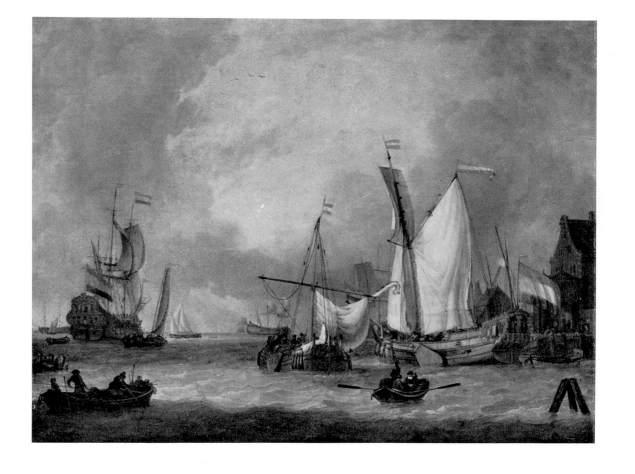

Jan Claesz. Rietschoof

Rough Sea

With monogram
Canvas, 61 × 81 cm.
Amsterdam, Rijksmuseum
No. 2033.

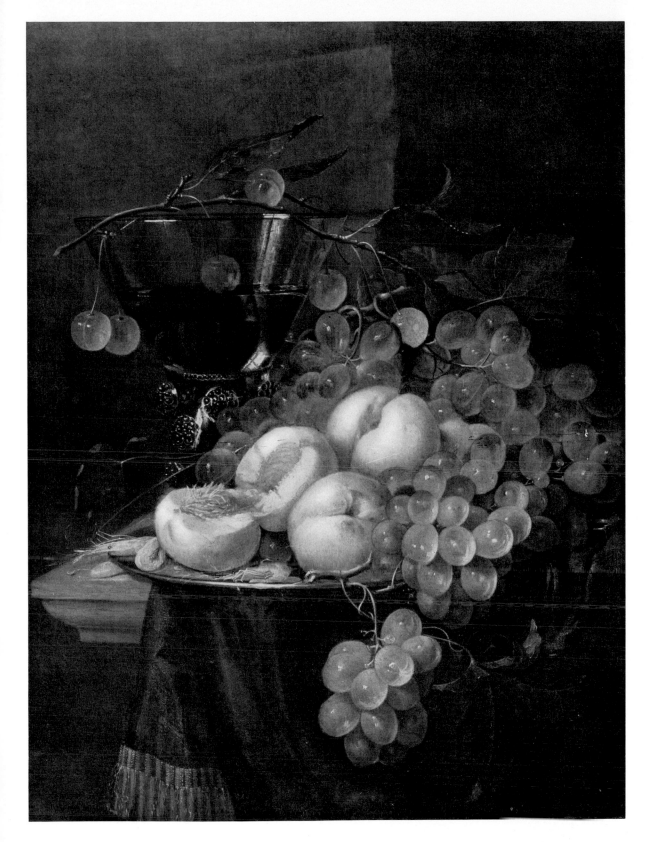

Pieter de Ring

FRUIT STILL LIFE

Signed with a ring
Wood, 48×37 cm.
Frankfurt, Staedel Institute
No. 1277.

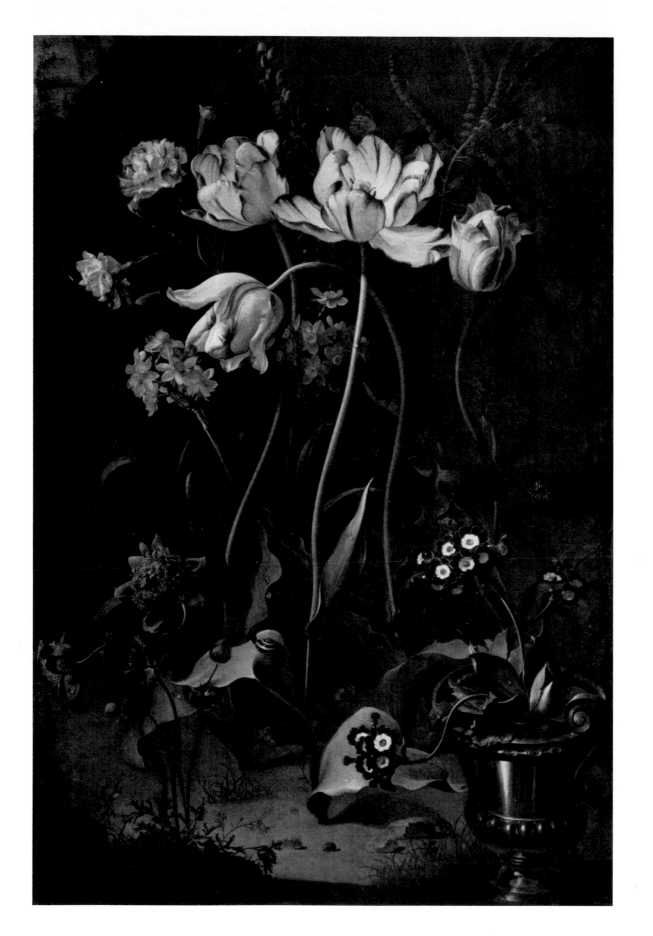

Conraet Roepel

FLOWERS IN A GARDEN

Signed and dated 1715
Canvas, 81.5 × 54.5 cm.
Miss K. McDonall (exhibited
London, Royal Academy, 1952
No. 634.)

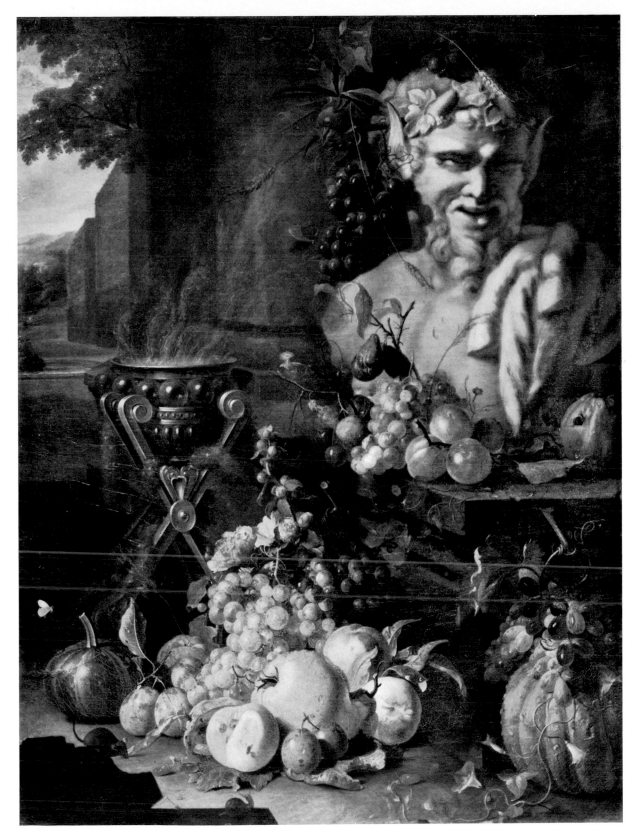

Conraet Roepel

<small>Fruit beside an
Altar of Pan</small>

Signed and dated 1723
Canvas, 97 × 76 cm.
Cassel, Gallery
No. 453.

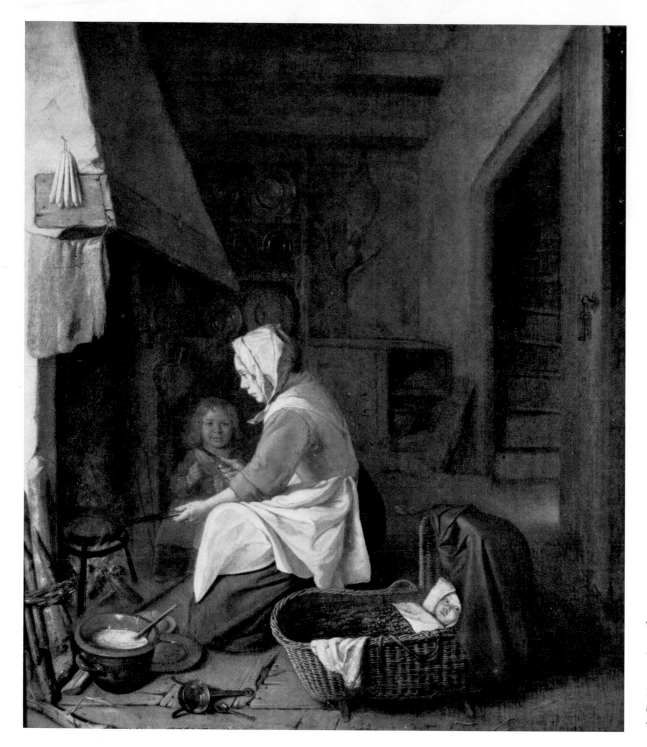

Pieter Gerritsz.
van Roestraeten

WOMAN FRYING PANCAKES

Signed and dated 1678
Canvas, 77.5×65 cm.
The Hague, Bredius Museum

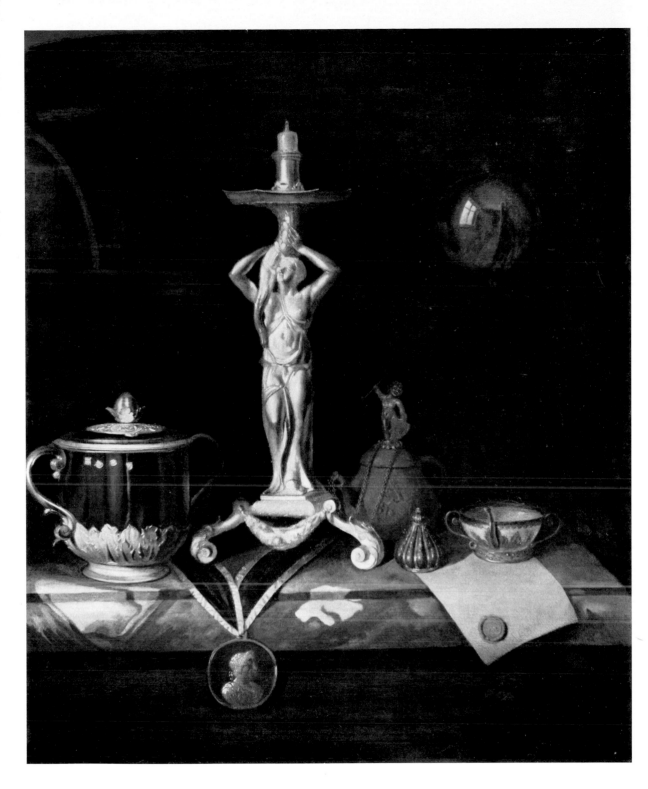

Pieter Gerritsz.
van Roestraeten

Still Life

Canvas, 76×62.5 cm.
Munich, art trade.

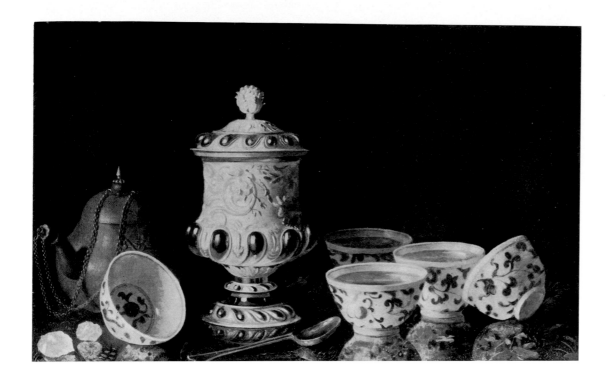

Pieter Gerritsz.
van Roestraeten

STILL LIFE OF CROCKERY
AND VESSELS

Canvas, 35 × 47 cm.
Berlin, Staatliche Museen
No. 2010.

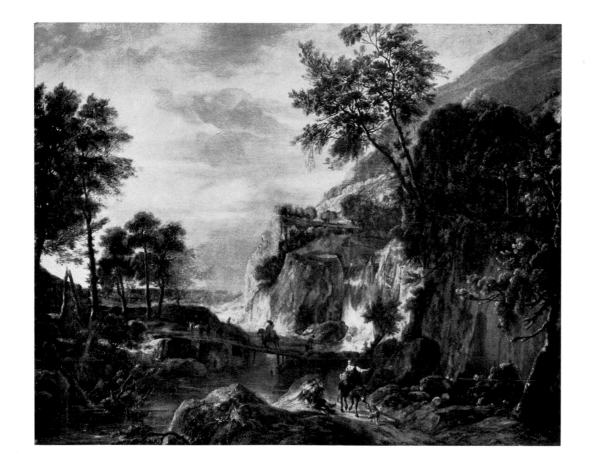

Roeland Roghman

MOUNTAIN LANDSCAPE
WITH TREES

Canvas, 123 × 151 cm.
Amsterdam, Rijksmuseum
No. 2045.

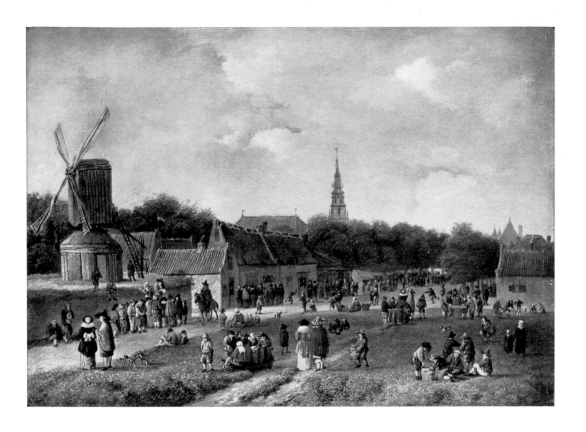

Gillis Rombouts

VILLAGE MARKET
NEAR A WINDMILL

Signed and dated 1657
Wood, 47.5 × 64 cm.
Dresden, Gallery
No. 1510.

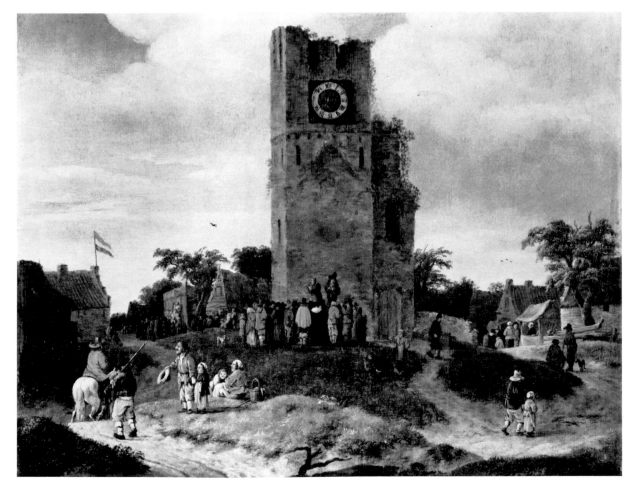

Gillis Rombouts

LANDSCAPE WITH
RUINED TOWER

Wood, 46 × 58 cm.
Munich, art trade.

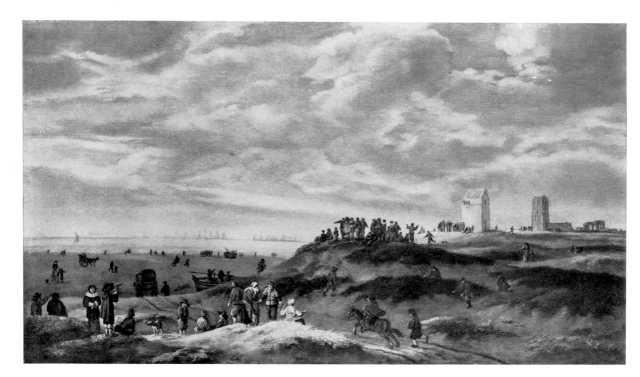

Gillis Rombouts

SEA-SHORE

Signed
Wood, 42 × 71 cm.
Formerly Munich,
Alte Pinakothek
No. 563.

Salomon Rombouts

FISHERMAN'S COTTAGE

Wood, 61 × 81.5 cm.
Frankfurt, Staedel Institute
No. 274.

Salomon Rombouts

PATH THROUGH THE WOODS

Signed
Canvas, 64 × 52 cm.
Budapest,
Museum of Fine Arts
No. 227 (534).

Salomon Rombouts

WINTER LANDSCAPE

Signed
Wood, 65.3 × 56.7 cm.
Recklinghausen,
private collection.